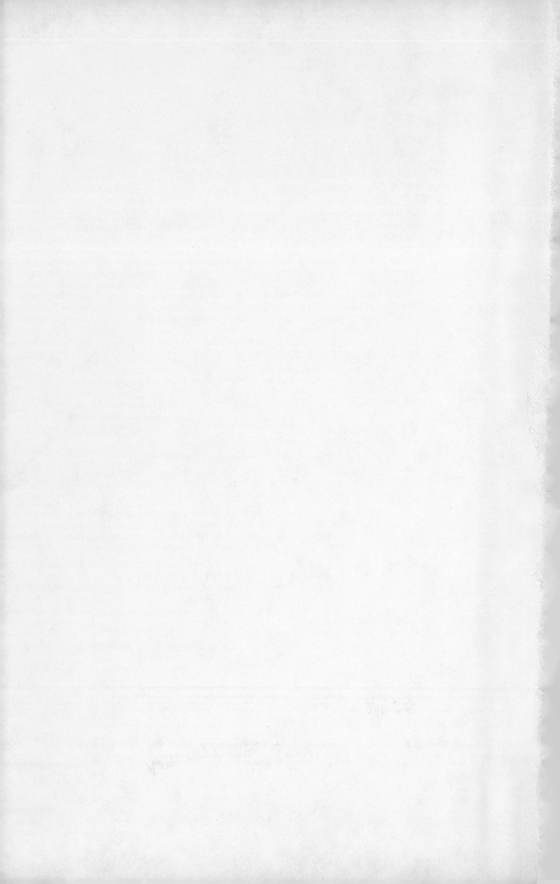

ROMANESQUE SCULPTURE
IN AMERICAN COLLECTIONS

Volume 1:
NEW ENGLAND MUSEUMS

Publications of the International Center of Medieval Art, 1

Romanesque Sculpture
in American Collections

Volume 1:
NEW ENGLAND MUSEUMS

WALTER CAHN *and* LINDA SEIDEL

Yale University *University of Chicago*

BURT FRANKLIN & CO., INC.
NEW YORK

Published in 1979 by Burt Franklin & Co.
235 East Forty-fourth Street
New York, New York 10017

© 1979 by Burt Franklin & Co., Inc.

Library of Congress Cataloging in Publication Data
Cahn, Walter.
 Romanesque sculpture in American collections.

 Includes bibliographies and indexes.
 1. Sculpture, Romanesque—United States—Catalogs. 2. Sculpture—United
States—Catalogs. 3. Art museums—United States—Catalogs. I. Seidel, Linda, joint
author. II. Title
NB175.C33 734'.24'074013 78-9908 ISBN 0-89102-131-0

Designed by Bernard Schleifer

Manufactured in the United States of America

Contents

Abbreviations of Frequently Cited Works

Aubert-Beaulieu,
Description raisonnée

M. Aubert and M. Beaulieu, *Musée du Louvre. Description raisonnée des sculptures du Moyen Age*, Paris, 1950

Brummer I

The Notable Art Collection belonging to the Estate of the late Joseph Brummer, Park I, Parke-Bernet Galleries, New York, April 20, 21, 22, and 23, 1949.

Brummer II

Part Two of the Notable Collection belonging to the Estate of the late Joseph Brummer, Parke-Bernet Galleries New York, May 11, 12, 13, and 14, 1949.

Brummer III

Classical and Medieval Stone Sculptures including Pieces Suitable for Garden and Patio, Furniture and Works of Art, Part III of the Joseph Brummer Collection, Parke-Bernet Galleries, New York, June 8 and 9, 1949.

Bull. mon.

Bulletin monumental

Bull. Soc. Nat. Antiq. France

Bulletin de la Société Nationale des Antiquaires de France

Congrès arch.

Congrès archéologique de France

George and Guérin-Boutaud,
Églises romanes

J. George and A. Guérin-Boutaud, *Les églises romanes de l'ancien diocèse d'Angoulême*, Paris, 1928.

Grivot-Zarnecki, *Gislebertus*

D. Grivot and G. Zarnecki, *Gislebertus, Sculptor of Autun*, New York, 1961.

Mesplé, *Sculptures romanes*

P. Mesplé, *Toulouse, Musée des Augustins. Les sculptures romanes*, Paris, 1961.

Salet-Adhémar, *Vézelay*

F. Salet and J. Adhémar, *La Madeleine de Vézelay*, Melun, 1948.

Scher, *Renaissance*

S. Scher, *The Renaissance of the Twelfth Century*, Museum of Art, Rhode Island School of Design, Providence, 1969.

Preface

The present volume is the first of an expected three which will constitute a comprehensive catalogue of Romanesque sculpture in American collections. The text is based on successive installments of an inventory which appeared in the journal *Gesta,* published by the International Center of Medieval Art, beginning in 1967. However, some revisions have been made to correct errors of both omission and commission. An effort has also been made to incorporate observations found in the scholarly literature subsequent to the beginning of the series. Acquisitions of Romanesque sculpture by museums in the period from 1967 to 1976, though not voluminous, have also been added to our list. Finally, it was possible in a number of instances to improve the visual record of this sculpture through the substitution of new photographs.

The carvings here studied are in their vast majority datable between the mid-eleventh and mid-twelfth centuries. The earliest of these chronological boundaries was fairly easy to draw since a considerable stylistic gap separates this sculpture from an older and comparatively smaller body of early Medieval sculpture, chiefly of north Italian and Hispano-Moresque origin, in public collections in this country. At the other end of the time spectrum, greater difficulties presented themselves since the dividing line between Romanesque and Gothic, scarcely very obscure in the abstract, is bound to stand out less sharply in the endless variety of idiomatic combinations encountered near the point of transition between the two styles. While works definitely classifiable as Gothic have been

excluded, we found it necessary to proceed with a measure of arbitrariness in those cases where the survival of Romanesque elements substantially qualified allegiance to the newer style. Thus, some carvings datable as late as the middle of the thirteenth century have been included, while others, much closer chronologically to the earliest formulation of Gothic art, have been omitted. In the adjudication of these borderline cases, works of exceptional interest were understandably apt to sway us into a more inflationary stance.

Sculpture has been taken to refer to works in stone or wood, following the distinction generally observed in the literature between "monumental" art and carving in ivory or goldsmithwork. Although this distinction should not be excessively emphasized, students of ivory carving are still well served by Goldschmidt's great corpus, now in the process of republication, which could usefully be completed by a handful of additional entries, but not easily superseded. Goldsmithwork has received less extensive attention, and we can only express the hope that the compilation of a detailed inventory of eleventh- and twelfth-century metalwork in this country will one day be undertaken under appropriate auspices.

The treatment of works of doubtful authenticity posed a more delicate problem. In the original *Gesta* publication, such works were omitted altogether, since it seemed to the authors that they could not literally be described as Romanesque sculpture. This course of action, however, was not devoid of sophistry, and also entailed the risk of some confusion, since readers were left to decide for themselves whether omission implied that the work in question could not be accepted as authentic, or only that we had overlooked it. In the present publication, we have therefore appended to our revised catalogue a list of questionable pieces, representing, in our judgment, carvings of comparatively recent workmanship.

We must acknowledge with gratitude the cooperation of the institutions whose collections of Romanesque sculpture are dealt with here, and especially the respective curators and registrars who facilitated our access to the works of concern to us. We also sought and received advice from scholars with special expertise in different aspects of the subject, to whom we wish to express our thanks: the late Professor René Crozet, Léon Pressouyre, Professor Whitney Stoddard, M. David Simon, Neil Stratford, Dorothy Glass, Ron Malmstrom, Pierre Quarré, and Marcel Durliat.

Introduction

History has exempted America from the experience of a European medieval past and left its land unmarked by ramparts, high vaulted halls, and spires. Men of the Enlightenment, the Founding Fathers were not disposed to repair this oversight. Although in the criticism of the monarchy of George III, they might refer with favor to the supposed freedom of the Saxon tribes, the art of the Middle Ages held no appeal for them and could be only a testimony to the effects of political oppression, religious superstition, and general ignorance. Medieval forms first arrived on this continent in the early decades of the nineteenth century, and especially after 1830, when the prevailing classicism was challenged by the vogue of the picturesque. Gothic architecture presented itself in this initial manifestation in an often playful and vaguely exotic guise. After its domestication, a more severe and archaeologically correct version of the style imposed itself. Romanesque architecture, as the late Carroll Meeks has demonstrated, entered into the stream of Romantic revivals in America with Richard Upjohn's Church of the Pilgrims in Brooklyn (1844–46). The style was preferred to Gothic by its defenders for its comparatively greater massiveness and severity of outline, which preserved something of the quality of Greek and Roman monuments. It was also felt in certain quarters to constitute an attractive contrast to the ornate aspect of many Gothic revival buildings in England with their unwelcome association with the aristocracy and the Anglican High Church. "Its entire

1

expression," wrote Robert Dale Owen in 1849, "is less ostentatious, and if political character may be ascribed to architecture, more Republican." What was understood to be Romanesque at this time by the practitioner was an eclectic mixture of late-Roman, Syrian, Norman, and other styles vaguely localizable somewhere between the end of the Roman Empire and the beginning of Gothic art, with, as a common point of reference, a predilection for sturdy masonry construction marked by round arches. This expansive definition corresponded well enough to the significance attached to the term when it was first introduced into the descriptive vocabulary of architectural history by the Norman antiquarian Adrien de Gerville in 1816: Romanesque had been the vernacular of peoples newly settled in the former Roman Empire, a kind of common speech on the outer margins of high latinity.

An idea more fruitful in its implications lay in the view of Romanesque as a style cut short in its development before it had reached full maturity. Nineteenth-century revivals combined a profound respect for historical styles with the notion that these, with the intervening progress of civilization, could be "resumed" and brought to perfection. The possibility of a further improvement of the Gothic style, however, seemed fraught with difficulty in view of the high level of refinement which it had achieved by the end of the fifteenth century. Romanesque, by contrast, was less constraining, because it was a "rude and clumsy" style to which the contemporary architect could minister with greater chances of success. Modern Romanesque, therefore, was not to imitate the monuments of the early Middle Ages, but to take them as a point of departure, completing the process of growth interrupted by the onset of Gothic architecture in the middle of the twelfth century.

Such a program was perhaps best realized, if not intentionally so, in H. H. Richardson's Trinity Church in Copley Square in Boston (1875). It is true that recent criticism has tended to minimize the specifically Romanesque component in this famous building and the architect's oeuvre more generally, emphasizing his equal interest in other styles and bringing to the fore the High Victorian roots of his art. The powerful and highly personal stamp which is impressed on his designs is certainly far from the spirit of pious archaeological replication. But the true nature of his achievement in a historical perspective may not be wholly synonymous with the picture formed by his contemporaries nor indeed with the aims of

the master himself. Compared to the Romanesque of the 1850s and 1860s, Richardson's was immeasurably more authoritative even if its relation to the original style could arguably be said to be nearly equally remote. It thus became habitual among historians of American architecture to take the building of Trinity Church as a start of the Romanesque revival and to credit Richardson with having initiated this development. According to Edward Freeman, writing only three years after the dedication of the church, the success of Romanesque architecture in America was indicative of the influence of one man unparalleled "in the progress of building art, except for the work of Sir Christopher Wren." And on the dimensions of this success in quantitative and qualitative terms, Montgomery Schuyler could write as early as 1891 that "the body of Romanesque work in this country is now more extensive and on the whole more meritorious than the building of any other style which our architects had previously taken as a point of departure, excepting only the Gothic revival."

The acquaintance of Americans with Romanesque in its original form must have been extremely limited at this time. Richardson could have seen some comparatively modest examples of it in and around Paris during his student days at the École des Beaux-Arts, but his interest, insofar as it was drawn to the style in these years was probably captivated by recent interpretations like Emile Vaudremer's Church of St. Peter in Montrouge rather than monuments of the early Middle Ages. It has been suggested that in the design of Trinity Church, Richardson may have used Henri Revoil's *Architecture romane du midi de la France,* and a photograph of the eastern end of St. Paul at Issoire found among his papers would seem to have been the source for the general massing and certain details. John La Farge also gave him an album of photographs of Spanish Romanesque churches, but Richardson's initial contact with Romanesque monuments first came in 1882 when he visited Auvergne, Provence, northern Italy, and Spain, returning north by way of Poitiers, where he greatly admired Notre-Dame-la-Grande. A by-product of this journey was his plan to have the portal of Saint-Trophîme at Arles copied to serve as the basis of the design of the main entrance of Trinity Church. A version of this scheme was set in place during the 1890s, some years after the architect's death.

Stanford White's portal, added in 1903 to Sands and Renwick's

St. Bartholomew's Church in New York City, introduced Americans in much the same manner to a second major monument of Romanesque sculpture, the façade of Saint-Gilles. White had begun his career as a draftsman in Richardson's office in 1872. His journey to Europe six years later in the company of his future partner Charles McKim and the sculptor Augustus Saint-Gaudens preceded his mentor's and introduced him to some of the same Provençal and Auvergnat sites. Although his involvement with Romanesque was ultimately to be less profound than Richardson's, he did record his admiration for Saint-Gilles, terming the portal of the church "the best piece of architecture in France." The adaptation at St. Bartholomew's some twenty-five years later when the movement initiated by the older master had more or less spent itself is at once a further token of this admiration for the French church and a means of staking out a position in relation to Richardson's church in Boston. Neither the Arles portico of Trinity Church nor the Saint-Gilles porch in New York, however, is a very faithful copy of the twelfth-century models. In Boston, a certain archaeological spirit, of which critics have made a somewhat negative assessment, is in evidence, but the sculptor indulged, as one writer has approvingly said, "in a very judicious intermingling of modern anatomical knowledge and twelfth-century design." In New York, the architectural scheme of Saint-Gilles was rather accurately reproduced, and the framing elements of the three doorways exhibit vegetal ornament executed in a dry and conventionally Romanesque style. But the tympana and frieze, entrusted to different sculptors—among them, Daniel Chester French—respectively follow the art of the Della Robbias and Rodin rather than the Provençal monument. Romanesque sculpture might well be brought in both projects to a stage of development which it never historically reached. We may also speculate that the appeal of Arles and Saint-Gilles to its late nineteenth-century admirers owes something to the affinity of Provençal Romanesque with the sculpture of Roman antiquity, sparing the spectator certain asperities which the style displays elsewhere. To this might be added a copiousness of invention and detail in these works that may also be said to represent an aspect of Victorian aesthetic sensibility.

Henry Adams' *Mont-Saint-Michel and Chartres* (1904) must surely be regarded as another landmark in the appreciation of Romanesque in America, even though the specific concern of the author

with sculpture is rather slight. It was Richardson who opened Adams' eyes to the qualities of the style. For reasons partly autobiographical, however, he was drawn to the art of the Normans rather than to south and central France. The literary and historical sensibility that Adams brought to the task also enabled him to place this art in a vividly colored setting dominated by faith and heroic action. The reader is introduced to the Norman building of Mont-Saint-Michel as William the Conqueror and Duke Harold the Saxon, on their way to subdue the Bretons, stop by to dine in the old refectory. Roland, Taillefer, Duke William, and other prestigious names step out of the pages of Wace and Benoît de Saint-Maure to lend their presence to the spectacle. Couched in terms of a pilgrimage or journey, the book offers an itinerary through the Romanesque and early Gothic churches of northern France, attaching to each a web of rich associations, while sparing the traveler any hint of hardship or discomfort. A more appealing invitation to follow the author on the same road could not be imagined. Along the way, the reader also meets various authorities eager to help with technical problems of construction, style, and chronology: Corroyer, Viollet-le-Duc, the Abbé Bulteau, Enlart, and many others. While these were not unknown to specialists, Adams' way with them has something of the mixture of deference and familiarity which organizers of cultural tours lavish on *érudits* grown old in the shadows of cathedrals.

In matters of formal interpretation, Adams bases himself entirely on these authorities. An idea developed in connection with the sculpture of the Chartres Portail Royal which permits him to counteract the prejudice still common in his time against the alleged crudeness of this and kindred works is that they represent an early stage of development comparable to the Greek archaic style: they are the "Aeginetan marbles of French art." This is allied to the view of Norman and of Romanesque art further south as *naif. Naiveté* is taken as a mark of robust spontaneity, contrasting favorably with the false airs of sophistication and overrefinement. Beyond the qualities of candor and simplicity, however, we find here the substance of the idea that "early" styles are governed by consistent principles of their own and must be evaluated on the basis of criteria appropriate to their own aims and range of possibilities. Emmanuel Loewy in his *The Rendering of Nature in Greek Art* (1900; English edition, 1907) worked out in detail the characteristics of

style in Greek archaic art and opened the way for an exploration of formal principles of Romanesque sculpture along parallel lines. Broadly speaking, Adams' brief remarks on the character of Romanesque and what would now be termed early Gothic art belong to the wider process of relativization of aesthetic norms achieved in the later years of the nineteenth century, leading to the rehabilitation of modes of expression formerly stigmatized as marked by ignorance or opposition to accepted canons of judgment and good taste.

Appreciation of a given style and the desire to collect are no doubt intimately related, but the former does not necessarily go hand in hand with the latter. As far as can be ascertained, none of Richardson's many professional and lay converts to Romanesque made efforts to acquire specimens of it. Adams himself owned a fine collection in which works of the Renaissance and the eighteenth and the nineteenth centuries were represented, but nothing of medieval origin seems to have been in his possession. The first collector in America to have acquired Romanesque sculpture was probably Isabella Stewart Gardner. Hers is a somewhat special case, however, since it was not so much the interest of the particular carvings as works of art as the charm of their collective evocative effect which, initially at least, attracted her to them. Undoubtedly influenced by Ruskin, whose ideas were echoed in Boston through the teaching of Charles Eliot Norton at Harvard, she had determined in the early months of 1896 to construct a new residence on the Fenway in the form of a medieval Venetian palace. Plans were drawn up by the architect Willard T. Sears, and in the summer of the same year, the Gardners were in Venice to purchase columns, capitals, reliefs, and other decorative elements for the structure. More material was obtained in Florence and Rome, and additional purchases were made in Venice in 1898 and 1899. Fenway Court was completed in the following year and opened to the public in 1903. The carved stone was set into the walls in a casual way to imitate the tattered and weather-beaten appearance of Venetian façades. The most conspicuous pieces are the numerous decorative roundels or *paterae*, mounted in the spandrels of the arches around the glass-covered inner court on three levels. Other fragments of sculpture were assembled to form an arch at the entrance of the Gothic Room on the third floor. Artistically the most significant are two lions of Tuscan and north Italian

origin, respectively, which guard an opening at the center of the west cloister walk into the central court, and the fragments of a pulpit from the Church of Santa Lucia in Gaeta, mounted in the wall of the north cloister. Because the function of this decoration was only to provide an appropriate setting for the paintings of Botticelli, Titian, and other masters, it did not challenge the value system which the spectator would have brought to the appreciation of an independent aesthetic object, and could be passed over in silence. This was all the more justifiable since the scheme as a whole, basing itself on a recognizable historical model, fit squarely within the architectural preconceptions of the time.

The works of Romanesque sculpture acquired by the Metropolitan Museum in New York in 1908 and 1909 fall into a different category since it was intended that they should be appreciated as independent objects. These acquisitions took place during the tenure as director of the museum of John Pierpont Morgan (1905–1912), whose interest in Medieval art is well known. In 1907, Morgan purchased the celebrated collection of the Parisian architect George A. Hoentschel, a vast ensemble of sculpture, furniture, and minor arts of the Medieval period and of the eighteenth century. The medieval objects were placed on indefinite loan in the museum, which undertook the construction of a new wing to house them and the creation of a Department of Decorative Arts. Although the collection is best known to students of Romanesque art for its ivories and goldsmithwork, it included one monumental carving in wood of real distinction, an Auvergnat cult image of the Virgin and Child. The curatorial responsibility fell on Wilhelm R. Valentiner, who was brought over from Berlin, where he had been an assistant of Wilhelm Bode at the Kaiser Friedrich Museum. Before he was forced to return to Germany by the outbreak of World War I, a number of additional pieces of Romanesque stone carving entered into the collections of the museum: a ciborium from the church of Santo Stefano near Fiano in central Italy, now exhibited at the Cloisters; a column support with the figure of St. Hilary, lately identified as coming from the monastery of Sant'Ellero in Galeata (Forli); and some elements of Venetian decorative sculpture similar to those that embellish the Gardner Museum. A *Catalogue of Romanesque, Gothic and Renaissance Sculpture*, edited by Valentiner's assistant and eventual successor, Joseph Breck, appeared in 1913, and even though the space devoted in this publication to the sec-

ond and third of the three styles mentioned in the title far out-
weighs that given to the first, the explicit reference of the latter on
an equal footing with its more respectable companions must have
had a novel ring. In Valentiner, of course, the Metropolitan forged
a link with the encyclopedic tradition of collecting allied with
scholarship firmly established in Berlin, where men like Oskar
Wulff and Wilhelm Vöge had produced comprehensive catalogues
of the German museum's late Antique and Medieval sculpture. A
certain inclination in the pattern of acquisitions of Romanesque
sculpture by the Metropolitan in favor of Italy at this time probably
reflects another aspect of this tradition. The Berlin collections were
strong in this area, and Valentiner himself was not only to make
substantial scholarly contributions in the field of Italian sculpture,
but was also actively to promote its acquisition when later in his
career he became director of the Detroit Institute of Arts.

The beginning of the second decade of the century marks the
appearance on the scene of Arthur Kingsley Porter, who may be
credited with a role nearly equal to Richardson's as an exponent on
behalf of Romanesque art in this country. As in the case of
Richardson, Porter's embrace of the style is not fully explained by
what is known of his early intellectual biography. Porter had ini-
tially chosen law as a career. Conversion to architectural history
was the result of the strong impression made upon him by the
Cathedral of Coutances, which he saw in the course of a first
European tour following graduation from Yale University. *Medieval
Architecture*, an impressive first work completed at the age of
twenty-five, was published in 1909. Shortly thereafter, Porter
turned his attention to the art of the eleventh and twelfth centuries
in north Italy, which was to be the subject of his monumental *Lom-
bard Architecture*, published in 1915. A good deal of attention in this
work is lavished on sculpture, to which the author also devoted a
number of articles, beginning in 1911 with a study on the Met-
ropolitan's then recently acquired St. Hilary from Galeata. An arti-
cle entitled "The Rise of Romanesque Sculpture," which appeared
in 1918, reveals the major theoretical threads that run through his
entire work in the sphere of Romanesque art. First, there is the
view that "all schools [of Romanesque sculpture] are interrelated"
since various analogies that can be observed all over Europe cannot
have been due to chance. Hence, the importance of establishing
lines of affiliation and settling questions of precedence in the ap-

pearance of styles, techniques, or motifs. Second, the author emphasized the role of the churches situated along the pilgrimage roads in the codification and transmission of artistic ideas, comparing their function to that of an academy. This idea, which Porter developed more fully in his multivolume *Romanesque Sculpture of the Pilgrimage Roads* (1923) seems ultimately to have been inspired by J. Bédier's influential *Les légendes épiques* (1913), where the agents of sponsorship and diffusion of literary themes are similarly localized in the important religious houses on the roads leading to Compostela. It was an idea that has had wide resonance and, even before Porter's own formulation of it, could be found in the pertinent chapters of A. Michel's *Histoire de l'art* and in the writings of another enthusiastic early admirer of Romanesque art whom Porter appreciatively cited, Georgiana Goddard King.

Porter's impact on the specialized literature in the period immediately following World War I was considerable. In France, he was taken to task for the strong claims which he advanced on behalf of the art of northern Italy. There were to be more disputes over the precedence of France or of Spain in the development of Romanesque, and on the chronology of the capitals of Cluny. While these debates in the perspective of time appear to us depreciated by an excess of simplification and partisanship, there is no question of Porter's success in having framed the problems that were to determine the focus of inquiry for many of his contemporaries. Illustrative of this is an article entitled "The Sources of Romanesque Sculpture" written in 1919 by the distinguished Princeton medievalist Charles Rufus Morey. In spite of the broad avenues of speculation and detailed analysis which would seem to be promised by such a discussion, it is only a rejoinder to Porter's earlier remarks on the same subject, differing in its point of view, but entirely encompassed within the position staked out by the latter. Porter's career as professor of fine arts at Harvard University until his tragic death in 1931 also marks the entry of Romanesque art into the sphere of serious academic study in this country. This is a development to which a number of other scholars active in the 1920s, most notably King at Bryn Mawr, Morey at Princeton, and W. W. S. Cook, also substantially contributed. But it is already fully explicit in the unbridgeable gap which separates the gentle musings of Adams and the efficient argumentation of Porter even in his earliest essays, with its formidable parade of little-known

monuments, documentary, and bibliographic data. The latter espe-
cially, as may be gauged by the catalogue of monuments found in
Lombard Architecture, still compels admiration for the remarkable
scope of the author's erudition.

During the same decades, an ever increasing amount of
Romanesque sculpture was imported into this country. Among the
public institutions seeking to add to their collections in this field,
the most active was again the Metropolitan Museum of Art and
museums in the northeastern part of the United States seem gener-
ally to have been ahead of those in the rest of the country. The
Boston Museum of Fine Arts acquired its first examples of
Romanesque sculpture—a pair of capitals of rather routine quality
and comparatively late date—in 1919, the Fogg Art Museum ob-
tained its head supposedly from Saint-Denis in 1920, and the
Philadelphia Museum of Art entered the lists in 1923 when it ac-
quired a group of carved panels from a north Italian pulpit or
chancel. At the urging of the young Bernard Berenson, whose
sympathies for the sculpture of the twelfth century do not other-
wise seem to have been conspicuous, Mrs. Gardner purchased in
1916 an imposing if unfortunately much restored ensemble of
carvings from the church of Notre-Dame de la Couldre at Par-
thenay in western France; in the following years she acquired a
moving wooden and polychromed Christ from a Catalonian De-
position. These works were then and remained for a time the most
substantial examples of Romanesque sculpture on public view on
these shores, and the first-mentioned eventually achieved some-
thing close to handbook renown. Before 1930, several private col-
lections with large holdings of Romanesque sculpture came into
being, associated with such names as George Grey Barnard,
Raymond Pitcairn, and William Randolph Hearst. Finally, we must
not overlook the collections of plaster casts formed chiefly by art
schools and university museums, which were to be for many their
first contact with major monuments of Romanesque art. For educa-
tional institutions, casts had the advantage of lower cost and also
made it possible to exhibit for study purposes works of major artis-
tic importance of which the supply was bound to be insufficient
and unpredictable. One of the tasks that the founding members of
the College Art Association set for themselves was the distribution
by that organization of casts of outstanding monuments of
sculpture of various periods. The list of plaster reproductions avail-

able to college museums given in the *Art Bulletin* for 1919 included such works as the Vézelay portal, a pilaster and a portion of the façade frieze of St. Trophîme at Arles, and selected pieces from Moissac and Notre-Dame du Port at Clermont-Ferrand. Italian Romanesque sculpture was represented by Antelami's Deposition from the Cross in Parma Cathedral and Guido da Como's relief from the pulpit of San Bartolomeo a Pantano in Pistoia; Germany by the Hildesheim doors and two figures from the choir of Bamberg Cathedral. Changes in methods of teaching have now relegated these casts to attics and basements nearly everywhere.

Near the end of World War I, a number of dealers were specializing in the sale of Medieval art and making the disposition of Romanesque sculpture a sizable part of their business. The best known were George Demotte, Joseph Brummer, and the sculptor George Grey Barnard. Unlike more traditional fields, there were few ready sources in existence which could nourish this commerce. Thus, it became necessary to scour the countryside in search of sculpture detached by accidents of time or the injuries of man from its original setting. In France at least, the source of most of this material must have been buildings abandoned as a result of demographic changes or demolished in the aftermath of the French Revolution. Restorations of medieval buildings also contributed their share to the supply of old stones. Faced with the task of consolidating old structures, architects often avoided the admittedly more difficult path of selective repairs, preferring instead the simple expedient of replacing the entire fabric. Badly worn and less eroded carvings alike were replaced with copies, and the originals disposed of. Viollet-le-Duc's substitution of new carvings for a number of twelfth-century capitals at Vézelay, somewhat gratuitous to our eyes, is an example of this procedure, though in this instance, the original carvings were fortunately preserved. Much more questionable in its intention and not always easy to detect was the substitution in a number of places of casts for original sculpture, with some of the displaced pieces finding their way into the trade. From the present vantage point, a most regrettable aspect of the circumstances which surrounded the search for Romanesque sculpture by dealers and collectors was the loss in many instances of data concerning provenance and archaeological context. Many, if not most, of the carvings which were transported to America are thus like tesserae from a mosaic whose contour and

location we can now only vaguely guess. On the positive side, it is fair to say that the absorption of this material into mercantile circuits not infrequently saved it from neglect and ultimate destruction.

The most notable figure and a pioneer in the commerce of medieval sculpture on behalf of patrons on this side of the Atlantic was George Grey Barnard. A sculptor of considerable talent, he had gone to France in 1903 in order to carry out a large commission for the Pennsylvania State Capitol at Harrisburg. When this project became embroiled in political scandals, Barnard sought to supplement his meager resources by selling works of art, making a specialty of Romanesque and Gothic art. Encouraged by the favorable prospects which he encountered along this path, Barnard eventually arranged to purchase several major ensembles of medieval sculpture, among them parts of the cloisters of Saint-Michel de Cuxa and Saint-Guilhem-le-Désert. Barnard's attitude toward this booty was to change in time. Toward 1910, he was no longer interested wholly in its sales value but had begun to formulate a plan for its display in this country as a permanent collection, designed to acquaint Americans who could not go to Europe with medieval monuments and to foster in youth an appreciation for "the use of the chisel." In 1925, the building, along with the entire collection was acquired for the Metropolitan Museum of Art by John D. Rockefeller, Jr., and became the nucleus of the present Cloisters in Fort Tryon Park, opened to the public in 1934. Barnard himself thereafter resumed his activities as a supplier of medieval sculpture to museums in America, assembling a second collection which was dispersed in 1945 after his death. He remains for us a peculiar mixture of idealism and shrewd entrepreneurial practicality. Although scarcely disdaining financial reward, he was genuinely imbued with the hope that his activities would awaken in the untutored public a love for the beauty of medieval art. In his career as a sculptor, he could similarly imagine the financing and sponsorship by the Detroit manufacturer of Lincoln automobiles of a project to install his colossal statue of the martyred president on all major federal highways.

Barnard's interests also point to an important aspect of the patronage of Romanesque sculpture in America: the comparative advance of private collectors in this field over public institutions. Attached to the traditional concept of the museum as a repository of

accepted masterpieces, the latter were bound to find in the boldly stylized forms of this art little to admire, just as they were apt to resist the more daring manifestations of contemporary painting and sculpture. Institutions which understood themselves to be more progressive were moved by the idea that the museum's role was to document the evolution of art as an aspect of the progress of the human spirit. This notion favored the display of "representative" specimens of the artistic expression of various cultures, including those deemed by general consensus to be most retrograde. Yet we find here no basis for the building up of large collections such as those that had come into being in the fields of Classical Antiquity or Renaissance art. Private collectors could well afford to ignore such compunctions. Moreover, there was a long tradition of manorial and castellated residences in which medieval sculpture, painting, or stained glass could be appropriately incorporated without calling into question the good sense or taste of the owner. The enormous hoard of sculpture, furniture, and building materials brought together by William Randolph Hearst (1863–1951) plainly falls into this category, since it was designed to furnish the tycoon's palatial homes. San Simeon in the Santa Lucia Mountains of California, begun in 1919 following the plans of Julia Morgan, absorbed a good share of this work. More went into Hearst's other homes in this country and abroad, and later into storage vaults and museums, while the Cistercian cloister of Sacramenia, which Hearst was forced to abandon during the Depression, was eventually set up on the outskirts of Miami. In this vast acquisitive enterprise, one discerns the workings of an imagination operating on the scale and at the level of profundity of Cecil B. de Mille's exotic extravaganzas.

The episcopal seat and attendant scholastic institution of the Church of the New Jerusalem (Swedenborgian) at Bryn Athyn, Pennsylvania, houses another collection of Medieval art comprising a good deal of Romanesque sculpture, which was assembled at a comparatively early date and under private auspices. The guiding lights behind this enterprise were several generations of the Pitcairn family. John Pitcairn undertook the construction of the cathedral, designed in 1912 by the firm of Cram and Ferguson, well known for their championship of medieval architecture. After his death in 1916, his son Raymond took charge of the enterprise and under his aegis the site became, in Cram's words, "a sort of

epitome of English church building from the earliest Norman to the latest Perpendicular." Stained glass, metal fittings, and other decorative elements were produced by local workshops, in a conscientious effort to approximate the conditions which prevailed on the medieval *chantier*. It seems to have been the intention that the original works of art brought together on the site serve as inspiration and models for study in this utopian scheme. Something of the richness of the collection was revealed to the public when part of it was exhibited at the Philadelphia Museum of Art in 1931, but only a few scholars have been granted the privilege of firsthand examination at Bryn Athyn itself, and, to this day, it is difficult to gain a precise picture of its actual scope.

The rising interest in Romanesque sculpture in this country during the 1920s and 1930s also brought in its wake a traffic of modern imitations. Some of these, not necessarily intended to deceive, were sold for the decoration of gardens and patios of private homes, and are even at the present time still encountered on the premises of florists and interior decorators on the Continent. But there are also cases of a less innocent nature, such as the completion or "improvement" of fragmentary originals, and the production for the burgeoning market of copies, adaptations, and outright inventions. The fact that these have often escaped detection is an indication of the necessarily slow process by which connoisseurship in this field reached a certain threshold of expertise. Whereas artistic judgment could in more traditional areas rely on the accumulated experience of several generations of criticism and sharpen its focus by direct contact with original works, Romanesque sculpture was as yet little studied and much less accessible to close scrutiny. Moreover, the common tendency to emphasize the primitive and "expressive" qualities of this art no doubt led observers to be more tolerant of the unfamiliar or the incongruous than they might have been in the face of styles with more classical connotations. Given the seemingly inexhaustible inventiveness of Romanesque imagery, who would be prepared to draw an inflexible line between the merely strange and the altogether unbelievable?

The 1930s likely mark the high point in favor and critical fortunes enjoyed by Romanesque sculpture in this country. In the newly opened Cloisters Museum the public could see in splendid installations the Cuxa and Saint-Guilhem cloisters, soon to be augmented by other important ensembles like the chapter house of

Pontaut and the chapel of Langon. The Philadelphia Museum of Art opened its new Medieval galleries in 1931. In the same year, the Cleveland Museum of Art acquired in the Guelph Treasure a priceless collection of goldsmithwork rivaling the Metropolitan's Morgan collection and illustrating the achievement of eleventh- and twelfth-century artisans on a more intimate scale. Men who were to leave their imprint on the growth of American museums and were at the same time enthusiastic proponents of the cause of medieval art like James Rorimer at the Metropolitan, Francis Henry Taylor in Philadelphia, and William Milliken in Cleveland came to the fore. In the sphere of scholarship, this was a time of exploration in depth, of the systematic search for underlying formal laws and principles. The acceptance during these years of modern art as a serious and viable phenomenon led scholars to view the abstraction and expressive distortion of medieval work in a more positive light. The work of Meyer Schapiro in this country and of Henri Focillon in France gives the most authoritative account of these concerns. The former at Columbia University and the latter in his brief career as a visiting professor at Yale exerted lasting influence as teachers. At Focillon's impulse especially, there was a shift in emphasis to the formative processes in the development of Romanesque sculpture during the eleventh century, paralleling in some way the attention focused on this period from the point of view of social and institutional history in Marc Bloch's classic *La société féodale*. The publication in 1927 of Charles Homer Haskins' *The Renaissance of the Twelfth Century* also enlarged the intellectual ground upon which Romanesque art could be seen to flourish, attaching to it all the connotations of a revival phenomenon. The rise of National Socialism in Germany also brought to this country's universities and museums many scholars of foremost ability and renown, who had concerned themselves to a greater or lesser extent with Romanesque art: Paul Frankl, Georg and Hanns Swarzenski, Erwin Panofsky, Richard Krautheimer and Trude Krautheimer-Hess, Adolf Katzenellenbogen, and Wilhelm Koehler.

The postwar period up to the present day has a less distinctive profile and even something of the mark of anticlimax. Romanesque art is now an accepted part of the college curriculum and not infrequently taught as a specialized subject. Museums have continued to acquire Romanesque sculpture, and collections without at least a token specimen would most likely reckon this condition as a

serious gap. The sale of the Brummer Collection in 1949 was for many institutions an opportunity to enter the field or improve their holdings. But the supply of first-rate examples of monumental sculpture of the eleventh and twelfth centuries has become much rarer. The understandable concern in European countries over the loss of the cultural patrimony has led to stronger legislation designed to control the export of works of art. In this country, museums have in recent years been forced by both philosophic and budgetary considerations to reexamine their sometimes one-sided commitment to policies of unlimited acquisition. However these developments may be envisaged, they are bound to be overshadowed by others of much greater magnitude and urgency. The accelerated process of modernization of Western European countries in recent years has exposed the monuments themselves to unprecedented dangers. The renewal of the urban fabric, the relentless building of new roads near or across the path of historical monuments, air pollution from vehicular traffic, and supersonic bangs now threaten their very survival. We must hope that the attraction which they have exerted on past generations will not fail to inspire in us the combination of ingenuity, study, and instruction necessary to their preservation.

I

The Wadsworth Atheneum

HARTFORD, CONN.

1. VIRGIN AND CHILD. Germany.
Oak, with faint traces of polychromy. Second half of the XIIth century.
H. 31 ½″ (80 cm.).
No. 1949.182. Gift of the Hartford Foundation for Public Giving.
Formerly Albert Welti (Zurich), Louis Lion (New York), and Hans
Wendland (Lugano). Repurchased by Lion in 1931 and placed on
sale by him at Parke-Bernet Galleries, New York, in 1946, where it
was purchased by J. Brummer. Fig. 1.

The enthroned Virgin is severely frontalized and holds the Child
on Her left knee. He is seen in profile, holding a book in one hand,
while the other is raised in a gesture of blessing. The summary
modeling at the forehead and the flat cut of the back of the head
indicate that the Virgin once wore a crown. The holes drilled into
the head of the Child—one at the top, one on each side—once
housed a metallic (?) halo. A dowel hole also marks the position of
the Virgin's right hand, now missing, and presumably carved from
a separate block. There is a large and regular cavity in the back of
the throne. The work as a whole shows considerable wear and
tear.

The image is a descendant of the type of the Virgin of Bishop
Imad of Paderborn (1051–76), which is taken up in a number of
German representations of the Virgin and Child of the twelfth and
first half of the thirteenth centuries, like the statues of the
Liebighaus in Frankfurt and the Bonn Rheinische Landesmuseum,

17

the choir screen relief of Gustorf, and the tympanum of Geln-
hausen. Comparison with these examples suggests that the
Hartford Virgin originally held a short scepter (R. Hamann, "Die
Salzwedeler Madonna," *Marburger Jahrbuch für Kunstwissenschaft*,
1927, p. 113ff. and figs. LIb, LIIb, LIIIb, c, and d). In its general
appearance, the work is closest to the Gustorf Madonna, datable
around the middle of the twelfth century.

Bibliography

C. F. Foerster, *Die Sammlung Dr. Hans Wendland, Lugano mit einigen Beiträ-
gen aus anderen Besitz* (XI. Versteigerungs Katalog der Firmen Her-
mann Ball und Paul Graupe), Berlin, 1931, p. 84, No. 261; *Gothic and
Renaissance Bronzes . . . Property of an Eastern Art Museum, a Western
Museum . . . Parke-Bernet Sales Catalogue No. 804, November 18, 1946*,
p. 18, No. 87; *Brummer II*, p. 101, No. 423; Wadsworth Atheneum,
Annual Report for the Year 1949, Hartford, 1950, pp. 11, 14; *Religious
Art of the Middle Ages and Renaissance in the Collection of the Wadsworth
Atheneum*, 1950, pp. 5, 16, and pl. IV; A. Harding, *German Sculpture
in New England Collections*, Boston, 1972, pp. 86 and 25, fig. 11;
I. H. Forsyth, *The Throne of Wisdom: Wood Sculptures of the Madonna
in Romanesque France*, Princeton, 1972, p. 207.

2. PIER. Saint-Martin de Savigny, Rhône.
Limestone. Second quarter of the XIIth century.
H. 58", W. 19" (157 × 48 cm.).
No. 1949.224-5. J. J. Goodwin Fund.
Formerly J. Brummer. Figs. 2 and 3.

The pier is carved with a standing figure in relief on each of the
four sides, and must once have formed the corner block in the ar-
cade of a cloister. At an unknown time, it was sawed in half and
the reliefs on two sides severely damaged. Moreover, one of these
sides was more or less methodically pared down. The two best
preserved sides have also sustained wear and damage, which is
especially marked in the heads. The four figures, in all probability
representing the four Evangelists, are framed by arched recesses
punctuated at the corners by little projecting turrets. The two-tiered
gables of four additional turrets are seen at the corners of the block
in the area of the base. The four figures stand in full frontality,
with the weight evenly distributed on both feet. One may infer on

the basis of the two relatively well-preserved sides that all four held books to which they pointed.

Our pier belongs to the type inaugurated in the first years of the twelfth century in the cloister of Moissac. There are examples from the Cathedral of Narbonne in the Toulouse Musée des Augustins (Mesplé, *Sculptures romanes,* No. 261), at Chamalières-sur-Loire (R. de Lasteyrie, *L'architecture religieuse en France à l'époque romane,* Paris, 1929, p. 711, fig. 721), and single slabs with standing figures in relief within arcades are especially frequent in the regions of Languedoc and Provence. According to the Brummer Sales Catalogue (*Brummer III,* p. 143, No. 599), the Hartford pier stems from Saint-Martin at Savigny, a Benedictine abbey of some importance located about fifteen miles northwest of Lyon. The provenance was confirmed to us by M. Bonnepart, a long-time resident of Savigny, who recalls the sale of the work to a collector in Aix-en-Provence.

Saint-Martin de Savigny was founded in the early ninth century under Carolingian royal auspices. During the twelfth century, its history seems to have been dominated by difficult struggles for independence from the archbishops of Lyon. In a letter of 1208, Pope Innocent III announced its destruction, but a revival soon took place, just as the church of Lyon was itself forced into a defensive position by the communal uprisings of the mid-thirteenth century. The monastery was suppressed in 1790, and the buildings destroyed shortly thereafter. The remains of a cloister arcade could still be seen around 1840, but there is no mention of our pier in a description made at that time (A. Roux, "Savigny et son abbaye," *Album du Lyonnais,* 1844, p. 201). Some fragments of sculpture from Savigny have been signaled in villages in the area, and a certain number were collected by M. Coquard on his property at Savigny. The Hartford pier, however, does not figure among those which have been made known (H. M., *Bulletin historique du diocèse de Lyon,* 1924, pp. 326–27, and 1925, pp. 59–61). In style, the sculpture of Savigny, as exemplified by the Coquard pieces, was not homogeneous. Some fragments, like the attractive capital with the Virgin and Child (now in a private collection in this country), are clearly related to the agitated manner of the portal of Charlieu. Other elements show the characteristically stolid forms of the earlier sculpture of Lyon and Vienne. None of these important though still little-known remains show definite links with the Hartford

pier, but the general stylistic affinities of the work definitely lie with the sculpture of the Rhône Valley and upper Provence. There are comparable features notably in the monumental figures of the cloister of Montmajour (H. A. von Stockhausen, "Die romanischen Kreuzgänge der Provence. II. Die Plastik," *Marburger Jahrbuch für Kunstwissenschaft,* 1936, pp. 97–107). For other Savigny sculpture, see below Wellesley, No. 1; and perhaps Boston Museum of Fine Arts, No. 4; and Cambridge, Fogg Art Museum, No. 16.

Bibliography

Brummer III, p. 143, No. 599; Wadsworth Atheneum, *Annual Report,* p. 34; *Wadsworth Atheneum Handbook,* Hartford, 1958, p. 23; *Religious Art,* p. 14 and pl. I; R. C. Moeller in Scher, *Renaissance,* pp. 136–37. On the sculpture of Savigny generally, see D. Cateland-Devos, "Sculptures de l'abbaye de Savigny-en-Lyonnais du haut Moyen Age au XVe siè-cle," *Bulletin archéologique du Comité des travaux historiques et scientifiques,* N.S. 7, 1971, pp. 151–205.

3. CAPITAL. Burgundy.
Limestone. Beginning of the second quarter of the XIIth century.
H. 13 ½", L. 12 ⅜", W. 10" (34 × 31 × 25 cm.).
No. 1949.213. Henry D. Miller Fund.
Formerly J. Brummer. Fig. 4.

The capital exhibits a fantastic composition informally disposed over two sides of the block, dominated by a figure holding a viol and a sword, and sitting astride a huge fish. Such representations of marine cavaliers occur also on the Tomb of Adeloch in the Church of St. Thomas in Strasbourg, at Andlau (V. Debidour, *Le bestiaire sculpté du moyen âge en France,* Paris, 1961, figs. 394, 415) and on a capital from Mozac in Auvergne (J. Baltrusaitis, *La stylistique ornementale dans la sculpture romane,* Paris, 1931, p. 119, fig. 290). They are usually seen as personifications of the sea, based on classical representations of Erotes mounted on sea monsters. In none of these examples, however, does the figure display the puzzling attributes seen on the Hartford capital, and while the sea personifications assume a female guise, the figure on our capital has undeniably virile characteristics. It is possible that the figure might have been designed as a representation of Arion, the poet of

Lesbos who was cast into the sea by sailors on a voyage to Corinth and borne on his way on the back of a dolphin which he had charmed with his music. In line with this interpretation, the pair of heads with flowing hair which flank the poet might be explained as personified winds. It is more difficult to account for the sword wielded by the figure, though it should be noted that the sources describe the poet's attributes as a lyre and an ivory wand. There is another representation of Arion on his dolphin, holding a lyre and blowing a horn, in the remarkable drawing of the Harmony of the Spheres, dated around 1170, which prefaces a copy of the Pseudo-Isidore's False Decretals in Reims (Bib. Mun. Ms. 672, fol. 1. H. Swarzenski, *Monuments of Romanesque Art*, Chicago, 1954, p. 80, No. 492). But we can offer no explanation for the serpentine forms which seem to traverse the space behind the fish-borne musician.

The graphic refinement and small-scaled quality of the carving point to Burgundy rather than Italy as indicated in the Brummer Sales Catalogue and in the record of purchase of the museum. The use of the drill to mark the pupil of the eye, intended to receive a pellet of lead, is common in Burgundian sculpture. The work belongs to the following of the Vézelay narthex portal workshop, and compares well, for example, with the sculpture of the porch at Per-recy-les-Forges (Salet-Adhémar, *Vézelay*, p. 166ff.).

Bibliography

Brummer III, p. 135, No. 571; Wadsworth Atheneum, *Annual Report*, p. 34; *Religious Art*, pp. 14–15, pl. II; W. Cahn, "A Romanesque Capital from Burgundy," *Bulletin of the Wadsworth Atheneum*, Winter 1967, pp. 2–16; Scher, *Renaissance*, pp. 31–33, No. 3.

4. TWO CAPITALS. Auvergne.
Sandstone. Second quarter of the XIIth century.

(a) H. 12 ½", W. 11" (32 × 28 cm.).
No. 1971.52.133.

(b) H. 12 ½", W. 11" (32 × 28 cm.).
No. 1971.52.134.

Bequest of Henry Schnakenberg. Formerly J. Brummer. Figs. 5 and 6.

The capitals have nearly cubic baskets. One shows a large mask at each of the four corners. Pearly bands fastened within the corners of the clenched jaws twist in the middle of each side and connect with the volutes at each of the four corners. Two of the grotesque heads bare their teeth, the others extend their tongues. At the center of the upper section of the block on each of the four sides, a broadly splayed acanthus leaf appears within a heart-shaped outline.

The second capital is covered with vegetal decoration. The foliage is borne by two branches rooted at opposite corners of the basket and deploys itself in sluggish convolutions over the entire block. Erosion of the soft sandstone has left only the larger outline of the design in view. The style of the carving and the material are probably best associated with south central France, and more specifically with the area of Cantal comprised within Haute-Auvergne.

Bibliography

Brummer III, p. 152, No. 621.

5. CAPITAL. Valley of the Rhône.
Limestone. Second quarter of the XIIth century.
H. 8 ½", W. 9" (21.5 × 23 cm.).
No. 1949.181. Hartford Foundation for Public Giving.
Formerly L. Demotte, Arnold Seligmann and Rey, and J. Brummer.
Fig. 7.

The capital shows the Virgin and Child, with the Magi on horseback, one on each of the three remaining faces. Their advance is from left to right. The cavalier closest to the enthroned Madonna points to the star of Bethlehem, as in the representation of the tympanum of Saint-Gilles. The second rider holds a falcon, while the third seems to exert himself to control his mount. Both style and iconography localize the carving in the region of Lyon. The Virgin holding the Child high and to one side may be compared to the very similar characterization on the capital in the choir of Lyon Cathedral, and the idea of isolating each of the Magi on a single face of the block occurs in Lyon, Saint-Maurice of Vienne, and on a capital from the now destroyed abbey of Savigny near Lyon

(*Bulletin historique du diocèse de Lyon*, 1924, pp. 226–27). The squatly proportioned Madonna, with heavily inelegant features, has a parallel in the Virgin of the tympanum of Saint-Alban-sur-Rhône. The indication of the garment folds by means of raised ridges is an idiomatic aspect of the style in Romanesque sculpture of this region.

Bibliography

Brummer II, p. 208, No. 766; Wadsworth Atheneum, *Annual Report*, p. 36; *Religious Art*, p. 14; R. Calkins, *A Medieval Treasury*, Ithaca, N. Y., 1968, pp. 135–36, No. 50.

6. CAPITAL. Angoumois or Charente.
Limestone. Second quarter of the XIIth century.
H. 10 ½″, W. 8″, D. 8 ½″ (26.5 × 20 × 21.5 cm.).
No. 1949.123. Henry and Walter Keney Fund.
Formerly Garnier (1926) and J. Brummer. Fig. 8.

Carved on two sides only, this capital of medium dimensions must once have been mounted at the base of an intrados arch. It shows affronted lions united under a single head, with twin foliate shoots issuing symmetrically from the parted jaws. The tails of the beasts are likewise fashioned in the form of a leafy growth. The characteristics of style point to the region of western France around Angoulême. There is a very similar capital at Vindelle in Charente, if somewhat battered and weaker in execution (George and Guérin-Boutaud, *Églises romanes*, fig. 264A), and the motif of the affronted and foliage-eating lions appears also at Mérignac and La Couronne in the same area. Other examples are found at La Sauve-Majeure near Bordeaux (Debidour, *Bestiaire*, fig. 241) and in nearby Saint-onge and Poitou.

Bibliography

Brummer I, p. 140, No. 557; Wadsworth Atheneum, *Annual Report*, p. 35; *Religious Art*, p. 14.

7. CAPITAL. Southern France.
Limestone. First quarter of the XIIth century.
H. 9 ½", W. 10" (24 × 25.5 cm.).
No. 1949.124. Henry and Walter Keney Fund.
Formerly J. Brummer. Fig. 9.

The lower zone of the block on the two principal faces is occupied by a pair of birds joined in a single head which is seen emerging from the interstices of a leafy aureole. The upper surfaces are filled by winged hybrid monsters perched on their backs, a pair symmetrically grouped on each face. The two remaining sides of the capital are less developed and show only a turgid carpet of foliage. The capital is rather worn and battered.

 Although precise parallels are lacking, the formal vocabulary of the carving invites an attribution to an Aquitanian workshop. Suggestive in this sense is the presence of the palmette, a conspicuous motif in manuscript illumination of southwestern France in the second half of the eleventh and first half of the twelfth centuries. A companion piece is in the museum of the Academy of the New Church at Bryn Athyn, Pennsylvania (C. Gómez-Moreno, Exh. Catal. *Medieval Art from Private Collections*, New York, 1968, No. 21).

Bibliography

Brummer I, p. 140, No. 558; Wadsworth Atheneum, *Annual Report*, p. 35.

8. CAPITAL. Southwestern France (?).
Limestone. First half of the XIIth century.
H. 7", W. 8" (18 × 20.5 cm.).
No. 1949.125. Walter and Henry Keney Fund.
Formerly Simon-Trichard (1932) and J. Brummer. Fig. 10.

The four faces of the block show a pair of lions seated on their hind quarters and facing each other in heraldic symmetry. The tails are extended to form vegetal shoots and interwoven to unite each pair of beasts back to back. The small dimensions of the work and the shallow treatment of one of the sides indicates that the carving was originally paired with a similar capital. The spur of the supporting colonnette, peculiarly carved in the same block, is visible at the base.

The origin of the piece is uncertain. Stylistically, it can be con-
nected with a capital in the Fogg Art Museum (No. 1949.47.25. See
below, No. 22) and possibly stems from the same as yet uniden-
tified southwestern French site.

Bibliography

Brummer I, p. 140, No. 558; Wadsworth Atheneum, *Annual Report*, p. 35.

9. LION. Southern Italy.
Marble. Beginning of the XIIth century.
H. 14 ⅛", L. 31 ¾", W. 10 ½" (36 × 80.5 × 26.5 cm.).
No. 1949.215. Henry D. Miller Fund.
Formerly J. Brummer. Fig. 11.

The animal is carved on the back of a marble slab which must once
have formed part of the cornice of an antique building. Part of an
egg-and-dart molding running vertically at the back of the hind
quarters is still visible. Only the head, outwardly angled toward
the viewer, is fully disengaged from the block. The body is in relief
and was anchored to a retaining surface. With a companion piece
in the Fogg Art Museum (No. 1949.47.35. See below, No. 48), the
carving likely served as one of a pair of consoles sustaining a lintel,
as in the church portal of Bagni di Lucca (M. Salmi, *Chiese
romaniche della Toscana*, Milan, 1961, pl. 73) and San Cassiano di
Controne (Salmi, *L'architettura romanica in Toscana*, Milan-Rome,
n.d., pl. CCXV). The smooth, unmuscular body and the elongated
snout of the beast resemble the portal lions of San Nicola in Bari,
under construction in 1089.

Bibliography

Brummer III, p. 141, No. 590; Wadsworth Atheneum, *Annual Report*, p. 34;
 Religious Art, p. 13.

10. LION. Northern Italy.
Marble. Second quarter of the XIIth century.

H. 11 ½", L. 29", W. 9 ¼" (29 × 73.5 × 24 cm.).
No. 1949.214. Henry D. Miller Fund.
Formerly Pacifici (1937) and J. Brummer. Fig. 12.

The beast has a cushion with a base carved on its back and was designed as a support for a colonnette forming part of the substructure of a pulpit, chancel, or portal arcature. The legs are broken off. The features of the animal and the musculature are strongly emphasized. The head is framed by a sharply outlined mane and the forehead, snout, and areas of the jaw ribbed with parallel grooves and marked with the drill. This type of characterization lends itself to comparison with the portal lions of San Zeno in Verona, as well as the lion capital within the church (W. Arslan, *L'architettura romanica veronese,* Verona, 1939, pl. CXVII).

Bibliography

Brummer III, p. 141, No. 590; Wadsworth Atheneum, *Annual Report*, p. 36; *Religious Art*, p. 13.

11. HOLY WATER FONT. Italy.
Marble. XIth century.
H. 10", D. 14" (25.5 × 35.5 cm.).
No. 1949.180. Gift of the Hartford Foundation for Public Giving.
Formerly Bardini, Florence (1930), and J. Brummer. Fig. 13.

The shallow basin is crudely incised with a foliage pattern on the outer surface, marked out with the help of the drill. The plant forms allude to the idea of regeneration through the "life-giving" waters of Paradise and of the Prophets (Isa. XII:3; Ezek. XLVII:1–12). The same iconographical program is given more imposing form in the font of the Parma baptistery (G. de Francovich, *Benedetto Antelami,* Milan-Florence, 1952, I, pp. 228–29, and II, fig. 286), the basin in Carcassonne said to stem from the nearby abbey of Fontfroide (L. Bégule, "Fontaine d'ablutions conservée à l'Hôtel de Ville de Carcassonne," *Congrès arch.,* 1906, pp. 310–16) and several English fonts in lead (G. Zarnecki, *English Romanesque Lead Fonts,* London, 1957, Nos. 75, 77, and 78).

Bibliography

Brummer II, p. 209, No. 776; Wadsworth Atheneum, *Annual Report*, p. 36; *Religious Art*, p. 13.

12. DECORATIVE ROUNDEL. Veneto.
Marble. XII–XIIIth centuries.
D. 11″ (28 cm.).
No. 1971.52.132. Bequest of Henry Schnakenberg.
Formerly J. J. Klejman (1961). Fig. 14.

The roundel, chipped at the top and along the right edge, shows on its slightly concave surface a quadruped—apparently a rabbit—in the snares of a bird perched on its back. Such carved medallions were most commonly employed in the decoration of Venetian palace façades in the later Middle Ages (W. Arslan, *Gothic Architecture in Venice,* London, 1972). The prototypes were probably Byzantine imports, and much the same design as on the Hartford relief can be seen incised in low relief on a thirteenth-century roundel from Haghia Sophia in Trebizond (Exh. Catal. *L'art byzantin, art européen,* Athens, 1964, p. 134, No. 10) and on earlier pieces of the same kind (ibid., p. 133, No. 7). The fluid modeling and lightly controlled articulation of surface texture argues for a date beyond the more robustly tectonic effects of the initial synthesis of Byzantine and Romanesque elements within Venetian twelfth-century sculpture. (See also for additional pieces of this kind Mount Holyoke, No. 4; Isabella Stewart Gardner Museum, No. 14; and for the problem of origin and diffusion, the studies of H. G. Franz, "Das Medaillon als architektonisches Schmuckmotiv in der italienischen Romanik," *Forschungen und Fortschritte,* 1957, pp. 118–25, and "Das Schmuckmedaillon in der Baukunst des Mittelalters in Italien, Byzanz und dem islamischen Orient," *Zeitschrift für Kunstwissenschaft,* 1959, pp. 111–38.)

13. CORNER CAPITAL. Spain or southern France.
Limestone, with traces of polychromy. First half of the XIIth century.

H. 9″, W. 17 ½″ (23 × 44.5 cm.).
No. 1949.216. Gift of the Hartford Foundation for Public Giving.
Formerly Brimo de Laroussilhe, Paris (1937), and J. Brummer, Fig.
15.

Flat block, part of the stepped jamb of a portal. The exposed sec-
tion at the corner is given the form of a capital with Corinthian
volutes, carved in low relief. The body of the design shows a pair
of affronted ostriches, bending down to peck at their legs. The
work is a rustic formulation of a motif which appears on capitals
from the Cathedral of Pamplona, San Esteban in the province of
Saragossa (J. Gudiol Ricart and J. A. Gaya Nuño, *Ars Hispaniae*, V,
figs. 229 and 231) and on the other side of the Pyrenees in several
examples from Saint-Sernin in Toulouse, now in the Musée des
Augustins (Mesplé, *Sculptures romanes*, Nos. 224, 228, 229, and 227).

Bibliography

Brummer III, p. 141, No. 592; Wadsworth Atheneum, *Annual Report*, p. 34;
Religious Art, p. 14.

II

Rhode Island School
of Design Museum of Art
PROVIDENCE

1. CRUCIFIX. Northeastern Spain.
Oak, with traces of polychromy. Second half of the XIIth century.
H. 7'1", W. 7'1" (180 × 180 cm.).
No. 43.156. Purchased from J. Weissburger.
Formerly Garcia y Palencia, Madrid. Fig. 16.

This most impressive work is typologically related to two other
monumental crucifixes in wood, the first from Santa Clara near
Palencia now in the Cloisters (J. J. Rorimer, *The Cloisters. The
Building and the Collections of Medieval Art*, New York, 1963, pp.
39–41), and a second in the Church of Sancti Spiritus in Salamanca
(J. E. Cirlot, *Salamanca y sua provincia*, Guias artisticas de España,
Barcelona, 1956, p. 108). A third work at Palacios de Benaver,
though more distantly related, would seem to belong to the same
group (G. Gómez de la Serna, *Del Pirineo a Compostela*, Madrid,
1965, p. 150). In these monuments, Christ is represented im-
passively disdaining suffering and death, in conformity with the
iconography of the Crucifixion which predominated in the earlier
Middle Ages. The eyes are fully open, the expression serene, and
the limbs firmly outstretched in a gesture of prodigious self-confi-
dence and power. In the crucifixes of Palencia and Salamanca, this
triumphal aspect is further emphasized by Christ's crown, an attri-
bute which the Providence carving appears to have lacked. One
may note in the latter the equal dimensions of the corpus in height

29

and width, an aspect of the idealized conception of Christ as embodying the figure of perfect man.

Although they cannot be considered to be the work of the same master or atelier, the four monumental crosses have the same stylistic features in common. The definition of the rib cage, marked at the center by the oval depression of the sternum, as well as the handling of the perizonium, connect the Providence crucifix especially with the work in Salamanca. The Providence carving has unfortunately lost its polychromy, exposing the surface of the wood. Arms and head can be seen to have been carved from separate sections of wood, and the former appear to be modern replacements (Scher, *Gesta*, IX/2, 1970, p. 60). Both hands and feet are damaged, and there are numerous abrasions and other losses to the surface.

Bibliography

A. Mayer, *El estilo romanico en España*, Madrid, 1931, p. 74; A. M. B., "A Spanish Romanesque Crucifix," *Museum Notes,* September 1943, *Art News*, December 1943, pp. 26–27; W. W. S. Cook and J. Gudiol Ricart, *Ars Hispaniae*, VI, Madrid, 1950, p. 363, fig. 405; *Spanish Medieval Art* (Exh. Catal. The Cloisters, New York), 1954, No. 38; *Treasures of the Museum of Art*, Rhode Island School of Design, 1956, unpaged; Scher, *Renaissance*, pp. 108–10, No. 39; Scher, *Gesta*, IX/2, 1970, p. 60.

2. ST. PETER. Cluny.
Limestone, Ca. 1115.
H. 28 ½" (72.5 cm.).
No. 20.254. Formerly Collection of M. Thiebault-Sisson, Paris, and Nevers dealer (1905). Purchased from Durlacher Brothers, New York. Fig. 17.

The fragmentary figure of the apostle holding the keys came without indication of original provenance from a private collection in Paris. It has been convincingly identified on grounds of style as being from the portal of the abbey church of Cluny (Cluny III) by Helen Kleinschmidt, an attribution endorsed by Professor K. J. Conant. The figure was broken off from the surface of the block from which it was carved. It was bonded to this surface along a vertical path extending downward from the shoulder at the right

side of the back. Free from the block except for this narrow link, it projected from the plane of the portal wall at an angle of some thirty to forty-five degrees. Since Kleinschmidt's publication, the unsightly restoration of the nose has been removed and the joint of the head and body has been laid bare. This joint was discovered not to be the true one. The two parts were approximately fitted together with the help of the restorer's chisel and fastened by means of a dowel. This operation was no doubt responsible for the loss of a section of the neck, which accounts for the rather unsatisfactory stoop-shouldered aspect of the work. Because of the factitious connection of head and body, there has been some speculation that the two parts did not originally belong to the same body. Such a view is in a certain measure encouraged also by the physiognomic traits exhibited by the head, which are not those of the stereotypical Petrine type. Yet the features of the Providence figure are very close to those of the apostle on the right splaying of the central portal at Vézelay. The Vézelay carving is the work of a sculptor who was either a close follower of the Master of the Cluny portal, or, as F. Salet has suggested, the Master himself (Salet-Adhémar, *Vézelay*, p. 166ff.). The matter has been definitively settled by a thorough analysis of the work made in 1972 under the supervision of Kathryn McCauley, assistant curator of the museum, which uncovered fossil patterns straddling the break, proving that head and torso were carved from the same block.

The Cluny portal was destroyed by explosives in 1810. Its location on the site and its dimensions have been established through the excavations and studies of Professor Conant. For knowledge of the appearance of the portal, we are dependent on a description made in the middle of the eighteenth century and later transcribed by Philibert Bouché in his unpublished history of the Burgundian town and monastery (Paris, Bibl. Nat. Ms. Nouv. Acq. fr. 4336, p. 108ff.), and a number of views, none very satisfactory. The Providence figure can be identified as one of the four figures mentioned in Bouché's description as situated in the spandrels above the right and left halves of the voussoir arch: *"Sur le cadre qui règne entre la plate-bande et le grand cintre du portail on voit de chaque côté deux statues en relief hautes d'environ 4 pieds ½."* The size given corresponds approximately with the Providence apostle, which in a complete state would have measured about five feet in height. The spandrel reliefs do not appear in the watercolor of Lallemand,

qualitatively the best among the graphic representations, but they are recorded in the painstaking but mediocre engraving made by Lemaître after a lost drawing by J. F. Garnerey (A. Erlande-Brandenburg, "Iconographie de Cluny III," *Bull. mon.*, 1968, pp. 321–22). Since the other known views of the portal—those of Sagot and the anonymous engraving in Lenoir's *Monumens des arts libéraux, mécaniques et industriels de la France*—have been shown to depend on Lemaître's plate rather than on direct observation, it is this latter representation which alone has to be relied upon for an indication of the apostle's original disposition on the portal. The Lemaître view shows the outermost pair of figures standing, with the innermost seated. Since the Providence apostle faces inward toward the viewer's right, he must have been located on the left (north) spandrel. Kleinschmidt proposes to identify as our figure the seated personage closest to the center in this zone. Although this suggestion is thoroughly acceptable on iconographic grounds, it must be admitted that the inaccuracy of the engraver defeats all attempts at detailed comparison.

The iconography of the Cluny portal still requires detailed study. So far as the combination of *Majestas Domini* with the four apostles is concerned, there is a basis of comparison with the tympanum of Carennac (Lot). The date of the work is also in dispute. According to Conant, the sculpture was planned in the period 1106 to 1109, before the death of St. Hugh, and finished and placed in position toward 1112. The terminal date in this chronology is furnished by the fifteenth-century inscription in the Chapelle des Bourbons indicating that the *major ecclesia* was completed in the span of twenty-five years. This is understood by Conant to embrace the period beginning with the *fundatio* in 1088 to the year 1113 (*Cluny. Les églises et la maison du chef d'ordre*, Mâcon, 1968, p. 100ff.). F. Salet, however, has argued forcefully that the church began by St. Hugh was completed not long before 1132 when the Norman chronicler Orderic Vital took part in ceremonies there, or possibly in time for the dedication by Pope Innocent II on October 25, 1130 (Salet, "Cluny III," *Bull. mon.*, 1968, p. 281ff.). A probable date is suggested by the appearance of sculptors manifestly dependent on the style of Cluny at Vézelay, after the fire of 1120.

Bibliography

R. van Marle, "Twelfth Century French Sculpture in America," *Art in America,* December, 1921, pp. 3–16; L. E. Rowe, "A Piece of Romanesque Sculpture," *Bulletin of the Rhode Island School of Design,* July, 1926, pp. 30–32; J. Talobre, "La reconstitution du portail de l'église abbatiale de Cluny," *Bull. mon.,* 1944, pp. 225–40; H. Kleinschmidt, "The Cluny St. Peter," *Studies. Museum of Art. Rhode Island School of Design,* 1947, pp. 17–31; J. Evans, *Cluniac Art of the Romanesque Period,* Cambridge, 1950, p. 24; W. Wixom, *Treasures from Medieval France,* Cleveland Museum of Art, 1967, pp. 61, 351–52; K. J. Conant, *Les églises et la maison du chef d'ordre,* Mâcon, 1968, pp. 101, 104; Scher, *Renaissance,* pp. 24–28, No. 1; Margaret Williams, unpublished study in the files of the museum.

3. PORTAL. Loire Valley or western France.
Limestone. End of the first quarter of the XIIth century.
H. 13', W. 13'5" (overall). Opening: H. 9'8", W. 4'10" (2.64 × 1.47m.).
No. 40.014. Formerly Collection of William Randolph Hearst.
Purchased from Brummer Galleries, New York. Fig. 18.

As R. Crozet points out (*L'art roman en Poitou,* Paris, 1948, p. 136), portals constructed with a heavy engaged half column on the inner face of the arch are very common in Poitou. Some decorative motifs of the portal can also be associated with western France. The sawtooth frieze of the impost occurs at Contré (ibid., pl. XV) and in a number of churches in Angoumois. It is found in association with the looping band forming a continuous chain of ovoid spaces which is seen on the oblique faces of the block above the capital with the pair of pecking birds at Moulède de Saint-Saturnin near Angoulême (George and Guérin-Boutaud, *Églises romanes,* p. 35, fig. 15). The rather dry handling and fernlike design of the palmette forms which decorate the smaller capitals of the left outer splay have much in common with sculpture of Puyperoux and Saint-Michel d'Entraigues (ibid., p. 238, figs. 168A and B). Nevertheless, there is insufficient evidence for a firm attribution, since the occurrence of these motifs cannot be rigidly circumscribed within a single region and may be demonstrated on a selective basis in adjoining areas.

Bibliography

Scher, *Renaissance,* pp. 60–62, No. 20.

4. TWO APOSTLES. South central France.
Limestone. Beginning of the second quarter of the XIIth century.

(a) H. 34″, W. 10″ (76.5 × 25.5 cm.).
No. 41.045.

(b) H. 32 ½″, W. 10 ½″ (72.5 × 26.5 cm.).
No. 41.046.

Formerly J. Altounian, Mâcon (1929). Purchased from J. Brummer.
Figs. 19 and 20.

The two reliefs constitute with four apostles in the collection of
Duke University, a St. Peter in the Smith College Museum of Art,
an angel and an additional apostle in the University of Rochester
Memorial Art Gallery, the remnants of a monumental Ascension
(R. C. Moeller III in Scher, *Renaissance,* pp. 50–58, Nos. 10–18, with
the bibliography up to date). The style of this sculpture clearly
points to the region of Rouergue and Quercy. An inquiry to the
dealer brought the reply that "the relief (of the angel) came from a
place forty to sixty kilometers from Moissac, from a small church
which had collapsed because its foundations had been washed out
by the river many years ago and was in private ownership" (letter
of J. Brummer dated November 1, 1943, in the files of the Univer-
sity of Rochester Memorial Art Gallery). R. C. Moeller has made a
striking comparison with the sculpture of the church of St. Martin
at Brive, but the monument from which the dismembered composi-
tion stems remains for the moment still unknown.

Regarding the nature of the original composition, either a portal
with tympanum and lintel (Cahn, *Gesta,* VII, 1968, pp. 53–54) or an
arrangement with reliefs distributed over the entire façade (L. Pres-
souyre, *Bull. mon.,* 1969, p. 246) have been envisaged. The second
hypothesis seems the more plausible one in view of the large di-
mensions which a portal reconstruction would demand. The effect
of weathering on the side of the reliefs also indicates that they can-
not have been joined together in very recent times. At the same
time, it is troublesome that façade compositions of the Ascension

are found in western France (Angoulême Cathedral, Ruffec, Pérignac) rather than in Quercy and Languedoc, where the tympanum format prevails (Cahors, Mauriac, Collonges). This might make a more westerly site, like Périgord, a more promising terrain for the question of localization. A group of seven apostles from another Ascension is now embedded in the façade of the church at Bussières-Badil (J. Secret, *Périgord roman*, Collection Zodiaque, 1968, p. 55ff.).

Bibliography

R. C. Moeller III, *Sculpture and Decorative Arts*, Raleigh, N.C., 1967, p. 17; Moeller, *College Art Journal*, 1967–68, pp. 182–84; Moeller, in Scher, *Renaissance*, pp. 50–58, Nos. 10-18; R. Calkins, *A Medieval Treasury*, Ithaca, N.Y., 1968, No. 54; L. Pressouyre, *Bull. mon.*, 1969, p. 246; Pressouyre, *Revue de l'art*, 4, 1970, pp. 98–99.

5. CHRIST IN MAJESTY. Santa Marta de Tera (Zamora).
Marble. First quarter of the XIIth century.
H. 38 ½", W. 22" (97 × 65 cm.).
No. 69.196. Collection of John Nicholas Brown, Providence, R. I.
On long-term loan to the Rhode Island School of Design Museum of Art. Fig. 21.

The seated Christ raises His right arm in blessing and displays an open book on which appear the words EGO SVM LVX MVNDI (John VIII:12). The head is encircled by a cruciform halo and the stolidly proportioned figure clothed in an ample garment covered by the priestly chasuble. The outer vestment is lined around the neck and down the front by an embroidered band. Although Christ is occasionally characterized as a priest through the attribute of the stola (F. Rademacher, *Der thronende Christus der Chorschranken aus Gustorf*, Cologne-Graz, 1964, p. 146ff.), representations of Him wearing the chasuble are rare, though some additional Spanish examples are known (P. Braude and S. Scher in Scher, *Renaissance*, p. 105). The Providence relief was in all probability the central piece in a theophany composition in which Christ was flanked by angels and surrounded by the symbols of the Evangelists. The rough and pocked surface around the edges of the relief, which

appears to be of recent origin, may have been due to a restorer's work in removing traces of a mandorla. But it should be noted that all old views available to us show the work in its present state.

The fleshy features and heavy garments creased by bulging folds indicate that the sculptor's style was formed through contact with the production of the ateliers responsible for the Miègeville portal and west façade of Saint-Sernin of Toulouse or the Porta del Cordero and Porta del Perdon at San Isidoro of León. These works take us into the middle and final years of the second decade of the twelfth century. The relief stems from the church of Santa Marta de Tera, located about halfway between the cities of León and Zamora, where it was seen around the beginning of this century by M. Gómez-Moreno ("Santa Marta de Tera," *Boletín de la Sociedad española de excursiones*, XVI, June 1908, pp. 81–87). The carving had then already been detached from its original setting, which is not known. The church itself is an edifice in the form of the Latin cross, with a groin-vaulted nave of three bays, transept, and choir of a single square bay. The capitals in the interior and sculpture of the portals constitute additional evidence of a connection with the ateliers of León. A monastery is mentioned on the site in the tenth century and received endowments from the kings of León in 1033 and again in 1063. In 1085, King Alphonsus VI founded there an abbey of regular canons. The church, probably erected some time after that date, again secured important benefits from Alphonsus in 1129.

Bibliography

M. Gómez-Moreno, "Santa Marta de Tera," *Boletín de la Sociedad española de excursiones*, XVI, June 1908, pp. 81–87, esp. p. 87; Gómez-Moreno, *Catalogo monumental de España. Provincia de Zamora*, Madrid, 1927, pp. 185–86; A. K. Porter, *Spanish Romanesque Sculpture*, New York, 1928, pp. 68, 120; A. Gomez Martinez, *Zamora y su Provincia* (Guias artisticas de Espana), Barcelona, 1958, p. 172; Scher, *Renaissance*, pp. 103–105, No. 37; A. Vinayo Gonzalez, *León roman* (Collection Zodiaque) 1972, pp. 319–22. The relief was cited in 1928 by Porter as being in the hands of a dealer in Madrid, but Gomez Martinez and Vinayo Gonzalez still claim that it may be seen within the church.

6. CAPITAL. Nivernais. Saint-Laurent l'Abbaye (?).
Limestone. End of the first quarter of the XIIth century.
H. 20 ½", W. 22" (52 × 56 cm.).
No. 40.166. Fig. 22.

Designed to surmount an engaged columnar shaft, this capital is a variant of the Corinthian family, showing a figure in bust length at the center in the place normally occupied by the rosette. The type has Roman antecedents (Ch. Picard, "Un chapiteau historié du Colisée," *Revue archéologique*, 1955, p. 74, and Picard, "Sur quelques chapiteaux historiés des Thermes d'Antonin à Carthage," *Karthago*, 1953, pp. 99–118) which we see distantly reflected in the schematized architectural representations in early medieval illuminated manuscripts, as in the ninth-century lectionary of Pfäfers (A. Bruckner, *Scriptoria Medii Aevii Helvetica*, I, Basel, 1935, p. 86ff. and pls. XVIII and XIX) and two codices of the Ottonian period, the Gospels of Otto III in Aachen and the Book of Pericopes of Henry II in Munich (H. Jantzen, *Ottonische Kunst*, Munich, 1947, pp. 44 and 47). A more substantial number are found in the stone sculpture of the Romanesque period (cf. J. Adhémar, *Influences antiques dans l'art du moyen âge français*, London, 1939, p. 170, and the capital from Sant Pere de Roda in Worcester inventoried below).

The capital was acquired by the museum with the understanding that it came from Nevers. A similar capital of matching dimensions in the Philadelphia Museum of Art (No. 1945.25.34. M. Weinberger, *The George Grey Barnard Collection*, New York, n.d., p. 7, No. 34) has been attributed to Auvergne. According to M. Jacques Palet (correspondence in the files of the Philadelphia Museum of Art), the two carvings stem from the Church of Saint-Laurent l'Abbaye, a former house of Augustinian canons now standing in ruins some eight kilometers east of La Charité-sur-Loire. Two other capitals in Philadelphia can be recognized on an old photograph of the partially standing section of the nave arcade (Mon. Hist. 47.139) and the impressive portal of the church was earlier acquired by the same museum, but these do not decisively settle the question of provenance (Cahn, *Gesta*, XIII/1, 1974, No. 1 and addenda, Nos. 3–4, 7 and 10.

Bibliography

Scher, *Renaissance,* pp. 44–45, No. 7; Scher, *Gesta,* IX/2, 1970, p. 59, No. 2.

7. CORBEL. Aunis.
Limestone. XIIth century.
H. 16″, W. 7 ½″ (41 × 19 cm.).
No. 51.316. Formerly Collection Duthil, Bordeaux, and Julius Böhler, Munich. Purchased from F.A. Drey, London. Fig. 23.

The carving shows a small keg suspended from a hook and supported from below by two outstretched hands. The subject has been interpreted as a comment on the vice of intemperance. Similar representations of barrels, sometimes alone, sometimes held by acrobatic little figures, are frequent in Angoumois, Saintonge, and Aunis. (A number are listed by George and Guérin-Boutaud, *Églises romanes,* p. 266, and the same authors' "Barriques, barils et coffinas sculptés sur quelques églises romanes de l'Angoumois," *Bulletin et mémoires de la Société archéologique et historique de la Charente,* 1914, pp. L–LIII.)

The Providence corbel is stated to have come from the church of Nuaillé-sur-Boutonne (Charente-Maritime), a modest single-nave edifice located between Aulnay and Saint-Jean d'Angély. The church was a dependency of the bishops of Saintes (Ch. Dangibaud, "Pouillé du diocèse de Saintes en 1683," *Archives historiques de la Saintonge et de l'Aunis,* 1914, pp. 249 and 270). The corbel is one of a group of five now dispersed with the same or similar sounding given provenance. A second, showing a man blowing a horn is in the Yale Art Gallery (1956.17.3; see below, No. 4) and a third, with a representation of a figure tugging at the beard or distending the mouth is in the Stockholm National Museum (C. Nordenfalk, "Troll och Helgon," *Årsbok för Svenska statens Konstsamlingar,* XII, 1964, p. 41ff.). A fourth, with a leonine monster playing a viol, is in the collection of Mrs. M. H. Drey (Exh. Catal. *Romanesque Art,* Manchester, 1959, p. 35, No. 66) and the fifth, showing a standing female figure holding an unidentifiable object in her hand, perhaps an allegorical personification, is in the collection of Ernest Erickson, New York (Nordenfalk, "Troll och Helgon," p. 44, fig. 3).

Bibliography

R. Berliner, "Intemperance: A Romanesque Sculptured Corbel," *Museum Notes*, November 1951; Scher, *Renaissance*, pp. 70–72, No. 22; Scher, IX/2, 1970, p. 60. On the church, see E. Dahl, "Nuaillé-sur-Boutonne," *Congrès arch.*, 1956, pp. 297–303. For the type of barrel shown, R. Hallo, "Altfranzösische Barilia," *Repertorium für Kunstwissenschaft*, 1930, pp. 148–67.

8. COLUMN. Central Italy.
Marble. Second half of the XIIth century.
H. 61", D. 5¾" (154.9 × 14.6 cm.).
No. 62.120.9a. Gift of Mrs. Davenport West. Fig. 24.

The shaft is divided into five roughly equal parts, alternatively showing a striated and a vertical membering. Similar columns can be seen along the enclosure of the upper section of the paschal candlestick of San Clemente in Casauria (M. Moretti, *Architettura medioevale in Abruzzo*, Rome, n.d., p. 209) and in the same region, along the portals of the churches of Santi Pietro e Paolo at Alfedena and San Massimo at Penne (ibid., pp. 458–59 and 462). A foliate capital formerly mounted at the top of the piece (No. 62.120.9b) is of uncertain authenticity.

Bibliography

Exh. Catal. *Raid the Icebox I with Andy Warhol*, Providence, 1970, p. 53, No. 51.

III

Worcester Art Museum

WORCESTER, MASS.

1. VIRGIN AND CHILD. Spain. Catalonia (?).
Walnut with polychromy. Second half of the XIIth century.
H. 36 ⅛", W. 12" (front), ca. 9" (side) (81.5 × 30.5 × 23 cm.).
No. 1933.160. Purchased from Durlacher Brothers. Fig. 25.

The seated Virgin faces the beholder in full frontality. The Child is turned leftward in a three-quarter pose. He displays an open book, while His right arm is raised in a magisterial gesture. The back of the statue has a hollow cache in all probability intended for relics. The work has suffered considerable damage from insects, especially in the lower zone and at the sides. The right hands of both Virgin and Child, originally carved from separate blocks and attached by dowels, are now missing. The Child's head is broken off, and the sides of the throne have been stripped of their original revetment. Extensive traces of polychromy of undetermined date are still visible on the upper part and right side of the Virgin's body. Other parts of the statue have been stripped down to bare wood.

The statue is said to come from the Cathedral of Autun in the dealer's bill of sale, but this presumption is untenable. It should be noted that the iconographic cult statue type with the Child in three-quarter view or seated to one side and exhibiting an open book appears with great frequency in Spain. It is the type illustrated by the statue of Santa Eulalia la Mayor (Huesca), Yequeda (Huesca), and in the stone images of Ciudad Rodrigo (Salamanca)

40

and the Cathedral of Tudela (J. A. Sanchez Perez, *El Culto Mariano in España,* Madrid, 1943, figs. 37, 212, 32, and 34). The Worcester Madonna has more than a casual kinship with the cult statues of the Cathedral of Gerona and the related image of Montserrat. The softly pliant definition of the drapery recalls the sculpture of the Gerona cloister, while the idiomatic characterization of the breast is paralleled in the Virgin of the Annunciation group of Lerida Cathedral. Although these comparisons still leave much room for argument, they seem to establish a tenable case for a Spanish attribution.

Bibliography

Worcester Art Museum Bulletin, XXIV, No. 4, 1934, pp. 103, 105–108; *Worcester Art Museum Annual Report,* 1934, pp. 12, 15, 28; *Art through Fifty Centuries from the Collections of the Worcester Museum,* Worcester, 1948, p. 36, fig. 47, *Worcester Art Museum News Bulletin and Calendar,* October 1953, p. ii; S. L. Faison, *A Guide to Art Museums in New England,* New York, 1958, p. 187, fig. 8; I. H. Forsyth, "The Mabon Madonna," *Mary the Throne of Wisdom,* St. John's University, Collegeville, Minn., 1963, pp. 4–12; Forsyth, *The Throne of Wisdom. Wood Sculptures of the Madonna in Romanesque France,* Princeton, 1972, p. 191, No. 72.

2. **TWO CAPITALS.** Notre-Dame de Montermoyen, Bourges.
Sandstone. Second quarter of the XIIth century.
H. 27", W. 24 ¾" (68.5 × 63 cm.).
Nos. 1941.42 and 1941.43. Formerly Collection of George Grey Barnard. Figs. 26 and 27.

The two capitals are part of a group of five to have survived from the church of Notre-Dame de Montermoyen in Bourges, demolished in the nineteenth century. The three others are in the Musée du Berry in Bourges. The church of Montermoyen stood on the site of a convent founded in 646 as *monasterium medium* and later transformed into a house of Augustinian canons. The church was situated in the eastern sector of the space comprised within the early medieval walls of Bourges. A plan in the Archives Départementales du Cher, published in a somewhat schematic form (R. Crozet, *L'art roman en Berry,* Paris, 1932, p. 85, fig. 7) shows us a

structure with a very short nave of two bays flanked by aisles, a modestly projecting transept, and a rather more extensive choir of a simple Benedictine type, with aisles terminated by flat walls in the east at the level of the apse. Since the Worcester capitals are carved on all sides, they must have surmounted two of the eight columnar shafts which divided the sanctuary from the flanking aisles. According to the seventeenth-century historian of Bourges, Catherinot, the church was rebuilt in 1080, but as in the case of a number of other Berrichon churches for which firm dates of consecration have come down (Méobecq, 1048; Saint-Genou, 1066), this information is not compatible with the archaeological evidence. The style of the capitals suggests a date not before the end of the first quarter of the twelfth century.

Like the famous Temptation capital at Plaimpied, the Worcester capitals are the work of an exceptional talent whose hand is difficult to find in other sculpture of the region. In a recent and suggestive hypothesis, they have been linked with the capital of Daniel in the Lions' Den believed to come from Saint-Aignan-sur-Cher (W. Wixom, *Treasures from Medieval France*, Cleveland, 1967, pp. 64, 252–53). Something of the same formal conception and crisp definition occurs in the capitals of Les Aix-Angillon (M. Deshoulières, *Congrès arch.*, 1931, pp. 289–300) and, as pointed out by Crozet (*L'art roman*, p. 240), at La Chapelle-Saint-Ursin near Bourges.

One of the two capitals shows three rows of highly stylized leaves. The other has monsters belaboring helpless little naked men. The latter occupy the four corners, one standing on the head of a second, whose body is abbreviated at the torso by the astragal. In the upper zone of the capital, winged beasts joined in pairs under a single head and united by intertwined tails prepare to devour their prey. Below, symmetrically paired lions imprison the victim in their jaws. On the fourth side, which is different, the roles are reversed and the beasts are dominated by an impassive and finely accoutered hero who stands between them. There are numerous iconographic parallels, notably among the capitals of Saint-Michel-de-Cuxa in the Cloisters, at La Berthenoux in Berry (Deshoulières, *Congrès arch.*, pp. 577–83), and at Charlieu, Vézelay, Gourdon, and Issy-l'Evêque in Burgundy.

Bibliography

Buhot de Kersers, *Histoire et statistique monumentale du Cher*, Bourges, 1883, II, p. 216ff. and pl. XIX; M. Deshoulières, *Les églises du Cher*, Paris, 1932, pp. 49–50; Deshoulières, "Nouvelles remarques sur les églises romanes du Berry," *Bull. mon.*, 1922, pp. 24–25; M. Weinberger, *The George Grey Barnard Collection*, New York, 1941, pp. 2–3, pl. IV, No. 14; *Worcester Art Museum News Bulletin and Calendar*, October 1941, No. 1; *Art through Fifty Centuries*, p. 35, fig. 46; L. Grodecki, "Les chapiteaux de l'église de Montermoyen à Bourges," *Mémoires de l'Union de la Société Savante de Bourges*, III, 1951–52, pp. 13–29.

3. CHAPTER HOUSE. Le Bas-Nueil, Poitou.
Limestone. Third quarter of the XIIth century.
L. 32'8", W. 21'9", H. 14'8" (inner walls) (9.95 × 6.62 × 4.47 m.).
No. 1927.46. Figs. 28, 29, and 30.

The chapter house is an oblong space divided into six rib-vaulted bays. The room is entered through a round-arched opening at the center of the north wall. This portal is flanked on each side by a window subdivided into double bays. A row of five closely spaced colonnettes which spans the width of the dividing double arches conveys an impression of the enormous thickness of the wall. The outer profile of portal and windows is decorated with a running band of four-petaled flowers. The vaults of the chapter house repose on a pair of free-standing columns marking the longitudinal axis of the space. Along the walls, they are sustained by engaged colonnettes, single shafts at the corners, and triple ones along the flat sections. The diagonal ribs are composed of double rolls. The lateral and longitudinal arches, on the other hand, are squarish in section. As M. Aubert already observed many years ago ("Les plus anciennes croisées d'ogives," *Bull. mon.*, 1934, p. 162, note 2), their path does not conform to the more pointed profile of the vaults, and the blocks which compose them become progressively longer toward the apex, in order the fill the gap.

Le Bas-Nueil (also called Nueil-sur-Dive) is situated near Loudun (Vienne) in the diocese of Poitiers. It is first mentioned in 1075, when a certain Alo conceded a church situated in the *villa* on the site, as well as other privileges, to the monastery of St. Peter of Bourgueil, near Chinon (M. Dupont, *Monographie du car-*

tulaire de Bourgueil, Tours, 1962, pp. 29 and 155). The site of the priory, long abandoned, is now occupied by a farmhouse which harbors parts of the north transept and sanctuary of the church, originally dedicated to St. John. The chapter house stood in the axis of the north transept arm whose end wall it abutted. A sculptured portal now in the Cloisters (Acq. No. 25.120.878) may also have formed part of this ensemble of constructions. In letters dated May 18, 1927, and January 31, 1929, the director of the Worcester Art Museum was assured that this was so by George Grey Barnard, who sold both monuments to their present owners (these letters, in the files of the museum, were called to my attention by the late Professor R. Crozet). The Cloisters portal is of more refined workmanship and perhaps some years later in date than the Worcester chapter house, but they are not stylistically incompatible.

The chapter house belongs to the first penetration of Gothic art in the Loire Valley and western France. The already noted discrepancy between the paths of the vault and transverse ribs are evident signs of the builders' yet uncertain grasp of the new aesthetic. The double-roll profile of these ribs marks a specific stage in the development of early Gothic architecture, while the soft and unmuscular quality of the acanthus foliage in the Corinthian capitals is fairly typical of Anjou and Poitevin work of this period.

Bibliography

Worcester Art Museum Annual Report, 1928, pp. 7, 14–15; *The Arts,* January 1928, pp. 35, 39; *Worcester Art Museum Bulletin,* XXIV, No. 4, 1934, pp. 77–81; R. Crozet, "L'église du prieuré de Nueil-sur-Dive," *Bull. mon.,* 1934, pp. 461–68; *Pierres de France,* January–March 1938, pp. 27–29; L. Dresser, "A Visit to Le Bas-Nueil," *Worcester Art Museum News Bulletin and Calendar,* March, 1958, No. 6; A. Mussat, *Le style gothique dans l'Ouest de la France,* Paris, 1963, pp. 42–44.

4. FRAGMENT OF A CAPITAL. Northern Italy.
Marble. First quarter of the XIIth century.
L. 11 ⅝", W. 9 ⅝", H. 5 ½" (29.5 × 24.5 × 14 cm.).
No. 1933.10. Gift of Lucien Demotte. Fig. 31.

The carving is a trapezoidal block approximately half its original length in its present state. The shape suggests that it was designed either as a capital or as a corbel block for a portal, but the fact that both sides are decorated with figures in relief and were consequently exposed would argue in favor of the first possibility. As a capital, the fragment is most likely to have been employed in the arcade of a dwarf gallery, such as may be seen immediately below the roof line of numerous Romanesque buildings, most frequently in those of Italy. Each side of the block shows a little helmeted figure. Both are in the same pose, with one arm bent back to grasp the neck and the other extended across the body to touch the hip. The sloping underside of the block between them is occupied by a lion. Stylistically, the work should be related to the production of the immediate followers of Wiligelmo and might be suitably compared with the sculpture of the Porta de Principi at Modena (A. C. Quintavalle, *La Cattedrale di Modena*, Modena, 1964–65, pls. 87–95).

Bibliography

A. D. MacDonald, "An Architectural Fragment of the Twelfth Century," *Worcester Art Museum Bulletin*, XXIV, No. 3, 1933, pp. 65–67; *Worcester Art Museum Annual Report*, 1933, p. 31.

5. **CAPITAL.** Sant Pere de Roda, Catalonia.
Marble. Middle of the XIIth century.
H. 18 ⅛", W. 14 ¾" (46 × 37.5 cm.).
No. 1934.33. Gift of Arthur Byne, Madrid. Fig. 32.

According to a letter of the donor in the files of the museum, the capital "was purchased on the site [of the monastery of Sant Pere de Roda] by myself." Although somewhat battered, it is of superb quality. The four sides are covered with an intricate network of stylized foliage, flattened to embrace the simplified contours of the block and pitted with deep recesses in the manner of late Antique "basket weave" capitals. On one of the sides, the place of the rosette is taken by the bust of a bearded and long-haired patriarch (for this type of capital, see above, Rhode Island School of Design

Museum of Art, No. 6). The expressive delineation of the features and such idiomatic touches as the eyeball isolated in its socket by deep undercuts at the corners mark the carving as the work of the Master of Cabestany, as first noted by M. Durliat (*La sculpture romane en Roussillon*, IV, Perpignan, 1954, pp. 22–23. This scholar was misled, however, in his observation "Un personnage . . . tient dans les mains le cou de volatiles").

The Master is the sculptor whose oeuvre has been reconstituted around the tympanum of the little parish church of Cabestany in the Roussillon. It has been suggested by E. Junyent, followed by G. Zarnecki, and most convincingly by L. Pressouyre, that he was of Tuscan origin and that the capitals of Sant'Antimo (Montalcino, Siena), Castelnuovo dell'Abbate, and a carved pillar at San Giovanni in Sugana, may be considered early works. The Master is attributed an extensive series of undertakings on both sides of the Pyrenees, among them the sarcophagus of Saint-Sernin at Saint-Hilaire (Aude), the portal frieze at Boulou (P.-O.), and capitals and other decorative sculpture at Rieux-Minervois and Saint-Papoul. The relief with the Calling of Peter (Museo Marés, Barcelona), surely his most impressive achievement stems, like our capital, from Roda.

Owing to the lack of a detailed topographical study of the ruins of the monastery, it is impossible to ascertain with complete assurance the original location of our capital and of other Roda fragments on the building site. Fragments in the same style still in place make it possible that these were part of a construction appended to the western façade of the eleventh-century church, which consisted of an atrium preceded by a monumental porch. According to R. Crozet, however, the large size of our capital and the fact that it is carved on all four sides would suggest that it stems from another type of monument, perhaps a chapter house or ciborium (Crozet, "A propos du Maître de Cabestany: Notes sur un chapiteau de Sant Pere de Roda au Musée de Worcester," *Annales du Midi*, LXXXIV, 1972, pp. 77–79).

Bibliography

Worcester Art Museum Bulletin, XXIV, No. 4, 1934, p. 115; *Worcester Art Museum Annual Report*, 1935, p. 15; M. Durliat, "Sculptures de marbre de l'église de Sant Pere de Roda," *La sculpture romane en*

Roussillon, III, Perpignan 1950, pp. 56–64; Durliat, "L'oeuvre du Maître de Cabestany," *La sculpture romane en Roussillon*, IV, Perpignan 1954, pp. 6–49, E. Junyent, "L'oeuvre du Maître de Cabestany," *Actes du quatre-vingtsixième Congrès des Sociétés Savantes*, Montpellier, 1961 (1962), pp. 169–78; G. Zarnecki, "A Sculptured Head Attributed to the Maître de Cabestany," *Burlington Magazine*, 1964, pp. 536–39; Scher, *Renaissance*, pp. 111–13, No. 40; L. Pressouyre, "Une nouvelle oeuvre du Maître de Cabestany: Le pilier sculpté de San Giovanni in Sugana," *Bulletin de la Société Nationale des Antiquaires de France*, 1969, pp. 30–54; R. Crozet, "A propos du Maître de Cabestany: Notes sur un chapiteau de Sant Pere de Roda au Musée de Worcester," *Annales du Midi*, LXXXIV, 1972, pp. 77–79.

IV

Mead Art Building, Amherst College

AMHERST, MASS.

1. DOUBLE CAPITAL. Languedoc.
Limestone. Second half of the XIIth century.
H. 15", L. 20 ¾", W. 13 ¾" (38 × 52.5 × 35 cm.).
No. 1942.81. Purchased from J. Brummer. Fig. 33.

The long faces of the block show a pair of lions under a single head at the center. They are supported on the backs of addorsed griffons, themselves locked in combat with lions symmetrically paired on the shorter sides of the capital. The abacus, carved from the same block, is decorated with a palmette frieze. Although stylistically less advanced, the work has parallels in a number of capitals in the Toulouse Musée des Augustins representing the production of regional workshops at a point in time near the dissolution of Romanesque art in southern France (Mesplé, *Sculptures romanes*, No. 313ff. See also below, Yale Art Gallery, No. 3, and Boston Museum of Fine Arts, Nos. 4 and 5). The motif of the paired winged monsters back to back, separated by a leonine mask at the center, and the use of the chip-carving technique in the abacus are recurrent features in this group. These features are found also in a capital of the Cleveland Museum (No. 16.1981. *Handbook of the Collection*, Cleveland, 1966, p. 47) that is particularly close to the Amherst carving. None of these pieces, however, has a secure provenance, and dissimilarities in size and workmanship are sufficiently marked to make it conceivable that they were executed for

48

different projects by sculptors schooled in the same Languedocian atelier and working more or less *en série.*

Bibliography

S. L. Faison, *A Guide to Art Museums in New England,* New York, 1958, p. 66, No. 8; Scher, *Renaissance,* pp. 78–79, No. 26.

V

Mount Holyoke College
Art Museum

SOUTH HADLEY, MASS.

1. CAPITAL. Angoumois.
Limestone. First half of the XIIth century.
H. 13 ½", L. 11 ½", W. 11 ½", (34 × 29 × 29 cm.).
No. M. 011.1.1959. Gift of Baroness Cassel van Doorn and Marguerite Pick. Fig. 34.

This is a corner capital, carved on two adjoining sides with palmettes alternately upright and facing downward. A number of examples of the same design and in nearly identical form occur in and around Angoulême. See in particular two capitals from Notre-Dame de Beaulieu in that city (George and Guérin-Boutaud, *Églises romanes*, p. 237, fig. 185A, and p. 238, fig. 187A).

Bibliography

College Art Journal, 1959–60, p. 169.

2. CAPITAL. Southern France.
Limestone (?). First half of the XIIIth century.
H. 11", W. 10 ¾", L. 9 ½" (28 × 27.5 × 24 cm.).
No. T. 011.1.1959. Gift of Baroness Cassel van Doorn and Marguerite Pick. Fig. 35.

A winged harpie in heraldic frontality appears at the four corners of the block, with the tails of the creatures improbably extending over two of its longer faces. In the middle of the upper zone of each side, there is an animal mask. The surmounting abacus, hewn from the same block, is decorated on three sides by a meandering foliate tendril with trilobed leaves in profile. There is some damage through abrasion and chipping, and the authenticity of the piece is not altogether assured. A similar capital is found in the Toulouse Musée des Augustins (Mesplé, *Sculptures romanes*, No. 326) where there are a number of other capitals in the same advanced, late Romanesque style stemming from as yet unidentified sites in the region. (For other carvings of the same kind, see below Yale Art Gallery, No. 3, and Boston Museum of Fine Arts, Nos. 4 and 5, and on the style generally, P. Mesplé, "L'art roman décadent du Sud-Ouest," *Bull. mon.*, 1957, pp. 15–22, and J. Baltrušaitis, "La troisième sculpture romane," *Formositas Romanica. Festschrift für Joseph Gantner*, Frauenfeld, 1958, pp. 47–84.)

Bibliography

College Art Journal, 1959–60, p. 169.

3. CAPITAL. Austria or northern Italy.
Marble. Ca. 1200.
H. 8 ½″, L. 9 ¾″, W. 9 ¾″ (21.5 × 24.5 × 24.2 cm.).
No. P. 011.6.1959. Gift of Mrs. Caroline Hill. Figs. 36 and 37.

Three sides of this unusual capital are occupied by a nude female figure whose head is imprisoned in the jaws of a lion, while her feet are devoured by another beast. A third animal, whose head is broken, stands perched on the back of this second beast. The chaste gesture of the figure would encourage an interpretation of the scene as the martyrdom of a saint rather than as a punishment of vice. A possibly comparable scene, whose subject is likewise unclear, is found among the poorly preserved paintings of the north tribune of Le Puy Cathedral (P. Deschamps and M. Thibout, *La peinture murale en France*, Paris, 1951, p. 58 and p. 57, fig. 14). The

surface of the remaining side of the capital is occupied by an anthology of anthropomorphic and zoomorphic motifs that is not easily deciphered: between the large bearded head of a man and a harpie at the corners is a smaller human head whose hair is consumed by a serpent. The globular and masklike definition of the heads with downturned mouths accentuated at the corners through the use of the drill and hair laid out in irregularly meandering parallel striations call for comparison with the sculpture of Schöngrabern in upper Austria (F. Novotny, *Romanische Bauplastik in Oesterreich*, Vienna, 1930, p. 8ff. and figs. 1–21) and less insistently, perhaps, with the work at St. James in Regensburg and Berchtesgaden in Bavaria (H. Karlinger, *Die romanische Steinplastik in Altbayern und Salzburg*, Augsburg, 1924, pp. 19ff. and 70ff.). A defensible case might also be made for a localization somewhat further south since the stylistic character of this art is ultimately traceable to certain provincial productions of north Italy.

Bibliography

College Art Journal, 1959–60, p. 169.

4. ARCHITECTURAL FRAGMENT. Northern Italy.
Marble. Middle of the XIIth century.
H. 21 ½", L. 23", W. 9 ½" (51.5 × 58.5 × 24 cm.).
No. P. 011.4.1958. Gift of Mrs. Caroline Hill. Fig. 38.

The block is a section of the dado zone from a portal construction. One of the narrow faces shows a crouching Atlante whose feet, now broken, rested on the foreparts of a lion. The bearded figure is clad in a long garment belted at the waist. The missing arms were bent upward at the elbow to assume part of the burden which fell upon the shoulders. A half colonnette surmounted by a capital of the Corinthian type has been chiseled out of the right side of the slab. Judging by the absence of weathering, it was embedded in the masonry and must betoken some earlier employment of the stone. The characterization of the figure is comparable to the Atlante from Cremona in the Castello Sforzesco, Milan (G. G. Bel-

loni, *Il Castello Sforzesco di Milano*, Milan, 1966, p. 61, No. 8. For the
type and its stylistic connections, see T. Krautheimer-Hess, "Die
figurale Plastik der Ostlombardei von 1100 bis 1178," *Marburger
Jahrbuch für Kunstwissenschaft*, 1928, p. 280ff.). For the motif of the
Atlante standing on a lion, there is a parallel in the episcopal
throne of Parma Cathedral (G. de Francovich, *Benedetto Antelami*, I,
Milan-Florence, 1952, p. 113ff.).

Bibliography

College Art Journal, 1959–60, p. 169.

5. TWO ROUNDELS. Veneto.
Marble. XII–XIIIth centuries.

(a) D. 12", Thick. 5" (30.5 × 12.5 cm.).
No. P. 11.7.1959.

(b) D. 12⅜", Thick. 4⅜" (31.5 × 11 cm.).
No. P. 11.8.1959.

Gift of Mrs. Caroline Hill. Figs. 39 and 40.

A pair of addorsed birds with heads bent back to peck a stylized
plant appears on one of the reliefs. The second is a concave disk
with a wide rim showing a rabbit in the claws of a bird perched on
its back and nipping its head. Both of these motifs are common in
this type of medallion employed in great profusion in the decora-
tion of Venetian palace façades (W. Arslan, *Gothic Architecture in
Venice*, London, 1972). (For the problems connected with this
sculpture, see the studies of H. G. Franz cited in the entry for
Wadsworth Atheneum, No. 12, and the discussion below, Isabella
Stewart Gardner Museum, No. 14.)

VI

Smith College Museum
of Art

NORTHAMPTON, MASS.

1. ST. PETER. South central France.
Limestone. Beginning of the second quarter of the XIIth century.
H. 33″, W. 12″, D. 7″ (84 × 30.5 × 17.5 cm.).
No. 37:12-1. Purchased from J. Brummer. Fig. 41.

The apostle displaying the keys stems from an Ascension portal
that can be partially reconstructed with the help of other fragments
in the Rhode Island School of Design Museum of Art in Provi-
dence, the University Museum in Durham, N.C., and the Memorial
Art Gallery of the University of Rochester. See above, Rhode Island
School of Design Museum of Art, No. 4.

Bibliography

Art News, January 1938, p. 17; E. H. P., "A Romanesque Statue of Saint
Peter," *Smith College Museum Bulletin*, 1938, pp. 3–6; G. de Fran-
covich, "Wiligelmo e gli inizi della scultura romanica," *Rivista del R.
Istituto d'archeologia e storia dell' arte*, VII, 1940, p. 272; *Smith College of
Art. Supplement to the Catalogue of 1937*, Northampton, 1941, p. 8; R.
C. Moeller III, *Sculpture and Decorative Arts*, Raleigh, N. C., 1967, pp.
8–17; Moeller, *College Art Journal*, 1967–68, pp. 182, 184.

2. COLUMN. Venice.

Marble. Ca. 1200.
H. 51 ¼", D. 5 ¾" (130.15 × 14.6 cm.).
No. 1960 TR892. Formerly Paul Drey, New York. Fig. 42.

The shaft is covered over much of its surface with a decoration in low relief, consisting of stylized foliage, rosettes, and crosses set in a network of interlocking lozenges. Narrow zones of contrasting vegetation, delimited by flat stripes, appear top and bottom. Another narrow band, slightly above the center of the column, shows busts of four haloed apostles, separated by trees. One of the figures holds a book and Peter's keys. Another, balding and wielding a sword, can be identified as Paul. These figures are of a thoroughly Byzantine quality, but the style of the entire work suggests a Venetian origin. Close in both design and style is another column in the Victoria and Albert Museum in London, tentatively thought to come from San Salvatore on Murano (No. A.1-1961). Here, however, the busts of the apostles appear in roundels. A fragment of what was likely another column of this kind is in the Rijksmuseum, Amsterdam (J. Leeuwenberg, *Beeldhowkunst in het Rijksmuseum. Catalogus,* Amsterdam, 1973, p. 342, No. 572) and the entire scheme of apostles set between broad fields of foliage decoration characterizes also the candlestick of San Lorenzo in Lucina, Rome (M. Schneider-Flagmeyer, "Der Osterleuchter in der Kirche San Lorenzo in Lucina in Rom—ein Werk des Vassalletus III," *Aachener Kunstblätter,* 41, 1971. *Festschrift für Wolfgang Krönig,* pp. 59-64). The Smith column possibly was once one of the supports of a ciborium.

Bibliography

College Art Journal, 1961, p. 160 and fig. 4.

Bibliography

Brummer III, p. 101, No. 475.

3. CAPITAL. Languedoc or Narbonnais.
Marble. Ca. 1125.
H. 14 ½", L. 17 ½", W. 9 ¼" (37 × 42.5 × 24 cm.).
No. 1949.24. Rogers Fund, 1949. Formerly J. Brummer. Figs. 45 and 46.

The rather narrowly proportioned trapezoidal block is a double capital, no doubt originally incorporated in a cloister arcade. The four sides show lithe and small-scaled nude figures disporting themselves in foliage. On the principal face, the pliant web describes a double arch which shelters two personages, inducing them into a comparatively formalized pattern of behavior. The design of the narrower sides is more informal. On one, a figure strides upward in the foliage to consume grapes in the manner of Bacchic putti in late Antique vine scrolls. On the other, a figure straddles the tendrils and grasps the foliage above his head for support, while his feet repose on the heads of a pair of birds intertwined at the neck. The second of the two larger surfaces, from which a wedge-shaped section has been amputated at the top, shows a pair of wrestlers. The broad and fleshy features of the two figures on the major face are duplicated on a capital of unknown provenance, formerly attributed to Saint-Pons-de-Thomières, in the Toulouse Musée des Augustins (Mesplé, *Sculptures romanes,* No. 276; see especially the head of the unidentified apostle at the center of one of the narrower sides, to the left of Simon), and a cruder version of the same forms is found at Saint-Aventin (Haute-Garonne). A second capital in the Musée des Augustins (ibid., No. 278) offers a parallel for the little figures entwined in foliage at Wellesley. Ornament and figure style have a graphic equivalent in the decoration of the Glossed Psalter and Apocalypse in Albi (Bibl. Mun. Ms. 45; J. Porcher, *French Miniatures from Illuminated Manuscripts,* London, 1960, p. 26 and pl. XVII). A double capital showing foliage interwoven within a web of interlace in the Cloisters (No. 51.124) and a second foliage capital in Cincinnati (No. 1973.502) must stem from the same monument.

Bibliography

Brummer II, p. 144, No. 581. Scher and P. Braude in *Renaissance,* pp. 80–82, No. 27.

VIII

Lawrence Art Museum, Williams College

WILLIAMSTOWN, MASS.

1. (a) CAPITAL. Saint-Raphaël near Excideuil, Périgord.
Limestone. Beginning of the second quarter of the XIIth century.
H. 22″, L. 22″, W. 14″ (56 × 56 × 35.5 cm.).
No. 49.9. J. O. Eaton Fund. Fig. 47.

(b) TORSO. Saint-Raphaël near Excideuil, Périgord.
Limestone. Beginning of the second quarter of the XIIth century.
H. 18 ½″, W. 13″, D. 6 ½″ (47 × 33 × 16.5 cm.).
No. 47.10. Gift of J. O. Eaton. Fig. 48.

The capital, which must have surmounted an engaged pier, shows a bearded figure chained by the neck in the cauldron of Hell and belabored by a pair of demons. The latter are very battered and some details of the scene are thus no longer clearly legible. Still terrifyingly vivid, however, are the gruesome tortures inflicted upon the body of the damned: his side is flayed with a knife wielded by the demon on the right side of the capital, while his genitals are clawed by the satanic agent at the left. The fragmented obstruction in the victim's mouth evidences either an assault on the organ of speech, a theme represented elsewhere in Romanesque art (W. Cahn, "A Defense of the Trinity in the Cîteaux Bible," *Marsyas*, 1962–64, pp. 58–62), or the expulsion of the soul of the damned in the form of a diminutive demonic figure, as shown on a relief from York (A. S. Prior and A. Gardner, *An Account of Medieval Figure Sculpture in England*, Cambridge, 1912, p. 212, fig. 191). The Wil-

liams capital was seen before its removal in the garden of the presbytery adjoining the church of Saint-Raphaël near Excideuil (Dordogne) by a Périgord antiquarian (A. de Roumejoux, "Saint-Raphaël," *Bulletin de la Société historique et archéologique du Périgord*, 1890, pp. 127–30). As may be ascertained with the help of a study of the sculpture of Saint-Raphaël by Professor Brooks Stoddard, two capitals embedded in the walls of the sacristy at Saint-Raphaël are closely related in style, and possibly by the same hand as the Williams carving (M. A., Institute of Fine Arts, New York University, 1961, pp. 70–73, Nos. 6 and 7; summary in the author's "The Romanesque Sculpture from the Church of Saint-Raphaël près d'Excideuil," *Gesta*, X/1, 1971, pp. 31–38).

The church of Saint-Raphaël is listed among the dependencies of the abbey of St. Peter of Tourtoirac six miles to the southwest in a charter of Callixtus II dated 1120 (*Gallia Christ.*, II, *Instrumenta*, 491). In a document of 1466, both houses are mentioned as possessions of the abbey of Uzerche (J. B. Champeval, *Cartulaire de l'abbaye d'Uzerche*, Paris-Tulle, 1901, p. 418). Of the original building, which was reconstructed in late medieval times, a polygonal apse, choir with transept, and a short nave of two bays are still standing. Two piers standing freely some thirty-eight feet in front of the present façade show the structure in its original state to have extended westward by two additional bays at least. The bust of a figure holding a book at Williams was in all probability part of the decoration of the original façade. It is a headless torso, clad in an ample robe bordered at the neck and sleeves by an ornamental band regularly punctuated by a running series of circular depressions. A section of the nimbus is still visible on the slab from which the relief was carved. The façade scheme must also have included the angel still at Saint-Raphaël and two fragmentary torsos in the Fogg Museum (see below, Nos. 29d and e). To this ensemble should also belong the fragment of another angel in the Philadelphia Museum of Art (M. Weinberger, *The George Grey Barnard Collection*, New York, 1941, p. 14, No. 65). Other fragments of sculpture from the church are in the collection of the Fogg Art Museum (see below, Nos. 29a-r) and dispersed in the village of Saint-Raphaël.

The stylistic orientation of the sculpture of Saint-Raphaël is most pronounced in the direction of western France. In the aggressive plasticity of the carving, however, an impulse of Aquitanian origin may also be detected.

Bibliography

A. de Roumejoux, "Saint-Raphaël," *Bulletin de la Société historique du Périgord*, 1890, pp. 127–30; *Brummer III*, p. 141, No. 593 (capital); B. W. Stoddard, "The Romanesque Sculpture of the Church of Saint-Raphaël près d'Excideuil," *Gesta*, X/1, 1971, pp. 31–38; Stoddard, Exh. Catal. *The Medieval Sculptor*, Bowdoin College, 1971, No. 4 (torso); Scher, *Renaissance*, pp. 75–76, No. 25 (capital).

2. CAPITAL. Church of Aubiac, Gironde.

Limestone. Second quarter of the XIIth century.
H. 22″, L. 17″, W. 14″ (59 × 43 × 38 cm.).
No. 49.8. Formerly Joret (1936) and J. Brummer, 1949. Fig. 49.

The exposed faces of this corner capital are occupied by a pair of figures locked in struggle beneath a sketchy canopy of Corinthian volutes. The standing personage at the left has upended his companion whose buttock he grips with one hand while tugging at the hair with the other. The latter maintains himself in a precarious equilibrium with one foot planted on the ground and a grip on his opponent's beard. Weathering has been equally unkind to the hard-pressed combatant, obscuring the definition of forms to a considerable degree on his side of the relief. The standing figure, by contrast, is comparatively well preserved. The gnomic tubular-limbed figures are characteristic examples of the sculpture of the region of Bordeaux and are most nearly duplicated at Notre-Dame de la Grande-Sauve. The carving and three other capitals whose present whereabouts are unknown were formerly mounted above the doorway of the church of Saint-Maurice at Aubiac, near Verdelais (Gironde), as shown on an engraving made by the Bordelais antiquarian Léon Drouyn in 1845 (see the Exh. Catal. *Sculpture médiévale de Bordeaux et du Bordelais*, Bordeaux, 1976, pp. 306 and 309, No. 277). This church is listed in a Bull of Alexander III of 1165 as a possession of the monastery of Sainte-Croix in Bordeaux (Ch. Higounet, *Histoire de Bordeaux*, II, Bordeaux, 1963, p. 130).

The subject treated by the sculptor is a variant of the beard-tugging and wrestling groups of which there are numerous examples in Romanesque art. The origin and significance of the motif have yet to be satisfactorily elucidated, and the range of opinions that

have been expressed represents a fair cross-section of critical approaches to the problem of interpretation of Romanesque decorative vocabulary. Emile Mâle, commenting on the design as it appears on a capital of Saint-Hilaire in Poitiers, saw here a demonstration of his thesis concerning the impact of book illumination and especially of the Beatus of Saint-Sever on Romanesque sculpture (*L'art religieux du XIIe siècle en France*, Paris, 1922, p. 15). For René Crozet, the motif derives from the observation of daily life (*L'art roman en Poitou*, Paris, 1948, pp. 213–14). Other writers lean toward an allegorical interpretation and view the scene as a representation of discord. In one instance at least (Engelberg, Stiftsbib. Ms. 3, fol. 72v. F. Fosca, *L'art roman en Suisse*, Geneva, 1943, fig. 56), the beard-pulling wrestlers function as an illustration of the scriptural injunction *oculum pro oculo* (Exod. XXI:24).

Bibliography

Brummer III, p. 147, No. 606; Exh. Catal. *Sculpture médiévale de Bordeaux et du Bordelais*, Bordeaux, 1976, pp. xv, 306, 309, No. 277.

3. FRAGMENT OF A CAPITAL. Burgundy.
Limestone. Middle of the XIIth century.
H. 8″, W. 10 ¼″, D. 3″ (20.5 × 26 × 7.5 cm.).
No. Sfr. 9. Purchased from J. Brummer in 1941. Fig. 50.

Separated by a stylized plant, a pair of birds back to back peck grapes. The fragment is the upper part and narrow section of the front face of a capital, and is said to come from Moutiers-Saint-Jean (Burgundy). In comparison with the splendid series of the capitals from this site, now divided between the Fogg Art Museum (see below, No. 1a–m) and the Louvre, neither wholly invalidates nor substantiates this claim. The formal conception of the birds and foliage derives, like the work at Moutiers-Saint-Jean, from Autun and Cluny (see, for example, Grivot-Zarnecki, *Gislebertus*, pls. 7, 8, 14a, and 15). There is a carving very similar in design among the decidedly still Romanesque capitals belonging to the first phases of construction of the Cathedral of Sens (M. Aubert, *La Bourgogne. La*

sculpture, I, Paris, 1930, pls. 14 and 3). The peculiar design of the abacus, with rosettes at the center and at the corners is found also at Saint-Rémi in Reims among the capitals belonging to the reconstruction of the façade generally attributed to Abbot Peter of Celle (L. Demaison, "Eglise Saint-Rémi," *Congrès arch.,* 1912, pl. facing p. 72).

Bibliography

Stoddard, *Medieval Sculptor,* No. 3.

4. CAPITAL. Angoumois or Charente.
Limestone. Second quarter of the XIIth century.
H. 9 ¼", L. 8 ½", W. 8 ½" (23.5 × 21.5 × 21.5 cm.).
No. 49.7. J. O. Eaton Fund. Fig. 51.

In the midst of foliage which it consumes is a leonine beast. The decoration embraces three sides of the capital and is much weathered. The style and execution are typically western French. An example of much the same art, though better preserved, is in the Wadsworth Atheneum (see above, No. 6).

Bibliography

Brummer III, p. 133, No. 559 (1).

5. CAPITAL. Roussillon.
Limestone. Second quarter of the XIIth century.
H. 10", L. 10", W. 9" (25.5 × 25.5 × 23 cm.).
No. 49.6. Formerly J. Brummer. Fig. 52.

The capital shows harpies at two of the corners. Their heads are bitten on one side by serpents intertwined, and on the other by birds mounted on their backs. The monsters' hind quarters meet in

a cascade of feathery strands at the back of the block. The work is a slightly cruder version of an otherwise identical capital from Saint-Pons-de-Thomières, now in the Virginia Museum of Fine Arts, Richmond, Va. (*European Art in the Virginia Museum of Fine Arts,* Richmond, 1966, p. 106, No. 186; see earlier J. Sahuc, "L'art roman à Saint-Pons-de-Thomières," *Mémoires de la Société archéologique de Montpellier,* 1908, p. 39, pl. B, No. 3). A variant of the same design is found at Espira de l'Agly (M. Durliat, *La sculpture romane en Roussillon,* IV, Perpignan, 1954, p. 79, fig. 50) and another in the façade of the town hall of Saint-Antonin (T.-et-G.) (L. Seidel in Scher, *Renaissance,* p. 90).

Bibliography

Brummer III, p. 133, No. 559 (2); L. Seidel in Scher, *Renaissance,* pp. 86–92, No. 30; Stoddard, *Medieval Sculptor,* No. 2; L. Seidel, "Romanesque Capitals from the Vicinity of Narbonne," *Gesta,* XI/1, 1972, p. 35.

6. CAPITAL. Ile-de-France or northeastern France (?).
Limestone. Third quarter of the XIIth century.
H. 11 ½", L. 10", W. 10" (29 × 25.5 × 25.5 cm.).
No. 49.5. Gift of J. J. Rorimer.
Formerly J. Altounian, Mâcon (1926) and J. Brummer. Figs. 53 and 54.

Approximately half of the available surface is given over to an Adoration of the Shepherds. Framed by a pair of trees, two shepherds accompanied by a dog tend to a group of five sheep. A tree at the center of the scene separates the men from their flock. One of the shepherds carries a staff; the other, a horn. The remainder of the space is occupied by a large dragon whose tail curls upward to create a void at the center, which is filled by a *clipeus* with a bust-length figure pointing to a scroll. Another capital with the Holy Family must have originally completed the Adoration composition. The figure in the *clipeus* is most probably Isaiah witnessing the fulfillment of his prophecy (Isa. 7:14). Various forms of the same iconographic combination are known. The twelfth-century lintel of the portal of St. Anne at Notre-Dame de Paris and a capital from the church of the Cordeliers in Le Puy (R. Gounot, *Collections*

lapidaires du Musée Crozatier du Puy-en-Velay, Le Puy, 1957, pp. 251–52) show the prophet as a participant in the Infancy narrative. At Notre-Dame du Port in Clermont-Ferrand, the figure of the prophet is one of the monumental reliefs flanking the doorway while the Incarnation scenes occupy the lintel. At Saint-Gilles and Donzy-le-Pré (Nièvre), he shares the space of the tympanum with the Virgin in Majesty, and in an Italian Breviary of the second half of the twelfth century, Isaiah is enthroned at her side (Rome, Vallicelliana Ms. C. 13, fol. 133. E. B. Garrison, *Studies in the History of Medieval Italian Painting,* IV, 2, Florence 1961, p. 219, fig. 154).

The freedom of handling in the foliage and the relaxed and airily picturesque definition of the forms suggests a date beyond the most advanced chronological limits of Romanesque art. But in some aspects of the work, like the curling dragon and the persistence of the idea of the historiated capital as such point to a still lively attachment to pre-Gothic conceptions. The localization remains problematic. There is a generalized congruence of form with the sculpture of the crown lands and northern France (crypt capitals of Saint-Denis, sculpture of the chapter house of Saint-George de Boscherville), though inadequate evidence for a more precise determination of origin. Another capital in the same style showing a *clipeus* and an angel with a sacrificial animal (Sacrifice of Isaac?) is in the Pitcairn Collection at Bryn Athyn, Pennsylvania.

Bibliography

Brummer I, p. 139, No. 553. Scher, *Renaissance,* pp. 140–42, No. 49; S. Scher, *Gesta,* IX/1, 1970, p. 60.

IX

Yale University Art Gallery
NEW HAVEN, CONN.

1. CRUCIFIX. Catalonia or Roussillon.
Wood with polychromy. Second half of the XIIth century.
H. 51", W. 36" (125.5 × 91.5 cm.).
No. 1930.41. Maitland F. Griggs Collection. Purchased from Arthur
Byne, Madrid. Figs. 55 and 56.

The crucifix is one of a number of typologically related monumental
crosses from churches in Catalonia and Roussillon. The frail and
inarticulate body encased in a long robe, the waistband tied in a
studiously delineated flat knot before dividing into two even
strands over the thighs, the otherworldly poise in the unflinching
gaze and the stiffly extended hands and feet are all duplicated in
the crosses of La Llagona (M. Durliat, *Christs romans du Roussillon et
de Cerdagne*, Perpignan, 1956, p. 14, fig. 4); Lluca (ibid., p. 20, fig.
8); Ellar (J. Brutails, "Notes sur quelques crucifix des Pyrenées-
Orientales," *Bulletin archéologique du Comité des travaux historiques*,
1891, pl. 28) to mention only a few examples. For the date, the
crucifix of Seo de Urgell (1147) in Barcelona can be cited for com-
parison (P. de Pallol, *Early Medieval Art in Spain*, 1967, p. 484, No.
160). It was the view of Emile Mâle, often echoed after him, that
the source of inspiration for this group was the widely famed *Volto
Santo* of Lucca, which was reputed according to legend to have
been carved from a cedar of Lebanon by Christ's disciple
Nicodemus (*L'art religieux du XIIe siècle*, Paris, 1922, pp. 253–57). Al-
though the cult of this relic was in existence by the end of the elev-

67

enth century and perhaps earlier, the *Volto Santo* in its present form appears to be a copy of the original work made by a follower of Benedetto Antelami at the end of the twelfth century (G. de Francovich, "Il Volto Santo di Lucca," *Bollettino storico Lucchese*, 1936, pp. 3–29). For A. Kingsley Porter, however, the comparatively large number of Spanish and southern French crosses in existence tended to argue for the possibility that the original *Volto Santo* was itself a Spanish work imported to Tuscany (*Spanish Romanesque Sculpture*, II, Paris, 1928, p. 8ff.). The entire problem requires a reexamination, which must come to grips with some additional factors that have more recently been brought to light. For one, the diffusion of the *Volto Santo* type appears to have been more extensive than had been realized, examples having been signaled in Saxony and England (E. Panofsky, "Das Braunschweiger Domkruzifix und das 'Volto Santo' zu Lucca," *Festschrift für Adolph Goldschmidt*, Leipzig, 1923, pp. 37–44; R. Haussherr, "Der Imerwardkreuz und der Volto Santo Typ," *Zeitschrift für Kunstwissenschaft*, 1962, pp. 129–70; D. T. Rice, "The Iconography of the Langford Rood," *Mélanges Crozet*, I, Poitiers, 1966, pp. 169–71). As Durliat has pointed out, moreover, liturgical evidence for the cult of the *Volto Santo* in Catalonia is altogether wanting. But several calendars from the region—that of Gerona as early as the tenth century—list commemorations for another miraculous image of the Lord crucified, the crucifix of Beirut. According to a legend first recorded in the Acts of the Council of Nicaea (787) and later by Leo the Deacon in the tenth century, this was a cross which shed blood when it was ill used by Jews, blood whose miraculous healing power ultimately confounded them. Nothing is known of the appearance of this cross, which is said to have been taken to Constantinople by the emperor John Tzimiskes in 976. The character of the legend would lead one to expect an image of suffering *(Christus piangens)* rather than the impassive figures of the Spanish crosses. But it is not to be excluded that with the passing of time, the distinctive elements in the typology of the *Volto Santo* and Beirut crucifix, both images with a somewhat similar Eastern ancestry, became blurred or merged.

The lobed cross of the Yale *majestas*, unlike the *corpus*, has retained substantial vestiges of its surface decoration. The pattern emphasizes the geometric components of the cross, rosettes at the extremities of the four arms and at the center alternating with rec-

tilinear panels carried out in tooled gesso simulating the effect of repoussé technique in metalwork. A number of Catalan altar frontals executed in this manner have survived (W. Cook and J. Gudiol Ricart, *Ars Hispaniae*, VI, Madrid, 1950, pp. 323–34, figs. 329–30 and 331). On the back, the pattern is formed by flatly applied hues outlined in black. Since the cross is somewhat larger than the dimensions of the *corpus* would seem to justify, it was suggested by the late W. W. S. Cook (letter of January 10, 1929 to the director of the Yale Art Gallery) that the two parts of the work may not have been intended for each other. A recent technical examination has confirmed this surmise. Doubts concerning its authenticity, and indirectly, the authenticity of the entire work (M. Trens, *Las Majestats Catalanes*, Monumenta Cataloniae, XIII, Barcelona, 1966, p. 149), however, do not seem justified. The lobed form of the cross and the tooled rosettes as such are paralleled in the crucifix of the Lerida Museo Diocesiano (*Ars Hispaniae*, VI, p. 325, fig. 335).

The Yale crucifix is said to have come from the church of Sant Pere de Montgrony, situated at some distance to the southwest of Ripoll, on the road from Berga to Campdevanol (Province of Gerona). An altar frontal from the same site is in the Vich Museo Episcopal (J. Gudiol i Cunill, *Els Primitius*, II, Barcelona, 1929, pp. 210 and 213; J. Vilalta, *Historia del Santuari de Santa Maria de Montgrony* cited by this author, was not available to us).

Bibliography

M. Trens, *Les Majestats Catalanes* (Monumenta Cataloniae, XIII), Barcelona, 1966, p. 149, pl. 56, No. 31. There is a vast body of literature on the *Volto Santo*, most conveniently assembled in R. Haussherr, "Der Imerwardkreuz und der Volto Santo Typ," *Zeitschrift für Kunstwissenschaft*, 1962, pp. 129–70. The primary source material has been edited by G. Schnurer and J. M. Ritz, *St. Kummernis und Volto Santo* (Forschungen zur Volkskunde, Heft 13–15), Düsseldorf, 1934.

2. ARCHITECTURAL FRAGMENT. England. Herefordshire(?).
Red sandstone. Middle of the XIIth century.
H. 11 ¾", L. 22", D. 21" (29.5 × 59 × 53.5 cm.).

No. 1966.91. Enoch Vine Stoddard Fund. Purchased from K. J. Hewitt, London. Figs. 57 and 58.

The carving shows a lion, only partially preserved, entwined with an equally fragmentary, lizardlike beast. The latter is equipped with a human face. The peculiar configuration of this face and its implausible connection with the body of the beast suggest a later recarving. The nature of the larger whole from which the fragment stems is difficult to determine. Possibly, it was part of the base of a font, like the receptacle at Castle Frome. The characterization of the lion also lends itself to comparison first with the beast shown on the same font, and still more tellingly, with those of the west portal at Leominster in the same region (S. Jónsdóttir, "The Portal of Kilpeck: Its Place in English Romanesque Sculpture," *Art Bulletin*, 1950, pp. 171–80, figs. 5, 10, and 12).

Bibliography

Yale University Art Gallery Bulletin, Winter 1967–68, p. 8; A. C. Ritchie and K. B. Neilson, *Selected Paintings and Sculpture in the Yale Art Gallery*, New Haven and London, 1972, No. 116.

3. CAPITAL. Languedoc.
Limestone. Late XIIth or first half of the XIIIth century.
H. 10 ¼", L. 9 ½", W. 9" (26 × 24 × 23 cm.).
1943.283. Bequest of Maitland F. Griggs. Fig. 59.

This carving is probably half of a double capital, with a pair of dragons back to back on the three sides worked on by the sculptor. On one face, left unfinished, the wings of the beasts frame the shieldlike form of an unexecuted lion mask. The lizardlike characterization of the biting animals and the design of the capital generally should be compared to capitals in Cleveland (No. 16.1984), the Warsaw National Museum (Inv. No. 126189), and a number of similar pieces in the Musée des Augustins, Toulouse (Mesplé, *Sculptures romanes*, Nos. 319, 320, 327, and 328).

Bibliography

Bulletin of the Associates in Fine Arts at Yale University, November 1944, p. 6; P. Ratkowska, "Trois chapiteaux romans au Musée National de Varsovie," *Bulletin du Musée National de Varsovie,* XIII, 1972, p. 9, Nos. 2–3.

4. CORBEL. Aunis.
Limestone. First half of the XIIth century.
H. 16", W. 7 ½", D. 7 ½" (40.5 × 19 × 19 cm.).
No. 1956.17.3. Purchased from Mathias Komor, New York.
Formerly M. Duthil, Bordeaux. Fig. 60.

The corbel is one of five seemingly traceable to the church of Nuaillé-sur-Boutonne in the diocese of Saintes, a structure of some repute for its finely decorated portal. The other pieces are in the Stockholm National Museum, the Rhode Island School of Design Museum of Art (see above, No. 5), a private collection in New York, and the collection of a London dealer. (For other examples of the motif of the horn blower on corbels in western France, see E. R. Mendell, *Romanesque Sculpture in Saintonge,* New Haven, 1940, p. 84; L. Drouyn, "Promenades archéologiques dans le département de la Gironde," *Société archéologique de Bordeaux,* 1875, p. 35; and A. Brutails, *Les vieilles églises de la Gironde,* Bordeaux, 1912, p. 229.)

Bibliography

S. McK. Crosby, "Medieval Sculpture and Jewelry," *Bulletin of the Associates in Fine Arts at Yale University,* February 1957, pp. 12, 33; Scher, *Renaissance,* pp. 70–72, No. 23; S. Scher, *Gesta,* IX/2, 1970, p. 60.

5. FRAGMENT OF A CAPITAL. Saint-Etienne de Dreux.
Limestone. Middle of the XIIth century.
H. 18" (without base) (45 cm.).
No. 1938.103. Formerly R. Stora, Paris. Fig. 61.

The carving shows a crowned and haloed seated figure holding a

sword. The stone has been closely and roughly trimmed on all sides and at the back. A photograph in the A. Kingsley Porter collection in the Fogg Art Museum at Harvard University with a notation made in 1926 shows the fragment in a more complete state. It was part of a capital with a rectilinear termination at the right of the figure. On the left, there was a section of a pearly halo and part of a second figure. When the work was sold at auction in Berlin in 1931, the bulky mass of stone along the right side had been reduced to form a straight and narrow border. It was said at this time to have been part of the portal sculpture of a church in Dreux (C. F. Foerster, *Die Sammlung Dr. Hans Wendland, Lugano, mit einigen Beiträgen aus anderen Besitz*, Berlin, 1931, p. 85, No. 268). In the period between this date and its acquisition by the Yale Art Gallery in 1938, the carving was more radically trimmed to its present configuration. The photographs of the older states leave no doubt that the fragment once completed a capital in the Musée d'Art et d'Histoire in Dreux showing the Adoration of the Magi, flanked on the smaller left face by the *Virgo lactans* (P. Pradel, *Sculptures romanes des Musées de France*, Paris, 1958, p. 15, No. 51). The Yale king filled the right side of the block and must represent Herod, though no sensible justification can be given for the presence of the halo.

The larger section of the capital in Dreux is known to have come from the collegiate church of Saint-Etienne, situated within the walls of the castle overlooking the town. The church is mentioned as *"nostro constructa"* in a charter of King Louis VI dated 1131. An inscription formerly located along the outer wall of the ambulatory between the chapel of the Virgin on axis and that adjoining it on its southern flank gives the date 1142. An edifice of eight bays flanked by aisles, with a handsome tower along its southern flank, it was demolished in the aftermath of the French Revolution. Some of the capitals were preserved and stored in the crypt of the Chapelle Saint-Louis, the mausoleum of the House of Orléans erected on the site in the first half of the nineteenth century, before they were acquired by the Dreux Museum in 1950. A single block showing the Three Marys at the Tomb serves as a baptismal font in the church of Saint-Pierre de Dreux, while at least three smaller corner capitals were reemployed in the nineteenth-century ramparts of the castle. The style of this sculpture all but ignores the more or less contemporaneous developments in the formulation of early Gothic art represented by the Chartres west façade, a rela-

tively short distance from Dreux. It would seem rather to mark a continuation in a more evolved form of the regional Romanesque style before the arrival of the Chartres west portal atelier. There are some connections with the capitals of the north tower of the Chartres façade, and further, with the sculpture of the portal along the south side of Sainte-Madeleine at Châteaudun.

Bibliography

C. F. Foerster, *Die Sammlung Dr. Hans Wendland, Lugano, mit einigen Beiträgen aus anderen Besitz* (XI. Versteigerungs Katalog der Firmen Hermann Ball und Paul Graupe), Berlin, 1931, p. 85, No. 268; W. Cahn, "A King from Dreux," *Yale University Art Gallery Bulletin*, 1973/74, pp. 14–29.

6. CAPITAL AND ABACUS. Southern France (?).
Limestone. Middle of the XIIth century.
H. 20″, L. 21″, W. 21″ (51 × 53.5 × 53.5 cm.).
No. 1943.356. Bequest of Maitland F. Griggs. Fig. 62.

This Corinthian capital, of good quality, has foliage and volutes articulated in simplified, striated masses. The abacus, which is of a coarser stone and shows a crisper touch in the delineation of the forms, seems nonetheless to be the capital's rightful companion. Torus plinth and the section above it are modern. The provenance is uncertain.

7. ARCHITECTURAL FRAGMENT. Provence or northern Italy.
Marble. Second half of the XIIth century.
L. 12″, W. 4″, D. 4″ (30.5 × 10 × 10 cm.).
No. 1977.20. Provenance unknown. Fig. 63.

The fragment is carved on three sides and is probably a part of a barrier or railing. The more deeply undercut frontal face shows the right section of a once symmetrical composition of a lion mask with swirling foliage departing from the jaws. This motif is much in evi-

dence at Saint-Trophîme, Arles (W. S. Stoddard, *The Façade of Saint-Gilles-du-Gard,* Middletown, Conn., 1973, figs. 391–94), and the style also points in this direction or to related work in northern Italy. The other two decorated faces are carved in a different spirit. The top shows a luxuriant acanthus rinceau enlivened by the use of the drill. On the rear face, there is a spiky variety of foliage in swirling configurations, upon which are superimposed a lithe dragon and a bird pecking the snout of a lion.

8. ANNUNCIATION. Monastery of Cambron, Sadaba (Saragossa).
Limestone, with traces of polychromy. Second quarter of the XIIth century.
H. 34 ¼", W. 27 ¼", D. 7 ½" (87 × 73 × 19 cm.).
No. 1968.37. Maitland F. Griggs and Leonard C. Hanna Funds. Purchased from Wildenstein, New York. Fig. 64.

The relief was formerly imbricated within a niche along the west wall of the church of the former monastery of Cambron, a Cistercian foundation dependent on Santa Cristina de Somport, located three miles from the town of Sadaba (Zaragoza). As is clear from photographs made prior to its removal, it was not then in its original position, but the present state of the church, now part of a farmhouse, does not permit any definite conclusion on its original location. Other fragments of sculpture in the same style, however, are signaled on the site (F. Abbad Rios, *Zaragoza. Catalogo monumental de España,* Madrid, 1957, p. 603 and fig. 1579).

The archangel at the left side of the relief holds a flowering rod and points to an open book held across the body. The Virgin at the right stands impassive with hands half upraised and joined in a gesture of submission. She wears a crown over a wimple. Both figures are dressed in long pleated robes under an ample mantle bordered by strips simulating jewel encrustation and embroidery. In the pair of bands emerging below the concentric pleats of the archangel's outer garment, one may recognize the stole worn by priests. The figures are sheltered by a molding whose inner profile is superficially inscribed with a chevron border. The lower part of the relief is unfortunately damaged, depriving the figures of a secure foothold. The original form of the slab in this zone must re-

main conjectural, but it may be suggested that the base of the relief was formed by a wedge-shaped molding similar to that at the top. The work thus very possibly resembled the slabs which decorate the churches of San Pedro de Tejeda in Castile (A. Rodriguez and L.-M. de Lojendio, *Castille romane*, I, Paris, 1966, figs. 111–12) and San Quirce (Burgos) and might have formed part of a friezelike arrangement including other subjects from the Infancy of Christ, such as the Visitation, Nativity, and Adoration of the Magi.

Although representations of the Annunciation in Romanesque art are anything but rare, some aspects of the relief are sufficiently unusual to warrant additional comment. The open book of the archangel in all likelihood alludes to the prophecy of Isaiah concerning the miraculous conception of the Virgin. The motif of the open book occurs in a very similar way at San Salvador of Leyre in Navarre (J. Gudiol Ricart and J. A. Gaya Nuño, *Ars Hispaniae*, V, Madrid, 1948, p. 143, fig. 232) and in a somewhat different form in a capital of the cloister of Estella in the same province of Spain (L.-M. de Lojendio, *Navarre romane*, Paris, 1967).

The crown of the Virgin is also unusual in the context of an Annunciation. There is another example at Eguarte in Navarre (Gudiol Ricart and Gaya Nuño, *Ars Hispaniae*, p. 172, fig. 292), while the Annunciate is shown receiving the crown on a relief in the cloister of Silos, of a later date (ibid., p. 254, fig. 402; see also the archangel carrying a crown in the relief from Reggio Emilia in Princeton, attributed to the circle of Antelami, *Gesta*, X/1, 1971, No. 5). A more famous parallel is the crowned Virgin in the Visitation of the lintel of the south portal of the west façade at Chartres.

The style of the relief has parallels in the same region of northeastern Spain as the iconography. There is some basis for comparison with the decoration of the façade of Leyre and with the figures in the arcades above the doorway of Santa Maria la Real at Sanguesa. The few firm dates in the chronology of Romanesque art of Navarre and Castile—1135 for the construction of Santa Maria de Uncastillo, 1127–42 for the cloister of Pamplona—suggest that the relief was carved in the earlier years of the second quarter of the twelfth century.

In addition to the damage suffered by the carving along the lower edge, there is a break running across the upper part of the angel's wings, the neck of the figure, and the upper shoulder of the Virgin. The head of the angel is separated from the body by a

break, and the lower section of this head, as well as the forearms and hands of both figures are broken. But the odd disjunction between the head and body of the Virgin is a gauche touch of the sculptor.

Bibliography

Scher, *Renaissance,* pp. 114–15, No. 41.

9. ARCHITECTURAL FRAGMENT.
Limestone. XIIth century.
L. 11", W. 8", D. 4 ⅜" (28 × 20.5 × 11 cm.).
No. 1940.120. Gift of Maitland F. Griggs. Fig. 65.

The molding has an acanthus border, allegedly of Burgundian origin. The variant of the design in which the foliage is bound by a pearly band may be observed at Semur-en-Brionnais (lintel of the main portal) but is more common in the art of the Rhineland and northwest Germany. See for example St. Andreas in Cologne and Bonn Cathedral (W. Meyer-Barkhausen, *Das grosse Jahrhundert kölnischer Kirchenbaukunst, 1150 bis 1250,* Cologne, 1952, figs. 103 and 104) and Knechtsteden (H. A. Diepen, *Die romanischen Bauornamentik in Klosterrath,* The Hague, 1931, pl. LV, fig. 4).

X

The Isabella Stewart Gardner Museum

BOSTON

1. (a) TWO KINGS. Notre-Dame-de-la-Couldre, Parthenay.
Limestone. Middle of the XIIth century.
H. 66 ½″, W. 39″, D. 10 ½″ (169 × 119 × 26.5 cm.).
No. S7n2. Purchased from L. Demotte, Paris, in 1916. Fig. 66.

(b) ENTRY INTO JERUSALEM. Notre-Dame-de-la-
Couldre, Parthenay.
Limestone. Middle of the XIIth century.
H. 49″, W. 53″, D. 8″ (137 × 134.5 × 20 cm.).
No. S7n1. Purchased from L. Demotte, Paris, in 1916. Fig. 67.

Much notoriety has surrounded these sculptures since their ap-
pearance on the Paris art market shortly before World War I. The
facts are nevertheless reasonably clear. Prior to their removal from
Parthenay, four reliefs from torso-length figures of kings, the
Gardner Entry into Jerusalem, and a relief with the Annunciation
to the Shepherds could be seen in the garden adjoining the ruins
of the church of Notre-Dame-de-la-Couldre. Two of the kings and
the Annunciation were purchased by the Louvre, and the other
pieces made their way to Boston. In the meantime, however, the
sculptures had been drastically cleaned and refinished, while the
four royal torsos had acquired lower bodies. In 1926, the Gardner
Museum was privately advised that these lower parts were made
by the sculptor Boutron, who was persuaded by his client that if
"the kings should not be represented barefooted . . . bare feet
would be an interesting novelty." Although controversy over the

pieces lingered on, a technical examination of the Boston figures by J. Rorimer definitively established that the lower sections were modern (Rorimer, "The Twelfth Century Parthenay Sculptures," *Technical Studies in the Field of Fine Arts,* January 1942, pp. 122–30).

In addition to the widely publicized Louvre and Gardner reliefs, two other fragments in all likelihood from the same Parthenay ensemble have been signaled. A badly weathered and apparently crowned head in the Fogg Museum (see below, No. 28) may be the rest of a fifth king. Still another figure of the same type is in the Pitcairn Collection at Bryn Athyn, Pennsylvania (reproduction in *Art News,* March 21, 1931, p. 33). The Parthenay provenance of the monumental crowned head in the Metropolitan Museum (No. 44.85.1), however, is in doubt. Although said to be from Notre-Dame-de-la-Couldre, the nature of the material and stylistic character of the work stand apart from the pieces earlier enumerated (M.A. thesis by R. B. Franciscono, "A Problematic Twelfth-Century Head in the Metropolitan Museum of Art," Institute of Fine Arts, New York University, 1962). Not otherwise known to the writer is a figure, described as a saint from the same church, forty-six centimeters in height, in a private collection in Argentina (Exh. Catal. *Exposición de escultura Medioeval y Renacentista,* Buenos Aires, 1963, p. 27, No. 8).

Only the lower story of the façade of Notre-Dame-de-la-Couldre still stands. The Gardner and related sculpture now dispersed is presumed to have decorated the upper parts. The Entry into Jerusalem and the Louvre Annunciation were possibly housed in niches, echoing those of the lower tier, which still exhibit the poorly preserved remains of a Samson with the lion and an even more fragmentary equestrian figure (Constantine?). The original position of the kings is more problematic. Possibly, each of the figures occupied a blind arcade in a disposition of the type seen at Notre-Dame-la-Grande in Poitiers and at Ruffec (Vienne), but this is mere speculation. Because of the abrupt and unaccustomed termination of the figures only a short distance below the waist, it is reasonable to suppose that they were originally carved in full length.

There has been some disagreement concerning the identification of the Gardner riding figure as well as the restored torsos. A. Kingsley Porter has rightly observed that the crown worn by the cavalier is an anomaly in the iconography of the Entry into

Jerusalem and proposed to see in the relief a representation of one of the Magi kings, narratively coordinated with the Louvre Annunciation (Porter, *Romanesque Sculpture of the Pilgrimage Roads*, Boston, 1923, p. 334). Yet the presence of the tree at the right—the remains of its branches can be seen near the rider's upraised hand—can best be understood as part of an *adventus* composition in which the Lord is greeted at the gates of the Holy City with the cutting and throwing of palm branches. As for the troublesome motif of the crown, it may be discovered as well in the Entry of the tympanum of Pompierre (Porter, "Spain or Toulouse? and Other Questions," *Art Bulletin*, 1924–25, p. 8, fig. 12). The choice of subject is perhaps to be explained as a pendant of the triumphant Constantine as master of Rome on the lower tier of the façade. The same combination of an Entry into Jerusalem and a representation of Constantine trampling upon Maxentius occurs on a capital of the cloister of Arles (a parallel kindly called to my attention by Professor Meredith Lillich). As regards the royal torsos, their identification as Apocalyptic Elders raises far fewer difficulties than the various alternative suggestions that have been made. The problematic element has been the puzzling gourdlike attribute of one of the Louvre figures, especially as it appears in the old engraving of Sadoux made before restoration (B. Ledain, *La Gatine historique et monumentale*, Paris, 1876, p. 79, fig. 76). A photograph of the figure made before its removal from Parthenay (W. S. Stoddard, *The West Portals of Saint-Denis and Chartres*, Cambridge, Mass., 1952, pl. XXXIII, fig. 6) shows a somewhat more rounded form cradled in the bent right arm in the manner of a viol-like musical instrument. Weathering on the badly exposed outer surface of the object has obliterated all detail, and will no doubt continue to frustrate a more incontrovertible reading.

The church of Notre-Dame-de-la-Couldre stood within the precinct of the castle of the lords of Parthenay, whose feudal allegiance was disputed by the counts of Anjou and Poitou. The latter seized the castle in 1122 (G. T. Beech, *A Rural Society in Medieval France. The Gatine of Poitou in the Eleventh and Twelfth Centuries*, Baltimore, 1964, p. 42ff.). In 1135, during the schism of Anaclet II, Count William X met Bernard of Clairvaux at Parthenay and made his peace with orthodoxy. Local tradition since the seventeenth century has it that this meeting took place before the façade of Notre-Dame-de-la-Couldre, but the saint's biography does not

specify which of Parthenay's seven twelfth-century churches was the scene of this event (*Acta SS.* August, IV, p. 288). The stylistic evidence would argue in favor of a rather later date for the Gardner sculpture.

Bibliography

Ch. Arnauld, *Monuments religieux, militaires et civils du Poitou,* Niort, 1843, pp. 95–98; Ch. Auber, "Notice sur l'église de la Couldre à Parthenay," *Bulletin du Comité historique des arts et monuments,* 1849, pp. 125–28; B. Ledain, *La Gatine historique et monumentale,* Paris, 1876, p. 75ff.; "Notre-Dame-de-la-Couldre," *Congrès arch.,* 1903, pp. 46–48; A. Michel, "Les sculptures de l'ancienne façade de Notre-Dame-de-la-Couldre à Parthenay," *Monuments Piot,* 1918, pp. 179–95; R. van Marle, "Twelfth-Century Sculpture in America," *Art in America,* 1921, pp. 3–16; G. Turpin, "L'église Notre-Dame-de-la-Couldre à Parthenay et ses sculptures," *Bulletin de la Société historique et scientifique des Deux-Sèvres,* 1922, pp. 79–91; A. K. Porter, *Romanesque Sculpture of the Pilgrimage Roads,* Boston, 1923, pp. 334–36; P. Deschamps, *La sculpture française a l'époque romane,* Paris, 1930, p. 72; J. Rorimer, "The Twelfth Century Parthenay Sculptures," *Technical Studies in the Field of Fine Arts,* January 1942, pp. 122–30; R. Crozet, *L'art roman en Poitou,* Paris, 1948, passim; Aubert-Beaulieu, *Description raisonnée,* pp. 51–53. G. W. Longstreet and M. Carter, *The Isabella Stewart Gardner Museum. General Catalogue,* Boston, 1935, pp. 49–50.

2. CAPITAL. Angoumois.

Limestone. Beginning of the second quarter of the XIIth century.
H. 14", L. 18", W. 13" (35.5 × 45.5 × 33 cm.).
No. S9n3. Formerly Emile Peyre Collection, Paris.
Purchased in 1897. Fig. 68.

A dense weave of tentacular, muscle-bound foliage covers the surface of the block. The corners are marked by standing, helmeted figures each blowing a pair of horns. The motif derives from calendrical illustration occasionally employed for the month of March (L. Pressouyre, "Marcius Cornator. Note sur un groupe de représentations médiévales du mois de mars," *Mélanges d'archéologie et d'histoire,* 1965, pp. 395–473). Stylistically, the work has close affinities with certain Angoumois productions, as shown by comparison

with a very similar capital in the Angoulême Archaeological Museum (Gudiol Photo No. 2113). Another capital of the same type with horn blowers is found at Ronsenac (George and Guérin-Boutaud, *Églises romanes*, p. 283, fig. 264C).

Bibliography

Longstreet and Carter, *General Catalogue*, p. 62.

3. IMPOST BLOCK WITH SCENES OF THE PASSION. Western France.
Limestone. Beginning of the second quarter of the XIIth century.
H. 11″, L. 24″, W. 17 ¾″ (28 × 61 × 45 cm.).
No. S9n2. Formerly Emile Peyre Collection, Paris.
Purchased in 1897. Fig. 69.

The sequence of scenes unfolds on two adjoining faces of the squatly proportioned block in a somewhat disjointed way. On the shorter side, a pair of figures brandishing swords flank an imperturbable personage in a frontal stance, bearing a short, Tau-headed staff (Mocking of Christ?). On the larger side, the Kiss of Judas (left) and Peter cutting the ear of Malchus (right) can be clearly read. The Carrying of the Cross at the center, which is out of place, is perhaps best explained as the result of the sculptor's unwitting transformation of a Roman soldier's pike or halberd into the instrument of the crucifixion.

The puppetlike proportions and the small-scaled, doughily untectonic handling of the figures is a sketchier version of the kind of sculpture found at Notre-Dame de Saintes and some of the work at Aulnay. The head of the grimacing Malchus has a close parallel in one of the fantastic creatures decorating one of the lateral portal archivolts of the latter monument (*Congrès arch.*, 1913, pl. opposite p. 106).

Bibliography

Longstreet and Carter, *General Catalogue*, p. 61.

4. CAPITAL OR IMPOST BLOCK. Western France.
Daniel in the Den (?).
Limestone. Beginning of the second quarter of the XIIth century.
H. 10″, L. 21 ¼″, W. 15 ¾″ (25.5 × 52 × 33 cm.).
No. S9n4. Formerly Emile Peyre Collection, Paris.
Purchased in 1897. Fig. 70.

A figure stands between a pair of addorsed lions, grasping their bodies in a powerful embrace. At the right, a second personage thrusts an object into the jaws of the beast near him. The same composition is repeated on the left side of the block. In his address to the startled Nabuchadnezzar, Daniel attributes his miraculous salvation to the intervention of the Lord's angel who "shut the lions' mouth, that they have not hurt me" (Dan. 6:22). This is the event which may be illustrated here. The right face of the block shows a plant between a pair of rosettes, considerably more summary in execution. The work and that described in the previous entry in all probability have a common origin.

Bibliography

Longstreet and Carter, *General Catalogue*, pp. 61–62.

5. PORTAL. La Réole (Gironde).
Limestone. End of the XIIth century.
H. 11′ 11″, W. 7′ 11″ (3.63 × 2.41 m.).
No. S7w10. Purchased from L. Demotte, Paris, in 1916. Fig. 71.

The doorway is depicted still *in situ* on an engraving which appears in the Bordeaux antiquarian L. Drouyn's *La Guienne militaire* (1865). It was the entrance of an important medieval private house in La Réole, a town located on the Garonne some fifty miles upstream from Bordeaux, commonly known as the *Maison Séguin,* and more rarely, *Maison de la Synagogue.* The building, now demolished, was presumably the residence of an influential local family, the Séguins, who are documented at La Réole as early as the fourteenth century. In its original location, the portal was situated at the head of a flight of stairs and gave access to the first story of the house.

In spite of its unarguable provenance, the work betrays a lack of homogeneity and may have been pieced together with elements fortuitously obtained. The three heads inserted in the lobes at the summit of the arch are an especially jarring feature of the design. The base of the lobed arch itself and the heavy cornice molding on which it rests impinge on the lintel decorated on its outer face by a meandering ribbon. The lower section of the portal, an architecturally coherent nucleus in the ensemble, is a stepped construction with single colonnettes in its embrasures sustaining capitals in which the block appears to be consumed by lion masks. Such capitals could also be seen in the arcading of the windows of the Séguin house (Drouyn, *Guienne militaire*, pl. 57).

The portal or at least its component parts find parallels in the sculpture of the region of Bordeaux near the end of the Romanesque era. The three heads are stylistically comparable to those which appear in large, corbel-like fashion, on the capitals in the Langon chapel in the Cloisters. The multilobed arch, a more ubiquitous motif in southwestern France, is found in the region in the portal of the Templar Church at Villemartin.

Bibliography

M. Lapoujade, "Essai de statistique archéologique. La Réole," *Actes de l'Académie Royale des Sciences, Belles-Lettres et Arts de Bordeaux*, VIII, 1846, pp. 337–38; L. Drouyn, *La Guienne militaire*, I, Paris-Bordeaux, 1865, pp. 161–62; Longstreet and Carter, *General Catalogue*, p. 51; J. Gardelles, "La sculpture monumentale en Bordelais et en Bazadais à la fin du XIIe et au début du XIIIe siècle," *Bull. mon.*, 1974, 1, pp. 29–48; Gardelles, Exh. Catal. *Sculpture médiévale de Bordeaux et du Bordelais*, Bordeaux, 1976, p. 121, No. 120.

6. ARCHITECTURAL AND SCULPTURAL ELEMENTS OF AN AMBO. Santa Lucia, Gaeta.

Marble with Cosmati work. First quarter of the XIIIth century.
Nos. S9e5, S9e6, S9e7, and S9e8. Purchased from Ditta Pio Marinangeli, Rome, in 1897. Figs. 72–77.

(a) Lion of St. Mark.
H. 17 ⅜", W. 20" (44 × 50 cm.).

(b) Oxen of St. Luke.

H. 18 ⅝", W. 20 ⅛" (47 × 51 cm.).

(c) Panel with a stag.
H. 18 ⅝", W. 20 ⅛" (47 × 51 cm.).

(d) Panel with a basilisk.
H. 17 ⅞", W. 19 ⅞" (45 × 50 cm.).

**(e) Three sections of a vertical
 border.**
(1) H. 17 ¼", W. 4 ⅝" (43 × 11 cm.).
(2) H. 17 ⅝", W. 4 ⅛" (44 × 10 cm.).

(3) H. 18 ⅛", W. 3 ½" (46 × 8 cm.).

**(f) Three sections of a horizontal
 border.**
(1) L. 8¾", W. 17" (22 × 43 cm.).
(2) L. 8 ⅝", W. 28" (22 × 71 cm.).
(3) L. 8", W. 18 ⅝" (20 × 47 cm.).

The larger fragments are four panels with carvings in relief framed by strips of Cosmati work (considerably restored). Two of the slabs exhibit the symbols of the Evangelists Mark and Luke. A third shows a stag, while a fourth shows a perching rooster with a dragonlike tail, to be identified, in accordance with Medieval descriptions, as a basilisk. The complementary pair of Evangelist symbols and two further panels respectively showing a griffon and a siren can still be seen in the church of Santa Lucia in Gaeta, as originally pointed out to me by Professor R. Malmstrom. The Gaeta panels are presently mounted against the terminal walls of the aisles of the church, in the narrow spaces adjoining altars of post-Renaissance date. In its original state, the dismantled ambo included at least four additional panels with purely ornamental Cosmati inlay designs, which form a part of the present Gaeta reconstitution, and possibly additional slabs of the same type or reliefs now lost. The monument was typologically related to the ambos of San Cesareo in Rome and San Maria in Civita Castellana (E. Hutton, *The Cosmati*, London, 1950, pls. 46 and 47) so far as the paneled composition is concerned. But in the incorporation of reliefs with fantastic creatures, it is perhaps most closely reflected in the representation of an ambo in the Exultet Roll of the Pisa Museo Civico, dated in the eleventh century (M. Avery, *The Exultet Rolls of South Italy*, Princeton, 1936, p. 25, pl. LXXXIX). The three fragmentary marble and Cosmati work strips visible in the upper part of the haphazard arrangement of the Gardner Museum match the design of the architectural framework at Gaeta. As indicated by the contrasting treatment of the edges of each strip, the panels were alternately framed by egg-and-dart and leaf-and-tongue borders. How the narrower strips on the right side of the Boston arrangement and the two fragments with rinceaux at the center fitted into the scheme is unclear.

The church of Santa Lucia in Gaeta—Santa Maria in Pensulis in medieval times—is a modest three-aisled edifice of the twelfth century. Some authors have suggested, though without giving evi-

dence, that the dismantled ambo stems from the Duomo (S. Aurigemma and A. de Santis, *Gaeta-Formia-Minturno,* Rome, 1955, p. 14). The date of the work, too, remains problematic. It is noteworthy for its expert and subdued classicism—a quality now better exemplified in the Gaeta than in the Boston fragments, the surfaces of the latter having suffered some abrasion. This stylistic orientation is in contrast to the greater crowding and agitated manner of the reliefs decorating the famous monumental paschal candlestick of the Duomo, which is markedly later in date. G. Matthiae, the most recent authority to have dealt with the Gaeta fragments, has made a good case for a date no earlier than the first quarter of the thirteenth century ("Componenti del gusto decorativo cosmatesco," *Rivista dell'Istituto Nazionale d'Archeologia e Storia dell'Arte,* 1952, pp. 267–68). The monument is perhaps best understood as a manifestation of the strong subcurrent of interest in the Antique in the art of Rome and southern Italy in the decades surrounding the year 1200 (for the principal monuments and the historical background, see H. Wentzel, "Antiken-Imitationen des 12. und 13. Jahrhunderts in Italien," *Zeitschrift für Kunstwissenschaft,* 1955, pp. 29–72).

Bibliography

Longstreet and Carter, *General Catalogue,* p. 60; on the Gaeta fragments, see A. L. Frothingham, "Notes on Byzantine Art and Culture in Italy and especially Rome," *American Journal of Archeology,* 1895, pp. 203–205; E. Bertaux, *L'art dans l'Italie méridionale,* Paris, 1904, pp. 608–609; P. Fantasia, "Sui monumenti medievali di Gaeta e specialmente sul Campanile e sul Candelabro," *Annali del R. Istituto Tecnico Giovan Battista della Porta in Napoli,* 1920, pp. 226–35; for the church, see most recently A. Venditti, *Architettura bizantina nell' Italia meridionale,* II, Naples, 1967, p. 684ff. and passim.

7. STYLOBATE LION. Tuscany.
Marble. Second half of the XIIth century.
H. 24 ¾", L. 47", W. 14" (63 × 119.5 × 35.5 cm.).
No. S10s3. Purchased from Stefano Bardini, Florence, 1897. Fig. 78.

An embattled figure, imprisoned in the claws of the beast, plunges

a knife in its flank (the vertical slab visible in front of the animal's hind quarters is a modern insert which does not serve a recognizable purpose). The masterfully crisp handling of the stone brings into sharp relief the contained ferocity of the beast, whose sleekly angular body is massively weighted by the cylindrical bulk of the head. The flamelike tufts of the flattened mane are worked out with the help of the drill. The work should be compared to the stylobate lions of the pulpit in the Collegiata at Barga and the support of the lectern at Pescia (W. Biehl, *Toskanische Plastik des frühen und hohen Mittelalters,* Leipzig, 1926, pls. 141 and 58a and b). The gesture of the slave knifing the animal is duplicated in one of the portal lions of San Giovanni Fuorcivitas at Pistoia, (ibid., pl. 56a). (For the Classical antecedents of such combats, see R. Bernheimer, *Romanische Tierplastik und die Ursprünge ihrer Motive,* Munich, 1931, pp. 114–15.)

Bibliography

Longstreet and Carter, *General Catalogue,* p. 63.

8. STYLOBATE LION. Northern Italy.
Red Marble. End of the XIIth or beginning of the XIIIth century.
H. 23 ¾", L. 40 ½", W. 13 ¾" (59.5 × 103 × 35 cm.).
No. S10s5. Purchased from Stefano Bardini, Florence, 1897. Fig. 79.

The animal holds a rabbit or doglike beast in its claws. The burden of the base of a column on its back is shared by a kneeling Atlante on its right flank. The corresponding space on the other side is filled by a wedge-shaped block, roughly hewn along a vertical section where the work was separated from its point of anchor. The combination of lion and Atlante, a compressed version of the tiered arrangement of the same motifs found in the supports flanking the major entrances of the cathedrals of Trani and Ferrara, is seen again in Giovanni da Campione's north portal at Santa Maria Maggiore in Bergamo (S. Angelini, *Santa Maria Maggiore in Bergamo,* Bergamo, 1968, pp. 48–49). The characterization of the lion, periwigged in a loosely undulating mane, is echoed in the some-

what grosser animals from Quattro Castella near Reggio Emilia now in the Cloisters (No. 53.64.1.2) as well as more distantly in a number of examples around Parma and Verona. A. Kingsley Porter, with the present monument in mind, alluded to "the strongly Nicolò-esque character of . . . the lions in the courtyard of Fenway Court" (*Pilgrimage Roads,* p. 299, note 1), but the work is decidedly more advanced in style than the sculpture of this master and his school. Indeed, the conception of the animal and especially that of the kneeling figure presupposes the sculptor's acquaintance with works of Antelami or his circle.

Bibliography

Longstreet and Carter, *General Catalogue,* p. 63.

9. (a) BASIN. Northern Italy. Milan (?).
Marble. Ca. 1100.
H. 10 ½", L. 24 ½", W. 22 ½" (26.5 × 62 × 57 cm.).
No. S10n9. Purchased from Stefano Bardini, Florence, in 1897. Fig. 80 (above).

The rim is underscored by a broad band of interlace. Below, on two sides, is a pair of crouching lions back to back and joined at the corners under one head. One of the remaining faces shows a lion and a bird. The other was left undecorated. The carving in low relief and the characterization of the beasts in combination with geometric interlace is very close to Milanese work of the late eleventh and early years of the twelfth centuries, notably the pulpit of Sant'Ambrogio and the capitals of Santa Maria Aurona in the Castello Sforzesco (see notably E. Arslan, *Storia di Milano,* III, Milan, 1954, p. 524ff., with older bibliography).

(b) CAPITAL. Northern Italy.
Red Marble. End of the XIIth or beginning of the XIIIth century.
H. 12", L. 19", W. 19" (30.5 × 48 × 48 cm.).
No. S10n8. Fig. 80 (below).

relief sketched by Ruskin at the Casa Falier is similar in showing peacocks flanking a double column, though only a single bird is perched at the top (J. Ruskin, *Stones of Venice*, II, London, 1853, pl. XV).

Bibliography

Longstreet and Carter, *General Catalogue,* p. 42.

13. FRAGMENT OF A DECORATIVE RELIEF. Venice.
Marble. XIIth century.
H. 23″ (58.5 cm.).
No. S5n21. Purchased from Francesco Dorigo, Venice, in 1897. Fig. 85.

The upper section of an upright slab is vertically divided by a tree flanked by a pair of confronted griffons. Below, heads entwined in foliage, is a pair of birds in the same heraldic stance. The wiry, unsubstantial forms which characterize the work, uncommon in the vast production of Venetian decorative sculpture, are found again in a decorative relief in the Victoria and Albert Museum (J. Pope-Hennessey, *Italian Sculpture in the Victoria and Albert Museum,* London, 1964, p. 25, No. 25).

14. DECORATIVE ROUNDELS. Venice.
XII–XIIth centuries.
Purchased from Francesco Dorigo, Moise dalla Torre, and Dino Barozzi, in 1897.

The decorative roundels here inventoried are but a small part of the vast production principally employed in the embellishment of the façades of Venetian palaces and mercantile structures like the Fondaco dei Turchi from the twelfth century onward. Although the use of stone or terra-cotta ornamental roundels is well documented in the early Medieval architecture of Armenia and the lands around

the eastern and southern Mediterranean (on this subject, see espe-
cially the studies of H. G. Franz cited above under Wadsworth
Atheneum, No. 12). the immediate impulse behind this Venetian
production was of Byzantine origin and came through the medium
of imports of Byzantine decorative sculpture. The medallions in the
courtyard of the Gardner Museum show considerable variation in
style and quality, and they no doubt include works of widely dif-
ferent dates. Their chronology is unfortunately bound to remain
most uncertain since an adequate investigation of this type of
sculpture, much of which still graces the walls of the city and the
surrounding territory's old houses and churches, has yet to be
undertaken. Eight medallions embedded in the marble revetment
of the north façade of San Marco, which have been related to the
work of the late eleventh-century local ateliers, should furnish a
point of departure (F. Zuliani, *I marmi di San Marco,* Venice, 1970,
p. 156ff., Nos. 134–41, and H. Buchwald, "The Carved Stone Or-
nament of the High Middle Ages in San Marco, Venice," *Jahrbuch
der Oesterreichischen Byzantinischen Gesellschaft,* 1962–63, pp. 169–
209). A few among the Gardner pieces exhibit the same rimless,
slightly concave disks and come fairly close to the dry precision
which characterizes these carvings (14b). The plump forms of the
striking medallion with a lion attacking a centaur (14e), which
strongly recall the sculpture in ivory on Byzantine rosette caskets,
roughly approximate the style of a series of ornamental slabs deco-
rated with animals in combat or heraldically flanking a tree at San
Marco, perhaps still executed in the late eleventh century
(Buchwald, "Carved Stone Ornament," figs. 23, 26–27, and p.
185ff.). In another group among the Gardner medallions, which
must be substantially later in date, the disk is outlined by a rim
and deeply hollowed out, with the design correspondingly more
autonomous of the block (14g,i). In the treatment of the animal
motifs, it is possible to follow within an avowedly conservative
branch of artistic production, the broad transitions which mark
Venetian sculpture in the twelfth and thirteenth centuries, from
Byzantine to the tense muscularity of an indigenous Romanesque
(14g), and, ultimately, the picturesque tendencies in the late phases
of this style (14p,t).

(a) A griffon attacking a deer (?). Rim decorated with a pearly
band. Diam. 13″ (33 cm.). No. S5n19.

(b) Eagle, wings outspread, ensnaring a hare in its claws. Identical design in the University of Kansas Museum at Lawrence, Kansas (*Handbook*, Lawrence, 1962, p. 20). Diam. 15″ (38 cm.). No. S5n18. Fig. 86.

(c) A pair of bears (?) addorsed, with heads turned back face to face. Wide rim with bead-and reel design. Diam. 14 ½″ (37 cm.). No. S5n16.

(d) Griffon attacking a deer. The same motif occurs on a medallion at San Marco (Zuliani, *Marmi,* No. 141) and on one of the ornamental slabs in the basilica (ibid., No. 120). Diam. 12 ½″ (32 cm.). No. S5n15.

(e) Striding griffon, wings outspread. Diam. 14″ (35.5 cm.). No. S5w24.

(f) A bird on the back of a hare, pecking at its head. Motif in wide circulation with other examples at Brescia (G. Panazza, *L'arte medioevale nel territorio Bresciano*, Bergamo, 1942, fig. 181); Vienna (L. Planiscig, *Die Estensische Kunstsammlung*, I, Vienna, 1919, p. 6, No. 12); and in Venice, at Santa Maria dei Carmini, the Courtyard of the Ca'd'Oro, and other sites. Diam. 12″ (30.5 cm.). No. S5w23. Fig. 87.

(g) A pair of addorsed hounds, with facing heads joined. Rim with incised groove. Other examples on a house in the Campo Sta. Mater Domini and an "Antico Palazzo a S. Apostoli" (P. Selvatico, *Sullo architettura e sulla scultura in Venezia*, Venice, 1847, p. 74). Diam. 14″ (35.5 cm.). No. S5w21. Fig. 88.

(h) A dolphinlike animal swallowing a fish. Wide, upcurved rim. Diam. 14″ (35.5 cm.). No. S5w20.

(i) Centaur attacked by a lion. The same composition inverted in No. S5w22, which is possibly a modern imitation (not inventoried here). Diam. 17″ (43 cm.). No. S5w19. Fig. 89.

(j) A hare in the snares of a bird. Similar to No. S5w23 (above, 14f)

though inverted and cruder in execution. Diam. 12″ (30.5 cm.). No. S5w18.

(k) A lion sinking its teeth in the neck of a smaller feline beast. Diam. 10 ½″ (26.5 cm.). No. S5e27.

(l) A pair of confronted ostriches, with necks overlapping and beaks joined. Their claws rest on a pommel. Denticulated rim. Other examples of the paired bird motif in the Ca'd'Oro and in the Ravenna Museo Nazionale (M. Salmi, *L'abbazia di Pomposa*, Rome, 1936, p. 113, fig. 220). Diam. 14″ (35.5 cm.). No. S5e24. Fig. 90.

(m) A bird attacking a hare. Design as in Nos. 14f and j; grooved rim as in 14g. Diam. 14″ (35.5 cm.). No. S5e21.

(n) A pair of addorsed birds with heads turned back, jointly pecking a leaf. Similar design in the University of Kansas Museum at Lawrence (*Handbook*, p. 20). No. S5e8.

(o) A bird attacking a hare. Design as in Nos. 14f, j, and m, though seemingly earlier in date. No. S5e9.

(p) Eagle in frontal view, wings outspread, holding in its claws a serpent which bites its wing. Wide, heavily ornamented border. Decorative roundel with the same motif at San Marco (Zuliani, *Marmi*, No. 139). The iconography has been dealt with by R. Wittkower, "Eagle and Serpent: A Study in the Migration of Symbols," *Journal of the Warburg Institute*, 1938–39, pp. 209–25, and W. Déonna, *Deux études de symbolisme religieux* (Collection Latomus, XVIII), Brussels, 1955, p. 54ff. No. S5e10. Fig. 91.

(q) A pair of birds, the first standing on the back of the second and pecking its head. Ruskin recorded a similar piece on a house belonging to the Erizzo family near the Arsenal (*Stones of Venice*, II, pl. XVII) and another example is in Vienna (Planiscig, *Estensische Kunstsammlung*, p. 6, No. 11). No. S5e14.

(r) A pair of lions (?) in combat, one sinking its teeth into the neck of the other. No. S5n7.

(s) Houndlike animal with head twisted back, chewing on a morsel. No. S5n8.

(t) Griffon attacking a hare. Similar to No. 14d. No. S5n9. Fig. 92.

(u) A pair of confronted pheasants or partridges, beaks joined. Comparable group in a Venetian relief in Berlin (O. Wulff, *Altchristlische und mittelalterliche Bildwerke*, Berlin, 1911, pp. 24–25, No. 1745). Virtually identical to S5e13, possibly a modern copy (not inventoried here). No. S5s8.

(v) A pair of confronted hounds standing on a semicircular mound, with heads turned back to bite their tails. No. S5s9.

(w) A pair of addorsed peacocks, with heads turned back and beaks joined. No. S5s12.

(x) Four lions joined at the center in a single head. The same design occurs on a medallion of San Marco (Zuliani, *Marmi*, No. 138) and in mosaic on the pavement of Otranto. No. S5s13. Fig. 93.

(y) Bird on the back of a hare, pecking at its head. Crude version of the design in No. 14f, j, and m. No. S5w7.

(z) Bird on the back of a hare, pecking its head. Similar to the above, but reversed. No. S5w8.

(aa) Bird attacking bird. Similar to No. 14r. No. S5w9.

(bb) Bird attacking bird. Similar to the above. No. S5w10.

15. SECTIONS OF ORNAMENTAL ARCHES. Venice.
Istrian marble. XII–XIVth centuries.
Purchased from Francesco Dorigo and Moise dalla Torre, Venice, in 1899.

The architectural fragments here described are strips with meandering tendrils carved in low relief, occasionally enlivened by pecking birds. In Venice, the portal of the Seconda Corte del Mil-

ion is the earliest of a series of doorways with this type of decoration still in place (E. Arslan, "Portali romanici veneziani," *Festschrift Ulrich Middeldorf*, ed. A. Kosegarten and P. Tigler, Berlin, 1968, pp. 15–19). The initial phases in the production of such decorative strips were connected with the building of San Marco, Pomposa, and other eleventh-century churches of the upper Adriatic region, where the same designs were employed for cornices and moldings (O. Demus, *The Church of San Marco in Venice*, Washington, 1960, p. 115ff., and Buchwald, "Carved Stone Ornament," p. 172ff.). However, in the twelfth and thirteenth centuries—the case parallels that of the ornamental medallions—the manufacture of decorative arches in Venice found its greatest outlet in secular rather than ecclesiastical architecture. For some of the major examples extant (Corte Bottera, Ca' da Mosto, portal near the Ponte di San Toma, Palazzo Foscolo in the Rio San Pantalon, Palazzo Barzizza, Palazzo Contarino Porta di Ferre, Palazzo da Mula on Murano, etc., see Arslan, "Portali").

(a) Section of an arch decorated with a continuously interwoven and looping strand which is filled by rosettes alternating with birds pecking fruit. L. 32 ½", W. 8" (82.5 × 20.5 cm.). No. S12w3. Fig. 94.

(b) Smaller fragment with a simplified vine tendril filled with fruit. L. 13", W. 5 ¼" (33 × 13.5 cm.). No. S12w4.

(c) Arch section with vine scroll decoration. L. 16 ½", W. 5 ¾" (42 × 14.5 cm.). No. S12w5. Another part of the same relief is one of five fragments of arches embedded above the entrance to the Gothic Room of the museum (No. S31s1; lower tier, left). The four others are listed below.

(d) Vine scroll inhabited by a bird pecking a leaf (upper tier, left).

(e) Floral rinceau with a hare. Bead-and-reel border (upper tier, center).

(f) Vine tendril with leaves pecked by a bird and a basilisk. Beed-and-reel border (upper tier, right).

(g) Rinceau with a fantastic beast consuming foliage (lower tier, center).

16. CORNICE MOLDING SECTIONS. Venice.
XI–XIIth centuries.

(a) Fragments of cornice moldings arbitrarily assembled to form a lintel. The largest segment consists of a palmette frieze interrupted at regular intervals by acanthus tips bent backward. In the smaller segments, acanthus foliage is found throughout. This type of cornice molding is in evidence at San Marco, the apse of San Donato on Murano, and Santa Sophia in Padua (H. Buchwald, "The Carved Stone Ornament of the High Middle Ages in San Marco, Venice," [Part II], *Jahrbuch der Oesterreichischen Byzantinischen Gesellschaft*, 1964, p. 144ff.). No. S13s1 [lintel].

(b) Denticulated section decorated with acanthus plants aligned in a continuous row. L. 25 ½", W. 7 ½" (65 × 19 cm.). No. S13w1. Fig. 95.

(c) Cornice fragment with acanthus foliage decoration. The projecting, inverted tips have been broken off. Their place is marked by vertical tonguelike incisions. L. 33 ½", W. 7 ½ (85 × 19 cm.). No. S13w3.

(d) Fragment with acanthus foliage decoration, similar to the above. In the place of the broken off projecting acanthus tips, there are crude vertical and parallel striations. L. 33 ½", W. 7 ½" (84 × 19 cm.). No. S13w6.

(e) Denticulated section with a continuous acanthus palmette frieze. The piece is curved, as from an apse or the springing of a dome. L. 34", W. 7 ½" (86 × 19 cm.). No. S13w8. Fig. 96.

(f) Very similar to the above, though straight rather than curving, and somewhat more summarily executed. L. 39", W. 6" (99.5 × 15 cm.). No. S13w10.

(g) Design as in Nos. 16e and f. The denticulated border courses

downward on the right edge to terminate the foliage frieze. L. 21 ½", W. 5" (54.5 × 13 cm.). No. S13w11.

17. CHRIST FROM A DEPOSITION GROUP. Catalonia.
Polychromed wood. Second half of the XIIth century.
H. 48", W. 37 ½" (122 × 92 cm.).
No. S13e2. Purchased from J. Brummer in 1917. Fig. 97.

The slim, angular figure was the central element in a Deposition group which can be visualized with the help of the still complete Spanish ensembles of Erill-la-Vall and San Juan de las Abadesas (W. Cook and J. Gudiol Ricart, *Ars Hispaniae*, VI, Madrid, 1950, pp. 308ff. and 322). The stiff right arm still hangs from the cross while the other limb is bent downward to the sorrowful Joseph of Arimathea. Serene in death, the softly chiseled head bore a crown, which has been lost. The resemblance of the work to the Louvre's so-called Christ Courajod has been noted by several writers (Aubert-Beaulieu, *Description raisonnée*, pp. 40–41, No. 28) though the figure in Paris is without doubt of greater mastery in design and surface refinement. The Louvre figure has traditionally been ascribed to Burgundy, though with insufficient evidence. With his customary vigor, G. de Francovich has upheld this attribution; but while affirming the relationship of this work with the Gardner corpus, he assigned the latter to southern France ("Il Volto Santo di Lucca," *Bollettino storico Lucchese*, 1936, p. 7ff.). The monuments extant most closely comparable to the Boston carving stem from Catalonia. Among these are the Christ of Salardu (Cook and Gudiol Ricart, *Ars Hispaniae*, VI, fig. 418) and the remnant of another monumental Deposition in the Barcelona Museo Marès (P. de Pallol, *Early Medieval Art in Spain*, New York, 1966, p. 485, fig. 164).

Romanesque Deposition groups divide along iconographic lines into two main types. In Italy, as in the monuments of Tivoli, Volterra, and San Antonio in Pescia (E. Carli, *La scultura italiana dal XII al XVI secolo*, Milano, 1961, pp. 30–32), Christ's arms are symmetrically extended to the Virgin and St. John in a composition of comparative formality. In the Spanish group, however, the participants are more actively engaged in the task of lowering the body, whose weight falls on Nicodemus and Joseph of Arimathea. The disposition of the figures is thus more informal, less controlled by ar-

chitectural considerations, more episodic in character (for the an-
tecedents of these contrasting types, see most recently O. Pächt,
The Saint Albans Psalter, London, 1960, pp. 70–71). All too little is
known about the liturgical function of these monumental Deposi-
tion groups and, more generally, about the basis in religious feeling
which underlay their appearance. The answer is likely to reside in
the increasingly demonstrative character of Lenten and Easter
liturgy from the eleventh century onward, in which a significant
place was given to the enactment of dramatic *tableaux vivants* illus-
trating certain moments of the Passion (see on this subject most re-
cently O. B. Hardison, Jr., *Christian Rite and Christian Drama in the
Middle Ages,* Baltimore, 1965, p. 80ff., and for the sources, J.
Taubert, "Mittelalterliche Kruzifixe mit Schwenkbaren Armen,"
Zeitschrift des Deutschen Vereins zur Kunstwissenschaft, 1969, p. 92ff.).

Bibliography

Van Marle, "Twelfth Century French Sculpture in America," p. 3ff.; A. K.
Porter, *Spanish Romanesque Sculpture,* II, Florence, 1928, pp. 17–18; G.
de Francovich, "Il Volto Santo di Lucca," *Bollettino storico Lucchese,*
1936, p. 7ff.; De Francovich, "A Romanesque School of Wood
Carvers in Central Italy," *Art Bulletin,* 1937, pp. 50, 53; Cook and J.
Gudiol Ricart, *Ars Hispaniae,* VI, Madrid, 1950, p. 317; Longstreet and
Carter, *General Catalogue,* pp. 180–81.

XI

The Boston Museum
of Fine Arts

1. **CAPITAL.** La Charité-sur-Loire.
Limestone. First quarter of the XIIth century.
H. 24 ½", W. 27", D. 16 ½" (62 × 68 × 42 cm.).
No. 49.534. Purchased from J. Brummer in 1949. Fig. 98.

The capital, which has a companion piece in the City Art Museum of St. Louis (No. 86.49), originally crowned a column engaged on the pier dividing the second and third bays of the northern aisle in the nave of the church of Notre-Dame at La Charité-sur-Loire. Plaster copies are now seen *in situ* (L. Pressouyre, "Substitution de moulages à des originaux dans les édifices français," *Bull. Soc. Nat. Antiq. France,* 1969, pp. 246–51). The capitals are shown lying on the ground with other fragments of sculpture in a possibly fanciful engraving in M. Morellet, M. Barat and E. Bussière's *Le Nivernois,* I (Nevers, 1840, p. 10), suggesting that they had been removed from their original locus at an early date.

On the principal face of the Boston capital, a pair of peacocks drink from a chalice around which a serpent is entwined. On the shorter sides, the same motif is enacted with a single peacock. The birds are perched on acanthus foliage tips and appear as confronted pairs at the corners. The abacus is bent inward toward the center, which is masked by a semicircular extension. The style of the carving reflects an awareness of developments in Burgundy. The St. Louis capital has a clear antecedent in the great transept at

Cluny III (K. J. Conant, *Cluny. Les églises et la maison du chef d'ordre*, Mâcon, 1968, pl. LXXV, fig. 168), while the Boston capital recalls some work at Vézelay, itself dependent on the sculpture of the great Burgundian abbey (Salet-Adhémar, *Vézelay*, pl. 31, No. 45).

The building history of La Charité-sur-Loire is one of the most problematic chapters in Romanesque architecture. According to general consensus, the nave of the church was constructed after the dedication of the original eastern parts (La Charité I) by Pope Paschal II in 1107. The most detailed archaeological study made of the church to date assigns bays eight to three of the vessel to a third campaign datable between 1107 and ca. 1115 (J. Vallery-Radot, "L'ancienne prieurale Notre-Dame de la Charité-sur-Loire. L'architecture," *Congrès arch.*, CXXV, 1967, pp. 43–85). Following this chronological schema, the Boston and St. Louis capitals should be dated nearer the latter of these two dates.

Bibliography

M. Morellet, M. Barat, and E. Bussière, *Le Nivernois. Album historique et pittoresque*, II, Nevers, 1840, p. 10; P. Beaussart, *L'église bénédictine de la Charité-sur-Loire, fille ainée de Cluny. Etude archéologique*, La Charité-sur-Loire, 1929, p. 119; *Brummer III*, p. 142, No. 595; J. Evans, *Cluniac Art of the Romanesque Period*, Cambridge, 1950, p. 49; M. Anfray, *L'architecture religieuse du Nivernais au moyen âge. Les églises romanes*, Paris, 1951, p. 261; *Bulletin of the Boston Museum of Fine Arts*, LV, Autumn-Winter 1957, p. 54; R. Raeber, *La Charité-sur-Loire. Monographie der romanischen Kirche Notre-Dame unter spezieller Berücksichtigung der Skulpturen*, Bern, 1964, pp. 93–94, No. A7; Scher, *Renaissance*, pp. 39–41; J. Vallery-Radot, "L'église prieurale Notre-Dame à la Charité-sur-Loire. L'architecture," *Congrès arch.*, CXXV, 1967, p. 69; L. Pressouyre, "Substitution de moulages à des originaux dans les édifices français," *Bull. Soc. Nat. Antiq. France*, 1969, pp. 246–51; Pressouyre, *Revue de l'art*, 7, 1970, p. 91; W. Cahn, *Gesta*, XIII/2, 1974, p. 56, No. 5.

2. CAPITAL. Saint-Michel de Cuxa.

Pink marble. Second quarter of the XIIth century.
H. 17", W. 17", L. 17" (43 × 43 × 43 cm.).
No. 24.156. Gift of George Grey Barnard, 1924. Fig. 99.

The cloister of Saint-Michel de Cuxa was dismantled around 1940 and the sculptural fragments scattered in various places in the region. Some ninety-four capitals remaining have been inventoried by M. Durliat (*La sculpture romane en Roussillon*, I, Perpignan, 1948, p. 23ff.). Fifty-one of these, brought to America through the activities of George Grey Barnard, were acquired by the Metropolitan Museum for its reconstruction in the Cloisters (J. Rorimer, *The Cloisters. The Building and the Collection of Medieval Art*, New York, 1963, p. 65ff.). One is in the Pitcairn Collection at Bryn Athyn, Pennsylvania (A. K. Porter, *Romanesque Sculpture of the Pilgrimage Roads*, V, Boston, 1923, No. 557a), a second is in the Philadelphia Museum of Art (M. Weinberger, *The George Grey Barnard Collection*, New York, 1945, p. 9, No. 45), and two more are in the Louvre (Aubert-Beaulieu, *Description raisonnée*, pp. 33–34, No. 22). A number have been returned to Cuxa or are in private hands nearby. The cloister is tentatively credited to the abbacy of Gregory, whose tomb was located in one of the galleries (Durliat, *Sculpture romane*, pp. 85–86). A recently discovered document indicates that the latter, first mentioned as abbot around 1130, became bishop of Tarragona in 1144. The erection of the cloister might tentatively be placed between these two dates (A. Cazes, "En parcourant les cartulaires," *Massana: Revue d'histoire, d'archéologie et d'héraldique du Roussillon*, IV, 1972, pp. 366–70).

The Boston capital is of the Corinthian type, with a single row of large and undetailed leaves. A narrow band decorated with a chevron ornament is visible in the interstices which they form at the center of the calyx. The rosette takes the form of a pine cone. The capital appears to be very similar to one which has been incorporated in the reconstruction of two arcades of the cloister at Cuxa (Durliat, *Sculpture romane*, p. 29, fig. 11, foreground left).

Bibliography

M. Durliat, *La sculpture romane en Roussillon*, I, Perpignan, 1948, p. 24; J. Rorimer, *The Cloisters. The Building and the Collection of Medieval Art*, New York, 1963, p. 72; Exh. Catal. *The Middle Ages. Treasures from the Cloisters and the Metropolitan Museum of Art*, Los Angeles and Chicago, 1970, p. 84, No. 37; M. Durliat, "La fin du cloître de Saint-Michel de Cuxa," *Les Cahiers de Saint-Michel de Cuxa*, July 1971, p. 15, No. 2.

3. APOSTLE. Languedoc.
Limestone. Middle or third quarter of the XIIth century.
H. 33 ¾", W. 10 ¼", D. 6 ½" (85 × 26 × 16.5 cm.).
No. 56.335. Charles Amos Cumming Fund, 1957. Purchased from
John Hunt, London. Fig. 100.

The haloed apostle is depicted in the characteristic cross-legged
stance, with feet resting on a sloping base. He holds a book and
makes a gesture of address. The squatly proportioned body is clad
in a long robe covered by a shorter overmantle; the outer cloak is
draped over the arms and shoulders. The surface of the relief has
been much dulled by weathering. According to the dealer, it is said
to come from the church of St. Pierre de Rhèdes at Lamalou
(Hérault), but nothing like it is found in this building and no trace
of the work appears in the literature which has been devoted to the
site since the later years of the nineteenth century. A head in a
similar style which passed through the hands of the Paris dealer
Wertheimer in 1960 is in the Abegg Collection, Riggisberg (Switzer-
land).

Despite a certain archaism, notably in the handling of the drap-
ery folds over the torso, the work must be of a comparatively ad-
vanced date. It is closest in style to an enthroned Madonna recently
purchased by the Minneapolis Institute of Arts (No. 66.24. *Annual
Report. Minneapolis Society of Fine Arts,* 1966, p. 7) assigned to Rous-
sillon, and to that group among the sculptures from Saint-Pons-de
Thomières represented by the capital with Emmaus scenes in the
Fogg Art Museum. This latter ensemble was executed toward the
middle of the twelfth century under Toulousain influence (L. Seidel
in Scher, *Renaissance,* pp. 88–89). A relief of a frontal apostle in the
Duke University Art Museum first published by S. Scher (ibid., p.
93ff., No. 33) and compared by him with the Boston apostle must
be somewhat earlier in date.

Bibliography

Boston Museum Calendar of Events, December 1956; Scher, *Renaissance,* pp.
93–95, No. 32.

4. CAPITAL. Languedoc.

Limestone. Late XIIth or first half of the XIIIth century.
H. 10", W. 8 ¼", D. 11" (25.5 × 21 × 28 cm.).
No. 19.68. Gift of J. Templeman Coolidge. Purchased from D. G.
 Kelekian. Fig. 101.

The capital and that described in the following entry are part of a
more or less homogeneous group executed in and around Toulouse
over a period of time from the later years of the twelfth century
onward. Other pieces in the same series are in the Yale Art Gallery
(see above, No. 3) and the Cleveland Museum, while stylistically
related sculpture can be found in the Toulouse Musée des Augus-
tins, at Foix, Agen, and other sites in the region. These works
exemplify the long-lingering hold of Romanesque art in one of its
earliest domains (P. Mesplé, "L'art roman décadent du Sud-
Ouest," *Bull. mon.*, 1957, pp. 15–22). The design of the capital here
inventoried is a virtual replica of that in the Yale Art Gallery, with
those parts left blank in the latter fully worked out. The long faces
of the block are occupied by a pair of addorsed dragons, whose
heads are implanted at the four corners. The diminutive heads of a
second pair of the same lizardlike animals, trapped in their jaws,
are seen on the narrower two sides. At the center between their
upraised wings, there is a detached head of the same type in mask
form. The capital has sustained a battering blow resulting in the
loss of one corner of the block.

5. CAPITAL. Languedoc.
Limestone. First half of the XIIIth century.
H. 10 ¾", W. 8 ¾", D. 8 ⅝" (27 × 22.5 × 22 cm.).
No. 19.645. Gift of Mrs. Albertine W. F. Valentine. Purchased from
 D. G. Kelekian. Fig. 102.

This capital is roughly comparable in design to that described in
the preceding entry (No. 4), though looser and likely somewhat
later in execution. The proportions of the block are more elongated,
the beasts less confined within its mass, and their characterization
of a tectonically more diluted effect. The large bearded and
crowned (?) heads at the center of the narrow sides must be due to
a recarving of the fourteenth century. See for the identical combi-
nation a corbel in the palace of the Popes at Avignon (J. Bal-
trušaitis, "La troisième sculpture romane," *Formositas Romanica.*

Festschrift für Joseph Gantner, Frauenfeld, 1958, p. 73, fig. 31).

6. SECTION OF A VOUSSOIR. Valley of the Rhône.
Savigny (?).
Limestone. Second quarter of the XIIth century.
H. 12 ¼", W. 16" (31 × 40.5 cm.).
No. 49.533. Wm. F. Warden Fund.
Formerly J. Brummer. Fig. 103.

As is indicated by the concave profile, the carving is a section of an arch. It shows an angel in half-length, with wings outspread. The figure is cradled along the bottom by a border of vine leaves filled with grapes. The lower zone of the relief is somewhat battered. Another section of the same arch, showing a hooded woman, is in the Fogg Art Museum (see below, No. 16). The design in a complete state may be imagined as having been similar to the arch framing the western portal of the Cathedral of Saint-Paul-Trois-Châteaux, while busts of frontalized angels emerging from foliage are also seen in isolated form on capitals of the choir of Saint-Gilles (R. Hamann, *Die Abteikirche von Saint-Gilles und ihre künstlerische Nachfolge,* Berlin, 1955, pp. 59–60). The style points to Provence or the Rhône Valley, and the peculiar keyhole-shaped indentations in the foliage more particularly point to some of the sculpture from Saint-Martin de Savigny (Rhône), now dispersed in various collections (see above, Jewett Art Center, Wellesley, No. 1). The ridging in the treatment of the drapery around the shoulders is also part of the regional idiom within Provençal and Rhodanian classicism, appearing in the sculpture of Vienne and its environs.

The collection of stones now deposited in the École d'Agriculture at Savigny (formerly Musée Coquard) contains other fragments of sculpture which may, with the arch recorded here, have formed part of the portal program of the abbey church. The most substantial is an impressive relief with the Washing of the Feet and the Last Supper, which must have constituted the lintel above the entrance.

Bibliography

Brummer III, p. 147, No. 605; L. Seidel, *Gesta,* XI/2, 1972, p. 57.

7. **RELIEF WITH AVARICE.** South central France or Limousin.
Limestone. Second quarter of the XIIth century.
H. 24 ½″, W. 12 ½″, D. 9″ (62 × 31.5 × 23 cm.).
No. 48.255. Charles Amos Cummings Fund.
Formerly Trichard (1929) and J. Brummer. Fig. 104.

The miser kneels on a circular coffer with a truncated conical lid. A pouch whose drawstrings he grasps with clenched hands is fastened around his neck. A grimacing demon behind him pulls his hair and claws at his arm. The general orientation of the figures toward the right suggests that the relief as originally mounted had a pendent, possibly a second scene of punished vice as in the porches of Moissac and Beaulieu, or a typologically contrasting subject as at Lagraulière in Limousin. The representation of the miser prostrate on his treasure chest as a parody of the act of worship has a fine mordant edge. The shape of the box differs from those shown at Ennezat (A. Gybal, *L'Auvergne, berceau de l'art roman,* Clermont-Ferrand, 1957, p. 372) and Blars (*Dictionnaire des églises de France. III. Sud-Ouest,* Paris, 1967, No. III B 23) and calls to mind casket types of Siculo-Arabic workmanship (P. B. Cott, *Siculo-Arabic Ivories,* Princeton, 1939, Nos. 98 and 101). S. Scher has made a very plausible case for localization of the work in the region of Limousin.

Bibliography

Scher, *Renaissance,* pp. 48–49, No. 9; M. Durliat, *Bull. mon.,* 1971, p. 57.

8. **CRUCIFIED CHRIST.** Salzburg (?).
Lindenwood with polychromy. Second half of the eleventh century.
H. 71″ (1.80 m.).
No. 51.1405. Formerly Fuld Collection. Fig. 105.

The impressive corpus is one of the very small number of eleventh-century crosses to have survived and a work of the first importance from the later phase of Ottonian art. In the iconography of the suffering Christ, the monument follows the precedent of the Gero Cross in Cologne Cathedral. But the lifeless body strains

downward in a softly arching spiral in contrast with the earlier work's vehement thrust. The downward tilt of the head is similar, though the features in the Boston cross are more composed and the hair arranged in three orderly strands rather than convulsively intertwined. The same concern for clarity of organization is manifest in the uninterrupted and unmodulated line which serves as the definition of the breast. The understated pathos of the characterization, however, may be somewhat exaggerated by the murky polychromy, which is not original. Traces of the brightly outlined border of the loincloth are visible below the present surface. The back is hollowed out.

When it was purchased on the Munich art market, the work was said to have come from Reichenhall, a short distance to the southwest of Salzburg. O. Schmitt and G. Swarzenski initially published it as south Bavarian and dated it at the beginning of the thirteenth century (*Meisterwerke der Bildhauerkunst in Frankfurter Privatbesitz*, I, Frankfurt am Main, 1921, pls. 5–6, No. 5), but the eleventh-century date later proposed by W. von Blankenburg is now generally accepted ("Das Holzkreuz der ehemaligen Sammlung Fuld in Berlin. Ein Dokument monumentaler ottonischer Plastik," *Jahrbuch der Preussischer Kunstsammlung*, 1934, pp. 39–53). But while that author placed the monument in the second half of the century, a date as early as the first or second quarter has more recently been defended (R. Wesenberg, *Frühe Mittelalterliche Bildwerke*, Düsseldorf, 1972, p. 42, with references). There are particularly close stylistic and iconographic relations with the cross in the crucifixion panel of the doors of Santa Maria im Kapitol in Cologne, and several other crosses seem to echo the same type, though somewhat more distantly: the cross from Salux (Grisons), now in a private collection at Oberkassel near Bonn (E. Poeschel, *Die Kunstdenkmäler des Kantons Graubünden*, III, Basel, 1940, pp. 273–74); a cross in the Friedhofskapelle at Schlehdorf in upper Bavaria, as noted by E. Syndicus (*Christus Dominator*, Innsbrück-Vienna-Munich, 1964, p. 179); and more distantly, the Cross of Stift Nonnberg at Salzburg, a work of the middle or third quarter of the twelfth century (K. Ginhart, *Romanische Kunst in Oesterreich*, Exh. Catal., Krems an der Donau, 1964, p. 138, No. 82). There is a consensus in expert opinion in favor of Salzburg on the question of localization. Wesenberg, however, has called attention in regard to the formulation of the type represented by the panel of

the Cologne doors and the Boston and Salux crosses to the depiction of the crucifixion in a group of eleventh-century St. Gall Sacramentaries (Stifstbib. Cod. 390/1, 338, 376, 340, and 341) and sees that monastery as the probable place of origin for the crosses and the source of influence on Cologne in the middle of the eleventh century.

Bibliography

O. Schmitt and G. Swarzenski, *Meisterwerke der Bildhauerkunst in Frankfurter Privatbesitz*, I, Frankfurt am Main, 1921, No. 5; W. von Blankenburg, "Das Holzkreuz der ehemaligen Sammlung Fuld. Ein Dokument monumentaler ottonischer Plastik," *Jahrbuch der Preussischer Kunstsammlung*, 1934, pp. 39–53; G. de Francovich, "Les origines du crucifix monumental sculpté et peint," *Revue de l'art*, LXVII, 1935, p. 212; R. Hamann-MacLean, "Ein ottonischer Kruzifix," *Zeitschrift für Kunstwissenschaft*, 1952, pp. 124, 128, 133–34; R. Wesenberg, "Der Ringelheimer Bernwardkruzifix," *Zeitschrift für Kunstwissenschaft*, 1953, pp. 10, 17–18; *Bulletin of the Boston Museum of Fine Arts*, LV, Autumn-Winter, 1957, p. 60; H. U. Haedecke, "Der Kruzifix von Monheim," *Wallraf-Richartz Jahrbuch*, 1958, p. 74; F. Fuhrmann, "Das romanische Marientympanon im Salzburger Museum Carolino-Augusteum. Zum Frage seiner Enstehungszeit," *Salzburger Museum Carolino-Augusteum, Jahresschrift*, 1959, p. 75ff.; T. Buddensieg, "Ein ottonischer Steinkopf in Fulda," *Jahrbuch der Hamburger Kunstsammlung*, 1960, p. 7 and note 6; E. Steingräber, *Deutsche Plastik der Frühzeit* (Blaue Bücher), Königstein-im-Taunus, 1961, pp. 12, 53; A. Schmid, "Zum Torso eines Kruzifixes im Museum von Freiburg im Uechtland," *Der Mensch und die Künste: Festschrift für H. Lützeler*, Düsseldorf, 1962, pp. 390–91; H. Schindler, *Grosse Bayerische Kunstgeschichte*, I, Munich, 1963, p. 175; R. Haussherr, *Der Tote Christus am Kreuz. Zur Ikonographie des Gerokreuzes*, Bonn, 1963, pp. 20–21; *Illustrated Handbook. Boston Museum of Fine Arts*, Boston, 1964, pp. 110–11; E. Pattis and E. Syndicus, *Christus Dominator*, Innsbrück-Vienna-Munich, 1964, pp. 17–18; H. Swarzenski, "A Medieval Treasury," *Apollo*, December 1969, p. 34; A. Harding, *German Sculpture in New England Collections*, Boston, 1972, pp. 21, 84; R. Wesenberg, *Frühe Mittelalterliche Bildwerke*, Düsseldorf, 1972, p. 42ff.

9. SPANDREL WITH AN ANGEL. Saxony or region of the Meuse.

Limestone with polychromy. Third quarter of the XIIth century.
H. 19 ¼", W. 33" (48.5 × 84 cm.).
No. 66.438. Charles Amos Cummings Bequest.
Formerly Hermann Schwartz Collection. Fig. 106.

The triangular relief shows a haloed angel with hands half upraised and glance directed to the right. It likely occupied the spandrel zone in the arcaded construction of a choir screen. J. A. Schmoll has identified a fragment of another monument of the same kind in a censing angel at Mettlach (*Kunstchronik*, 1961, p. 178; publication in P. Volkelt, *Die Bauskulptur und Ausstattungsbildnerei des frühen und hohen Mittelalter im Saarland*, Saarbrücken, 1970, p. 99ff. and Catal. No. 31). Another carving of an angel in the same triangular format is in the Musée du Périgord at Périgueux (M. Soubeyran, "Catalogue raisonné des elements de sculpture provenant de la cathédrale Saint-Front de Périgueux et conservés au Musée du Périgord," *Bulletin de la Société historique et archéologique du Périgord*, 94, 1967, pp. 170–71, No. A3249). The Boston angel has been stylistically connected with the choir screens of Hildesheim and Halberstadt. Dr. Swarzenski (oral communication) believes it to be of Mosan origin and compares it with the capitals of St. Mary's at Maastricht. The difficulty in uncovering really close parallels is attributable to the highly idiomatic quality of the carving, whose calligraphic animation and intensity can more readily be discovered in book illumination than in the sculpture of the region, as, for example, some decades earlier, in the Floreffe Bible and related manuscripts.

Bibliography

W. Beeh and H. Schnitzler, "Bewahrte Schönheit. Mittelalterliche Kunst der Sammlung Hermann Schwartz," *Aachener Kunstblätter*, Heft 21, 1961, p. 8, No. 2; J. Schmoll gen. Eisenwerth, "Die Sammlung Hermann Schwartz/ Mönchengladbach im Suermondt-Museum Aachen," *Kunstchronik*, 1961, p. 178; *The Museum Year. Museum of Fine Arts, Boston*, 1966, p. 38; Swarzenski, "Medieval Treasury," p. 34; P. Volkelt, *Die Bauskulptur und Ausstattungsbildnerei des frühen und hohen Mittelalter im Saarland*, Saarbrücken, 1970, p. 99; A. Harding, *German Sculpture in New England Collections*, Boston, 1972, pp. 24, 84.

10. FRAGMENT OF AN IMPOST BLOCK. Southern Italy or Sicily.
Marble. Second half of the XIIth century.
L. 10 ⅛", W. 7 ¼" (25.5 × 18.5 cm.).
No. 93.9. Gift of Michael Farah, 1893. Fig. 107.

The irregularly shaped fragment is part of an impost block whose four corners were decorated with lion masks sprouting foliate swags. Imposts of this type can be seen in the ciborium of the Cathedral of Barletta (F. Jacobs, *Die Kathedrale S. Maria Icona Vetere in Foggia*, Hamburg, 1968, I, p. 111 and II, fig. 76).

11. RELIEF WITH EAGLE AND LION. Central Italy.
Marble. Second half of the XIIth century.
H. 13 ¾", W. 12 ½" (35 × 31.5 cm.).
No. 49.532. William F. Warden Fund.
Formerly Barsanti, Rome (1928), and J. Brummer. Fig. 108.

The panel shows an eagle with outspread wings in whose claws a recumbent feline quadruped is fastened. The head and upper part of the bird are worked free of the block and secured by means of ties cut into the marble, following ancient Roman practice. The carving stems from a central Italian pulpit like those of Alba Fucense, San Lorenzo fuori le Mura and Santa Maria in Ara Coeli (H. Swarzenski, *Bulletin of the Boston Museum*, 1962, p. 45, note 25). It is stylistically closest to the relief still in place at San Lorenzo (E. Hutton, *The Cosmati*, London, 1950, pl. 32), though the plump, softly articulated forms favored by the sculptor invite comparison more urgently with work on a small scale, as on carved gems, than with monumental sculpture. The irregularly pocked stone behind the head of the bird was perhaps intended to receive a red paste filling or Cosmati work.

Bibliography

Bulletin of the Boston Museum of Fine Arts, LV, Autumn–Winter 1957, p. 59.

12. PILASTER. Central Italy.
Marble. Second half of the XIIth century.
H. 55 ½", W. 18 ½" (141 × 47 cm.).
No. 49.531. William F. Warden Fund.
Formerly Barsanti, Rome (1929), and J. Brummer. Fig. 109.

The slab is most probably the lower section of a portal jamb. Its decoration consists of two symmetrical strands of hybrid foliage which depart from the jaws of lions heraldically addorsed at the base. The vertical axis is marked by a bead-and-reel band and the long sides are edged by an acanthus border. The design as a whole resembles the rather worn panel still in place along the left side of the north portal of the west façade at Santa Maria Maggiore in Tuscania (H. Thummler, "Die Kirche S. Pietro in Tuscania," *Kunstgeschichtliches Jahrbuch der Bibliothek Hertziana,* II, 1938, p. 273). The crisply executed and oddly sinewy foliage is stylistically close to the sculpture of the doorway from San Nicolo in Sangemini in the Metropolitan Museum (M. Forsyth, "The Sangemini Doorway," *Bulletin of the Metropolitan Museum of Art,* June 1965, pp. 373–80).

Bibliography

Brummer III, p. 136, No. 576.

13. MADONNA AND CHILD. Lombardy.
Limestone with polychromy. Second quarter of the XIIth century.
H. 29", W. 15 ¾", D. 8 ½" (74 × 40 × 22 cm.).
No. 57.583. Maria Antoinette Evans Fund.
Formerly L. Albrighi, Florence. Fig. 110.

This striking work is said to have been found at Codogno near Lodi. It has been convincingly attributed by H. Swarzenski to a workshop based at Piacenza and active at Lodi Cathedral and at nearby Castellarquato. In spite of some divergences, notably in the pose of the Child, there is indeed a close relationship between the Boston image and the Madonna of the Castellarquato tympanum. The work is atypical for being in stone rather than wood, and so far as can be ascertained, it is without a reliquary cache. The seated Virgin and the Christ Child are locked in tender embrace. The sta-

ble configuration of the bodies across which attenuated limbs are diagonally cast to bring Mother and Son face to face is an invention of great expressive power. The composition adheres to the *Eleousa* or *Glykophilousa* type, though it does not faithfully reproduce any of the known representations in this form which might be cited as antecedents. Customarily in this type, the Child is not seated but cradled high in the Virgin's arms, whereas the seated position belongs to the more solemn or dogmatic icon families. This deviation from the norm makes less pointed the Child's vulnerability. By design or not, the sculptor has also imparted to Him a degree of maturity well beyond the stage of infancy. The characterization thus given to the relationship of Mother and Child partakes in something of the mystical union of Sponsus and Sponsa of the Song of Songs. The Madonna in Giroldo da Como's thirteenth-century relief at Montepiano is a reiteration of the same iconographic type (W. Biehl, *Toskanische Plastik des frühen und hohen Mittelalters*, Leipzig, 1926, pl. 165).

Bibliography

H. Swarzenski, "A Masterpiece of Lombard Sculpture," *Bulletin of the Boston Museum of Fine Arts*, 1959, pp. 66–71; *Illustrated Handbook. Boston Museum of Fine Arts*, 1964, pp. 112–13; *Art News*, September 1969, p. 47; Swarzenski, "Medieval Treasury," p. 43.

14. CARVED BASE WITH ROMULUS AND REMUS.
Tuscany (?).
Marble. Beginning of the XIIIth century.
H. 12 ⅞", W. 19", D. 19" (33 × 48 × 48 cm.).
No. 39.747.
Formerly Bardini, Florence, and J. Brummer. Figs. 111 and 112.

As fascinating as it is problematic, the work is a square marble block carved in ostensible imitation of a Roman monument. The heavy and moderately projecting base and cornice has a decoration of acanthus leaves running along all four sides. A pearly band is seen along the upper edge. The suckling Romulus and Remus is the subject which occupies the central section of one side. The opposite face shows a tripod flanked by a pair of griffons. The two

remaining sides exhibit the identical composition, a mask with a luxuriant moustache of spiraling foliage. One of the two versions of this motif, however, is of a comparatively more summary execution. The style of the carving, in which the drill is prominently used, reveals the artist to have been an attentive student of Roman sculpture in transition to the late Antique phase. The densely charged surfaces tend toward the *horror vacui* and the characteristic heightening of tonal contrasts is in evidence. At the same time, the brittle intensity of the interpretation is unmistakably medieval.

The purpose for which the work was made is most uncertain. The absence of weathering indicates that it must have been housed indoors, with the less finished side presumably facing a wall. The most likely supposition is that it was the socle of a sculptural monument, perhaps a candlestick. On the famous Lateran sarcophagus of the fourth century, the Good Shepherd stands on a base decorated with griffons flanking a tripod that is virtually identical with our block (W. F. Volbach, *Early Christian Art*, New York, 1961, No. 6). The intention in the Boston base may have been to exhibit an even more overt parallelism of pagan and Christian imagery, similar to that found on the late ninth-century ivory dyptich of Rambona, where a group of the She Wolf with Romulus and Remus appears below the Crucifixion (A. Goldschmidt, *Elfenbeinskulpturen aus der Zeit der karolingischen und sächsischen Kaiser*, I, Berlin, 1914, p. 86). In medieval exegesis, the foundation of Rome by the twin brothers was seen as foreshadowing the establishment of the divine city by the apostles Peter and Paul. For some authors, on the other hand, the killing of Remus by his brother recalled the story of Cain and Abel and showed mankind once more collectively incriminating itself at the start (P. E. Schramm, *Kaiser, Rom und Renovatio*, Leipzig, 1929, passim, and most recently, K. Hoffmann-Curtius, *Das Programm der Fontana Maggiore in Perugia*, Düsseldorf, 1968, pp. 27–29, for the primary sources).

The sculptor's source in ancient art is also likely to have been the base of a statue or the architectural suppost of a column or pier. Grave altars, which may exhibit the same kind of imagery, tend as a rule to have more upright proportions (W. Altmann, *Die römischen Grabaltäre der Kaiserzeit*, Berlin, 1905). The kind of work which must have been available as a model is exemplified by a base with representations of Leda and the Swan with *amorini* in Vienne (E. Espérandieu, *Recueil général des bas-reliefs, statues et bustes de la*

Gaule romaine, I, Paris, 1907, pp. 256–57, No. 35D). Now supporting a column, it has the squat silhouette of the Boston block and the same rather assertive cornice and base. The depiction of the She Wolf follows not the famous Lupa Capitolina, but another compositional type widely diffused on coins and a variety of reliefs showing the animal with the head bent back protectively toward the twins (E. Strong, "Sulle trace della Lupa Romana," *Scritti in onore di Bartolomeo Nogara,* Rome, 1937, pp. 475–501).

The carving is thought to be of central Italian origin. The evidence for a positive attribution, however, seems inadequate. The florid *Tiefendunkelstil* effects have some parallels in sculpture of the Campania as on the ambos of Salerno and Sessa Aurunca, but they are known as well in Tuscany. The characterization of the She Wolf recalls the animals of the façade cornice frieze of the Cathedral of Pisa (P. Sanpaolesi, "La facciata della Cattedrale di Pisa," *Rivista dell'Istituto Nazionale d'archeologia e storia dell'arte,* 1956–57, pp. 327–31), while the open acanthus leaves seen full face which frame the central group of the nursing twins have parallels in the Romanesque half of the lintel of the Porta San Ranieri in the same church (ibid., p. 298, fig. 117) and at Santa Maria Forisportam, Lucca. Reliefs with leaf masks reused as spoils are found in a number of Roman churches (M. Wegner, "Blattmasken," *Das siebente Jahrzehnt. Festschrift für Adolf Goldschmidt,* Berlin, 1935, p. 47), but this motif, which occupies two sides of the block, seems in the Romanesque period to have been especially favored in northern Italy (A. C. Quintavalle, *La Cattedrale di Modena,* Modena, 1964–65, figs. 67, 134, and 373).

Bibliography

Exh. Catal. *Arts of the Middle Ages,* Boston, 1940, p. 47, No. 147; C. R. Vermeule, *European Art and the Classical Past,* Cambridge, 1964, p. 23.

15. PILLAR FROM A PULPIT. Tuscany.
Marble. Last quarter of the XIIth century.
H. 38½", D. of shaft 9⅜" (98 × 23.5 cm.).
No. 68.549. J. H. and E. A. Payne Fund. Fig. 113.

The work is part of a pulpit for the reading of the Epistle, showing, as is customary in these monuments, the apostles James, Peter, and Paul joined in a monolithic pillar. The block above their heads in the form of an inverted pyramid must have sustained a flat slab on which the book could be laid. The Pisan pulpit at Cagliari and the later construction in the Church of San Bartolommeo a Pantano in Pistoia exemplify two possible arrangements in which the Boston pillar might originally have appeared (Biehl, *Toskanische Plastik,* figs. 48a and 154). Stylistically, the carving is closer to the corresponding group from the Cathedral of Pescia (ibid., p. 51ff. and fig. 58), which belongs to the following of Master Guglielmus, active at Pisa in the middle years of the twelfth century.

Bibliography

The Museum Year. Boston Museum of Fine Arts, 1968, pp. 37–38; H. Swar-
zenski, "Before and after Pisano," *Bulletin of the Boston Museum of
Fine Arts,* LXVIII, 1970, p. 181ff.

16. LION. Southern Italy (?).
Carbonaceous limestone. Second quarter of the XIIIth century.
H. 30 ¾" (78 cm.).
No. 40.784. Gift of Mrs. Charles Gaston Smith's group.
Formerly R. Stora, New York. Fig. 114.

The animal is seated on its hind quarters, with the head turned to one side. The four legs are broken off. The right foreleg was lifted, indicating that it may have originally reposed on a victim. The absence of architectural attachments of any kind makes it difficult to divine the context in which the work originally functioned. There are a number of instances of the use of such free-standing lions in Italian Romanesque sculpture. The lions of the royal thrones of the Cathedral of Monreale are similarly seated on hind quarters and apparently worked free (W. Krönig, *The Cathedral of Monreale,* Palermo, 1966, figs. 55 and 56). In the Palazzo d'Afflitto at Ravello, there is a lion in the same posture suckling a cub from the pulpit of the church of San Eustachio di Pontone (*Napoli Nobilissima,* 1962, p. 169, fig. 10). Occasionally, such animals unattached to masonry flank a portal, as at San Lorenzo in Agro Verano and Santi

Giovanni e Paolo in Rome (G. Rivoira, *Lombardic Architecture*, I, London, 1910, p. 216, figs. 318–19).

The sleek proportions of the animal and the comparatively loose handling of the mane suggest a fairly advanced date in the chronology of Italian Romanesque sculpture. The provenance is uncertain. G. Swarzenski's initial attribution to southern Italy rests on insecure foundations but remains for the moment the most plausible suggestion.

Bibliography

Arts of the Middle Ages, Boston, 1940, No. 153; G. Swarzenski "A Romanesque Stone Lion," *Bulletin of the Boston Museum of Fine Arts*, XXXIX, June 1941, p. 32–35.

17. PORTAL AND SCULPTURAL ELEMENTS. San Miguel
de Uncastillo.
Sandstone. Second half of the XIIth century.
No. 28.32. Francis Bartlett Donation. Purchased from S. Babra, Barcelona. Figs. 115, 116, 117, 118, and 119.

The church of San Miguel de Uncastillo comprises a single nave of four rectangular bays terminated by a round choir. The entrance was located in the second bay on the south side of the structure. After its abandonment in 1915, the building was stripped of its sculptural decoration both within and without. In addition to the portal, the dealer offered for sale the sculptural elements from an arched window on the right side of the doorway, twelve capitals with columns and two bases purportedly from the apse and thirty-eight corbels from the zone of the cornice. The reconstruction of the museum makes use of eight of the latter, embedded in a row at the top of the wall above the portal (not visible on our photograph). The remaining stones are housed in several storerooms of the museum, though it was not possible to account for every item on the dealer's list.

(a) Portal. H. 16o 1 ½" (4.91 m.). Doorway: H. 8' 9", W. 4' 6" (2.67 × 1.37 m.). Figs. 115 and 116.

The portal, which an old photograph shows still *in situ* (J. Gudiol Ricart and J. A. Gaya Nuño, *Ars Hispaniae*, V, Madrid, 1948, p. 154), has a stepped, triple archivolt design. The outer and innermost of these concentric arches repose on colonnettes bearing historiated capitals. Of particular interest is the treatment of the voussoirs with its playful handling of the rather prominent molding behind which figures give the illusion of disappearing, the lower part of the body reemerging beyond the obstruction in the space of the intrados. Where the subjects require less space, two are found on adjoining faces of the same voussoir, the molding serving as the dividing line between them. The same features are found also in the closely related portal of Santa Maria at Uncastillo (F. Abbad Rios, *Catalogo monumental de España. Zaragoza*, II, Madrid, 1957, pp. 1719–20). They seem, indirectly at least, to have been inspired by western French practice. The choice of imagery is of an unbounded fancifulness and defies systematic interpretation. There are acrobats, musicians, hunters, a man holding a drinking vessel and a variety of animal and vegetal motifs. Surely the most unusual subject is a figure complaining of a toothache to a companion who brandishes an enormous pair of pincers.

The tympanum, which must have been executed by another hand, shows St. Michael struggling with a demon for possession of a diminutive soul. The figural group forms an arch over the *signum* of the Lord at the center. The composition is a somewhat awkward combination of two normally independent entities. The underlying schema is given by the motif of the Constantinian monogram customarily flanked by a pair of angels, which is extremely common in tympana of northern Spain (A. Sené, "Quelques remarques sur les tympans à chrisme en Aragon et en Navarre," *Mélanges offerts à René Crozet*, I, Poitiers, 1966, pp. 365–81). Michael's pose is largely modeled on the stance assumed by such flanking angels, and the symmetry indispensible to depictions of this kind has been maintained as best as possible. The characterization is most benign and remarkably devoid of the expected emphasis on the grotesque. The tympanum does not fit well in the available space and may not be in the place for which it was originally made, though there is no positive evidence to bear this out. It is framed by a palmette border carved in low relief which partly fills the remaining void.

In the zone of the jambs, the connection with neighboring Santa Maria is once again evident. The same type of twisted and deco-

rated colonnettes, one with a palmette ornament, another with a basket-weave design occur in both portals. The capitals and the pair of corbels sustaining the tympanum are unfortunately much damaged. Only the innermost capital on the left side is reasonably well preserved. It shows a sword-wielding personage threatening a smaller figure while a companion seeks to restrain him (Sacrifice of Isaac?). On the outermost capital on the right side, a beast rampant in foliage can be discerned. Some of the capitals in the nave of Santa Maria la Real at Sanguesa are very similar in style and may be the work of the same sculptor (C. M. Weber, "La portada de Santa Maria la Real at Sanguesa," *Principe de Viana*, 1959, pp. 139–86, pls. XXXVIII–XXXIX).

The date of this sculpture is difficult to establish with precision. The pointed arches and ribbed vaults of the church should betoken a date well along in the second half of the twelfth century for the construction. The documents indicate that the closely related work at Santa Maria in Uncastillo was apparently begun around 1135 and the church dedicated in 1155 (J. M. Duque, *Cartulario de Santa Maria de Uncastillo [Siglo XII]*, Estudios de Edad Media de la Coroña de Aragon, VII, Saragossa, 1942, pp. 647–70, summarized by J. Lacoste, "La décoration sculptée de l'église de Santa Maria de Uncastillo," *Annales du Midi*, 83, 1971, pp. 149–72). But evidence of building activity extends as late as 1174 (L.-M. de Lojendio, *Navarre romane*, Paris, 1967, p. 35. The source is unfortunately not given). The sculpture of Santa Maria and San Miguel must have been executed close in time and by the same workshop. It is, however, free of the influence of early Gothic art which manifests itself at San Martin de Uncastillo, dedicated in 1179. Here, the thinly striated garments of the four statue columns of the apostles in the apse are a distant echo of the style of the Chartres west portals (A. de Egry, "Esculturas romanicas ineditas en San Martin de Uncastillo," *Archivo español de arte*, 1963, pp. 181–87). The style practiced by the workshop also clearly antedates the sculpture of the cloister of Tudela Cathedral, apparently under construction in 1186 (De Egry, "La escultura del claustro de la catedral de Tudela," *Principe de Viana*, 1959, p. 66). The work thus would seem to fit most comfortably around the beginning of the final quarter of the twelfth century.

The capitals and corbels, carved in a rather soft sandstone, have suffered a good deal of surface erosion. The forms are generally

more gross than those of the portal, the undercutting deeper, the hand on the chisel more hesitant and flaccid. Stylistically, they seem more advanced, if of a more diluted general effect. The capitals originally crowned colonnettes at the springing of the ribs in the angles formed by the projection of the flat piers from the perimeter walls.

(b) Corner capital. Animal masks at the three corners with a kind of stringy foliage issuing from the jaws. The foliage is cut free from the basket in places. H. 10 ¼", L. 11 ⅜", W. 11" (26 × 29 × 28 cm.). Fig. 117.

(c) Corner capital. Basket weave with stepped denticulated pattern. H. 11", L. 11 ½", W. 11 ⅝" (28 × 29 × 29.5 cm.).

(d) Corner capital. Single row of Corinthianizing leaves. The abacus has a wedge-shaped block in the place of a rosette. H. 10 ⅝", L. 11 ½", W. 11 ½" (27 × 29 × 29 cm.).

(e) Corner capital. A pair of striding lions with heads joined at the corners. The place of the rosette is taken by a human head. H. 10 ¾", L. 10 ½", W. 10 ½" (27 × 26.5 × 26.5 cm.).

(f) Corner capital. Very similar to the above, though the feline beasts have joined human heads. H. 10 ⅝", L. 10 ¾", W. 11" (27 × 27 × 28 cm.).

(g) Corner capital. Single row of Corinthianizing leaves. Similar to No. 17d (above), though the rosette is here marked by human heads. H. 12", L. 10 ½", W. 9 ½" (30.5 × 26.5 × 24 cm.).

(h) Corner capital. A pair of large striding lions with heads joined at the corners. H. 11 ½", L. 10 ½", W. 10 ½" (27 × 26.5 × 26.5 cm.). Fig. 118.

(i) Corner capital. Quite similar to the above, though in more damaged condition. H. 11 ½", L. 10 ½", W. 10 ½" (29 × 26.5 × 26.5 cm.).

(j) Corbel. Acrobat doubled back, holding his legs at the shins. L. 20 ¾", W. 7 ½", H. 13 ½" (52.5 × 19 × 34 cm.).

(k) Corbel. Figure struggling with a lion. L. 22 ½", W. 7 ⅝", H. 13 ½" (57 × 19.5 × 34.5 cm.). Fig. 119.

(l) Corbel. Half-length figure wearing a shepherd's cape and playing a musical instrument. L. 23 ½", W. 7 ¾", H. 14" (60 × 19.5 × 35.5 cm.).

(m) Corbel. Man playing a harp. L. 23 ½", W. 7", H. 15" (60 × 18 × 38 cm.).

(n) Corbel. Crowned (?) harpist. David (?). L. 22", W. 7 ¾", H. 15 ⅝", (56 × 19.5 × 39.5 cm.).

(o) Corbel. A ram. L. 23", W. 7 ½", H. 13 ¾" (58 × 19 × 35 cm.).

(p) Corbel. Canine mask devouring stylized foliage. L. 33", W. 13 ¾", H. 7 ¾" (84 × 35 × 19.5 cm.).

Bibliography

A. K. Porter, *Spanish Romanesque Sculpture*, I, Florence, 1928, p. 72. E. J. Hipkiss, "A Romanesque Doorway," *Bulletin of the Boston Museum of Fine Arts*, XXVIII, October 1930, pp. 78–82; E. B. Arbunies, "El arte en la villa de Uncastillo," *Boletin del Museo Provincial de Bellas Artes de Zaragoza y de la Real Academia de Nobles y Bellas Artes de San Luis*, 1942, Secunda Epoca, pp. 53–72, No. 2; J. Gudiol Ricart and J. A. Gaya Nuño, *Ars Hispaniae*, V, Madrid, 1948, p. 154; F. Abbad Rios, *El romanico en Cinco Villas*, Saragossa, 1954, p. 64; Abbad Rios, *Las iglesias de Santa Maria y San Miguel de Uncastillo* (Cuadernos de Arte Aragones, 11), Saragossa, 1955; Abbad Rios, *Zaragoza* (Catalogo Monumental de España), I, Madrid, 1957, pp. 722–23; J. A. Gaya Nuño, *La arquitectura española en sus monumentos desaparecidos*, Madrid, 1961, pp. 153, 155; R. Crozet, "Recherches sur la sculpture romane en Navarre et en Aragon," *Cahiers de civilisation médiévale*, 1962f., passim; J. Lacoste, "La décoration sculptée de l'église de Santa Maria de Uncastillo (Aragon)," *Annales du midi*, 83, 1971, p. 66ff.

XII

The William Hayes Fogg Art Museum

CAMBRIDGE, MASS.

1. THIRTEEN CAPITALS. Moûtiers-Saint-Jean.
Limestone. Ca. 1125.
Given by the Friends of the Fogg Museum.

Three narrative and nine foliate capitals from Moûtiers-Saint-Jean, the oldest Benedictine abbey in Burgundy, were acquired by A. Kingsley Porter from the dealer Demotte in 1922. Another foliate capital and a waterspout, found in Avallon by Paul Sachs, were added to the collection three years later. The thirteen capitals, permanently installed in a lofty hall in the museum, constitute one of the most imposing ensembles of Romanesque carving that exists outside of France.

Little remains of the monastery founded by the fifth-century cenobite John and dedicated to the Virgin Mary. An eleventh-century copy of a charter supposedly granted by Clovis exists nearby in the library at Semur-en-Auxois (published in E. Pérard, *Recueil de plusieurs pièces curieuses servant à l'histoire de Bourgogne*, Paris, 1664, pp. 1–2). Under a twelfth-century abbot, Bernard II (1109–33), the holdings of the monastery were greatly expanded and the abbey, which lay near a stream called the Réome, was restored ("Bernardus reomaensem ecclesiam renovavit a fundamentis." P. Roverius, *Reomaus, seu historia monasterii S. Ioannis Reomaensis in tractur lingonensi*, Paris, 1637, p. 190). An engraving of 1689 shows a typical monastic conglomeration, dominated by a church of the Latin Cross type with a rounded apse and crossing tower (L.

120

Courajod, *Le Monasticon Gallicanum,* Paris, 1869, pl. 41). In the view, the seven bays in the nave and the three bays to the east of the slightly projecting transept are each pierced by three clerestory windows; a single window lights the lower aisle wall. The arrangement shown corresponds to that employed at Cluny and copied at Paray-le-Monial before the collapse of the former's nave vault in 1125. In contrast, a modified system, in which single sources of light punctuate the high walls of a somber nave, was used shortly thereafter at Autun in possible reaction to the recent disaster at Cluny (Grivot–Zarnecki, *Gislebertus,* p. 163). By 1636, when Moûtiers was joined to the Congregation of Saint-Maur, the church was already dilapidated. U. Plancher observed that only the nave and portal of the church still existed (*Histoire générale et particulière de Bourgogne,* I, Dijon, 1739, p. 516), suggesting that the east end may already have been pulled down. In 1797, the abbey was bought for use as a quarry over the protests of the townspeople who, as early as 1791, had petitioned the departmental authorities not to sell the church. Whatever remains of the abbey is presently occupied by a farmer (A. Vittenet, *L'abbaye de Moûtiers-Saint-Jean; Essai historique,* Mâcon, 1938; W. R. Taylor, "The History of Moûtiers-Saint-Jean" [1939], typescript, Fogg Art Museum Library).

Several capitals, in addition to those in the Fogg, have survived the destruction of the church and exist in France. A delightful one in the Louvre displays three vintners busily at work cutting, carrying, stomping, and pouring; a second less celebrated capital in Paris has large medallions containing a fantastic animal or a rosette on each of its three faces (Aubert-Beaulieu, *Description raisonnée,* I, p. 37ff., Nos. 25 and 26). Sculptures still in the environs of Moûtiers have been mentioned briefly in the literature (J. Masson-Baylé, "La sculpture romane en Côte-d'Or," *Positions des thèses des élèves de l'Ecole du Louvre,* 1944–1952, II, Paris, 1956, p. 119). Photographs of several capitals in the region were sent to the Fogg in 1969 by Yves Peyre of the Geological Laboratory, Institut National Agronomique; Paris (Fogg Archives). Neil Stratford generously made available his own photos of these and other works together with his notes on their dimensions and exact locations. A diminutive capital with a symmetrical arrangement of leaves, in the collection of the present tenant on the site of the abbey, and two others, one with busts of angels and another showing a lamb against

foliage (both in the collection of General Altemeyer at Bard-les-Époisses a few kilometers away), are distinguished from the series of nave capitals in the Fogg and the Louvre by their size and style. Five foliate capitals in the vicinity of the abbey are close in design and identical in size to those in the Fogg and are discussed along with them below. Two fragments of capitals, one with architectural elements and one with foliage, have recently been discovered in the park of the château at Bard-les-Époisses, where the vintage capital in the Louvre had also been found (*Mémoires de la Commission des Antiquités du Département de la Côte-d'Or*, XXVI, 1963–1969, pp. 121–23, figs. 23 and 23bis).

Among the pieces in American collections, only a fragment with a half-length figure of an angel in the Cloisters, New York, has been convincingly linked to the Moûtiers sculptures. Similarities in the handling of drapery and facial type were discussed by Scher (*Renaissance*, p. 35) and related by him to work at the Cluny portal. Although the broken face of a small capital at Williams College, on which addorsing birds peck at grapes, is similar in composition to the diminutive leaf capital still at Moûtiers mentioned above, the carving lacks the vitality and variety found in sculptures known to have come from the abbey (see above, Lawrence Art Museum, No. 3). The attribution to Moûtiers of two isolated broken figures in private collections cannot be accepted despite the fact that drapery conventions corresponding to those found on the figures of Elizabeth and her companion on the Fogg Zachariah capital reappear on the figures. Questions concerning the original function of both fragments need to be clarified (*Alumni Treasures; Phillips Academy,* Andover, 1967, p. 99, No. 337; *Judaica and Medieval and Renaissance Art; Collection of Dr. S. Zalman Yovely,* Sale Catalogue, Parke-Bernet, March 17, 1955, p. 50, No. 207). A fragment of a bas-relief in the Museum of Art, Carnegie Institute, Pittsburgh (No. 71.48) is said to have come from Moûtiers. Here an angel with a censer is shown acclaiming two joyous souls in a manner virtually identical to that presented by the central group on the left-hand portion of the Autun lintel. Discrepancies in style and carving distinguish the piece from the Moûtiers oeuvre (cf. Grivot-Zarnecki, *Gislebertus,* pl. A; *Rare Judaica . . . ,* Sale Catalogue, Parke-Bernet, February 24, 1956, p. 96, No. 444). Details of the lion-shaped Sachs waterspout acquired for the Fogg (1925.9.2) recall in a subtle way the arrangement of elements on foliate capitals from Moûtiers. But the coy

pose of the whimsical beast as well as questions about its function cast doubt on the plausibility of the spindly limbed animated gutter (see below, Chap. XIII, p. 217).

Twenty-two capitals, each of which is about two feet tall, can be attributed to the church at Moûtiers. All are carved in limestone and are well preserved despite the effects of exposure revealed in occasional surface abrasion and the appearance of lichen. Fifteen capitals belonged to engaged columns while seven came from pilasters (five of these are in the Fogg, two are still at Moûtiers). This division suggests an architectural arrangement similar to that found at Paray-le-Monial in which pilasters were addorsed to piers on the nave side while engaged columns were used on the remaining three sides (M. Aubert et al., *L'art roman en France,* Paris, 1961, p. 342). The distribution of subject matter among the carvings may have a bearing on this hypothesis: column capitals are decorated with varied vegetal ornamentation and with the narrative scenes of the vintage and Zachariah; pilaster capitals carry repetitive Corinthian-derived designs in addition to the commanding didactic representations of *Cain and Abel* and the *Journey to Emmaus.* In the north side of the choir at Autun, a similar *Emmaus* carving is prominently placed along with three sober Corinthian capitals reminiscent of the pilaster decoration from Moûtiers (Grivot-Zarnecki, *Gislebertus,* plan VI and pls. 2, 58, 62, and 63). The relationship between these carvings indicates that all the surviving pilaster reliefs from Moûtiers may have come from the east end of the church (cf. La Charité-sur-Loire, Photo Marburg 170560), though this should not be taken to contradict my earlier observations concerning the variety of supports in the nave.

A "Moûtiers master" was identified by Zarnecki as an assistant to Gislebertus at Autun. Two reasons were given for the attribution to him of the adjacent, undistinguished capitals in the nave of Saint-Lazare representing Samson and the *Washing of the Feet* (Grivot-Zarnecki, *Gislebertus,* pls. 29 and 31 and p. 75). Zarnecki's observation that foliate elements appearing in the background of the *Washing* scene are similar to forms on one of the Fogg capitals acknowledges only that some standard features of composite capitals, ultimately attributable to Cluny, are unimaginatively used in both carvings. The cramped effect of this Autun sculpture contrasts dramatically with the bold conception and sparse execution of the surviving Moûtiers capitals. The second decisive factor in Zar-

necki's identification of hands was the similarity between the Autun and Moûtiers representations of the *Journey to Emmaus* (ibid., pp. 65–66 and pls. B1 and B2). Indeed, in this instance, the dependence of Moûtiers on Autun for the compositional scheme seems likely. Awkward aspects of the Fogg capital, such as the overlapping of the figures, their stiff postures, discrepancies in size and illogical or contradictory drapery systems, can best be understood as consequences of a naive attempt to adapt a composition from a cylindrical drum to a flat surface. But the treatment of the forms and the interpretation of narrative betray a thoroughly different mentality. The Moûtiers figures are palpable, their heads large, their postures vigorous and stable, and their anatomy emphatic. It is not difficult to identify the event depicted because of the emphasis on mundane aspects of the narrative and the sequential manner in which the forms are arranged. In contrast, the Autun figures are attenuated, linear abstractions that interact ecstatically in ambiguous, ornamental surroundings. Even though divergent styles are exhibited by other sculptures from Moûtiers (e.g., *Cain and Abel*), the use of volumetric, organic forms, literally described, distinguishes all extant work from that church.

Sources for both the foliate and the figurative motifs used at Moûtiers can be found either among the sculptures still *in situ* in the transept at Cluny or amid the debris unearthed by J. K. Conant and preserved in the Musée Ochier. Simple robust designs with large, flat, vertical leaves and pendant fruit, thick trunks with branches linked by entwined flowering stems, detailed arrangements of overlapping leaves, stalks, and volutes, all these types abound in Cluniac work (Conant, "Mediaeval Academy Excavations at Cluny, III," *Speculum*, IV, 1929, pls. IV, C115; VI, C137, C141; V, C133; III, C107; I and II). In addition, peculiarities observed at Moûtiers, such as the appearance of masks at the source of a foliate spray or the application of isolated enframed fleurons against the leafy drum of a capital, exist on sculptures from Cluny (Conant, *Cluny: Les églises et la maison du chef d'ordre*, Mâcon, 1968, fig. 224). Most striking of all, the heart-shaped units of leaf and thistle found on the beautiful Moûtiers "arum" capital (No. 1e), juxtaposed by Zarnecki with an elegant attenuated one from Autun (*Gislebertus*, pl. B7 and B8), reappear in an identical arrangement and with comparable élan on a fragment found by Conant at a house near the railroad station in Cluny and now in a private col-

lection at La-Roche-Vineuse (*Cluny,* fig. 183 and conversation, March 1972).

Comparable evidence for the figural work is equally persuasive of Cluniac contacts. Although Pierre Quarré correctly differentiated the style of the Moûtiers capitals with *Cain and Abel* and the *Winemakers* from that showing the *Emmaus* scene, it was unnecessary for him to seek equivalents for the former in Languedoc ("Les apports languedociens et rhodaniens dans la sculpture romane de Bourgogne," *Bulletin du Centre international d'Études romanes,* 1965, p. 37 and note 9bis). As he remarked in a note, Cluny, especially the tympanum sculpture, provides ample instances of thickly banded drapery combined with interest in anatomical structure (cf. Conant, *Cluny,* fig. 203).

According to Zarnecki's reconstruction, Gislebertus was trained at Cluny and at Vézelay before arriving at Autun ca. 1125. By 1131 or 1132, Zarnecki hypothesizes, work on Saint-Lazare could have progressed as far as the fourth pier in the nave and at this point, Gislebertus' assistant, the sculptor of the *Samson* and *Washing of the Feet* capitals located there, could have left to work at Moûtiers (*Gislebertus,* pp. 166–78). But the single compelling link between Autun and Moûtiers, the *Emmaus* carving, lies further to the east. It could have been put in place soon after work was begun in the apse of Autun early in the 1120s. This observation, in addition to the striking connections that link Moûtiers to Cluny, indicates a probable date in the mid-1120s for the restoration of the abbey church at Moûtiers and the commencement of the sculptural decoration.

Bibliography

P. Roverius, *Reomaus, seu historia monasterii S. Joannis Reomaensis in tractu lingonensi,* Paris, 1637; *Gallia Christiana,* IV, Paris, 1728, pp. 658-68; U. Plancher, *Histoire générale et particulière de Bourgogne,* I, Dijon, 1739, pp. 516-18; L. Courajod, *Le Monasticon Gallicanum,* Paris, 1869, pl. 41; E. de Lanneau, "L'abbaye de Moutiers-Saint-Jean," *Bulletin de la Société des Sciences historiques et naturelles de Semur,* VI-VII, 1869-70, pp. 66-72; A. K. Porter, "Romanesque Capitals," *Fogg Art Museum Notes,* No. 2, 1922, pp. 22-30; Porter, *Pilgrimage Roads,* I, p. 114ff., and II, pl. 62–66; *International Studio,* October 1922, pp. 37–38; M. Aubert, "Un chapiteau roman de Moutiers-Saint-Jean au Musée du Louvre," *Monuments Piot,* XXX, 1929, pp. 141–50; A. Vittenet, *L'ab-*

baye de Moutiers-Saint-Jean. Essai historique, Mâcon, 1938; W. R. Tyler, The History of Moutiers-Saint-Jean, 1939 (typescript), Fogg Museum Library; Aubert-Beaulieu, Description raisonnée, p. 37ff., Nos. 24–26. J. Masson-Baylé, "La sculpture romane en Côte-d'Or," Positions des Thèses des élèves de l'Ecole du Louvre, 1944–52, II, Paris, 1956, pp. 117–21; Mémoires de la Commission des Antiquités de la Côte-d'Or, XXIV, 1954–58, p. 45; Grivot-Zarnecki, Gislebertus, passim; Annales de Bourgogne, XXV, 1963, p. 257; P. Quarré, "Les apports languedociens et rhodaniens dans la sculpture romane de Bourgogne," Bulletin du Centre international d'études romanes, 1965; N. Müller-Dietrich, Die romanische Skulptur in Lothringen, Berlin, 1968, pp. 137–38 and 493; Scher, Renaissance, p. 35; Mémoires de la Commission des antiquités du Département de la Côte-d'Or, XXVI, 1963–69, pp. 121–23.

(a) CAPITAL FROM AN ENGAGED COLUMN. The Annunciation to Zachariah in the Temple: Elizabeth and John (?).
H. 25", W. (top) 24 ½", Diam. 23" (top; carved portion 14")
(63.5 × 62.2 × 58.4 [35.6] cm.).
No. 1922.19. Figs. 120 and 121.

A tripartite architectural structure, the equivalent of a "bay," encompasses the narrative and eases the transitions between sides and levels on this bell-shaped capital. On the main face, an angel, wings overlapping a billeted archivolt, stands immobile before the figure of a long-haired, bearded man originally shown swinging a censer over an altar. On the left, beneath a similar archivolt, an awkward and aged woman converses with a youthful male dressed in a tunic and cape. A crenelated tower, with a diminutive bell-ringer standing in an arched opening, accents the right angle and is extended around the side by a representation of the exterior of two bays of a lower structure; a hooded workman and a demon are seen above.

The subject of the main representation is based on Luke I:8–20, Gabriel's Annunciation to Zachariah in the Temple that his wife Elizabeth will bear a son. The figures on the left, identified by A. K. Porter as Elizabeth "accompanied by a handmaiden or possibly a youth" ("Romanesque Capitals," p. 27), may represent Elizabeth and the young John, perhaps in hiding, an event described in the Protoevangelium of St. James, XXII:3 (M. R. James, The Apocryphal New Testament, rev., Oxford, 1953, p. 48; cf. the discussion by A. Heimann, "The Capital Frieze and Pilasters of the Portail Royal at

Chartres," *Journal of the Warburg and Courtauld Institutes*, XXI, 1968, p. 81).

The architectural frame resembles that employed at Autun on the St. Peter capital (*Gislebertus*, pl. 33a) although no comparable sense of figural movement is achieved here. At each level the Moûtiers sculptor's approach to the problem of space seems to change: jeweled edges and folds bring the draperies together on the surface of the drum while the position of the feet and the three-quarter pose of the shoulders thrust the extremities of the figures deep within the structure. The fully modeled winsome heads contrast with the linear bodies and leap out beyond the frame. An inquisitive air, created by pointed chins, puckered mouths, and staring eyes, recalls the expressions on two figured capitals in the small nave of the church at La Rochepot near Beaune (*Gislebertus*, fig. D4, Balaam; an Annunciation is carved on a second capital).

Despite shortcomings in the handling of the figures, accurate descriptions of texture and occupation provide the carving with strong and original appeal. The characterization of ball-fringe on the altar cloth, geometric design on a prayer shawl, imbrications in the masonry, recessed frames around windows, and the volumetric ornamentation of the two arches provide exceptional and rich visual delight. Observation of architectural detail in Burgundy is exact; the ornamentation of arches simulates that visible on the north transept at Paray (H. Focillon, *Art of the West, I: Romanesque*, London, 1963, pl. 132). Identical decoration is known to have existed at Cluny (cf. the decoration of a choir screen, Conant, *Cluny*, fig. 184) and may have been present at Moûtiers as well. Corinthian pilasters and triple lights in the upper story were also characteristics of Moûtiers' own plan. The cowled workman with a beaded collar shown tiling the roof, his hammer suspended above him, recalls contemporary Cistercian representations of laborers (e.g., illustrations for St. Gregory's *Moralia in Job*, Dijon, Bibl. Mun. 170, fol. 75, cutting wheat; Dijon, Bibl. Mun. 173, fol. 41, cutting down a tree). The whimsical relation of the diminutive bell-ringer, with carefully twisted rope and handle, to the demon, seen pulling his own hair at the top of the tower, emphasizes the anecdotal character of the carvings from Moûtiers (cf. also the manuscript illumination in which the hanging of Haman is shown, Bible of Stephen Harding, Dijon, Bibl. Mun. 14, fol. 122v). The sequence of occupations portrayed on this Fogg sculpture is reminiscent of that seen on the

wine-makers capital in the Louvre although the execution of the Paris work is closer to the work on the Fogg *Cain and Abel* carving.

Bibliography

Porter, "Romanesque Capitals," figs. 1, 2, 3; Porter, *Pilgrimage Roads,* II, pls. 62, 63, 64; Scher, *Renaissance,* p. 35, fig. 4a.

(b) CAPITAL FROM A PILASTER. Sacrifice of Cain and Abel, Inscribed ABEL CUM PRIMICIIS and CAIN CUM LOLIO.

H. 26", W. 25" (top; 17 ½" bottom), D. 23" (19" carved at top, 5 ½" carved at bottom) (66 × 63.5 [44.5] × 58.4 [45.7, 14] cm.). No. 1922.18. Fig. 122.

The most celebrated of the Fogg capitals is the one on which the scene of the Sacrifice of Cain and Abel is ceremoniously presented. The moralizing content of this popular theme, which appeared elsewhere in Burgundy during the same period on distinctly narrative capitals at Vézelay, at Chalon-sur-Saône and at Neuilly-en-Donjon, is emphasized by the inscriptions at the front angles of the abacus and by the symbolic elements placed on the sides behind the protagonists. Beardless, benign Abel genuflects at the left, protecting his uplifted offering with veiled hands. To the right, the bearded profile of a solemn Cain extends, on bent arms, his neatly bound wheat amidst which weeds are carefully distinguished. Above, on the abacus, the mighty hand of God the Father emerges from an undulant cloud pattern; below, a provocative two-headed eagle, overshadowed by the offerings, functions as an altar for the gifts.

Heaven and the two brothers, the dominant elements in the event recounted in Gen. IV:3–6, thus form the top and side frames of the inverted trapezoidal face of the capital. The offerings they present animate the rusticated space of the inner field. The only losses on this side are an edge of the drapery with which Abel cloaks the lamb and three fingertips of the great hand; around on the right, more extensive damage has destroyed the upper torso of the figure shown riding a leonine serpent. The refined, detailed

workmanship of the sculpture is, apart from these areas, remarkably well preserved.

A close dependence on Cluniac figurative sculpture is obvious. The compact, neat head of Abel, the palpable, logical anatomy of both figures, as well as the predilection for form-enhancing draperies with horizontal banding and prominent trim at the neck are all reminiscent of fragments excavated by Conant and attributed to the tympanum (*Cluny*, figs. 192 and 203). Characteristic transformations have occurred: the smooth, graded planes, crisp incisions, and regular shadows of the Cluny carvings are replaced by a variety of robust, irregular forms and a plethora of textural details.

The exceptionally tight orchestration of form and content heightens the expressive and didactic value of this Moûtiers sculpture. Cain's kneeling position is immobilized through its identity with the contour of the capital. Above, the tightly organized inscription, Cain with his tares, abuts his head and is itself impinged upon by the aggressive adjacent cloud pattern. The truncated form of the offering and its abrupt position near the hand lock Cain at the angle and cut him off from the other elements. In contrast to Cain's earthbound exclusion, Abel is weightless, buoyed in space through intense concentration on the mighty hand. His ornamental halo and drapery add to his prominence and emphasize his detachment from the ground. The longer inscription that accompanies him, Abel with his firstlings, is inscribed in ample space and is raised overhead like a triumphant banner.

The inscriptions depart from Genesis and present an explanation of the story that is derived from Hebrew and Christian commentary. Whereas Abel was described in the Bible as having selected the fatted sheep of his flock, Cain, it was said, chose only of the fruit of the ground. Jewish writers attributed the rejection of his offering to a reluctant manner and inferior selection (see L. Ginzberg, *The Legends of the Jews,* I, Philadelphia, 1909, pp. 107–108). The weeds present in his sheaf and explicitly cited in the inscription above the carving may refer to the weeds said to have grown amid the good seed in the Parable of the Tares (Matt. XIII:24–42). A tradition begun by Irenaeus in the second century and continued by Prudentius in the fifth equated sinners and heretics with weeds. Following arguments put forth by P. Braude, Cain represented to the Middle Ages the heretic and the Jew as well as the delinquent Christian ("Cokkel in oure Clene Corn," *Gesta,* VII,

1968, pp. 15–28). The comment by the great twelfth-century church-man Peter the Venerable that "the church of God . . . , by the zealous hands of her husbandmen, roots out the brambles and thorns which are detrimental to the Lord's sowing" (from his Tract against Saracens, cited by J. Kritzeck, *Peter the Venerable and Islam,* Princeton, 1964, p. 38) provides contemporary textual support for the interpretation of the forms in the sculpture.

Early Christian commentators saw the story of the brothers primarily as a confrontation of types: Abel, as the first martyr, was seen as an antetype of Christ; Cain was understood as a disciple of the Devil (discussed in P.-H. Michel, "L'iconographie de Cain et Abel," *Cahiers de civilisation médiévale,* I, 1958, p. 194ff.; see also L. Réau, *Iconographie de l'art chrétien,* II/i, pl. 5 and pp. 94–95). The objects carved on the sides of the capital behind the brothers' backs emphasize these natures. The fragmentary figure overcoming the fictitious, scaly bellied beast is analagous to contemporary represen-tations of Samson or David fighting a lion and, like them, probably signifies the triumph over evil (a lion was juxtaposed behind Cain on a contemporary capital from southwestern France exhibited at the Cloisters in 1968; C. Gómez-Moreno, *Medieval Art from Private Collections,* New York, 1968, No. 24). The heavily laden tree behind Abel possibly represents the Tree of Life that grew in Paradise. A tree with similar fruit forms the background against which the brothers make their offerings on the capital at Chalon-sur-Saône (Photo Marburg LA778/10); a more schematic tree stands behind Abel with his offering on the bronze doors at San Zeno in Verona (Braude, "Cokkel," fig. 3). The Tree of Life was an important ele-ment in Jewish Art throughout the Middle Ages where it was often shown accompanied by two birds (Z. Ameisenowa, "The Tree of Life in Jewish Iconography," *Journal of the Warburg Institute,* II, 1938–39, pp. 329–42). Although no birds perch in the tree behind Abel on the Moûtiers capital, the two-headed eagle on the front face, itself a motif common in Near Eastern textiles (D. Jalabert, "De l'art oriental antique à l'art roman," *Bull. mon.,* 194, 1938, pp. 173–76), might be linked with the vegetal form. A chain of bicephalous eagles decorates an abacus in the cloister at Moissac; the capital below is adorned with pairs of birds entwined in flow-ering trees, an ornamental variant on the Jewish theme (Photo James Austin QV 8). The juxtaposition of the motifs on the Moissac sculpture suggests that they are thematically related. In at least two

other instances, the double-headed bird is associated with the punishment of sin. At Vouvant, the winged creature is located just above a representation of the Temptation in the main archivolt on the north portal (Photo Marburg 42710 and 42704). The bird, both heads drinking from chalices, accompanies a representation of St. Michael overcoming the demon in a late eleventh-century manuscript at Mont-Saint-Michel (Avranches, Bibl. Mun. 50, fol. 1; *Art de Basse-Normandie*, No. 40, p. 41). The heraldic two-headed bird at Moûtiers thus sustains the theme of the triumph over evil in contrast to the demonic tricephalous creatures actively pursued on contemporary Burgundian capitals at Vézelay, Perrecy-les-Forges, Autun, and originally at Cluny (Grivot-Zarnecki, *Gislebertus*, pls. B12, 14, 15, and 16). On a capital at Chalon-sur-Saône, a heavy, ornamental collar unites the necks of two eagles whose beaks peck at the crowned heads of a man and woman, perhaps as punishment (Photo Marburg LA 779/8).

The position of the bird on the Moûtiers carving suggests that it serves as an altar as well. The location is analagous to that occupied by a bifurcated slender sprout that rises between Cain and Abel on the capital of their Sacrifice at Vézelay (Salet-Adhémar, *Vézelay*, pl. 28, No. 94). Both elements may relate to the transformation of the setting of the story noted by Michel to have occurred early in the twelfth century. A presentation capital at Autun, which resembles in composition the Moûtiers Cain and Abel work, also includes a foliate sprout placed between two figures offering a church (Grivot-Zarnecki, *Gislebertus*, pls. 13a and B9; cf. also the ivory carving of Cain and Abel in the Walters Art Gallery No. 71.289, illustration in *Arts of the Middle Ages*, Boston, 1940, pl. XXIII, No. 127).

Bibliography

Porter, "Romanesque Capitals," figs. 6, 16; Porter, *Pilgrimage Roads*, II, pl. 66.

(c) CAPITAL FROM A PILASTER. The Journey to Emmaus.

H. 24", W. 24 ½", D. 23" (14" carved at top; 6 ½" bottom)
(61 × 62.2 × 58.4 [35.6, 16.5] cm.).
No. 1922.17. Fig. 123.

The presence of staffs identifies the three main figures as pilgrims; since one of them wears a cruciform nimbus and has his hand raised in salutation, it seems likely that the subject is Christ meeting two disciples on the way to Emmaus (Luke XXIV:13–28). On the left side, an angel is seen hovering above foliage; on the right, a figure with a horn leans out of a window in an inhabited, locked architectural structure that ornaments the adjacent side.

Grivot and Zarnecki used this sculpture to confirm the identification of the representation on the similar capital in the choir at Autun (Grivot-Zarnecki, *Gislebertus,* p. 65). In fact, that work probably served as the inspiration for this one: the curious sizes of the figures, inclined postures, and excited draperies, all awkward aspects of the Fogg carving, are probably the result of the transference of the Autun figures from a convex surface where they were propped by "air cushions" to a planar one where they are located on a common ground line. Other discrepancies in style, more prominent on this sculpture than on any of the others from Moûtiers, may also relate to the use of a powerful model. The lower parts of both tall figures are too meager for their large heads and broad upper parts; the draperies vacillate between the roles of form defining, as in the draperies around Christ's legs, and ornamental, as in the confusing cape on the tall disciple which thoroughly conceals the anatomy beneath.

Numerous similarities to sculpture from Cluny indicate that the capital at Autun was but a secondary model for the Moûtiers master. The three-quarter pose and apron folds on the short disciple and Christ derive from those on the figure of God the Father on the Adam and Eve capital (Conant, *Cluny,* fig. 159). The rolled edges of hair, drilled eyes, and broad, sharp-edged facial planes recall the organization of the head of an angel thought to have come from the tympanum at Cluny (ibid., fig. 193); beaded, ornamental collars, heavily banded bodices, as well as the close-cropped beard reappear on another tympanum fragment (ibid., fig. 206). Even the foliage beneath the angel, with its long fronds and furled tip, seems to be directly inspired by work at the mother abbey (cf. Fogg No. 1922.16). The diminutive architecture to the right with its bead-

ed archivolt, prominent cornice, fluted pilasters, and Corinthian capitals duplicates forms on the surviving tower at Cluny; heads that peer out from this structure recall those that peek down at the shoemaker on the well-known *enseigne* in the Musée Ochier (ibid., fig. 94, and Photo Marburg 35757; see M. Schapiro's comments on such sculptural marginalia, "From Mozarabic to Romanesque in Silos," *Art Bulletin*, XXI, 1939, p. 341).

The obvious influence of two other workshops notwithstanding, several distinct Moûtiers characteristics are apparent. The concern with capital contour as an explicit frame for the sculptural field, the emphasis on ornamental, salient, globular forms, such as heads, as the organizers of the design, the differentiation between figure and ground and the fascination with accumulated, assertive details are all used on the figurative sculptures at Moûtiers in service of the art of storytelling; these characteristics appear as well on the foliate carvings discussed below.

Otto Pächt analyzed the interest manifested during the second quarter of the twelfth century in representing rationalized sequences of time; he linked this phenomenon to contemporary developments in religious drama (*The Rise of Pictorial Narrative in Twelfth Century England*, Oxford, 1962). The Emmaus story, which was the subject of a Mystery Play, the *Peregrinus*, owed its popularity to its celebration of both devotional pilgrimage and liturgical feast. The two events were frequently depicted in the art of the twelfth century (Réau, *Iconographie*, II/ii, pp. 562–65). The curious double staff Christ carries appears again in the hands of one of the figures on the capital frieze at Chartres; the figure is identified by it as a pilgrim (Heimann, "The Capital Frieze," p. 86). The close-fitting hat worn by the lower figure in the architecture on the right of the Fogg capital is identical to the vertically striped hat worn by the pilgrim from Santiago on the Autun lintel (Grivot-Zarnecki, *Gislebertus*, pl. Q); the hat contrasts with the beaded hats worn by the neighboring lintel pilgrim to the Holy Land and by the shorter disciple on the Autun Emmaus capital (ibid., pl. 2a).

Bibliography

Porter, "Romanesque Capitals," figs. 4, 5, 15; Porter, *Pilgrimage Roads*, II, pl. 65; J. Pijoan, *Summa Artis*, IX, Madrid, 1944, p. 222.

(d) CAPITAL FROM AN ENGAGED COLUMN.
H. 25 ½", W. 24", D. 19" (14" carved at top) (64.8 × 61 × 48.3 [35.6] cm.).
No. 1922.26. Fig. 124.

The acanthus decoration on this tall Corinthian work recalls that on the large capital from an engaged column in the transept at Cluny (Conant, "Excavations at Cluny, III," pl. I, C111). In the Moûtiers version, the stalks have been eliminated and the upper row of leaves has been retracted under the helices and volutes. The leaves themselves are divided by vigorous modeling into a system of palpable ridges and furrows; their furled ends have been elaborated into tonguelike forms. Although occasional drill holes, short double grooves at the base of diverging leaf shoots (techniques employed also at Cluny), and long linear incisions along selected petals bring surface relief to the deeply carved forms, the rich staccato pattern of angular darks that enlivens the Cluny sculpture is noticeably lacking. The isolation and enframement of a fleuron at the bottom of the main axis just above the damaged base recurs on the Cluny transept capital mentioned above.

Bibliography

Porter, "Romanesque Capitals," fig. 11.

(e) CAPITAL FROM A PILASTER.
H. 23", W. 24 ½", D. 25" (17" carved at top) (58.4 × 62.2 × 63.5 [43.2] cm.).
No. 1922.16. Fig. 125.

Rectangular leaves with furled tips are staggered in two rows beneath a salient, elevated arrangement of stalks, helices, and volutes. Along the central axis at the top, a large rosette awkwardly masks the transition between the artificially convoluted collar of the drum and the deeply recessed ornamented abacus. The capital demonstrates the difficulty of adjusting a design conceived for a circular surface to a planar one and the consequent loss of rhythm and vitality. The conservative acanthus ornamentation recalls that

on the engaged capital in the transept at Cluny discussed above. The individual elements on the Fogg piece are isolated and flattened out, the leaves reduced by grooves to a collection of rectangular elements. These latter forms resemble those on a fragmentary capital with acanthus leaves at Vézelay (Photo Marburg 53432); both derive from more coherent and abstract foliage forms such as those on a fragment of a pilaster capital from Cluny unearthed by Conant (unmounted Conant photo, Fogg collection No. 333 [?]). The tightly curled detached ends of the leaves under the volutes correspond closely to the tonguelike protrusions mentioned on the previous Moûtiers capital (No. 1d); both are similar to the ornamental buds suspended from the tips of the leaves on the Cluny fragment and the Vézelay sculpture. Two flatter pilaster capitals from the north side of the crossing at Autun with comparable Corinthian decoration can also be compared to this sculpture (Grivot-Zarnecki, *Gislebertus*, pls. 62–63).

Bibliography

Porter, "Romanesque Capitals," fig. 13.

(f) CAPITAL FROM AN ENGAGED COLUMN.
H. 25", W. 25", D. 23" (14" carved at top) (63.5 × 63.5 × 58.4 [35.6] cm.).
No. 1922.27. Fig. 126.

The careful arrangement of the three distinct decorative elements against the cylindrical drum emphasizes the volumetric geometry of the design. Two collared stalks, supporting slender helices and volutes, rise from central intervals between the three large leaves that form the middle zone of the capital. A collar formed around the lower third of the block by a projecting beaded band is ornamented with a row of six fleur-de-lis enclosed within arched frames (cf. the punched decoration on Fragment 522 from the ambulatory at Cluny, Conant, "Medieval Excavations at Cluny, VI," *Speculum*, VI, 1931, pl. Ib). One of the capitals Conant attributed to the cloister uses a comparable but less rigid scheme of leaves encased in tendril arches as appliqués against the acanthus-wrapped

drum (*Cluny*, fig. 224). The heaviness of the organic forms is relieved primarily by the dry, inky shadows that fill the grooves and by holes separating the tubular components of the vegetation. The liberated upper forms contrast strongly with the lower collar of crowded, shallowly cut motifs (cf. the beaded band on the angel capital at Bard-les-Époisses).

Bibliography

Porter, "Romanesque Capitals," fig. 12.

(g) CAPITAL FROM A PILASTER WITH TRACES OF POLYCHROMY.
H. 25″, W. 25″, D. 27 ½″ (15″ carved at top; 5 ¼″ carved at bottom) (63.5 × 63.5 × 70 [38.1, 13.3] cm.).
No. 1925.9.1. Formerly Collection Jean Peslier, Avallon. Fig. 127.

Neither the motifs nor the organization of this capital offers anything new to the study of the Moûtiers oeuvre. The superimposition of three registers is similar to that observed in 1e and f; the treatment of the volutes and upper angles is comparable to that of 1h. Beaded stems arch over the central motif on 1l and the theme of pine cones is repeated on 1m.

The quality of this pilaster capital is markedly inferior. The coarse foliage lacks any interior life and the pine cones seem suspended in shapeless voids. The most emphatic part of the design is the series of tear-shaped intervals above the calyx of each pine cone in the middle zone. Despite the severe damage to the lower left corner, it is clear that the upper forms on this side were never completed. Beading in the arched stem and texturing of the fruit are both missing; only the rosette receives distinctive treatment.

(h) CAPITAL FROM A PILASTER.
H. 24 ½″, W. 24 ¾″ (top; 19 ½″ bottom), 24″ (15″ carved at top; 6″ carved at bottom) (62.2 × 62.9 [49.5] × 61 [38.1, 15.2] cm.).
No. 1922.20. Fig. 128.

Heavy rectangular angles are reinforced on this capital through the union of tightly wound volutes with three large, thick, concentric leaves centered beneath them. The vast triangular shadows behind the scrolls and the drill holes at their centers provide the angles with a curiously animistic air. Four aggressively furled leaves with semicircular contours and two half-leaves regularize the base of the capital; crudely folded around the angles, they are unable to enliven the front face of the work. Attention on this side is unfocused: none of the forms is sufficiently powerful to organize the design. At the top, a multipetaled conical rosette is lodged between a bit of cylindrical drum and the ornamented involuted abacus. On the right side, a shoot emerging from the stalk fills the place of the rosette.

A pilaster capital at the château of Bard-les-Époisses is similarly dominated by heavy volutes with drilled nuclei which rise from a central collared stalk. Deep triangular pockets of shadow and the dense packing of leaves below the volutes also distinguish the well-preserved upper part of this work and relate it to the Fogg carving. A second comparable sculpture in the collection of M. Chanu on the site of the abbey employs five lacy leaves in a row along the base of a flatly carved capital. The workmanship on this latter piece especially recalls carvings at Langres and in the narthex at Autun (W. Schlink, *Zwischen Cluny und Clairvaux,* Berlin, 1970, figs. 27, 30, and 31).

Bibliography

Porter, "Romanesque Capitals," fig. 14.

(i) CAPITAL FROM AN ENGAGED COLUMN.
H. 25 ½", W. 25", D. 20 ½" (14 ½" carved at top) (64.8 × 63.5 × 52 [36.8] cm.).
No. 1922.21. Fig. 129.

(j) CAPITAL FROM AN ENGAGED COLUMN.
H. 25 ½", W. 25", D. 21 ½" (14 ½" carved at top) (64.8 × 63.5 × 54.6 [36.8] cm.).
No. 1922.23. Fig. 130.

A row of five tall flat leaves, adorned internally only by ovoid fruit at the summit of flat shaftlike veins, rises around the baskets of these capitals. From the intervals between these leaves emerge banded stalks which terminate in a single cleft fruit on the axis and additional cleft ones at the angles. Above, tiny recessed volutes are crushed under an unadorned and involuted abacus. The effect is rugged and regular with precise intervals and bold contrasts between rotund and planar, horizontal, vertical, and triangular units. The main difference between the works is that the tips of the leaves of 1i curl down ever so slightly, the crescent fruits are attached at the neck by tight bands and those on the second row rest on detached forked supports. Weathering of the surface on this piece has almost obliterated the central vertical ribs in the leaves. Similar leaf and fruit units can be found in a slightly different combination on capitals in the Cluny transept (Conant, "Excavations at Cluny, III," pl. IV, C115 and pl. V., C129), on a fragment excavated by Conant (unmounted photo 741, Fogg Collection) and on a capital recently found in the vicinity of the Cluny narthex (R. Oursel, "Nouvelles fouilles et découvertes à Cluny," *Archaeologia*, November–December 1965, p. 65, No. 7.) A capital, very much like 1i survives at the château of Bard-les-Époisses.

Bibliography

Porter, "Romanesque Capitals," fig. 8 (1j).

(k) CAPITAL FROM AN ENGAGED COLUMN.
H. 25 ½", W. 25", D. 23" (15 ½" carved at top) (64.8 × 63.5 × 58.4 [39.4] cm.). No. 1922.22. Fig. 131.

The trunk of a tree, placed at the center of the drum against a roughly worked ground, divides into two collared stems which rise toward the abacus and divide again. The upper branches and pendant fruit replace the traditional volutes and helices of the Corinthian capital. Two additional branches sprout from the middle of the trunk and cross over concealing the bifurcation. Each of these partly detached branches terminates in a leafy spray entwined at the angles with an idential shoot shown emerging from a comparable half-tree on the sides.

The massiveness of the sculpture is emphasized on close inspection by the prominence of tool marks. The foliate motifs used to knot the stems are surprisingly lyrical. The reverse heartlike curves of the upper leaves with their erect oval fruits can be seen in work at Cluny (Conant, "Excavations at Cluny, III," pl. III, C107; pl. V, C125 and C133). A more compact, seemingly squat capital still at Bard-les-Époisses utilizes the same motifs in a more abstract manner.

Bibliography

Porter, "Romanesque Capitals," fig. 7.

(1) CAPITAL FROM AN ENGAGED COLUMN.
H. 25 ½", W. 25", D. 14 ½" (64.8 × 63.5 × 36.8 cm.).
No. 1922.25. Fig. 132.

(m) CAPITAL FROM AN ENGAGED COLUMN.
H. 25½", W. 25", D. 14½" (64.8 × 63.5 × 36.8 cm.).
No. 1922.24. Fig. 133.

These two capitals are more delicately proportioned, tightly organized and crisply carved than the other foliate pieces even though they are of comparable size. Both pieces have been detached from the masonry block with which they would originally have been inset into the wall; this is also true of the five capitals still in the vicinity of Moûtiers. Both sculptures bear traces on the lateral surfaces of original polychromy.

The design of the capitals focuses on a heart-shaped motif of entwined, inverted leaves enframing an upright pine cone or thistle (D. Jalabert, *La flore sculptée des monuments du moyen-âge en France*, Paris, 1965, p. 68). On the first capital (1l), the device is centered beneath scaly arched stems on the main and side faces; the motif also appears beneath the angles in lieu of volutes, on the central block of the abacus as an organic extension of the central motif and, in a chain of five, defining a broad collar around the lower third of the drum. The unusually crisp treatment of the abacus, in which decorative motifs drawn from the vocabulary of geometric

and natural elements elaborated around the drum appear in a reg-
ularized pattern, is comparable to the scheme used on an elegant
capital from Autun (Grivot-Zarnecki, *Gislebertus,* figs. B7 and B8).
The juxtaposition of the two works points up considerable dif-
ferences between sculpture at the two churches. Whereas foliage
on the Moûtiers carving is presented as lush and energetic and the
motif is rhythmically and organically developed, the sprays on the
exquisite Saint-Lazare relief have the air of a dried aromatic
bouquet, the leaves and buds having shrunk away from their
ample frames. Subtle details on the Fogg piece such as the wavy
patterns between the fruit at the base, the undulant alternation in
the position of fruit on the upper level of the drum, and the strong
geometric reinforcement given to the articulation of the angle
foliage further distinguish this work above all the others from
Moûtiers.

The closely related fragment published by Conant (*Cluny,* fig.
183 and our introduction above) has recently been seen in a pri-
vate collection at La-Roche-Vineuse, south of Cluny. The attribu-
tion of this piece to the great Benedictine abbey has never been
doubted by Conant since fragments with strikingly similar thistle
motifs turned up during his excavations on the site of the great
portal (cf. fragment No. 1018.75, photo No. 575, unmounted Co-
nant photo in the Fogg). Although Conant identified the large frag-
ment as a piece of the conical support for the St. Michael's Chapel
above the portal (*Cluny,* p. 104 and fig. 80), the sloped surface of
the carving suggests that the piece may in fact have belonged to a
capital in that area. In addition to its greater size (about two inches
taller), a series of small details, such as banded collars at the necks
of the leaves, tubular rather than flat stems in the lower register,
and a herringbone rather than scaly pattern on the fruit in this
zone differentiate the piece at La-Roche-Vineuse from the Fogg
capital. The same characteristics can be found on other pieces from
or at Cluny—for example, a capital *in situ* in the Tour du Moulin. A
capital at Cluny sketched by Van Riesamburgh early in the
nineteenth century, with a twisted arum motif and active foliage,
also relates closely to the Fogg piece (A. Erlande-Brandenburg,
"Iconographie de Cluny III," *Bull. mon.,* 126, 1968, Catal. No. 29,
fig. 36).

On the second capital (1m), the arum motif appears on the
lower part of the main axis enclosed within beaded stems which

emerge from the mouths of grimacing, toothy masks at the sides. The shallowly carved heads are obscured by richly worked foliate sprays which also issue from their mouths, rise up toward the angles and furl back to display a diminutive fruit. The taut silhouettes of slender volutes which provide an upper frame for the main face are underscored and overlapped by the clawlike petals that issue from the leafy sprays of a central stalk. The entire surface is animated by a variety of triangular intervals which create pockets and chains of shadow.

The combination of heads with foliage is common in mature Burgundian Romanesque sculpture appearing at Autun (Grivot-Zarnecki, *Gislebertus,* pl. 59), Saulieu (Porter, *Pilgrimage Roads,* II, pl. 58), Chalon-sur-Saône (Photo Marburg LA 779/7), and Langres (Schlink, *Zwischen Cluny,* fig. 63), but the forms at these churches are all smaller, disengaged and genuinely anthropomorphic. The closest comparison to the treatment at Moûtiers occurs on sculpture from Cluny. The mouth of a masklike creature spitting foliage receives comparable emphasis on one of the plaques from houses (Photo Marburg 35779); in addition, two small capitals in the Musée Ochier carry animal heads as the source for arching foliate sprays (Photo Marburg 35755, Nos. 111 and 114). These latter sculptures may belong to the cloister at Cluny dated by Conant to the mid 1120s (*Cluny,* p. 107).

A striking, slender, well-preserved capital in the collection of M. Challan-Belleval at Moûtiers uses the arum motif encased in flat tendrils along the lower part of the drum. The upper part of the capital is devoted to an elaborate scheme of compartmentalized leaves beneath conventional volutes. The integration of the abacus block into the ornamentation of the main face is comparable to that described on the first of these two Fogg capitals. The fragment recently published by Quarré displays the sharp treatment of the tips of the leaves seen on the second work (1m; *Mémoires de la Commission des Antiquités du Département de la Côte d'Or,* XXVI, 1963–69, pp. 121–23).

Bibliography

Porter, "Romanesque Capitals," figs. 9 (1m) and 10 1l).

2. FRAGMENT OF A CAPITAL. Mâcon (?).
Limestone. Ca. 1125.
H. 8 ½", W. 10", D. 8 ½" (21.6 × 25.4 × 21.6 cm.).
No. 1949.47.94. Purchase Alpheus Hyatt Fund.
Formerly J. Brummer. Fig. 134.

Four distinct bands of ornament decorate the surviving upper part
of this engaged capital. A row of beads, juxtaposed with a register
of stylized leaves, simulates an impost. Below, a strongly articu-
lated architectural arrangement provides a heavy canopy under
which the remains of curled slender leaves evoke the lush foliation
that formerly embellished the drum. Severe penetrating cracks
have left this richly carved but battered fragment in fragile condi-
tion.

Brummer's original attribution to Cluny is supported by com-
parisons with sculptures from the abbey that display the same di-
minutive canopied configuration. One capital in the surviving
transept carries similar architectural forms at the angles although
these are poorly integrated with the foliate ornamentation below (J.
K. Conant, Photo C153, Fogg Collection). A small, complex capital
in the Musée Ochier shows lush tendrils woven through the aper-
tures on one side of the diminutive canopy at the top of the drum
(No. 113; Photo Marburg, 35755). The beading used to outline the
leaves on the remaining sides of this Cluny piece also appears on
the outer edge of a curled leaf on the Fogg sculpture. Another capi-
tal in the same photo (resting on one numbered 112) is organized
around two slender arched forms similar in texture and contour to
the fragmentary leaves on the Fogg sculpture. Occasional use of
the drill, visible on the Cluny sculptures said by Conant to have
come from Pontius' cloister (cf. Cluny, fig. 226), is also noticeable
on the Fogg fragment.

A striking comparison can be made with the canopied acanthus
leaf capital that crowns an unusual rectangular pier said to have
come from Cluny and photographed by A. Kingsley Porter at the
dealer Demotte's in 1926 (Fogg photo 275 F912 86 [By]; present
whereabouts are not known.) Only the arrangement of the com-
mon forms distinguishes the pieces: in the Demotte sculpture, the
bridge between the corner turrets is circular, the cornices above are
narrow and rectangular windows ornament the end sections of the
canopy. Fragments comparable to the Fogg carving survive in the

museum at Mâcon, remnants of a large portal to which our capital may once have belonged.

3. ARCHITECTURAL FRIEZE. Cluny or Mâcon (?).
Limestone. Second quarter of the XIIth century.
H. 9″, W. 15″ (22.9 × 38.1 cm.).
No. 1949.47.94. Purchase Alpheus Hyatt Fund.
Formerly J. Altounian, Mâcon, and J. Brummer. Fig. 135.

Representations of two arcaded structures fill the interval between the frames of a pair of broken beaded roundels and the remains of a molding on this small relief. The sculpture belongs to a series that originally included two large reliefs in the Pitcairn Collection: one panel was exhibited at the Cloisters in late 1968 (C. Gómez-Moreno, *Medieval Art from Private Collections*, New York, 1968, No. 29) while the second was exhibited at one time in Philadelphia (illustrated in *Art News*, March 21, 1931, p. 30). Unlike the former of these, which is decorated on the back with a frieze of small rosettes and a horizontal molding, the Fogg fragment has been split away from the original stone so that the miniature arcades, once screens against solid ground, are now pierced. These open parts have also sustained a series of breaks, one running through the door and continuous arcade, two others forming a wedge to the left of the central gable. Although the whole is dotted with lichen, the effects of exposure are limited, and weathering has not eroded the sharpness of the carving.

Gómez-Moreno suggested that such reliefs probably decorated the façade of houses at Cluny where they were installed above open arcades. Sculpture still *in situ* employs only rosettes to fill the bare ground in the spandrels above ornamented arcades (houses, rue Lamartine, rue de la République; cf. the house illustrated by Desjardins, "Maisons romanes de Cluny," *Bull. mon.*, XIII, 1847, pp. 539–42). The rectangular format of the piece shown at the Cloisters indicates that it was placed above a lintel, perhaps a gallery (as in the house photographed by Robert, No. III) rather than over an arcade. A large group of rectangular reliefs, decorated with foliage instead of architecture and displaying an alternation of animals and fleurons within the beaded roundels, is preserved in the Musée Ochier, Cluny (Photo Marburg 35774-35780). Fragments at

St. Vincent in Mâcon are similar to the relief in the Fogg and may be related to it.

Unusually careful observation of architectural detail is revealed in the Fogg sculpture. Coupled arcades separated by piers, as in the structure represented to the left, exist on the actual façades of the houses cited above. The inclusion of corbels and the elaborate treatment of the door are additional refinements on the Fogg fragment.

Bibliography

The Medieval Sculptor, Bowdoin College, 1971, No. 15.

4. ARCHITECTURAL FRAGMENT. Vézelay.
Limestone. First quarter of the XIIth century.
H. 10 ½", W. 13" (26.7 × 33 cm.).
No. 1949.47.88. Purchase Alpheus Hyatt Fund.
Formerly J. Brummer. Fig. 136.

A large deep circular plate contains a four-petaled rosette, the center of which is filled by a convex, floral motif. The surrounding rectangular field is hollowed out; one intact edge of the medallion projects in deep relief above the ground; the other merges with it. Although almost half of the roundel is broken away and the surface is quite dirty, the carving that remains is extremely crisp. The bold juxtaposition of identical convex and concave shapes as well as the calculated distribution of shadows create dramatic effects which, in their austerity, evoke work at Cluny. Foliate roundels are the common decoration of archivolts in Burgundy; however, the regular, rather than convex, surface of this piece suggests that it was more likely included in a frieze of medallions such as the one above the nave arcade at Vézelay (Salet–Adhémar, *Vézelay*, pl. 5). The fragment was said to have come from that site at the time of its acquisition.

5. ROSETTE FRAGMENT.
Limestone.

W. 4 ½", D. 2" (11.4 × 5 cm.).
No. 1949.47.23.
Given to Brummer by Jean Peslier, Avallon, in 1927. Fig. 136.

This fragmentary rosette is detached from the center of a voussoir
identical to that described above and is here reproduced beside it.

6. ARCHITECTURAL RELIEF. Vézelay. Cloister (?).
Limestone. Second quarter of the XIIth century.
H. 15 ½", W. 31" (composite), D. 5 ½" (39.4 × 78.7 × 14 cm.).
No. 1949.47.70. Purchase Alpheus Hyatt Fund.
Formerly Jean Peslier, Avallon, and J. Brummer. Fig. 137.

Fresh and unfinished carving in addition to traces of old mortar
along the surface suggest that this spandrel relief was broken and
then employed as building material early in its existence. In addi-
tion to the major loss, a vertical section containing the bow and
forearm of the figure to the left, several smaller losses have been
sustained at two of the extremities and along the lower left edge.
An arc of a circle, slightly larger than that of the roundel, is faintly
incised in the triangle of stone beneath the feet of the main figures.

An ingenious composition has massed a number of elements
within the shallow depression of the central field. A hatted, haloed
figure restrains a cloven-hoofed animal on the right while a hunter,
with a quiver at his waist, is depicted to the left. Beneath, a beast's
head is seen emerging from a leafy spray. The arrow the hunter
has just released lies, beyond the medallion, incised in the rough
ground to the right; the string of his bow flies free, etched in the
surface above and behind him.

The subject has been identified as St. Gilles protecting the hind
from the hunter. The animal's head would be that of the hunter's
dog. According to legend, the saint was nourished by a doe. One
day, hunters of the king pursued the animal into the cave of the
hermit wounding the latter instead of the beast with their arrow
(Acta SS., September, I, pp. 284–304). In the representation here,
the arrow has missed or passed its mark, an unusual scene.

The piece was attributed to Vézelay at the time of its acquisi-
tion. Certain technical elements, such as the color of the stone and
rustication of the uncarved surface with saw marks, are similar to

work at the great abbey church (e.g., the great tympanum, Salet–Adhémar, *Vézelay*, pls. 18–19) suggesting that the association with the structure is accurate. In addition, the partially concealed head of an apostle beneath Christ's right hand on the tympanum (Photo Marburg 33037) recalls the low-browed, thick-necked creatures in the roundel. However, supplementary comparison is difficult. The even, shallow depression on the medallion here is closest in design to that employed for the roundels on a series of rectangular reliefs in the Musée Ochier, Cluny (M. Aubert, *La Bourgogne. La sculpture*, Paris, 1930, pls. 182, 183). In particular, a roundel in which a human-headed quadruped grapples with two dogs and another in which a stag is attacked by two beasts present similarly compact, gyrating forms shown either interrupted by or passing through the circular frame (Photo Marburg 35779, 35780).

The relief was designed to fill the triangular zone above an arcade. It is impossible to say whether it was intended for use near a window on a façade or in a cloister. The arcaded plaques that survive from house façades at Cluny monotonously display flat open flowers in this area (Photo Marburg 35783); an elegant fragment, supposedly of a choir screen, is also decorated with only a modest rosette in the spandrel (Conant, *Cluny*, fig. 184). Comparable roundels with figurative decoration ornament spandrels in the cloister at Aix-en-Provence (H. A. von Stockhausen, "Die romanische Kreuzgänge der Provence," *Marburger Jahrbuch für Kunstwissenschaft*, VII, 1933, fig. 93 and VIII, 1936, fig. 183); two other roundels, from Saint-Seine-l'Abbaye, are now in the archaeological museum in Dijon. A rectangular fragment in the Louvre, with a mask inside a half-roundel, was found at Saint-Denis, supposedly on the site of the cloister (Aubert-Beaulieu, *Description raisonnée*, I, p. 56, No. 50).

Although nothing is known about the Vézelay cloister, aside from the fact that two galleries were standing in the seventeenth century, an association of this relief with that structure should be considered. Viollet-le-Duc apparently copied old fragments found in the ground for his reconstruction of the wall outside the chapterhouse (Salet–Adhémar, *Vézelay*, Melun, 1948, p. 91).

Bibliography

Medieval Sculptor, No. 14.

7. ARCHITECTURAL RELIEF. Vézelay. Cloister (?).

Limestone with traces of original polychromy. Second quarter of the
XIIth century.
H. 9½", W. 28", D. 5 ½" (24.1 × 71.1 × 14 cm.).
No. 1949.47.71. Purchase Alpheus Hyatt Fund.
Formerly Jean Peslier, Avallon, and J. Brummer. Fig. 138.

A second carved spandrel with a winged animal, also said to have
come from Vézelay, differs in certain technical aspects from the
preceding piece. The extremities are tapered and the surface shows
signs of wear, particularly along the right side. Moreover, the
roundel is curiously incomplete. The tightness and elegance of the
design suggests that the shallow arched edges of the block origi-
nally abutted the voussoirs of arcades although this would repre-
sent an exceptional treatment of the medallion motif. The bottom
point, beneath the animal's belly, is broken.

The animal is a griffin, possessing the body of a lion and the
head of an eagle; it is identical to one on the series of façade reliefs
in the Musée Ochier at Cluny (Photo Marburg 35776). The handsome
crisp border of acanthus leaves and punched rings against which
the animal's neck and wings are silhouetted in bold relief resembles
in position the inner ropelike frame around a grape-eating dog on
another of the Cluny plaques (Photo Marburg 35778). The design
and execution of the Fogg piece are more sophisticated and delicate,
however, than the workmanship on the Cluniac reliefs.

There is evidence of original paint in the eye and near the wing
indicating that the medallion was formerly a ravishing vermilion in
color. Subtle contrasts between powerful modeling of the body,
precise incision of the hair, ribs, and feathers, and ornamental drill
work in the border combine to confer on this piece uncommon
vigor and sensitivity. Among the diverse and miscellaneous frag-
ments preserved at Vézelay are several that display a comparably
powerful, ornamental style (cf. in particular, the fragmentary capi-
tal with St. George; Salet-Adhémar, *Vézelay*, narthex No. 51, pl.
47). The formal and iconographic similarities relating this piece and
the preceding one to work at Cluny may be linked to their compar-
able functions and relatively advanced dates.

Bibliography

Medieval Sculptor, No. 13.

8. ARCHITECTURAL FRAGMENT. Vézelay.

Limestone. Second quarter of the XIIth century.
H. 9", W. 14 ½", D. 4 ½" (22.9 × 36.8 × 11.4 cm.).
No. 1949.47.146. Purchase Alpheus Hyatt Fund.
Formerly J. Brummer. Fig. 139.

This carving originally formed a spandrel comparable in shape to
the pieces just discussed. The two slightly curved lower sides
would have abutted the arcade; the upper part of the decorative
roundel was lost during recutting. Mortar, covering chisel marks on
this long and broken side, survives from reuse of the fragment.
There is water damage along the right edge.

A wreath of leaves enclosing pine cones surrounds a central
foliate knob within the circular depression on this relief. A chain of
tiny pyramidal forms frames the motif in a manner similar to that
in which the preceding, slightly smaller disk is bordered. A com-
parably organized roundel containing pine cones pendant under
dry, brittle leaves appears on a less vigorously carved capital at
Vézelay, believed to have come from the cloister (Salet–Adhémar,
Vézelay, pl. 47). In terms of carving, the Fogg sculpture, with its
knob worked *ajouré*, more closely resembles a capital in the narthex
on which similar forms, in strong relief, are arranged in a more
conventional pseudo-Corinthian design (ibid., pl. 48, No. 5). De-
spite the fact that the tiny shoots that sprout up between vegetal
units in the Fogg medallion are akin to those that appear between
the zodiacal roundels in the archivolt at Autun (Grivot-Zarnecki,
Gislebertus, pls. 13–18), stylistic and formal evidence points toward
an attribution to Vézelay, possibly the cloister.

9. FRAGMENT OF A CAPITAL. Vézelay.

Limestone. Ca. 1130.
H. 7", W. 7" (17.8 × 17.8 cm.).
No. 1949.47.50. Purchase Alpheus Hyatt Fund.
Formerly J. Brummer. Fig. 140.

This delicately carved hand and portion of a draped knee display
the hallmarks of style characteristic of several fragmentary reliefs
attributed by Salet to an early west façade program for Vézelay
(Salet–Adhémar, *Vézelay*, pp. 47–48; illustrated in Grivot–Zarnecki,

Gislebertus, pls. B29 and B31). Such features as the exquisite organization of parabolic folds in the drapery, precise articulation and elongation of the anatomy, and the discrete use of beading all recall several evocative reliefs still at Vézelay. The right hand and leg of a figure in three-quarter pose are shown. The left edge of the block is original; the right results from a break. The proportion and position of the figure suggest that it belonged to a capital.

10. CAPITAL IN TWO FRAGMENTS. Vézelay.
Limestone. Ca. 1100.

(a) 1949.47.68. H. 5", W. 8", D. 4" (12.7 × 20.3 × 10.1 cm.).
(b) No. 1949.47.69. H. 5½", W. 6" (14 × 15.2 cm.).

Purchase Alpheus Hyatt Fund.
Formerly J. Brummer. Fig. 141.

The angle volute of a capital, composed of curled vegetal stalks, dominates one of the fragments (10a). Above, incised leafy forms spray forth from a thick shoot. The second piece is adorned with a palmette inscribed within its own semicircular frame (10b). A broken bit of the same motif appears on the side. The grooving of the leaves and the deep, irregular shadows that surround the palmette echo the treatment of sprouts on the first piece. A comparable treatment of foliage on a reemployed capital with Adam and Eve in the nave at Vézelay (Salet-Adhémar, *Vézelay,* pl. 13, No. 65) supports Brummer's association of these carvings with the church of the Madeleine. Léon Pressouyre, who pointed out that the two Fogg fragments belonged together, commented that he had seen similar pieces at Vézelay, possibly from the cloister there.

11. ARCHITECTURAL FRAGMENT. Vézelay.
Limestone. Ca. 1130.
H. 9", W. 11", D. 7" (22.9 × 27.9 × 17.8 cm.).
No. 1949.47.101. Purchase Alpheus Hyatt Fund.
Formerly Collection Abbé Terret and J. Brummer. Fig. 142.

This quadrangular stone fragment, attributed to Autun at the time of its purchase, is dominated by the remains of a figure poised at

the right edge facing left. A long sleeve dangling loosely from a bent raised arm overwhelms the torso which is still visible from approximately the shoulders to the knees. A trace of delicately incised ornamentation, composed of cross-hatching framed by drill holes and small regular beads, identifies the badly damaged form in the lower left corner as a piece of furniture, probably the edge of a chair or throne (cf. Grivot-Zarnecki, *Gislebertus,* pls. 10a, 12a, 33a, and 37b). The two carved elements are separated by a boldly shaped patch of bare ground. The fact that the carving of the figure to the right does not extend around to the back together with the absence of any tool marks along the edges of the piece suggests that the fragment was broken away from a larger work. The abraded and weathered nature of the surface and the presence of two iron stains along the edge of the pendant sleeve indicate that the sculpture was directly exposed to harsh conditions for some time. The piece appears to belong to a better preserved fragment at Vézelay, perhaps the remains of the original west façade program. That piece shows the legs of a frontal seated figure with the profile legs of a standing figure to the right (ibid., p. B31). Similar figures, viewed from the side and wearing decoratively incised draperies appear on fragments from the north portal at Saint-Lazare at Autun (ibid., pls. IV, V, VI, and VIII).

12. VOUSSOIR. Saint-Lazare, Autun, north portal.
Limestone. Ca. 1130.
H. 16″ (outer edge), W. 18″ (top, 40.6 × 45.7 cm.).
No. 1949.47.105. Purchase Alpheus Hyatt Fund.
Formerly Collection Abbé Terret and J. Brummer. Fig. 143.

The leg draperies of a seated figure, seemingly airborne with ankles crossed, is all that remains intact on this trapezoidal stone. The curved contour on the left, the slope at the top, and the presence of tool marks on all four sides identify the block as a voussoir. Robert C. Moeller further associated the piece with one of the angels described by Abbé Terret as belonging to the innermost archivolt around the tympanum on the north door at Autun (V. Terret, *La sculpture bourguignonne,* II, Autun, 1925, p. 50; cited in Grivot-Zarnecki, *Gislebertus,* pp. 180–81). That project has been

dated by Zarnecki to about 1130 (ibid., p. 164). From the diagonal placement of the figure on the stone, it is clear that the piece was inserted about midway up the arch. Its head and halo would have been carved on the adjacent stone above; the halo of the lower angel is outlined by the semicircular protrusion that appears at the base of the Fogg block.

The bit of carving that survives links the figure intimately to the imposing angel fragment in the Cloisters, New York, known to have come from Autun via Abbé Terret (ibid., p. VIII). The characteristic grouped striations in the drapery and alternation of beaded and drilled ornamentation distinguish both pieces. The elevated flourish of drapery above the ankles on the Fogg sculpture is an especially graceful invention. Hovering rather than seated, the attitude of the angel is enhanced by the detachment of the middle section of the body.

Bibliography

V. Terret. *La sculpture bourguignonne,* II, Autun, 1925, p. 50; Grivot-Zarnecki, *Gislebertus,* pp. 180–81; *Medieval Sculptor,* No. 12.

13. ARCHITECTURAL FRAGMENT. Saint-Lazare, Autun, north portal (?).
Limestone. Ca. 1130.
H. 8 ½", W. 5 ½" (21.6 × 14 cm.).
No. 1949.47.104. Purchase Alpheus Hyatt Fund.
Formerly Collection Abbé Terret and J. Brummer. Fig. 144.

Three narrow tubular bands framing two rows of beads traverse the slender cylindrical form seen rising abruptly from a broken angular base. Two crosses, marked by drill holes at the end of each arm and at the center, are aligned on either side of the beading. The pattern terminates at the right at what appears to be the original edge; at the left, the bands undulate continuously across an indentation in the surface.

This piece was among those attributed to Autun at the time it was acquired. A similar design, composed of two beaded bands framing a single cross, is found on the thigh of one of the apostles

on the Emmaus capital in the choir at Autun (Grivot-Zarnecki, *Gislebertus*, p. 2a). On the great Judgment tympanum there, the upright angel to the right of Christ's mandorla is shown with two crosses divided by a triple band of beads on the upper thigh and hip (ibid., pl. G). It is not clear what function the Fogg piece served at the church. Obviously a fragment of a larger sculpture, it may also have belonged to the decoration of the north portal.

14. FRAGMENT OF A TORSO. Autun, Lazarus' tomb (?).
Limestone. Mid XIIth century.
H. 11", D. 6 ¾" (27.9 × 17.2 cm.).
No. 1949.47.103. Purchase Alpheus Hyatt Fund.
Formerly Collection Abbé Terret and J. Brummer. Fig. 145.

This fragment of the upper torso of a figure was said to have come from Autun at the time of its acquisition. It is carved in the round. An unworked area down the center of the back suggests that the figure faced straight out; a coarse ridge at the level of the waist indicates the point at which the figure may have been attached. As the result of prolonged and extreme exposure, the surface is badly abraded and stained. A small repair in plaster has been attempted at the bottom. The figure is posed with its arms raised, shoulders turned slightly to the left. The long swirls of drapery, composed of coupled wormlike strands separated by sharp incisions, as well as thicker tubular folds, emphasize the movement and articulation of the body. Heightened interest in anatomy and a similar definition of drapery characterize the group of standing figures that survives from the monumental tomb built for St. Lazarus' relics during the fourth and fifth decades of the twelfth century (P. Quarré, "Les sculpteurs du tombeau de saint Lazare à Autun et leur place dans l'art roman," *Cahiers de civilisation médiévale*, V, 1962, pp. 169–74 and pl. IV, figs. 14 and 15). The Fogg torso may be a fragment from that project (cf. also R. H. L. Hamann, "Das Lazarusgrab in Autun," *Marburger Jahrbuch für Kunstwissenschaft*, VIII–IX, 1936, figs. 16, 25, and 29).

15. CORBELS. Burgundy (?).
Limestone. Ca. 1150.

(a) No. 1949.47.29. H. 11", W. 7", D. 10" (27.9 × 17.8 × 25.4 cm.).
(b) No. 1949.47.30. H. 11", W. 7½", D. 14½" (27.9 × 19.1 × 36.8 cm.).

Purchase Alpheus Hyatt Fund.
Formerly J. Brummer. Figs. 146 and 147.

The nude Atlas that peers out from the first of these two corbels (15a) is an example of the playful obscenities frequently encountered in the marginal zones of Medieval sculpture. The crouching figure is viewed from the back, one arm raised to support the molding above. His other arm reaches down diagonally toward his buttocks emphasizing the large anus and prominent genitalia readily visible from below. The theme is not an uncommon one; two similar and several related sculptures in the vicinity of Angoulême are discussed as representations of Luxuria by George and Guérin-Boutaud (*Églises romanes*, pp. 266–67, fig. 235 A–K).

The second, sexless, figure (15b) is viewed from the front; rhythmic striations on the underside of the thighs indicate drapery. Although general weathering of the figures has obliterated details which would be helpful in localizing the carvings, the vigorous detachment of the figures, the convincing articulation of the anatomy, and the broad flat facial type as well as the licentious themes bring to mind capitals at Anzy-le-Duc in Burgundy (nude and short-skirted figures inhabit these works as well (C. Pendergast, "The Lintel of the West Portal at Anzy-le-Duc," *Gesta*, XV, 1-2, 1976, p. 138). A series of animate corbels enlivens the roof line on the exterior of the nave and east end of the church (Photo Marburg 31316); photographic documentation was unavailable for close comparison.

16. SECTION OF A VOUSSOIR. Valley of the Rhône.
Savigny (?).
Limestone. Second quarter of the XIIth century.
H. 12", W. 8 ¼" (top), 9 ½" (base) (30.5 × 21 × 24 cm.).
No. 1949.47.11. Purchase Alpheus Hyatt Fund.
Formerly J. Brummer. Fig. 148.

A bust of a hooded female with piercing eyes dominates this small

trapezoidal relief. Details of carving, such as the drooping eyes, the lush acanthus and fruit from which she emerges, the armorial convolutions in the drapery around her upper torso, and the selective use of a drill (in a keyhole pattern) recall work in the Rhône Valley toward the middle of the twelfth century. Specifically, this piece belongs to the small group of sculptures in American collections thought to have come from the destroyed abbey of Saint-Martin at Savigny, northwest of Lyon (see above, Wadsworth Atheneum, No. 2; Jewett Art Center, Wellesley, No. 1; and Boston Museum of Fine Arts, No. 6). Other works, in particular, a capital with the Virgin and Child, were collected and photographed at the "Musée Coquard" near the site of the abbey early in the century (L. Bégule, *Antiquités et richesses d'art du Département du Rhône*, Lyon, 1925, p. 140, and most recently, D. Cateland-Devos, *Bulletin archéologique du Comité des travaux historiques et scientifiques*, N.S. 7, 1971, pp. 151–205).

Apart from some flaking of the surface, the sculpture retains its original delicacy and crispness. The subtle indentation of the ground behind the head recalls the surface contour on a molding with animal heads in foliage employed under the historiated frieze on the side portals at Saint-Gilles. This piece and the one in Boston may have belonged to an archivolt of deeply undercut heads set above foliage similar to the one that frames the portal at Saint-Paul-Trois-Châteaux (Photo Marburg 41775-6). Similar busts, comparably posed and dressed, appear on the angles of an altar table in Cléry (Savoie); these were identified by Raymond Ou sel as the Holy Women, dated by him between 1150 and 1180, and linked to work in Italy or Provence (*Congrès arch.*, 123, 1965, p. 105).

17. THREE CAPITALS. Saint-Pons-de-Thomières (Hérault). Marble. Ca. 1140.

The cloister at Saint-Pons-de-Thomières was sacked during the sixteenth century and completely destroyed in the aftermath of the French Revolution. As a result of the efforts of J. Sahuc, a local antiquarian who studied the surviving sculptures while they were still in the vicinity of the church late in the nineteenth century, it is possible to attribute to the cloister carvings done by diverse work-

shops from neighboring territories attracted to Saint-Pons during its period of great affluence, the twelfth and thirteenth centuries (*L'art roman à Saint-Pons-de-Thomières*, Montpellier, 1908). The oldest surviving group of capitals is closely linked to sculpture at Cuxa and Serrabone and probably dates from the 1130s (M. Durliat, *La sculpture roussillonnaise dans la seconde moitié du onzième siècle*, Perpignan, 1949, pp. 7–13, and L. Seidel in Scher, *Renaissance,* p. 89). Sculptures produced shortly thereafter by workmen familiar with carving at Saint-Gilles and in Toulouse repeat the particular size and curious shape of the earlier carvings although the style and iconography of these later works are vastly different. The three capitals from the Fogg discussed below belong to this series (R. Rey, *La sculpture romane languedocienne*, Paris, 1936, pp. 315–16, and idem, *L'art des cloîtres romans*, pp. 120–29). A fourth capital in Cambridge, acquired with the others by A. Kingsley Porter, represents a final thirteenth-century campaign to complete or enlarge the cloister. (For a discussion of other capitals of this type see P. Mesplé, "Les chapiteaux du cloître de Saint-Pons-de-Thomières," *La Revue des Arts,* 1956, pp. 111–14.)

Apart from an amply recorded assault on the monastery in 1170 by R. Trencavel, viscount of Béziers (*Gallia Christiana*, VI, Paris, 1739, Instrumenta, cols. 84–85), there is little informative documentary material on the once splendid Benedictine retreat that was founded in 936 in a narrow valley at the foot of the Cévennes by the count of Toulouse. Only the church itself, reoriented and modified, remains standing along the main road. Local excavations continue to turn up fragments from the cloister which lay to the south of the church.

Bibliography

L. Noguier in *Bulletin de la Société archéologique, scientifique et littéraire de Béziers,* 1893, 2 sér., XVI, pp. 565–70; J. Sahuc, "Notes sur l'archéologie religieuse dans l'ancien diocèse de Saint-Pons de Thomières," *Mélanges de littérature et d'histoire religieuse; Jubilé de Cabrières,* II, Paris, 1899, pp. 379–402; Sahuc, *L'art roman à Saint-Pons-de-Thomières,* Montpellier, 1908; Porter, "Romanesque Capitals," pp. 30–36; *International Studio,* pp. 38–39; Porter, "The Avignon Capital," *Fogg Art Museum Notes,* 1923, pp. 10–15; Porter, *Pilgrimage Roads,* I, p. 337, VIII, pls. 1265, 1270, 1271; M. Ohl Godwin, "Medieval Cloister Arcades from Saint-Pons and Pontaut," *Art Bulletin,* XV, 1933, pp.

174–85; Aubert-Beaulieu, *Description raisonnée* Nos. 5, 6, and 19; M. Durliat, "Saint-Pons-de-Thomières," *Congrès arch.*, CVIII, 1950, pp. 271–89; R. Rey, *L'art des cloîtres romans*, Toulouse, 1955, p. 116ff.; G. Laguerre, "Saint-Pons de Cimiez," *Provence Historique*, XVII, 1967, p. 409ff.; L. Seidel in Scher, *Renaissance*, pp. 89–91; W. Cahn, "Romanesque Sculpture in American Collections," *Gesta*, XIV/2 1975, pp. 63–65.

(a) DOUBLE CAPITAL. The Journey to and Supper at Emmaus; Noli me tangere.

H. 15″, W. 20″ (top), D. 13″ (38.1 × 50.8 × 33 cm.).
No. 1922.67. Gift of A. Kingsley Porter. Figs. 149 and 150.

The Journey to and Supper at Emmaus (Luke 24:13–31), dominating the long faces of this double capital, are connected on one short side by the scene of Christ's appearance to Mary Magdalene (John 20:14–17). The second short side displays a fortified city gate representing the town toward which the pilgrims travel depicted in the manner of contemporary seals (cf. Réau, *Iconographie*, II/ii, p. 562).

The Emmaus story was particularly popular during the twelfth century when its celebration of pilgrims was singularly relevant. In the Saint-Pons carving however, the Journey is overshadowed by the prominence given the Feast. The disciples are shown withdrawing in amazement from Christ whom they recognize as he breaks bread, an allusion to the institution of the Eucharist. Explicit associations of the risen Lord with the sacramental offering appear in other contemporary Provençal monuments. At Vandeins, Bellenaves, and possibly at Saint-Gilles, for example, a representation of the *Majestas* was juxtaposed with the Eucharistic scene of the Last Supper (R. Hamann, *Die Abteikirche von Saint-Gilles*, I, figs. 430 and 432). In contrast, in the region to the north, an identification between the Eucharist and the suffering body of Christ sacrificed was gaining prominence (A. Katzenellenbogen, *The Sculptural Programs of Chartres Cathedral*, Norton ed., New York, 1964, p. 13 and note 28).

The Emmaus sculpture was produced under the influence of the atelier that worked in Toulouse, carving a series of exquisite capitals with scenes from Christ's Passion for the cloister of La Daurade.

The arrival of the count of Toulouse in nearby Narbonne in 1134 may explain the sudden appearance of this lively narrative style at Saint-Pons.

Only three other capitals published by Sahuc can be linked to this one: one with scenes of the Entombment and Three Marys is now in the Louvre (Aubert-Beaulieu, *Description raisonnée*, No. 19), a depiction of Daniel amid the Lions has been acquired by the Victoria and Albert Museum (*Romanesque Art; Victoria and Albert Small Picture Book*, No. 15, 2d ed., London, 1961, pl. 7) and a small representation of sirens and snakes survives in two versions—one in the Virginia Museum of Fine Arts in Richmond and the other in the Williams College Museum of Art (Scher, *Renaissance*, pp. 89–90, Nos. 29–30, and Cahn, *Gesta*, XIV/2, 1975, p. 65). The relationship of the Fogg Emmaus carving to several other highly decorative narrative capitals still in and around Narbonne has been studied by this author ("Romanesque Capitals from the Vicinity of Narbonne," *Gesta*, XI/1, 1973 pp. 34–45).

Bibliography

Sahuc, *L'art roman*, pp. 78–79, pl. H 2–4; Porter, "Romanesque Capitals," p. 33, figs. 17–20; Porter, *Pilgrimage Roads*, VIII, pl. 1265; Porter, "The Avignon Capital," pp. 10–15; Rey, *Cloîtres romans*, fig. 88; Seidel in Scher, *Renaissance*, pp. 90–91, No. 31; A. Borg, "A Capital from Carcassonne," *Record of the Princeton Art Museum*, XXX-1, 1971, p. 4.

(b) DOUBLE CAPITAL. The Sacrifice of Blood and the Miraculous Feeding of the Four Thousand.
H. 15 ½", W. 20", D. 13" (39.4 × 50.8 × 33 cm.).
No. 1922.64. Gift of A. Kingsley Porter. Figs 151 and 152.

Chains of gesticulating figures, facing out, ornament the two long sides of this double capital. On one short face, a small beardless youth extends objects to attendants. One of these is doughnut-shaped and twisted; the other, a half-circle, is received on veiled hands. On the fourth side, the heads of two oxen appear on a Roman altar. The latter is framed by two figures: a priest wearing a

chasuble and carrying a sacrificial knife and an assistant in a tunic with a hatchet.

Sahuc identified the subject as the Sacrifice of Blood and Bread according to the Old Testament as mentioned in verses 2 and 8 of Deuteronomy, ch. 16 (*L'art roman*, pp. 81–82). Recently Adelheid Heimann discussed the theme of Blood Sacrifice in connection with the provocative *Rogerus* pilaster relief on the west façade at Chartres ("The Capital Frieze and Pilasters of the Portail Royal at Chartres," *Journal of the Warburg and Courtauld Institutes*, XXXI, 1968). She associated the appearance of the animal sacrifice there with the representation of a Eucharistic scene, the Last Supper, immediately above. Heimann also clarified the iconography of the Fogg carving by explaining the scenes as a typological juxtaposition of the Old Testament Sacrifice of Blood with the Miracle of the Feeding of the Four Thousand (Mark 8:1–9 and Matt. 15:32–39; in Heimann, "The Capital Frieze, pp. 97–99, note 140, and fig. 142b). The decoration of saw-teeth on the arch over the animals clearly links the sacrifice to the scene of Christ breaking bread at Emmaus in which a similar arch, serving as radiance, looms above and behind Christ (see above, No. 17a; on the iconography, see also J. Sanoner, "La Vie de Jésus-Christ dans les anciens portails," *Revue de l'art chrétien*, I, 1906 p. 46, note 1).

The charm of the carving lies in its insistent ornamentalism; the draperies, the gestures, the hair styles are all underscored by repetitious, undulant incisions which mimic the more varied and vigorous carving on the Emmaus capital. The organization of heads and bodies in a processional frieze culminating in action on the short sides links the capital directly to sculpture done for the chapterhouse of Saint-Etienne in Toulouse (illustrated in Mesplé, *Sculptures romanes*, Nos. 31, 34, and 37). The Provençal idiom is apparent primarily in the heavy proportions of the figures and the crowding (cf. the capitals in the east walk of the cloister at Arles; Hamann, *Saint-Gilles*, I, fig. 248). Four other capitals with identical mannerisms of style survive; two are in Toledo, Ohio, two are in Montpellier. Three of these depict scenes from the martyrdom of the third-century bishop Pontius, a Roman convert, and a fourth, with mounted knights, has been called a scene of Crusaders (M. Ohl Godwin, "Medieval Cloister Arcades from Saint-Pons and Pontaut," *Art Bulletin*, XV, 1933, pp. 181, 185, and fig. 3).

Bibliography

Sahuc, *L'art roman*, pp. 81–82, pl. K 5–6; Porter, "Romanesque Capitals," figs. 23–24; Porter, *Pilgrimage Roads*, VIII, pl. 1271; Rey, *Cloîtres romans*, fig. 85.

(c) SINGLE CAPITAL. Christ in Glory or The Ascension.

H. 15 ½", W. 15", D. 14" (39.4 × 38.1 × 35.6 cm.).
No. 1922.65. Gift of A. Kingsley Porter, Figs. 153 and 154.

An almond-shaped mandorla with an ornamental border enframes the small figure of Christ. He is wearing a cruciform nimbus and is shown standing before a faint throne, arms raised in an orant gesture. His face, like those of the angels to either side who support the mandorla, has been broken off. The presence of ten apostles, aligned behind the angels and forming a continuous procession around three faces of the single capital, indicates that the subject may be the Ascension rather than the unhistoric *Majestas*. The gestures as well as the upward glance of those figures to the right of the mandorla suggest that the event, awkwardly adjusted to the nature of the support, may have been modeled on a monumental typanum or façade representation. In contrast, a capital from the cloister at La Daurade in Toulouse spreads the scene ingeniously on a triple capital using the contours of the surfaces to emphasize the animation inherent in the story (Mesplé, *Sculptures romanes*, No. 151).

The figures are large headed, short legged, and heavy; the long toes of their immense feet grip the astragal like the claws of birds. A closely related fragment of a capital excavated earlier in the century in the vicinity of Saint-Pons is exhibited in the church. On it, the heads of two bearded, long-haired apostles are shown above simple, round-necked robes. The remains of an arch, crisply incised PHILIP and framed with a saw-toothed design at its outer edge, looms over one of the heads. The same architectural motif appears prominently on two other Saint-Pons capitals in the Fogg which, despite stylistic differences, are probably contemporary with this carving *(supra)*.

The marble is of poor quality and thick mortar overlays the feet. The distracting horizontal veins of black that run through the bodies of the apostles were probably hidden originally by polychromy. Joan Evans incorrectly localized the piece in the archeological museum at Montpellier (*Cluniac Art of the Romanesque Period,* Cambridge, 1950, fig. 113c and p. 109, note 4).

Bibliography

Sahuc, *L'art roman,* pl. K 3–4, p. 81, Porter "Romanesque Capitals," figs. 21–22; Porter, *Pilgrimage Roads,* VIII, pl. 1270.

18. TWO CAPITALS. Avignon. Cloister of the Cathedral of Notre-Dame-des-Doms.

Marble. Third quarter of the XIIth century.
(a) Scenes from the life of Samson.
H. 12 ½", W. 10 ½" (top) (31.8 × 26.7 cm.).
No. 1922.132. Gift of Meta and Paul Sachs.
Formerly Collection Garcin, Apt, and Bernard d'Hendecourt, Paris. Fig. 155.
(b) Acanthus decoration.
H. 12", W. 10 ¼" (30.5 × 26 cm.).
No. 1934.15. Gift of Grenville L. Winthrop.
Formerly Collection Garcin, Apt, and Alphonse Kann, Paris. Figs. 156 and 157.

The Samson capital, erroneously said to have come from the abbey of Grandbois in the Vaucluse when it was exhibited in 1913 (*Exposition des objets d'art du moyen âge et de la Renaissance organisée par la Marquise de Ganay; chez M. Jacques Seligmann,* Paris, 1913, No. 10, p. 7), shows the following scenes: Samson wrestling with the Lion (Judges 14:16); Samson carrying off the gates of Gaza (Judges 16:3); Delilah and the Philistines cutting Samson's hair (Judges 16:19); Samson destroying the house of the Philistines (Judges 16:25–30). The sculpture, carved in fine white crystalline stone like the Carrara marble that Pope Hadrian IV sought to acquire in 1156 for the decoration of the cloister at his former abbey of Saint-Ruf in Avignon, can be disassociated from that campaign and attributed

without reservation to the Cathedral of Notre-Dame-des-Doms in that city. A purchase document for some sculptures now in Marseilles describes the appropriation by a local mason, early in the nineteenth century, of several carvings from the newly destroyed cloister of the Avignon cathedral and the subsequent acquisition by Garcin, former owner of the Samson capital, of the best pieces in that collection (*Art roman de Provence*, Sénanque, 1977, 30–31). Association of the Fogg carving with the cathedral of Avignon now seems assured.

The delicate Samson capital, Paul Sachs's exquisite gift to the Fogg, is unquestionably the finest of all the Avignon carvings. An event from the biblical hero's life is enacted on each face of the slender drum. The scenes follow in narrative sequence yet the visual focus is clearly centered on the first and last events, the two instances of physical conquest: Samson's fight with the lion and his destruction of the Temple. While these two scenes as well as the one of the celebrated haircut are centered beneath or within a turreted arch, the setting for the scene of Samson carrying off the Gates of Gaza is ill-defined and appears to be unfinished.

A deviant and unfinished fourth face is found on the foliate sculpture as well. This arrangement suggests that both capitals may have been juxtaposed at this point with another carving to form a double support comparable to those employed in the cloister arcades at Arles, Montmajour, Saint-Paul-du-Mausolée, and Aix (H-A. von Stockhausen, "Die romanischen Kreuzgänge der Provence, II Teil: Die Plastik," *Marburger Jahrbuch für Kunstwissenschaft*, VIII–IX, 1936, figs. 105f, 124f, 134f, and 181f; see A. Borg's relevant remarks on "A Capital from Carcassonne," *Record of the Princeton Art Museum*, XXX/1, 1971, p. 4).

Von Stockhausen linked both of the capitals presently in the Fogg to others still in Avignon ("Kreuzgänge," pp. 124–134). The dense circlette of leaves that adorns three faces of the Fogg foliate piece (the whereabouts of which were unknown to Von Stockhausen) was compared by him to a façade capital at Arles (ibid., pp. 125–26); the same comparison had previously been made by R. Brimo ("A Second Capital from Notre-Dame-des-Doms at Avignon," *Bulletin of the Fogg Art Museum*, V, 1935–36). This design is very close to one that forms a frieze across the top of an altar table published by L. Labande in his monographic study of the Cathedral of Notre-Dame-des-Doms (*Bulletin archéologique*, 1906, pl.

LXXXII and p. 361). The symmetrical fourth face of the Fogg capital resembles the arrangement of forms on yet another capital from the Garcin Collection now in the Metropolitan Museum, New York (in Scher, *Renaissance*, p. 132, No. 46); the polygonal abacus reappears with geometric ornamentation rather than arcading on the capital with Evangelist symbols in the Avignon Museum (Von Stock-hausen, "Kreuzgänge," fig. 163). A more deeply undercut rinceau on another capital in the same museum invades the apertures of an arcade at the top of the drum. The treatment of this motif recalls the manner in which a curtain is drawn through a series of rings attached to the architecture in the scene of Delilah cutting Samson's hair on the Fogg capital (ibid., figs. 230–31).

Closed circular compositions and very regular patterns of drill holes on three sides of the capital are shared by both sculptures and relate them to one another despite the overt thematic and qualitative differences that distinguish them.

Bibliography

Seidel in Scher, *Renaissance*, p. 133.

19. HALF OF A DOUBLE CAPITAL. Rhône Valley.
Marble. Ca. 1150.
H. 7 ½", W. 8", D. 6 ½" (19.1 × 20.3 × 16.5 cm.).
No. 1949.47.91. Purchase Alpheus Hyatt Fund.
Formerly Émile Blaise, Beaune, and J. Brummer. Fig. 158.

A crouching figure, hands poised on outspread knees, adorns the front face of this half of a small, double capital. Two distinct planes worked into the flat left side of the piece suggest that the capital was closely juxtaposed at this point with another architectural surface; the right side is broken.

The combination of a curiously schematized depiction of draperies, grotesque facial features, and an acrobatic pose reoccurs on carvings associated with workshops in and around Vienne (L. Bégule and J. Bouvier, *L'église Saint-Maurice en Dauphiné*, Paris, 1914, figs. 125, 127, 137, 160–61; cf. especially the reliefs of angels

above the nave arcades there). A siren carved on a capital at Die incorporates an identical hoselike motif as the bridge between the figure's tail segments (ibid., fig. 155). The scale and material of the Fogg carving bring to mind the marble fragments from the Lazarus tomb in Autun which are attributed to a Rhône Valley atelier (Quarré, *Cahiers de civilisation médiévale,* 1962, p. 172). In particular, the pilaster relief with David playing a harp and the capitals with scenes of the birth of Christ, the Annunciation to the Shepherds, and the Presentation in the Temple display similarly inflated facial types (Hamann, "Das Lazarusgrab," figs. 53, 67, 83, and 87).

20. CAPITAL. Provence.

Limestone. Ca. 1150.
H. 8 ½", W. 8", D. 9" (21.6 × 20.3 × 22.9 cm.).
No. 1949.47.63. Purchase Alpheus Hyatt Fund.
Formerly Lemaire and J. Brummer. Fig. 159.

A nesting bird is centered on opposing faces of this small capital; wedges of vegetation, culminating in a folded acanthus leaf, ornament the intervening sides. Recarving beneath the angles gouges into the drum destroying the bottom of the capital and throwing the upper motifs into strong relief. It is possible that the capital was once decorated primarily with foliage and that the unusual nesting effect resulted from the reworking. A large hole penetrates the core of the drum.

One of the birds wears a jeweled collar and looks back with a long eye pierced by a deeply drilled pupil. A similarly posed bird, with a longer neck, stands between foliage on a capital inside the church of Saint-Maurice in Vienne (Fogg Photo 175 V676 2M [i] 16m). The manner in which the birds are wedged between the upper angles on the Fogg sculpture, the squareness of the block and the use of drill holes at the ends of the leaves point toward Provence as the probable provenance for the carving (cf. the organization of the Samson capital (No. 18a).

21. LITURGICAL SLAB. Provence.

Marble with encrustation. First half of the XIIth century.
H. 3", W. 8 ¾", L. 13 ¼" (7.6 × 22.2 × 33.7 cm.).

No. 1949.130. Gift of Mrs. George Metcalf. Fig. 160.

Five sides of a flat rectangular slab are ornamented with geometric, vegetal, and animal forms. The front face is defined by a pair of deer shown nibbling at two of the six fruit that hang from the branches of a short tree between them. The sides and back of the slab are identically decorated with pairs of entwined fleshy leaves; several drilled interstices retain their pasty encrustation. The ornamentation of the top is organized around a stepped depression in the shape of a rectangular hyperbola. Five squat arches containing stylized leaves and trees are centered on the long sides; the elements immediately above the deer are shown vertically within the arcades while the far group is organized in a horizontal chain. The angles beyond the arcades are filled with paired leaves which emerge from the continuous flat border along the edges. Centered over the short sides are similar circular designs with scalloped contours composed of four involuted leaves of five petals each. The vertical and horizontal axes of the motif to the right are emphasized by the tangential edges of the leaves, the furled corners of which are marked by drill holes. The smaller motif to the left is rotated forty-five degrees so that the axes bisect opposing leaves; an incised star lies at the heart of the pattern.

The decoration of the main surface is archaistic and recalls ornamentation on Merovingian reliefs known to have been copied during the Romanesque period (M. Durliat, "Quelques sarcophages inédits," *Cahiers archéologiques*, IX, 1957, pp. 28–29). In particular, a fragment of a tablette in the Musée Borély, Marseille, contains four-and-one-half arches of an arcade with stylized vegetation to either side of a central cross (F. Benoît, "Le sarcophage de Lurs en Provence," *Cahiers archéologiques*, X, 1959, p. 41 and fig. 18). The similarity to the design on the Fogg slab is striking. Additional motifs reminiscent of those under the arcades appear in the twelfth-century cloister at Aix-en-Provence. A vertical arrangement of squares containing varied motifs, such as a rosette, a treelike form, and a "snowflake" or star, occurs on one side of a pier-relief there; the other side is decorated with a leafy rinceau that recalls, less directly, the design on the sides of the Fogg slab (Von Stockhausen, "Kreuzgänge," figs. 179–80). A capital in the same cloister that displays a group of fleshy leaves with prominent tubular veins and a judicious sprinkling of drill holes also resembles work

on the narrow sides of the Fogg carving (Photo Marburg 31077-78).

What function did the piece originally serve? It has been called an altar base or portable altar and indeed should be compared to the group of lobed altar tables produced somewhere in Provence, possibly at Narbonne (M. Durliat, "Tables d'autel à lobes de la province ecclésiastique de Narbonne," *Cahiers archéologiques*, XVI, 1966, pp. 51–75) even though its tiny size and all-over decoration mitigate this comparison. The prominence of the deer, an important funerary (as well as baptismal) symbol, combined with the fact that the ornamentation accentuates the hole in the surface suggest that the slab was conceived as a kind of reliquary or container for relics to be enshrined in an altar (cf. a note in the files of the Fogg Registrar). (For other portable altars see J. Braun, *Der Christliche Altar*, I, Munich, 1924, pls. 74–99 and the discussion in part III, 419ff.)

22. CAPITAL. Southwestern France.
Limestone. Second quarter of the XIIth century.
H. 8 ½", W. 7", D. 10" (21.6 × 17.8 × 25.4 cm.).
No. 1949.47.25. Purchase Alpheus Hyatt Fund.
Formerly Metais and J. Brummer. Fig. 161.

Two nude figures, the left one of which is female, cavort above the speckled backs of two animals on the main face of the capital. The animals' forequarters wrap around the sides of the sculpture; their tails are used to initiate the ropey rinceaux that ornament the remaining sides of the capital and culminate on the back in a pattern of thick irregular interlace. The stone is porous and granular and much of the bottom as well as the upper part of the two sides has been broken off. The decoration, typical of work in western France, recalls the frieze of animals and humans that undulates across capital and wall surface at Saint-Amand-de-Boixe in Angoumois (George and Guérin-Boutaud, *Églises romanes*, fig. 26M). Two capitals in the Museé des Augustins, Toulouse, one with nude figures entwined with vines and a second with purely vegetal decoration, recall different aspects of this work (Mesplé, *Sculptures romanes*, Nos. 278 [origin unknown] and 215 [from Saint-Sernin]). The capital's diminutive size indicates it may have been used as a support for

a row of low arcades such as those that frame apostles on the façade at Ruffec (Porter, *Pilgrimage Roads*, VII, pl. 1028).

23. TWO CORBELS. Southwestern France.

Limestone. Ca. 1125.

(a) H. 12 ¼", W. 13" (31.1 × 33 cm.).
No. 1949.47.18. Fig. 162.

(b) H. 12 ¼", W. 13 ¾" (31.1 × 34.9 cm.).
No. 1949.47.152. Fig. 163.

Purchase Alpheus Hyatt Fund. Formerly J. Brummer.

A standing figure of an amply dressed male is carved on each corbel. The figures' heads face out and look up; their shoulders and feet are turned to the left (23b is barefoot; 23a is shod). The heavy draperies are bordered by coupled ridges; the hem of 23a is adorned with a pearly band. The surfaces of both pieces are badly stained and the face and arms of 23a are extensively damaged. The right side of each figure is freed from the block while the gestures on the left are supported by long strips of elevated ground; these bear marks of a claw-chisel and can be confused with wings.

The composite manner in which the figures' bodies are shown moving toward the side, the large heads with their slightly bulging eyes, puckered mouth, and low, striated cap of hair as well as the logically looped and hanging edges of drapery, all recall elements characteristic of the figures that adorn capitals made for the cloister of La Daurade in Toulouse under the influence of prior work in Moissac (M. Lafargue, *Les chapiteaux du cloître de Notre-Dame la Daurade*, Paris, 1940, and M. Schapiro, "The Romanesque Sculpture of Moissac: Part I [i]," *Art Bulletin*, XIII, 1931, p. 249ff.).

The absence of the rubbery, somewhat precious aspect that marks much of the work issuing from related shops in the southwest (contrast for example the capital exhibited at the Cloisters, *Private Collections*, No. 24) suggests that the work may have originated to the north toward Brive and the Périgord. The corbels bring to mind the dispersed apostle reliefs recently studied by Moeller and Cahn although they distinguish themselves from the latter by details in the handling of anatomy and drapery (Scher, *Renaissance*, 1969, pp. 50–58, and *Gesta*, X/1, 1971, p. 51).

24. CORBEL. Quercy (?).
Limestone. Ca. 1130.
H. 12", D. 22" (30.5 × 55.9 cm.).
No. 1949.47.131. Purchase Alpheus Hyatt Fund.
Formerly J. Brummer. Fig. 164.

The bust of a nude woman leaning on crossed arms, her right hand touching her left breast, emerges from the convex surface of this corbel. Thick hair frames the face and falls behind the well-modeled, slightly hunched right shoulder. Crude recutting around the eyes and brow combined with the loss of parts of the chin, nose, and left shoulder produce excessively harsh effects. Strong modeling, with particular attention to salient anatomical parts, brings to mind work in Quercy, in particular corbels at Moissac and at Cahors, on which strong gesticulations also accompany the busts (Photo Marburg 30755, 30759; M. Vidal, *Quercy roman,* Collection Zodiaque, 1959, p. 214, pl. 11). Although the figure lacks the snakey locks and serpentine torturers found on representations of *Luxuria,* it appears, nevertheless, to be related to those personifications of sensual gratification that appeared prominently in the same region during the first half of the twelfth century, (cf. ibid., p. 76, pl. 24). The upper torso of a nude, long-haired woman, carved along the molding at the top of the north portico at Cahors, can be compared to the Fogg corbel (ibid., p. 214, pl. 11). That figure's outstretched arms and flexed legs (seen through a bit of the architecture) indicate that she is a dancer or entertainer, an individual of easy morals.

25. CORBEL. Southwestern France.
Limestone. Second quarter of the XIIth century.
H. 16 ½", D. 16 ½" (41.9 × 41.9 cm.).
No. 1949.47.28. Purchase Alpheus Hyatt Fund.
Formerly J. Brummer. Fig. 165.

The seated figure of a robust woman with long hair fills the rectangular interval of the corbel. An irregular shape protrudes from under her hem between her shoes; it was probably connected to her arms, now broken. In contrast to the weathered front of the figure, the protected sides of the body are well preserved. Undula-

tions in the drapery on the figure's upper arm are delicately indicated, while folds at her waist are given greater dimension. The pleats of the skirt fan out from beneath two great hips and thighs and wrap around the legs in the manner employed on the Moissac porch reliefs (Porter, *Pilgrimage Roads*, IV, pp. 366–67). The head is broad and low browed; the eyes are round orbs in elongated sockets. For the coiffure, thick strands of hair are swept back concealing part of the ear and overlapping other strands, a treatment that recalls arrangement on reliefs at Moissac, Souillac, and Cahors (ibid., pp. 343, 426, and 429). The lock of hair on her right is clearly distinguished by zigzag imbrications to be a braid; that on her left retains a uniform stranding throughout. Similarly stubby sculptures can also be found at La Graulière and Ydes, away from the major Languedocian centers (Rey, *La sculpture romane*, figs. 200–201).

26. HEAD FROM A FRIEZE. Quercy (Moissac?).
Limestone. Ca. 1120.
H. 5″, W. 4 ½″, D. 5″ (12.7 × 11.4 × 12.7 cm.).
No. 1949.47.140. Purchase Alpheus Hyatt Fund.
Formerly J. Brummer. Fig. 166.

The vigorous modeling of this small head immediately associates the piece with work at the great Romanesque center of Moissac. The tapered individualized tufts of hair, the elongated orbs of the eyes and the emphatic contours of the cheeks recall the expressive though abraded heads of the tormented on the left wall of the porch at the abbey church. The Fogg head's open mouth, with its cavernous pockets of shadow to either side of the teeth and tongue, especially brings to mind the shrieking head of an old woman which protrudes from the spandrel surface beneath the representation of Abraham's bosom on the left frieze (M. Schapiro, "The Romanesque Sculpture of Moissac, Pt. I[i]," *Art Bulletin*, XIII, 1931, fig. 124). The Fogg head is somewhat leonine in aspect; its short neck terminates in a flat triangular break at the back. It originally served a function analagous to that of the Moissac head and may in fact have decorated the restored spandrel area on the right porch wall.

27. FRAGMENT OF AN ABACUS. Languedoc (?).

Limestone. Second quarter of the XIIth century.
H. 6 ¼", W. 20 ¼" (15.9 × 51.4 cm.).
No. 1949.47.56. Purchase Alpheus Hyatt Fund.
Formerly J. Brummer. Fig. 167.

A rinceau pattern of dry tendrils, which overlap and invade adjacent loops of the vine, ornaments each of two adjacent faces of an abacus that was originally engaged in an angle. The motif recalls the design on a fragment of a sarcophagus said to have come from Saint-Sernin, now in the Musée des Augustins, Toulouse (Mesplé, *Sculptures romanes*, No. 247).

28. CROWNED HEAD OF AN ELDER. Notre-Dame-de-la-
Couldre, Parthenay.

Limestone. Second quarter of the XIIth century.
H. 11", W. 5 ½", Diam. 7 ½" (27.9 × 14 × 19 cm.).
No. 1937.39. Gift of the Friends of the Fogg. Fig. 168.

This battered head is but a shadow of one in the Pitcairn Collection in Bryn Athyn, Pennsylvania (photos, Collection A. K. Porter, Fogg Library No. 175 P258 2N [z] 10, 10a). Traces of a straight nose, high cheekbones, protruding upper lip, and split, pointed beard are apparent beneath the weathered and stain-encrusted exterior. Long locks of straight hair ending in tight curls are found on the Pitcairn head as well. A hint of a crown is visible at the upper left of the Fogg head. Rorimer commented on the weathered condition of the sculpture and associated it with sculptures from Parthenay in the Louvre and Gardner museums. The head probably survives from a full or half-length figure of a crowned elder (see above, the Isabella Stewart Gardner Museum, No. 1). Similar aloof heads appear on voussoir figures on the west façades at Aulnay, Argenton-Château, and Chadenac in the vicinity of Parthenay (Porter, *Pilgrimage Roads*, VII, pls. 984, 989, and 1036).

Bibliography

J. Rorimer, "The Twelfth Century Parthenay Sculptures," *Technical Studies*

in the Field of Fine Arts, X, 1942, p. 130, fig. 6; W. S. Stoddard, *The West Portals of Saint-Denis and Chartres,* Cambridge, Mass., 1952, p. 47 and pl. XXXIII, fig. 5; W. Cahn, "Romanesque Sculpture in American Collections, IV. The Isabella Stewart Gardner Museum, Boston," *Gesta,* VIII/2, 1969, pp. 47–49.

29. ARCHITECTURAL FRAGMENTS AND OTHER SCULPTURE. Saint-Raphaël near Excideuil, Périgord.
Limestone. Ca. 1100-1130.
Purchase Alpheus Hyatt Fund. Formerly J. Brummer.

Sculpture from the partly destroyed church of Saint-Raphäel has recently been discussed at length by Brooks Stoddard. He distinguished two styles of carving at the church and attributed them to workmen whose productivity overlapped in time ending about 1120 (*Gesta,* X/1, 1971, pp. 37–38). The globular, immobile creatures observed on capitals and corbels still *in situ* at the east end of Saint-Raphaël were associated with work in the nearby cloister of Saint-Pierre at Tourtoirac. A more rhythmic style of slender forms, associated by Stoddard with a second building campaign in the nave and at the west end, is linked by him to work in the Poitou. Capitals that adorn surviving isolated piers or are imbedded into the wall of the sacristy at the ruined church, along with numerous dispersed fragments identified as the remains of a portal program for Saint-Raphaël, are all attributed to this workshop.

The little that is known historically about Saint-Raphaël has been mentioned either by Stoddard or by Cahn (*Gesta,* VIII/1, 1969, pp. 58–59 and X/1, 1971, pp. 82–84). The only source of information for the period in question is provided by a charter of Pope Callixtus II dated 1120. The document records that land on the site of Saint-Raphaël was given to Raymond of Thiviers, bishop of Périgueux between 1081 and 1099, for use as a cemetery; the church itself is mentioned in the charter as a new dependency of Saint-Pierre of Tourtoirac (Stoddard, *Gesta,* X/1, p. 32. An account of the nearby city and château of Excideuil is in the *Bulletin de la Société historique et archéologique du Périgord,* II, 1875, pp. 234–40.)

Study of sixteen fragments in yellowish limestone at the Fogg, acquired from the Brummer Collection with the attribution to Saint-Raphaël, has emphasized the relation of this sculpture to that

of several other churches nearby in the Périgord. Similarities to work in Quercy suggest contact with important centers further to the south. One of the Fogg fragments has been dropped from the twelfth-century oeuvre of the church (-.109); five more from the Fogg Collection have been added (-.116, -.128, -.129, -.130, -.135). In view of developments throughout southwestern France, a date around 1130 for this work in the Périgord seems appropriate.

Bibliography

A. de Rouméjoux, "Saint-Raphaël," *Bulletin de la Société historique et archéologique du Périgord*, 17, 1890, pp. 127–30; J. Secret, *Périgord roman*, Collection Zodiaque, 1968, pp. 15, 17, 31; W. Cahn, "Romanesque Sculpture in American Collections, III. New England University Museums," *Gesta*, VIII/1, 1969, pp. 58–59; Scher, *Renaissance*, pp. 75–76, fig. 25; B. W. Stoddard, "The Romanesque Sculpture from the Church of St. Raphaël près d'Excideuil," *Gesta*, X/1, 1971, pp. 31–38; *Medieval Sculptor*, Nos. 17, 18, 19.

(a) ARCHITECTURAL FRAGMENT.
H. 8", W. 7" (20.3 × 17.8 cm.).
No. 1949.47.108. Fig. 169.

A vigorously modeled fragment of a lion's face, with foliage issuing from an opened mouth, is close in conception and execution to the carving of a lion's head swallowing a man that supports a sausage-shaped archivolt at the easternmost window of the apse at Saint-Raphaël (Stoddard, *Gesta*, X/1, figs. 3 and 4 and pp. 33–34). The Fogg piece, despite serious losses to the right side of the nose and jaw, reveals similar drilled pupils within recessed almond eyes, an annular ear, and repetitious contouring around the mouth. A large fanglike tooth protrudes beneath the upper lip in both. The angle at which the right cheek is carved on the Fogg piece indicates that the head was conceived in a three-quarter view; it was probably placed in a manner similar to that of the lion carving still in place.

Stoddard related a cloister capital from nearby Saint-Pierre at Tourtoirac, in which abundant foliage emerges from a small animal's head, to these lion sculptures (ibid., fig. 7 and p. 34). A more

compelling comparison can be made with the vigorous head of a lion on a capital in the crossing of the church of Notre-Dame at Thiviers not far away (J. Secret, *Périgord roman,* Collection Zodiaque, 1968, pl. 119); Stoddard has pointed out that land on the site of Saint-Raphaël was given to Raymond of Thiviers, late in the eleventh century (see above and *Gesta,* X/1, p. 32). In addition, a similar but grander pseudo-capital appears beneath an archivolt on the outside of a window at the chevet of Saint-Jean-de-Côle. This church, established by the same bishop of Périgueux late in the eleventh century (Secret, *Périgord roman,* p. 139) lies near Thiviers, northwest of Saint-Raphaël. In the Saint-Jean sculpture, the fierce lion's head appears at the apex of a triangular composition dominating the heads and wings of two angels (ibid., pl. 42).

Among the carvings from Saint-Raphaël published by Stoddard, the corbel head now in the environs of the church especially shares mannerisms of carving, such as the treatment of whiskers, with the Fogg fragment. However, the head lacks the animation and plasticity of the animal fragment (*Gesta,* X/1, p. 36, fig. 11).

Bibliography

Medieval Sculptor, No. 17; Stoddard, "Romanesque Sculpture," fig. 4 and p. 34.

(b) FRAGMENT OF A CAPITAL.
H. 13 ¼", W. 16 ½", D. 11" (33.7 × 41.9 × 27.9 cm.).
No. 1949.47.113. Fig. 170.

The carving on this is surprisingly crisp, despite the fragmentary and bruised condition of the whole. The bodies of two lions, with neatly incised manes, emerge from a single head, now damaged, which formed the angle of the capital. The animals rise on their rear legs and embrace, each with a single front paw, the hindquarters of a second pair of lions. The interval on the long side of the carving created by their overlapped bodies gains prominence through the tense coupling of their phallic tails. The sculpture was originally engaged in an angle.

The theme of fighting lions appears inside the church at Mer-

land near Périgueux (dated to the second quarter of the twelfth century by Secret, *Périgord roman*, pp. 279–82 and pls. 122–24); however, the animals there lack comparable vigor. Similarly bold, more elegant creatures adorn the trumeaus at Souillac and Moissac further south (M. Vidal, *Quercy roman*, Collection Zodiaque, 1959, p. 268, pl. 8; p. 79, pl. 28). Others, with double bodies and single heads, adorn capitals inside the narthex at Moissac (ibid., p. 84 and pl. 33).

The fascination with discrete grooved patterns, such as those that distinguish the v-shaped locks of the mane and articulate the termination of the tails, relates the piece to the corbel head in the vicinity of Saint-Raphaël published by Stoddard (*Gesta*, X/1, fig. 11). The rich modeling of the surface and strong undercutting recall the other lion fragment from Saint-Raphaël in the Fogg (29a).

(c) ENGAGED CAPITAL WITH TRACES OF WHITEWASH.
H. 28 ½″, W. 28″ (front angles) (72.4 × 71.1 cm.).
No. 1949.47.135. Figs. 171 and 172.

The crouching figures of three men provide the architectonic decoration on this enormous half-capital. The men are shown at the center of each face stretching their long arms down toward the astragal around which their toes curve. The figures' flattened heads are abutted at the top of the capital by a projecting molding; shoots emerge from behind their necks and culminate at the angles in tiny spirals; below, bestial, bodyless heads replace the volutes. The surface of the capital is badly worn; in addition, the head at the left angle is broken and much of the central figure has been recarved. Reworking accounts for the ambiguity of the cylindrical form that appears to hang from the front figure's chin, the expressionless face and the curiously layered handling of the sleeves.

The figures on the sides, which bear a coating of whitewash, retain their original freshness. Approximately two-thirds of the one to the right and half of the one to the left exist at the center of the basket, the point at which the capital abruptly ends. On both sides, the dangling form is shaped like a cornucopia or a horn; the drapery falls cursively from the arms. The single eye on each figure

shows a heavy outline, pointed almond shape, and drilled pupil, characteristics that distinguish two corbels in the Fogg associated with Saint-Raphaël (below, 29 k and m). The long ropy strands of hair that sit low on the brow and the abutment of the head are other features found on other fragments from the now ruined church. The lateral heads on this capital resemble most closely the fleshy angel on a fragment still in the vicinity of Saint-Raphaël (illustrated in Stoddard, *Gesta*, X/1, fig. 14). The Fogg capital may originally have crowned an engaged column on a nave pier comparable to ones visible in an old photograph (ibid., fig. 1a).

(d) TORSO.
H. 16″, W. 11″ (40.6 × 27.9 cm.).
No. 1949.47.114. Fig. 173.

This torso has been separated from the original slab; losses to its right side are severe. A book, held formerly by two hands in front of the chest, is symmetrically framed by wide piped edges of drapery. The folds in the cape above and below the left arm are marked by single incisions. Just above the break, a chevron design adorns the waist. The fragment is identical in proportion to another piece in the Fogg (29e) and one at Williams College (see above, Lawrence Art Museum, No. 1b). All were probably used in a large decorative program. The stiffness, frontality and degree of attachment of the torso bring to mind the isolated relief figures on the west wall of the north transept at Saint-Amand-de-Boixe (Charente) as well as those on the west façade of Châteauneuf-sur-Charente and Saint-Jouin-de-Marnes (Porter, *Pilgrimage Roads*, VII, pls. 941–43, 1009–10, and 949–50). Figures at Notre-Dame in Poitiers, at Pérignac, and at Ruffec are carved in the round and are far more lively in pose than the fragments from Saint-Raphaël (ibid., pls. 952–55, 1019, and 1025).

Bibliography

Stoddard, "Romanesque Sculpture," p. 36.

(e) TORSO OF ST. PAUL (?).

H. 24 ½", W. 13 ½" (62.2 × 34.3 cm.).
No. 1949.47.118. Fig. 174.

A haloed figure holding a book in his right hand and gathering folds of his robe with his left emerges against this badly weathered, round-headed relief. The pose, with tightly bent arms and sloping shoulders, is similar to that of the torso in Williams College (see above, Lawrence Art Museum, No. 1b) and shares with it the triple ridge border around the neck of the cape and the double incisions for the clinging passages of drapery. This work, like the one at Williams, remains framed by the slab from which it was carved.

The Fogg piece lacks any of the rich drilled beaded motifs visible on many of the pieces from Saint-Raphaël (Stoddard, *Gesta*, X/1, figs. 8, 9, 10, and 13) although the remnants of the eyes indicate that they were treated in this fashion. Vestiges of hair, which suggest that the figure was represented as bald, and the beard are arranged in regular groups of wiry vertical grooves. The piece is closest in effect and style to the angel relief in Philadelphia (ibid., fig. 13) and probably belonged with it to a single decorative project.

Bibliography

Stoddard, "Romanesque Sculpture," p. 36.

(f) FRAGMENT OF A CORBEL.

H. 7 ½", W. 6", D. 6" (19.1 × 15.2 × 15.2 cm.).
No. 1949.47.110. Fig. 175.

The upper part of a head is crowned by a herringbone cap of hair which overlaps conventional vertical striations of a beard. The eyes are large ovals in which a deeply drilled pupil appears to float. Their elongated, drooping shape resembles that on the corbel head still in the environs of Saint-Raphaël (Stoddard, *Gesta*, X/1, fig. 11). A related treatment of hair, in which a comparable balance between vigor and hierarchical order is achieved, can be found on a capital at Thiviers (Secret, *Périgord roman*, fig. 109). This corbel recalls the rigid animal ones (29 g and h) in the Fogg.

(g) CORBEL.
H. 12″, D. 9″ (30.5 × 22.9 cm.).
No. 1949.47.111. Fig. 176.

The stark effect of this corbel is achieved by contrasting the flaring nostrils and staring eyes with the taut smoothness of the fleshy parts of the face. The worm-line contour of the eye, with its curious point at the outer edge, is characteristic of work from Saint-Raphaël (cf. No. 29a and Stoddard, *Gesta*, X/1, fig. 11; see George and Guérin-Boutaud, *Églises romanes*, fig. 207A and C for comparable corbels).

Substantial traces of bright pink polychromy in the mouth, ear, and nostril indicate that the animal's head was painted a vivid color. The drilled pupil at the right is now hollow but the pupil to the left has been filled with a pasty substance.

(h) CORBEL.
H. 13″, W. 15″ (33 × 38.1 cm.).
No. 1949.47.112. Fig. 177.

The stylized mane of this animal's head is wedged against the top of the corbel. Although the lower half of the face has been lost, it is clear from the positioning of the remaining part that the head did not lunge forth on a massive neck as do several of the other corbel heads from Saint-Raphaël (cf. 29g and i). Stark geometric shapes define the form: a flat trapezoid between conical ears is incised to define the mane; for the eyes, two concentric rings surmount a knoblike protrusion enclosing an unmarked pupil. The fragment recalls the stylized horses' heads used as voussoirs at Saint-Fort and formerly at Saint-Quantin de Rançanne in Saintonge (F. Eygun, *Saintonge romane*, Collection Zodiaque, 1970, pls. 140 and 149). A large angular indentation on the right side of the block indicates the point at which the carving intersected another architectural member.

(i) CORBEL.

H. 12", W. 12" (30.5 × 30.5 cm.).
No. 1949.47.115. Fig. 178.

The hairy head on this corbel lunges forward on an immense neck. The interval beneath the curve of the corbel is filled by groups of hairs each of which ends in a curl. The beard is similarly treated. A comparable arrangement of hair is observed on heads on the tympanum at Beaulieu in the Quercy, in particular that of a trumpeting angel (Vidal, *Quercy roman*, pl. 4, p. 300). The thrust of a powerful neck accompanies the corbel heads at the cathedral of Cahors (ibid., pls. 10 and 11, pp. 213 and 214) although the heads there are distinguished by richer and more subtle modeling. The long, slightly slanted eyes on the Fogg sculpture are badly damaged but traces of their abrupt contours and drilled pupils, typical of Saint-Raphaël, remain. The fleshy lip that protrudes beneath a broken nose and bit of moustache is similar to the lip on the head of the damned from the capital at Williams College (see above, Lawrence Art Museum, No. 1a, fig. 43). The Fogg head appears to have had a comparable ferocity.

The following corbels arrived at the Fogg without identification but are associated here with the Saint-Raphaël oeuvre.

(j) CORBEL.

H. 7", D. 16" (17.8 × 40.6 cm.).
No. 1949.47.116. Fig. 179.

A weathered head, with a low brow and long pointed chin, enlivens this support. A thin line suggests the mouth and two small drill holes indicate the eyes. The similarity of this head to the better preserved ones discussed below links it to Saint-Raphaël; compare, in particular, the more detailed corbel in the vicinity of Saint-Raphaël discussed by Stoddard (*Gesta*, X/1, fig. 11).

(k) CORBEL.

H. 13", W. 7 ½", D. 24" (33 × 19.1 × 61 cm.).
No. 1949.47.128. Fig. 180.

The pronounced contouring of the eyes and the piped border around the coif conform to the formulas used on sculptures from Saint-Raphaël (cf. Stoddard, *Gesta*, X/1, figs. 9 and 11; above, 29e). In addition, the familiar long chin and pursed lips, low brow, and powerful neck distinguish this carving. The corbels popular in Saintonge-Poitou are ordinarily more vigorously carved than are those attributed to Saint-Raphaël (cf. those at Echillais, illustrated in Eygun, *Saintonge romane*, pls. 114 and 117).

(l) CORBEL.

H. 10″, W. 7″, D. 24″ (25.4 × 17.8× 61 cm.).
No. 1949.47.129. Fig. 181.

Bulging eyes with drilled pupils and parted lips held askew distinguish this corbel head. The long chin and low-browed hairdo link the head to capitals in the east end of Saint-Raphaël (Stoddard, *Gesta*, X/1, figs. 2 and 6). There is a striking resemblance between the caricature type of this head and that of a more subtly modeled corbel bust at Moissac (Photo Marburg 30759). The piece has recently been broken in two at the point on its left side at which it was originally intersected by another block.

(m) CORBEL.

H. 13 ½″ W. 7 ½″, D. 25″ (34.3 × 19.1 × 63.5 cm.).
No. 1949.47.130. Fig. 182.

The twisting head, thrust forward on a long neck, collides with the upper molding of the corbel. The acutely outlined almond eyes, strong chin, and caplike hair link the head indisputably to the corbel head still near Saint-Raphaël (Stoddard, *Gesta*, X/1, fig. 11). The striated tongues of hair are the equivalent of the tufts in the lions' manes on the capital fragments in the Fogg (above, 29a and b). The thin mouth is emphasized by a puckered lower lip. A head from the Brummer Collection at Duke University resembles this corbel sculpture in particular (*Gesta*, XIV/2, 1975, p. 71, No. 5).

(n) VOUSSOIR.
H. 5", W. 19 ½", D. 11" (12.7 × 49.5 × 27.9 cm.).
No. 1949.47.117. Fig. 183.

A single striated stem, from which long flowering forms with tonguelike protrusions emerge, undulates across this stone. The regular ridging of the vine recalls the treatment of whiskers and foliage on the lion fragment in the Fogg. (29a); the rings that mark the point of diverging tendrils recur on frieze fragments still at Saint-Raphaël (Stoddard, *Gesta*, X/1, fig. 16). A more stylized version of the motif, including the striated vine and rings but with leaves instead of flowers, ornaments the similarly shaped abacus of a capital in the north transept of the church at Thiviers (Secret, *Périgord roman*, pl. 116). The Fogg piece probably belonged to a series that formed an arcade on the façade or exterior of the nave wall (cf. the treatment of a chevet window at Cénac, ibid., pl. 48).

(o) VOUSSOIRS.
H. 6", W. 16", D. 12" (15.2 × 40.6 × 30.5 cm.).
No. 1949.47.122.
H. 6", W. 14 ½", D. 11" (15.2 × 36.8 × 27.9 cm.).
No. 1949.47.123.
H. 6", W. 13 ½", D. 11" (15.2 × 34.3 × 27.9 cm.).
No. 1949.47.124.
Fig. 184.

A thin frame sets off the narrow concave face of each of the three voussoirs. The ornamentation consists of a ropy interlace that passes in two instances through the drilled orifices of a mask (.123–.124); in the third interlace, two berrylike fruits punctuate the interval beneath heart-shaped tendrils (.122). The striations on the interlace, the braided manner in which they overlap and the nature of the resultant intervals resemble, to a limited extent, the treatment of the foliate decoration on one of the capitals from Tourtoirac published by Stoddard (*Gesta*, X/1, fig. 7). Fragments of related archivolts still at Saint-Raphaël, one of which is ornamented with a mask, are visible in one of Stoddard's photos (ibid., fig. 16).

Thin ornamental archivolts constitute an important part of exterior decoration in western France and the Saint-Raphaël frag-

ments were probably carved for this function. At the façade of Corme-Ecluse, a mask interspersed with rinceaux is found at the base of a pair of archivolts (Eygun, *Saintonge romane*, p. 263); the pretzel pattern ornaments a frieze around the chevet at Jarnac-Champagne (ibid., pl. 190). A similar, but simpler intertwined band ornaments the outer archivolt of the portal at Besse, south of Périgueux (Secret, *Périgord roman*, pls. 104–108). At the church of Cénac, near Besse also in the Périgord, a dense pattern of interlace decorates the abacus of a capital in the choir (ibid., pl. 56). Additional similarities to the decoration of these provincial churches in the Périgord are discussed below in connection with the friezes from Saint-Raphaël.

Bibliography

Medieval Sculptor, Nos. 18 (-.123) and 19 (-.124).

(p) FRIEZE.
H. 8 ¼", W. 23", D. 19" (21 × 58 × 48.3 cm.).
No. 1949.47.119. Fig. 185 (above).

The concave face of this frieze is adorned with the *imago clipeata;* two animated angels support a beaded circular frame in which appears the *Agnus Dei* with a cruciform halo and a cross. The paired figures assume active crouching poses; the wings of the one to the left are widespread. Surface damage has obliterated much of the detail but fine passages in the drapery link the angels to the standing figures that support a mandorla of Christ on a capital still at Saint-Raphaël (Stoddard, *Gesta*, X/1, fig. 8). The motif of triumphant genii, borrowed from Roman imperial victory symbolism, gained prominence in southwestern France during the late eleventh-century revival of Gallo-Roman architectural forms. It figures prominently in the decoration of an altar table in Saint-Sernin in Toulouse (F. Gerke, *Der Tischaltar des Bernard Gilduin in Saint-Sernin in Toulouse*, Akademie der Wissenschaften und der Literatur in Mainz, VIII, 1958) and on related marble impost blocks in the cloister at Moissac (M. Durliat, "L'atelier de Bernard Gilduin à Saint-

Sernin de Toulouse," *Añuario de Estudios Medievales*, I, 1964, pp. 521–29, figs. 1–7).

In western France, the subject frequently adorns the keystone of portal arches (e.g. Talmont, E. Mendell, *Romanesque Sculpture in Saintonge*, New Haven, 1940, fig. 133). The absence of any carving on the sides of the Fogg block indicates that this piece was used as part of a frieze rather than as an impost.

Bibliography

Stoddard, "Romanesque Sculpture," fig. 15 and p. 35.

(q) FRIEZE.
H. 6 ½", W. 22", D. 18 ½" (16.5 × 55.9 × 47 cm.).
No. 1949.47.120. Fig. 185 (below).

The bust of a large-headed man holding what appears to be a bow in his raised hand is juxtaposed with the coiled hind quarter of an animal with forelegs. The looped body of a serpent terminates the piece at the right. The frieze of fantastic and grotesque forms may have been used in connection with the carving of running animals discussed below (29r) and, like it, can be compared to monuments further south. A large, grotesque head with raised arms appears on an abacus at Cénac (Secret, *Périgord roman*, pl. 55); another capital at the same church shows a similar full-length figure menaced by beasts (ibid., pl. 54). Serpentine forms adorn a second abacus at Cénac (ibid., pl. 57) while a looped form, similar to that on the Fogg frieze appears under the legs of St. Michael on the main archivolt at Bresse (ibid., pl. 108). Further south at Cahors, the façade of the portal is decorated with numerous drolleries consisting of grotesque little figures either in the archivolt, on the corbels, or along the frieze (Vidal, *Quercy roman*, pp. 212–15, pls. 9–13); at Moissac, large-headed, demonic busts support the frieze on the left wall of the porch (ibid., p. 74, pl. 22).

(r) FRIEZE.
H. 5 ¾", W. 18", D. 11 ½" (14.6 × 45.7 × 29.2 cm.).
No. 1949.47.121. Fig. 186.

The shape of this block, with its narrow upper frame and slightly concave relief surface, corresponds to that employed on all voussoirs and friezes from Saint-Raphaël. The strong modeling of the bodies recalls the treatment of the lions in the two Fogg fragments (29a and b). The subject is two running dogs. Themes of pursuit are popular in portal decoration in the region. At Besse, in the southern part of the Périgord, a running stag is shown on the archivolt over the main door (Secret, *Périgord roman*, pl. 104); another appears in the right portion of the archivolt over the porch at Cahors (Vidal, *Quercy roman*, p. 214, pl. 13). On the façade at Angoulême, a chase with two dogs pursuing a stag takes place amid foliage (C. Daras, *Angoumois roman*, Collection Zodiaque, 1961, pl. 44). A voussoir in the Musée Municipal in Limoges shows, in a comparable arrangement, a dog chasing a deer (*Guide du Musée Municipal. Collection archéologique*, Limoges, 1969, p. 80, No. 169).

30. ARCHITECTURAL FRAGMENT. Western France.
Limestone. Ca. 1125.
H. 8 ½" (20.5 cm.).
No. 1949.47.61. Purchase Alpheus Hyatt Fund.
Formerly J. Brummer. Fig. 187.

Large almond eyes and a wide moustache divide this face into distinct areas. The eyes, ringed by bulging lids, are closely framed by the broad, low brow. They fill shallow depressions above the high smooth cheekbones to either side of the aquiline nose. The sweeping ends of the thick moustache frame the lower section of the face; a flat fringe beards the chin. The shadows created by the small deeply cut mouth, the large drilled pupils and, at one time, the nostrils, punctuate the face underscoring its masklike hollowness.

Severe weathering, in particular of the nose, forehead, and the left part of the moustache, and a growth of lichen disfigure the sculpture. Study has revealed the extent to which airborne pollutants have attacked the chalky stone. The carving has been cut cleanly away from a large block and is little more than a slab. The

broad, immobile facial type with protruding pierced eyes, thick moustache, and flat beard reappears on a series of miscellaneous corbels in the museum at Beauvais (Photo Marburg 37615, 37616, 37627). The fragment can also be compared with metopes and corbels from such western churches as Chadenac and Saint-Symphorien (Porter, *Pilgrimage Roads,* pls. 1040 and 1007).

31. ARCHITECTURAL FRAGMENT. Western France.
Limestone. Ca. 1125.
H. 8", W. 6 ½", 5" (20.5 × 16.5 × 12.5 cm.).
No. 1962.321. Bequest of Lucy Wallace Porter. Fig. 188.

This feline face is missing one eye as well as much of its flamelike hair. A broad snubbed snout is set above an elongated mouth full of menacing teeth. Comparable catlike heads with staring eyes emerge from the corbels and metopes on churches in western France, for example at Notre-Dame-la-Grande at Poitiers and at Fenioux (Porter, *Pilgrimage Roads,* pls. 953 and 997).

32. ARCHITECTURAL FRAGMENT. Northern France.
Limestone. Ca. 1150.
H. 9", W. 15 ¼", D. 7 ½" (22.9 × 38.7 × 19.1 cm.).
No. 1949.47.87. Purchase Alpheus Hyatt Fund.
Formerly J. Brummer. Fig. 189.

A small man clutches the single hump of a crouching dromedary with one hand while, with the other, he commands the animal with a baton. A bit of entwined vegetation abuts the beast's head. Above, a pattern of saw-teeth frames this segment of a frieze.

The relationship between the rider and his mount is extremely well observed; depiction of the animal's hooves and the master's pantalooned costume and beaded belt reveal sustained interest in natural details. The combination of sharp and selective ornamentation with strong, generalized modeling of the figures recalls the treatment of the triforium capitals in the choir at La Charité-sur-

Loire (R. Raeber, *La Charité-sur-Loire*, Bern, 1964, figs. 35–38, 43–46). Other aspects of the piece such as the concavity of the ground with its sense of staged space, the association of bent figures with awkwardly positioned animals, and the inclusion of furled fragments of foliage characterize the Charité group as well (Photo Marburg 33929, 33932, 33938). The slightly irregular sawtooth pattern also separates the registers on the Transfiguration tympanum at the church (Raeber, *La Charité*, fig. 57).

33. HEAD OF A KING. Western France (?).
Limestone. Second quarter of the XIIth century (?).
H. 16 ¾", W. 9 ½" (42.6 × 24.1 cm.).
No. 1920.30. Wetzel Bequest.
Formerly Bing Collection. Fig. 190.

Since 1940, when Marvin Ross associated the head of a king in the Fogg with an eighteenth-century engraving of a jamb figure published in B. de Montfaucon's *Les monumens de la monarchie françoise*, the attribution of the sculpture to the west façade of Saint-Denis has remained controversial (*Journal of the Walters Art Gallery*, III, 1940, pp. 100–102). Although the head, in particular the feathery decoration on the crown, does resemble the illustration of one of the column statues that flanked the left door on the west portal at the royal abbey (Montfaucon, *Monumens*, I, pl. 16), the piece is stylistically inconsistent with both the reliefs *in situ* on Suger's portal and the fragments in the Louvre that can be associated with conviction with the program (Aubert-Beaulieu, *Description raisonnée*, I, p. 57, Nos. 52–55). Moreover, the head varies, particularly in size, from the two heads in Baltimore which Ross attributed, with stronger arguments, to the Saint-Denis façade.

The Fogg head was said to have come from the Poitou when it was purchased from the Parisian dealer Bing after World War I. It arrived in the United States at the same time as several other prominent and controversial carvings, such as the Parthenay pieces in the Isabella Stewart Gardner Museum (No. 1), the St. Peter in the Rhode Island School of Design Museum (No. 2), and the column statue in the Metropolitan Museum (W. Wixom, *Treasures from Medieval France*, Cleveland, 1967, p. 74), all of which were dis-

cussed in an article by R. van Marle ("Twelfth Century French Sculpture in America," *Art in America,* X, 1921, pp. 3–16). Suspicion, stimulated by that fortuitous grouping of objects, is reinforced by the appearance of the head at that moment. The face bore a long nose and restoration in the right eye was overgrown by lichen which also covered the head (ibid., fig. 5). Cleaning removed both additions and probably created the harsh and scratched appearance the eyes now have. Otherwise, the surface of the carving on inspection is uniform; ultraviolet light reveals no evidence of recent, twentieth-century carving and there is no way of determining the age of the carving beyond that observation.

While the tapered shape of the head, emphasized by its high cheekbones and bowed lips, does recall the physiognomy of carvings in western France, at Chadenac for example (Porter, *Pilgrimage Roads,* VII, pls. 1035–36), the rigidity and inorganic, additive aspects of the piece are inconsistent with those Aquitanian features and contradict the increasing tendency of the second quarter of the twelfth century toward the absorption of ornamentation into naturalism. The association of the head with Saint-Denis on the basis of the evidence of the engraving is far from conclusive. We know, for example, that Montfaucon's engravings were studied by Viollet-le-Duc while preparing his restorations at Notre-Dame (D. Reiff, "Viollet-le-Duc and Historic Restoration: The West Portals of Notre-Dame," *Journal of the Society of Architectural Historians,* XXX, 1971, pp. 18–19). The carving or recarving of the head could date from this period. Such a conclusion is in line with Sauerländer's observation "Echtheit und Herkunft nicht gesichert" (*Gotische Skulptur in Frankreich,* Munich, 1970, p. 63), which has, however, been contradicted by Pressouyre's recent study of Saint-Denis portal sculpture.

Bibliography

R. Van Marle, "Twelfth Century French Sculpture in America," *Art in America,* X, 1921, p. 11; M. C. Ross, "Monumental Sculptures from Saint-Denis. An Identification of Fragments from the Portal," *Journal of the Walters Art Gallery,* III, pp. 90-109; Aubert-Beaulieu, *Description raisonnée,* p. 57; W. S. Stoddard, *The West Portals of Saint-Denis and Chartres,* Cambridge, 1952, pp. 7–8; B. Kerber, *Burgund und die Entwicklung der französischen Kathedralskulptur,* Recklinghausen, 1966, p.

90, note 115; Scher, *Renaissance,* pp. 150–55; Scher, *Gesta,* IX/2, 1970, p. 60; W. Sauerländer, *Gotische Skulptur in Frankreich, 1140-1270,* Munich, 1970, p. 63; L. Pressouyre, "Une tête de reine au portail central de Saint-Denis," *Gesta,* XV/1-2, 1976, pp. 151-60.

34. FRAGMENT OF AN ABACUS. Ile-de-France.
Limestone. Ca. 1150.
H. 11", W. 9" (27.9 × 22.9 cm.).
No. 1949.47.57. Purchase Alpheus Hyatt Fund.
Formerly J. Brummer. Fig. 191.

The angle of an abacus is decorated with a bold pattern of tendrils which enclose heavy buds and are entwined by funnel-shaped leaves. Deep undercutting isolates the vegetal forms against the sharply sloped surface. Relationships to work in the Ile-de-France toward the middle of the century abound. The fibrous tendrils and subtly beaded leaves recur on a fragment from Sainte-Geneviève in Paris; a related but heavier florid rinceau frames both the retable from Carrières-Saint-Denis and the abacus of the composite capitals from Coulombs (Aubert-Beaulieu, *Description raisonnée,* Nos. 47, 73, and 71–72).

35. FRAGMENT OF AN ABACUS. Eastern France.
Limestone. Last quarter of the XIIth century.
H. 7 ½", W. 20", D. 13" (19.1 × 50.8 × 33 cm.).
No. 1949.47.134. Purchase Alpheus Hyatt Fund.
Formerly J. Brummer. Fig. 192.

A rinceau of flatly carved beaded ribbons and deeply undercut grooved leaves adorns the beveled two-thirds of this fragmentary abacus. Above, a wide vertical band bears original saw marks. Damage to the third side of the piece has destroyed much of the decoration on this face; the fourth side is broken. The motifs, their surrounding shadows, and the contour of the surface of the block recall the treatment of the decoration on the inner archivolt of the south portal at the Benedictine abbey Church of Sts. Peter and Paul

in Neuwiller-lès-Saverne (Bas-Rhin), which was rebuilt after a fire in 1177 (R. Will, *Alsace romane*, Collection Zodiaque, 1965, p. 305; Photo Marburg 26640). The colonnettes and archivolt on the well-known portal at Pompierre also display similar motifs (Aubert, *L'art roman en France*, p. 61). A fragment of a frieze in the Basel Historical Museum further localizes the Fogg abacus in this region (A. K. Porter Photo 5226, Fogg Collection).

36. ARCHITECTURAL FRAGMENT. Northern France.
Limestone. Ca. 1150.
H. 4 ⅝", W. 5" (11.8 × 12.7 cm.).
No 1962.320. Bequest of Lucy Wallace Porter. Fig. 193.

Five petals with prominent mid-lines radiate out behind a central knob. Strong relief combined with an emphasis on mass rather than delicacy distinguish the forms. Similar rosette motifs are prominent in the decoration of north Burgundian churches such as Avallon (Photo Marburg 169837), Auxerre (Raeber, *La Charité*, fig. 66), and La Charité-sur-Loire (ibid., fig. 11) where they are used to ornament archivolts and pilasters.

37. CAPITAL. Burgundy or Champagne.
Limestone. Third quarter of the XIIth century.
H. 30 ¼", W. 30" (top), D. 16 ½" (76.8 × 76.2 × 41.9 cm.).
No. 1949.47.125. Purchase Alpheus Hyatt Fund.
Formerly Peslier, Avallon, and J. Brummer. Fig. 194.

This large capital from a circular pier was associated with a church of St. Phal near Tonnerre at the time of its purchase. It is decorated with four delicately incised acanthus leaves each of which terminates at an angle of the capital. The elongated columnar shape and taut treatment of the vegetation with its brittle contours, striated surface, and points of shadow recall work on a capital in the nave at Daméry (Marne) (A. K. Porter Photo 69; Fogg Collection 175 D182 2c[i]2). A similar concept of foliage receives a more sculptural

treatment at the west portal of the church of Vermenton (Yonne)
(Photo Austin IU 3). While localization of the piece around Tonnerre
is plausible, attribution of the carving to the church of Saint-Phal
that is located near Troyes, built as a sepulchral chapel around 1500
(Vallery-Radot in *Congrès arch.*, 113, 1955, p. 390), cannot be sup-
ported.

38. FRAGMENT OF A CAPITAL. Eastern France.
Limestone. Fourth quarter of the XIIth century.
H. 11", W. 5 ½", D. 4 ¼" (27.9 × 14 × 10.8 cm.).
No. 1962.317. Bequest of Lucy Wallace Porter. Fig. 195.

A pair of split-leaf, hourglass-shaped vegetal forms, banded by tri-
ple rings at the center, frame a shoot which descends from the
angle of the narrow abacus. The shoot terminates in a tapered,
three-pronged leaf. The lack of articulation of the drum and the
emphasis on the texture of the ground recall carvings in eastern
France. The motif of banded shoots and multidirectional grooved
leaves arranged in alternation is frequently encountered in the dec-
oration of the cubic architectural surfaces at Marmoutier, at
Lautenbach, at Andlau and, above all, at Neuwiller-lès-Saverne in
the vicinity of Strasbourg (Aubert, *L'art roman en France*, pp. 44–48;
Will, *Alsace romane*, pl. 114; Photo Marburg 26654). A denser ar-
rangement of analogous motifs adorns a capital in the nave of
Saint-Etienne at Nevers (Photo Archives, No. 1929).

39. FRAGMENT OF A CAPITAL. Abbey of Dommartin,
Pas-de-Calais.
Limestone. Ca. 1160.
H. 9 ½", W. 10 ½" (24.1 × 26.7 cm.).
No. 1949.47.27. Purchase Alpheus Hyatt Fund.
Formerly Garnier and J. Brummer. Fig. 196.

A beaded collar fastens together two mirror-image whorls of a rin-
ceau; each tendril passes through a second pearly band before

spewing forth the two large flat leaves that fill and overlap the circular enclosure created by the vine. The piece is flat on the back with two large vertical grooves rendering it suitable for hanging. The plaque was obviously cut away from a larger fragment. Although its attribution in the Fogg files to the abbey of Dompierre in the Pas-de-Calais cannot be substantiated, resemblances to the upper sections of the large circular choir capitals that survive from the ruined abbey of Dommartin, near Abbeville, also in the Pas-de-Calais, suggest its accurate provenance. A well-preserved sculpture from Dommartin, now in the Musée de Picardie in Amiens, displays identically formulated rinceaux replete with beaded collars, shallow, somewhat angular surface carving, and a fondness for elongating the final frond on a leaf (Photo Marburg 162309, 162310). Other capitals surviving at the ruined abbey are similarly terminated by an octagonal abacus. Rinceaux contiguous with this flat surface are deeply undercut and serve as a screen in front of the receding circular drum. The Fogg fragment probably formed the transition between one side of an octagonal abacus and the continuous acanthus decoration of the lower drum.

Sculptures from Dommartin are dated to the decade between 1153, when the building began, and 1163 when a consecration took place. The superior quality of the carving, unusual in the region, was linked by Héliot to contemporary work in the Ile-de-France and in Champagne although close comparisons cannot be made (P. Héliot, *Les églises du moyen-âge dans le Pas-de-Calais*, Arras, 1951, pp. 164–66, 378 and pl. XV; see also the catalogue *Cathédrales*, Paris, 1962, No. 125).

40. FRAGMENT OF A BAPTISMAL FONT. Liège.
Dark calciferous stone. First half of the XIIth century.
H. 7 ¾", L. 33" (19.7 × 84 cm.).
No. 1949.47.52. Purchase Alpheus Hyatt Fund.
Formerly Brummer Collection. Figs. 197 and 198.

The salient heads and framed panel of paired palmettes readily identify this narrow curved fragment with a group of twelfth-century baptismal fonts from the vicinity of Liège in eastern Belgium. Comparison with these objects indicates that the decoration of the

bowl of the font from which the Fogg fragment survives consisted originally of four large panels with varied foliate and bestial ornamentation separated by four squat heads resting on consoles (L. Tollenaere, *La sculpture sur pierre de l'ancien diocèse de Liège à l'époque romane,* Namur, 1957, pls. 42–48).

The heads on the Fogg piece are constrained by the frame around the rim of the bowl which serves as a hat and by the remains of the console on which the shapeless chins rest. The heads lack mouths, ears, and hair and are distinguished only by their large elongated eyes and short straight noses. In addition to the main panel in which palmettes are enclosed by their own circular stems, the remains of a framed second panel with a central horned mask and a leaf-like wing can be seen. A font of unknown provenance in the Liège Museum (No. 24, inv. #591) and another in the church of St. Martin at Lubbeek are particularly close in decoration to the Fogg fragment (ibid., pls. 44B and C, 41c, and 50e, pp. 264 and 272–73).

41. FRAGMENT OF A FRIEZE. Maestricht (?).
Limestone. Third quarter of the XIIth century.
H. 4 ½", L. 21" (11.4 × 53.5 cm.).
No. 1949.47.53. Purchase Alpheus Hyatt Fund.
Formerly Brummer Collection. Fig. 199.

Two boldly carved yet small heads dominate the decoration on this narrow slab. The heads emerge from the shadowy intervals between three U-shaped leafy rinceaux each of which encloses the feathery belly of a frontal bird. A substantial portion of the relief, including the upper termination of the foliage, the birds' heads and much of the body of the creature at the left, has been lost. The curled leaves at the ends of the fragment indicate the original edges. The dense vigorous carving and curious facial type, with its low brow, large nose, and emphatic chin, recall work in Maestricht from the third quarter of the twelfth century. In particular, similar heads combined with the stems of a vine appear on a capital from the west work of the Church of St. Servais (J. J. M. Timmers, *De Kunst van het Maasland,* Assen, 1971, fig. 352, also figs. 314, 315, and 351).

42. PANEL FROM A CASSONE. Central Italy.
Wood. XIIth century.
H. 16 ¼", L. 49 ¼" (41.3 × 125 cm.).
No. 1936.129. Purchase Alpheus Hyatt Fund.
Formerly Collection Arturo Grassi. Fig. 200.

The panel was purchased in the early 1920s in Perugia and was said at that time to have come from a house near that town. It is thought to have served originally as one of the sides of a long wooden box such as those that became fashionable in the later Middle Ages for the storing of linen. A series of holes, perhaps for a lock, are visible in the upper right medallion. The decoration is a close adaptation of a pattern frequently found on textiles, for example on the Anagni Cope (W. R. Tyler, "An Early Italian Wooden Panel," *Bulletin of the Fogg Art Museum*, 1940, IX-3, fig. 2). Eight roundels are divided into groups of four by means of a vertical rinceau which reappears at either side as part of a broader frame. The four roundels in each section are clustered and are tangential; the shared spandrel spaces are filled with a flat stylized vegetal form. The bottom row of roundels to the left contains a lion and a griffon; their mirror images, except for small differences in carving, appear on the right. Above on the left are two sets of confronting birds and on the right two sets of human figures. A man in short pants and a woman in a flowing garment appear in the left of these medallions and two similarly attired women appear on the right. Although no other object of this type is known, the evidence of Islamic influence in the animal iconography and of Western contacts in the style point toward the cosmopolitan area of central Italy as the likely point of creation.

Bibliography

P. Toesca, *Storia dell'Arte Italiana*, I/2, 1927, p. 1143; *Arts of the Middle Ages: Catalogue of a Loan Exhibition, Museum of Fine Arts*, Boston, 1940, pl. XI, No. 308; W. R. Tyler, "An Early Italian Wooden Panel," *Bulletin of the Fogg Art Museum*, IX/3, 1940, pp. 49–55.

43. ARCHITECTURAL RELIEF. Northern Italy.
Marble. Second quarter of the XIIth century.
H. 22 ½", W. 9", D. 4 ½" (57 × 22.8 × 11.4 cm.).
No. 1936.17. Gift of Arthur Sachs. Fig. 201.

A frontal standing male figure, dressed in a tunic and a cape with a beaded border, holds an open book in his draped left hand and raises three fingers of his right hand. The book is inscribed across its pages: PETRUS: MONNINCI: ET PR: IUSSIT H(O)C OPUS FACERE. The figure stares out impassively. The pupils of the large asymmetrical eyes are drilled and set beneath recessed brows. The triangular nose is long and straight, the mouth, long and thin. The oval head is crowned by a tonsured cap of thick straight hair ending in a row of close flat curls. The lower limbs are particularly short and confer a dwarflike appearance on the figure.

Apart from an inordinate mount of dirt and discoloration which stain the smooth planar surfaces of the face and draperies, the sculpture is in excellent condition. The inscription is slightly abraded at the top and part of the ear on the right side and a fold of drapery have split away. The block on which the figure is carved is rusticated with tool marks on the surface around the figure; the ground slopes out forming a base beneath the pendant feet.

Although the figure was identified as Spanish when it was given to the Fogg, its similarities in type and style to north Italian sculpture are striking. Small reliefs of standing figures were regularly employed throughout the region on portals and pulpits from the early twelfth century on (R. Jullian, *Les sculpteurs romans de l'Italie septentrionale*, Paris, 1952, pls. XVIII and LXI-2). The compressed draperies on the Fogg piece with their rectangular folds, the immobile facial type, and the long fingers compare most closely to figures on capitals at Parma Cathedral (ibid., pls. XXXIV–XXXV). The small scale, delicate material, and excellent preservation of the carving suggest that it comes from an interior structure (compare the reliefs on the pulpit at Isola San Giulio, ibid., pl. XXXI-4, 5). The tonsured bearer of the tablets possibly represents a contemporary figure; the veiling of the hands implies that the book, with its commemorative inscription, is a sacred object. The place referred to in the inscription may be Monno, a town to the north of Brescia in Switzerland.

44. ARCHITECTURAL MEMBER. Northern Italy.

Limestone. Third quarter of the XIIth century.
H. 17 ½", W. 20 ½", D. 6" (44.5 × 52 × 15.2 cm.).
No. 1949.47.19. Purchase Alpheus Hyatt Fund.
Formerly Brummer Collection. Figs. 202 and 203.

Three architectural elements are carved from this single block. A rectangular impost, decorated on each long side by a fantastic quadruped with leaflike tail and wings, dominates the group. Beneath emerge the multiple triangular faces of small twin capitals which are enclosed by a cylindrical volute at either end; the faceted sides of the capitals create steeply arched intervals between the baskets. The bases of the capitals rest on a second smaller rectangular unit decorated with a foliate rinceau along the outer face. Neither end of the rectangular unit is decorated. A similar treatment of composite animals occurs on the south portal at Verona Cathedral; in both instances the beasts perch on the frame that encloses them within a rectangular field (E. Arslan, *La pittura e la scultura veronese*, Milan, 1943, figs. 96 and 97).

The Fogg capital seems to be a later development of a type encountered at San Procolo in Verona (W. Arslan, *L'architettura romanica veronese*, Verona, 1939, pl. III) as well as on the bell tower, in the cloister, and in the crypt of San Zeno (A. da Lisca, *La Basilica di S. Zenone in Verona*, Verona, 1941, figs. 3, 15, and 66). The handling of the capitals and the unification of the bases recalls the austere treatment of forms in the cloister and on the façade of San Zeno (W. Arslan, *L'architettura*, pl. CXXXI).

An inscription along the bottom frame on one side of the piece is badly abraded and barely decipherable: HO • CVMI[?] QIVI . . . TVS • C-VO.

45. ABACUS. Central Italy.

Limestone. First quarter of the XIIth century.
H. 5 ½", W. 12", D. 15" (14 × 30.5 × 38.2 cm.).
No. 1949.47.143. Purchase Alpheus Hyatt Fund.
Formerly Brummer Collection. Fig. 204.

A shallow pattern of interlace ornaments each face of this stone. On the longer side (left), diagonal movement dominates while on

the shorter face a less regular tangle results. Similarly structured interlace abounds in the decoration of central and north Italian churches, an inheritance from the pre-Romanesque period. Compare, for example, the archivolt of a window to the crypt of Santa Maria Forisportam in Lucca (W. Biehl, *Toskanische Plastik des frühen und hohen Mittelalters*, Leipzig, 1926, pl. 7a) as well as a cornice in the Civic Museum at Volterra (M. Salmi, *Romanesque Sculpture in Tuscany*, Florence, 1928, pl. XVI, note 48).

46. CORBEL. Northern Italy.
Marble. Ca. 1100.
H. 14 ½", W. 7 ½", L. 24 ½" (38.1 × 19.1 × 62.1 cm.).
No. 1949.47.54. Purchase Alpheus Hyatt Fund.
Formerly Brummer Collection. Fig. 205.

The head of a lion is shown devouring a small deer in its monstrous fanged jaws. The pupils of the beast's round eyes are inset with metal paste. The wiry mane with its rolled ends and the treatment of the deer's head bring to mind certain fragments from San Floriano (E. Arslan, *Scultura veronese*, figs. 104–11). These in turn perpetuate pre-Romanesque motifs. The encircled eyes and pitted forehead do recall the treatment of figures on some early eleventh-century capitals at Payerne in northwestern Switzerland (*Dictionnaire des Églises de France*, V, Paris, 1971, Section V-D, pp. 113–14).

47. ARCHITECTURAL FRAGMENT. Southern Italy.
Marble with traces of red polychromy. Second half of the XIIth century.
H. 9 ½", W. 16" (diam. shaft. 5 ½") (24.2 × 40.6 × 14 cm.).
No. 1949.47.31. Purchase Alpheus Hyatt Fund.
Formerly Brummer Collection. Fig. 206.

This massive marble fragment constitutes the upper portion of the right jamb of a doorway. The flat outer surface is decorated with furled addorsed acanthus leaves which carry a cluster of fruit or a

pine on the axis between them. A wide uncarved edge borders the design at the right. To the left, inset within a deep step, is the neck and part of a diagonally fluted column. The unit resembles the doorway frame still intact, except for the column, at San Leonardo near Siponto (C. Ricci, *L'architettura romanica in Italia*, Paris, 1925, pl. 197).

48. ARCHITECTURAL SUPPORT. Southern Italy.
Marble. Beginning of the XIIth century.
H. 14", L. 26", D. 11" (35.5 × 66 × 27.9 cm.).
No. 1949.47.35. Purchase Alpheus Hyatt Fund.
Formerly Brummer Collection. Fig. 207.

A crouching lion is carved in relief on the front face of a large, rectangular block. The flattened back of the animal probably served as a support for a long and shallow form above. Similarly rectangulated lions project from the façade and support the archivolt over the main door at Santa Maria di Siponto; these beasts rest on imposts over freestanding columns which are supported by additional lions carved fully in the round (Ricci, *L'architettura romanica*, pl. 199). The Fogg carving, which has lost its forelegs and most of its turned head, appears to be the pendant to a better preserved lion in the Wadsworth Atheneum (No. 9). That relief displays a similarly smooth body along with the same arching tail and flat, controlled treatment of the mane.

49. ARCHITECTURAL FRAGMENT. Southern Italy.
Marble. Late XIIth century.
H. 7", W. 13 ½" (28 × 34.3 cm.).
No. 1949.47.34. Purchase Alpheus Hyatt Fund.
Formerly Brummer Collection. Fig. 208.

Deep undercutting and strong use of the drill produce considerable élan on this small foliate fragment. The symmetrical design of paired leaves arching out from W-shaped tendrils transforms the surface of the stone into a decorative screen behind which loom the

shadowy recesses of the ground. The elegance and precision with which the intervals are drawn recall the crisp handling of interlace that bands the central section of the candelabrum at San Paolo fuori le mura (E. Hutton, *The Cosmati*, London, 1950, pls. 39–40). The vegetal design is particularly close to a frieze on the pulpit at Sessa Aurunca (Ricci, *L'architettura romanica*, pl. 242 bottom). This sculpture, somewhat more floridly executed than the Fogg fragment, intersperses figures carrying long leaves with the vine. Punctuation of the leaves by prominent veins and abundant drill holes characterize both carvings.

50. VOUSSOIR. Portugal (?).
Sandstone. Mid-XIIth century.
H. 22", W. 9", Diam. 13" (55.9 × 22.8 × 33 cm.).
No. 1949.47.12. Purchase Alpheus Hyatt Fund.
Formerly Elsberg and J. Brummer. Fig. 209.

A large-headed figure without a halo is cramped by a prismatic frame on this irregularly shaped block of coarse pebbly stone. The figure is shown holding a tiny book in his right hand and his robe in his left; the gestures are concentrated on the figure's right side. The wedge shape of the block; in addition to the slight curvature of the long sides, suggest that the figure may have been part of an archivolt.

The broad face, bulging eyes, and prominent brow point toward a northern Spanish attribution. Yet the soft stone and apparent structural use recall certain little-known sculptures in Portugal, for example those on an archivolt at the Church of Rates and others on a capital in the cloister at Leça de Balio (J. de Vasconcellos, *Arte romanica em Portugal*, Porto, 1918, pls. 121 and XXVIII).

51. VIRGIN FROM AN ANNUNCIATION (?).
Santa María de Tahull, Catalonia.
Wood with traces of polychromy. Ca. 1125.
H. 61", W. 15" (at shoulders) (154.9 × 38.1 cm.).
No. 1925.11. Gift of the Society of the Friends of the Fogg.

Formerly Collections of Henry Daguerre, A. Kann, A. Seligmann, Rey and Co., Paris. Fig. 210.

This handsome, enigmatic figure captured the attention of Edward Forbes, director of the Fogg, when he saw it in the fall of 1924 in an exhibition at the Carnegie Institute in Pittsburgh. The figure, identified then as an eleventh-century Burgundian Virgin of the Annunciation, had been given a more appropriate Spanish attribution by the time it was acquired in April 1925 (Fogg Archives). A. Kingsley Porter published the most extensive study on the carving in the *Fogg Museum Notes* for 1931. Perceiving the strong similarities between the Fogg figure and the frescoes from San Clemente de Tahull in Catalonia, Porter associated the sculpture with a group of then little-known Deposition carvings from that region. He dated the works shortly after the consecration of the church at Tahull, in the second quarter of the twelfth century ("The Tahull Virgin," *Fogg Museum Notes*, 1931, pp. 247–61). A photograph Porter had found in the late 1920s at the Institut d'Estudis Catalans in Barcelona appeared to assure association of the carving with Tahull. The picture showed the Fogg carving in the company of a group of five smaller figures, four of which—including a Virgin—constituted the remains of a Deposition scene; these are now in the Museum of Catalan Art in Barcelona. Porter noted that the group had been discovered in 1907, by an official Committee of the Institut, behind the retable in the Church of Santa María, a stone's throw from San Clemente (ibid., pp. 252–55 and fig. 6).

A second, larger Deposition group had been found the following year by the same team of Institut scholars in the bell tower at Erill-la-Val (Lérida). This group of seven figures is presently divided between the Barcelona Museum and the Museum in Vich (ibid., pp. 261–65 and fig. 13; also Porter, *Spanish Romanesque Sculpture*, II, New York, 1928, p. 16). Finally, a Virgin, lone surviver from a third such group, was transferred apparently in the early 1920s from the church at Durro (Lérida) to the Barcelona Museum (ibid., pl.71b, and J. Folch y Torres, *Museo de la Ciudadela: Catálogo de la Sección de arte románico*, Barcelona, 1926, p. 102, No. 47).

The use of such large, polychromed sculptures inside churches has not been well explored; it may be that such ensembles emerged in relation to the development of dramatizations of portions of the

Easter liturgy (see above Gardner Museum, No. 17). The most thoroughly documented Deposition ensemble, dating from the thirteenth century, has long been prominently displayed near the altar in the Church of San Juan de las Abadesas (Porter, "Tahull Virgin," pp. 255–59 and fig. 7).

The three vigorously carved wooden Virgins in Barcelona are strikingly similar to the Fogg figure in pose and attire. The most unusual attribute of all the women is their curious oval headdress which reappears on a standing Virgin in the apsidial fresco from San Clemente (ibid., fig. 3). The headdresses of the Virgins from Durro and Erill-la-Val are decorated with a carved pattern of interlaced ribbons; traces of black paint on the Fogg Virgin's modified coiffure indicate that her hat was formerly ornamented with a comparable design. However, the gestures of the Cambridge figure differ significantly from those on the Spanish sculptures and serve to distinguish the former work. On the Fogg piece, the lower arms are held close to the body and the right palm is raised against the chest, the traditional response of acknowledgment found in Annunciation scenes (e.g., the relief in the cloister at Silos; Porter, *Spanish Romanesque Sculpture*, II, pl. 84). In the Barcelona carvings, the bent arms are mournfully extended to receive the lifeless body of the descending Christ.

Shortly after the Fogg acquired its carving, a similar sculpture, showing a woman with both hands raised against her chest, appeared on the Paris market. It was purchased from the dealer Bacri by an anonymous American collector and its present whereabouts are unknown (J. Folch y Torres, "Nota al Treball del Professor Kingsley Porter, sobre 'La Verge de Tahull,' " *Butlleti dels Museus d'Art de Barcelona*, II, May 1932, pp. 136–37). The existence of this sculpture suggests that there may have been a number of such carvings not intended for Deposition groups. While Porter reportedly saw an angel in the Barcelona Museum which he thought to be a companion of the Fogg figure (*Annual Report*, 1924–25, p. 4), Puig i Cadafalch reported that the Virgin had been found with a St. John (*Anuari*, VII, pp. 207–208 and Porter, *Spanish Romanesque Sculpture*, II, p. 14). The original function of the Fogg sculpture is in need of further study.

Bibliography

Annual report of the Fogg Museum, 1924–25, p. 4; P[uig i] C[adafalch] in *Anuari, Institut d'Estudis Catalans,* VIII, 1921–26, pp. 207–208; A. K. Porter, "The Tahull Virgin," *Fogg Museum Notes,* II, 1931, pp. 246–72; Porter, "La Verge de Tahull," *Butlletí dels Museus d'Art de Barcelona,* II, 1932, p. 120ff.; Porter, *Spanish Romanesque Sculpture,* II, New York, 1928, pp. 13–17 and pl. 71; *Fogg Museum Handbook,* 1931, p. 24; F. Duran Canyameres, "Un nota sobre els 'davallments' romanics catalans," *Butlletí dels Museus d'art de Barcelona,* II, 1932, pp. 193–200; W. W. S. Cook and Jose Gudiol Ricart, *Pintura e Imaginería Románicas,* Ars Hispaniae, VI, Madrid, 1950, p. 322ff.; Juan Ainaud, "La sculpture polychrome catalane," *L'Oeil,* 1955, pp. 33–39, No. 4; *Spanish Medieval Art: Loan Exhibition in Honor of W. W. S. Cook;* The Cloisters, New York, 1955, No. 33; *L'art roman: Exposition organisée par le gouvernement espagnol sous les auspices du Conseil de l'Europe,* Barcelona, 1961, p. 183.

52. CORPUS FROM A DEPOSITION AND CROSS.
Catalonia.
Wood with traces of polychromy. Ca. 1200.
H. 6', W. 56" (182.9 × 142.2 cm.).
No. 1970.21. Gift of Joseph P. Richardson in memory of F. L. W. Richardson, Class of 1899. Fig. 211.

The serene head of the dead Christ inclines toward the left arching over his sloping shoulders and slender torso. The arms, which are lost, were originally carved separately; they appear, from the tilt of the shoulders, to have been loosened from the Cross. Christ's loincloth, bent right knee, and decoratively incised rib-cage and abdomen associate this carving quite closely with a group of Catalonian Depositions rather than with the hieratic, fully clothed Majestic Crucifixions of the Volterra type (see above, Gardner Museum, No. 17). The *corpus* particularly resembles the Christ from the Deposition group found early in this century at Santa María de Tahull and dated by A. Kingsley Porter, in part because of the bent posture of the legs, to the early years of the thirteenth century ("Tahull Virgin," pp. 259–61).

But there are more grace and pathos in the Fogg carving than in that Spanish one. The deeply gouged series of V-shaped folds in the loincloth, which emphasizes the diagonal movement of the

knee, recalls the vigorous carving on the Virgin from Durro and on
the St. John from Erill-la-Val, both originally from Catalonian De-
position groups (ibid., figs. 5 and 13). A patch of pink and red
pigment at the right of the chest dramatically preserves the wound;
unlike the Tahull figure, however, no supporting hand is visible
along the body of Christ. The austere head of the figure bears
patches of black paint along the drooping moustache and short
beard. The undifferentiated treatment of the hair as it falls behind
the round protruding ears recalls the handling of that area on a
Catalonian Crucifixion in the provincial museum at Vich (Fogg
Photo 276 Sp. 213 26C [f] 1a). Unlike the figures to which it can be
linked by style, Christ wears an unusual narrow rope fillet, which,
in appearance, is more suggestive of a crown of thorns than a di-
adem.

Both legs are lost at mid-calf. In addition, the body, which
though independent of the Cross is carved as a relief, is attached to
a seemingly new backing of wood. The lobed Cross itself, which
retains large patches of brick red polychromy, is extremely large for
the *corpus* and ill suited to its expressive posture. Although old, it
is very likely not the original mount for it.

53. COLUMNAR SUPPORT. Three addorsed apostles, halos inscribed + MATTHIAS ∴, ET IUDE ∴, + SIMONIS. Monas-
tery of San Pelayo Antealtares, Santiago de Compostela (Galicia).
Greyish white marble veined with black; traces of polychromy on
shaft. Second quarter of the XIIth century.
H. 45¾", D. 7" (top of shaft) (116.2 × 17.8 cm.).
No. 1933.100. Gift of the Republic of Spain through the Museo Ar-
queológico Nacional and Professor A. Kingsley Porter. Fig. 212.

According to a description of 1605, this column served as one of
four supports for the altar at San Pelayo, a Benedictine monastic
church immediately to the east of the great pilgrimage shrine of St.
James in Compostela. One of the supports was separated from the
group early in the eighteenth century when the altar was disman-
tled and replaced by a modern structure; its present whereabouts
are unknown. The remaining three columns survived at San Pelayo
until 1926 or 1927 when they were transferred to the National Ar-
cheological Museum in Madrid (A. K. Porter, "Santiago Again,"

Art in America, XV, 1927, pp. 109–10). In 1933, the Spanish government offered the Fogg one column in partial exchange for the celebrated eleventh-century sarcophagus of Alfonso Ansúrez which had been removed from Spain a few years before.

The apostles appear to be suspended against the Fogg column; they wrap their weightless, sandaled feet around coiled leaves which project, as supports, above the ornamented base of the shaft. The figures have smaller heads, are thinner, and are more simply dressed than are the forms on either of the columns in Madrid. They are also more uniformly posed. Each presses a bent left arm against his chest clutching either a book (Matthias, Jude) or a scroll (Simon) between palm and extended thumb. The right arms of the former two apostles reach diagonally across their bodies establishing a counterclockwise movement which is resolved in Simon; his stance is stabilized by the triangular arrangement of his stiff right arm and dangling scroll on the one hand and the un-broken sweep of drapery on the other. Yet the composition of the column, rather than being continuous, is calculated for two op-posing views: when the slightly broader, impassive Matthias is seen dominating one face, Jude and Simon, whose heads incline toward one another, share the complementary view.

The figures bear certain minor similarities in pose and paleog-raphy to apostle reliefs from the cloisters of Saint-Etienne in Toulouse and at Silos in Spain and should probably be dated with these sculptures early in the second quarter of the twelfth century (G. Gaillard, "Les statues-colonnes d'Antealtares à Saint-Jacques de Compostelle," Bull. Soc. Nat. Antiq. France, 1957, p. 177; M. Schapiro, "From Mozarabic to Romanesque in Silos," Art Bulletin, XXI, 1939, p. 354, note 147 and p. 366; W. R. Tyler, "A Spanish Romanesque Column in the Fogg Art Museum," Art Bulletin, XXIII, 1941, p. 52). Work in the cloister at Santiago was begun in 1124 and continued at least throughout the next decade (K. Conant, The Early Architectural History of the Cathedral of Santiago de Compostela, Cambridge, 1926, pp. 39, 41, and 42). The San Pelayo columns, analogous to the larger figured support in the cloister at Saint-Ber-trand-de-Comminges, may originally have been carved for this con-text (Porter, Pilgrimage Roads, IV, p. 492).

The monks of San Pelayo had served the altar over St. James's tomb until the rebuilding of the basilica forced them to move to the east in 1077. Lopez Ferreiro theorized that, at that time, they may

have taken the altar with them and had the figured columns carved as supports (A. Lopez Ferreiro, *Historia de la Santa A. M. Iglesia de Santiago de Compostela,* I, Santiago, 1898, pp. 277–79). Porter demonstrated that the altar had not left Santiago at that early date but was in fact remodeled in 1105; he attributed the columns to the early twelfth-century campaign (*Spanish Romanesque Sculpture,* II, pp. 5–7). Porter suggested that the columns, along with the original altar, were transferred to San Pelayo around 1135 when the bishop, Diego Gelmírez, began his second modernization of the altar over James's tomb and sealed the crypt. Tyler concluded that the original altar was never moved from Santiago. He pointed out that a second altar existed and that this could have come to San Pelayo at any time. He detached the columns from any relationship to the apostle's basilica but continued to view them in conjunction with the altar (Tyler, "Romanesque Column," pp. 46–47).

The use of such columnar supports for an altar table is virtually unknown. Recently L. Pressouyre called attention to the single stylized representation of an orant priest on a columnar support for the main altar at the Church of San Giorgio in Brancoli (Lucca) dated to the early twelfth century (Review of *The Renaissance of the Twelfth Century* in *Revue de l'Art,* VII, 1970, p. 100 and fig. 8). Although the priest, a worldly servant of the contemporary church, would have been acceptable as a type for inclusion in such a weight-bearing position, the apostles, who were perceived at the time as ideal "brethren" of the monks, were viewed only metaphorically as supports. This spiritual rather than architectonic function is stressed by the weightless pose of the figures on the columns. In addition, the absence of any base for the more massive column in Madrid and the disparate size and proportions of the three shafts suggests that the pieces were not planned as part of an intimate program.

Tyler noted that reconstruction of San Pelayo was begun in 1122 ("Romanesque Column," p. 46) contemporaneous with work in the Santiago cloister. The rebuilding was undoubtedly linked to Bishop Gelmírez' attempt to improve discipline at the Benedictine monastery (Lopez Ferreiro, *Historia,* IV, pp. 65 and 146–47). Representations of the apostles were included in the cloister program of several newly reformed abbeys during the first half of the twelfth century (see the author's "A Romantic Forgery: The Romanesque 'Portal,' of Saint-Etienne in Toulouse," *Art Bulletin,* L, 1968, pp. 33–42);

it is entirely possible that the Antealtares columns, which appear not to have been conceived as part of an altar, were originally carved in conjunction with this building campaign at San Pelayo.

Nevertheless, Pressouyre's suggestion that the statue-column as a type may have developed within the tradition of liturgical furnishings remains a provocative one worth further exploration. The insistence on the use of marble, even when the grain interferes with the design (as in Jude's legs), implies that the choice of that material was in itself an important factor in the conception of the San Pelayo columns; furthermore, the ornamental handling of the sculpture's surface is consistent with marble carving rather than monumental stone techniques of the period. The enclosure of smooth rounded areas with incised decorative ribbons is analogous to the composition of the enthroned Christ in the ambulatory at Saint-Sernin in Toulouse, a somewhat earlier marble piece of similarly uncertain usage (Porter, *Pilgrimage Roads*, IV, p. 296).

Figured shafts served multiple functions in liturgical furnishings of the twelfth and thirteenth centuries. In Italy, figured shafts appear frequently in the period serving as lecterns or introduced decoratively at the angles of pulpits. The Museum of Fine Arts in Boston recently acquired a work of the late twelfth century in which three standing figures holding books are arranged on three sides of a rectangular shaft. Hanns Swarzenski suggested that the group represented writers of the Epistles and served originally as a lectern on a Tuscan pulpit ("Before and After Pisano," *Bulletin of the Museum of Fine Arts*, LXVIII, 1970, pp. 181–82, and above, Boston No. 15). Among the royal tombs in the church of Las Huelgas in Burgos, Spain, is an anonymous one in the portico, dated in the third decade of the thirteenth century, which is crowned by a vaulted canopy resting on six figured columns. Peter and Paul face one another at the center across the bodies of the deceased while the paired angels at the heads and feet face the length of the lid. The whole rests on a richly carved sarcophagus with a representation of the Majestas flanked by apostles (M. Gómez-Moreno, *El Panteón Real de las Huelgas de Burgos*, Madrid, 1946, pls. XII–XIII and p. 13). Precedents for the Burgos tomb do not readily come to mind. We do know that the ciborium over the apostle's tomb at Compostela was supported by four columns (J. Vielliard, *Le Guide du Pèlerin*, 3d, ed., Mâcon, 1963, pp. 112–13) and M. Chamoso Lamas even suggested that the Antealtares sculptures were origi-

nally planned for that location (*Santiago de Compostela; Guias artisticas de España*, Barcelona, 1961, p. 138). A comparable usage inside San Pelayo should also be considered.

Bibliography

J. Fernandez Sanchez and F. Barreiro, *Santiago, Jerusalem and Roma*, I, Santiago, 1880, pp. 275–79; A. Lopez Ferreiro, *Historia de la Santa A. M. Iglesia de Santiago de Compostela*, I, Santiago, 1898, pp. 277–79; Porter, *Pilgrimage Roads*, I, p. 220, VI, pls. 705–708; Porter, "Santiago Again," *Art in America*, XV, 1927, pp. 96–113; Porter, *Spanish Romanesque Sculpture*, I, pl. 59 and II, pp. 4–8; J. Braun, *Der christliche Altar*, I, Munich, 1924, p. 165, pl. 19; X. C. Garcia, "Os piares do altar do mosteiro de San-Pelayo de Sant-Yago," *Boletín de la Academia Gallega*, 1931, pp. 8–9, pl. II; *Parnassus*, V, October 1933, p. 28; *Annual Report of the Fogg Art Museum*, 1932–33, p. 3; Anon, "A Gift of a Romanesque Sculpture from the Spanish Government," *Bulletin of the Fogg Art Museum*, III, 1934, pp. 14–17; E. Camps Cazorla, *El Arte románico en España*, Barcelona, 1935, p. 155, fig. 23; *Fogg Art Museum Handbook*, Cambridge, Mass., 1936, p. 36; M. Schapiro, "From Mozarabic to Romanesque in Silos," *Art Bulletin*, XXI, 1939, p. 354, note 147, p. 366. *Arts of the Middle Ages: Catalogue of a Loan Exhibition, Museum of Fine Arts*, Boston, 1940, pl. XXII, No. 166; W. R. Tyler, "A Spanish Sculpture in the Fogg Museum," *Art News*, March 2, 1940, p. 13; Tyler, "A Spanish Romanesque Column in the Fogg Art Museum," *Art Bulletin*, XXIII, 1941, pp. 45–52; H. Sedlmayer, *Die Entstehung der Kathedrale*, Zurich, 1950, p. 207; *Spanish Medieval Art: Loan Exhibition in honor of W. W. S. Cook*, pl. IV, No. 32; G. Gaillard, "Les statues-colonnes d'Antealtares à Saint-Jacques de Compostelle," *Bull. Soc. Nat. Antiq. France*, 1957, pp. 171–79; M. Chamoso Lamas, *Santiago de Compostela: Guías artísticas de España*, Barcelona, 1961, pp. 136–38; *L'Art roman*, Exposition organisée par le gouvernement espagnol sous les auspices du Conseil de l'Europe, Barcelona and Santiago, 1961, pp. 569–570, Nos. 1894, 1895; M. Durliat, *L'art roman en Espagne*, Paris, 1962, pp. 85–86, No. 236; R. Calkins, *A Medieval Treasury*, Ithaca, N.Y., 1968, pp. 137–38, No. 53; Seidel in Scher, *Renaissance*, Nos. 34–36, pp. 101–102, Nos. 34–36; L. Pressouyre, "La Renaissance du XIIe siècle," *Revue de l'Art*, VII, 1970, pp. 99–100 and fig. 7.

54. TWO CAPITALS AND TWO ABACI. Santa María de Lebanza (Palencia).

Limestone. 1185–90.

(a-1) CHRIST IN MAJESTY exhibiting his wounds; accompanied by the symbols of the Evangelists and by four apostles holding the instruments of the Passion. Capital from engaged twin columns. Red polychromy on robes and cross.
H. 25″, W. 24″ (top), D. 15″ (63.5 × 61 × 38.2 cm.).
No. 1926.4.1. Figs. 213 and 214.

(a-2) Abacus. Foliage on lower edge, inscribed above PETRUS CARO PRIOR (F)ECIT ISTA ECLESIA ET DOMUS ET CLAUSTRA OM(NI)A QUE AB E F(U)NDAT ERA MCCXXIII. Mortar and red polychromy.
H. 6″, W. 31″, D. 18 ¾″ (15.2 × 78.6 × 47.8 cm.).

(b-1) The Three Marys at the Tomb. Capital from engaged twin columns.
H. 25″, W. 25″ (top), D. 17″ (63.5 × 63.5 × 43.2 cm.).
No. 1926.4.2. Fig. 215.

(b-2) Abacus. Foliage on lower edge, inscribed above ISTO: ARCO FECI RODRICUS GUSTIUT VIR VALDE BONU(S) (M)ILLITE ORATE PRO ILO.
H. 6 ¼″, W. 31″, D. 18″ (15.9 × 78.6 × 45.8 cm.).

Gift of the Society of the Friends of the Fogg Art Museum. Formerly Arthur Byne and D. Antonio Augustin.

Two imposing historiated capitals with inscribed abaci, acquired for the Fogg by Paul Sachs from the Madrid dealer Arthur Byne, are all that survive of the medieval abbey of Santa María de Lebanza (also Alabanza) founded in the mountainous region northeast of León in 932 by Count Alfonso and his wife, Justa. A cartulary, preserved in the Episcopal Archive in Palencia, records a few gifts of land to the abbey during the tenth century. Royal confirmation in 1142 of the original foundation mentioned extensive holdings including some as far north as Liébana (R. Navarro García, *Catálogo monumental de la Provincia de Palencia*, III, 1939, pp. 275–76); these were increased with a donation by Alfonso's son Sancho III in 1158 (M. A. García Guinea, *El Arte Románico en Palencia*, 1961, p. 155). An entry of 1179 records that Bishop Raimundo of Palencia offered pardon to those who contributed to the enlargment and rebuilding of the abbey suggesting that construction was then underway (ibid.). The work would seem to have been completed six years later judging from an inscription on one of the Fogg capitals which

dates the rebuilding under Prior Peter to 1223 of the era, that is 1185 (fig. 214). When the church was destroyed late in the eighteenth century under Carlos III in order to permit the modernization of the structure (Navarro García, *Catálogo*, III, p. 190), the Fogg capitals were walled in at either side of an entrance arch in the new church (Porter, *Spanish Romanesque Sculpture*, II, note 883). In 1929, the church was described as having been cruciform in plan and in ruins (L. Huidobro Serna, "El arte visigótico de la Reconquista en Castilla," *Boletín de la Comisión provincial de monumentos históricos y artísticos*, 1929, p. 402, No. 25).

Both friezelike capitals originally crowned a pair of engaged columns; their iconography suggests that they may have been located at the crossing of the church. The upper portion of each piece is composed of three flat trapezoidal faces which intersect sharply and which provide excellent neutral fields for the presentation of bold narrative compositions. Carefully defined and projecting horizontal limitations—an "internal" abacus carved in low relief along the quadrangular crown of the drum and salient faceted astragals circling the cylindrical baskets below—create shallow stages for the figures. The main event of each representation is carefully centered and limited to the front face; related complementary figures are arranged on the sides framing these scenes.

Two distinct subjects are fused on the first Fogg capital. The combination of Christ shown with a cruciform nimbus, enthroned in a mandorla, surrounded by the four symbols of the Evangelists, and accompanied by standing figures on either side, essentially recalls the Majesty and *Apostolado* group on the façade of the nearby church of San Pedro de Moarves and another at the cathedral of Santiago in Carrión de los Condes (Porter, *Pilgrimage Roads*, VI, pls. 723–26 and 729). On the Fogg sculpture, the apocalyptic animals, instead of hovering beyond the frame of the mandorla, overlap it, the angel and eagle actually supporting themselves on the crosspiece of the Glory which serves as Christ's seat. The manner in which the latter two creatures grab the wrists of Christ's raised arms calls attention to the fact that Christ is not shown in Majesty on the Lebanza carving but rather is seen as the Redeemer, displaying the wounds in his hands and bared chest (for a discussion of the iconographical type see R. Berger, *Die Darstellung des thronenden Christus in der romanischen Kunst*, Reutlingen, 1926, esp. p. 192ff.). A similar figure of Christ appears on a capital from the

destroyed Palencian Church of Santa María la Real near Aguilar de Campoo a few miles southeast of Lebanza. On this carving, now in the Museo Arqueológico Nacional in Madrid, Christ's arms are held higher and he is shown without either a mandorla or beasts. He is accompanied to his right by a nimbed angel holding, on veiled hands, the bar of a jeweled Cross and, to his left, by another angel shown with the nails. Two additional angels appear on each of the sides of the capital holding other instruments of the Passion (García Guinea, *Palencia*, pl. 140a and p. 192, and E. Buschbeck, *Der Pórtico de la Gloria von Santjago de Compostela*, Berlin, 1919, p. 50 and fig. 56). Christ's companions on the Fogg capital are neither winged nor nimbed and are only four in number but they, like those on the Madrid sculpture, support a Cross at the left and nails, in addition to a lance, at the right.

The source for both capitals as well as for a rustic tympanum at the church of Bascones de Valdivia near Lebanza (García Guinea, *Palencia*, fig. 252) can only be Master Mateo's innovative carving begun in 1168 for the Pórtico de la Gloria at Santiago de Compostela. There Christ is shown in the tympanum over the central doorway with his chest bared, displaying his wounds and surrounded by the four Evangelists—three of which hold their appropriate apocalyptic beasts. To either side, along the base of the tympanum, stand angels holding the instruments of the Passion. The Fogg capital, by including aspects of both Majesty and Redemption, adheres closely to Mateo's invention. Both Lebanza and Aguilar de Campoo were located slightly to the north of the road which passed through Carrión de los Condes on its way from Santiago through León to Burgos (ibid., pp. 22–23) assuring frequent contact with the pilgrimage center. Although Mateo's name continued to appear in documents until 1217, an inscription on the portal dates completion of the Pórtico to 1188 (Buschbeck, *Pórtico*, pp. 10–12). A date in that decade is usually accepted for the sculpture and is compatible with the date applied to related work in Avila (see M. Gómez-Moreno, intro. to García Guinea, *Palencia*, pp. x–xii and José Pita Andrade, "Visión actual del románico de Galicia," *Cuadernos de estúdios Gallegos*, XVII, 1962, p. 147, No. 52 on the similarities between Compostela and Avila). A date between 1185 and 1190 has independently been suggested for the capital with the Redeemer from Aguilar de Campoo on the basis of stylistic similarities to work at Avila (W. Goldschmidt, "El sepulcro de

San Vicente de Avila," *Archivo Español de Arte y Arqueología,* 1936, p. 170).

The second capital from Lebanza again recalls a capital from Santa María la Real also in Madrid (García Guinea, *Palencia,* pl. 140b); this time an abridgment rather than expansion of the iconography is involved. The tall main field on the Lebanza capital shows a diminutive barefoot angel encased in heavy draperies, astride the tomb facing left. The figure turns its upper torso around and points dramatically to the right at the abbreviated inscription on the coffin's cover: SIMILE: SEPULCRO: D̄N: Q̄ADO. A flourish of drapery, in appearance like a tablecloth, emerges below the lid of the tomb. The first Mary stands behind the coffin, in the center of the capital, holding an ointment pot. Her feet, rather than straddling both astragals as do Christ's, are twisted so that they both rest against the left drum. She turns away from the angel and glances toward the second Mary who stands to the right holding one hand against her brow. The remains of a broken ointment pot can be seen on her veiled left hand. The third Mary, who repeats the hand gesture, is visible around on the right side; all three women wear high headdresses consisting of a crowned element from which a draped hood descends. Behind the angel, overlapped slightly by one of its heavily feathered wings, appears a male figure dressed in a short tunic and carrying an instrument with a picklike head that appears to be a mattock. The emphatic gestures of the main figures visually reconstruct the chain of responses found in the liturgical dramatization of the *Quem Quaeritis* passages from the Gospels of Matthew, Mark, and Luke in which the visit to the sepulchre by the holy women on Easter morning is recounted (see O. B. Hardison, Jr., *Christian Rite and Christian Drama in the Middle Ages,* Baltimore, 1965, and R. Donovan, *Liturgical Drama in Medieval Spain,* Toronto, 1958, p. 11). The sense of the inscription on the sarcophagus contributes further to the representational effect of the scene.

The style of both Fogg capitals is defined by stoic, large-headed figures whose ability to move freely in space is emphasized by abundant, wrinkled garments. The carving is deep and linear elements are well integrated with the faceted, at times exuberant, edges they describe. The facial type is especially memorable: eyes bulge from well-defined orbits producing a mildly ecstatic expression. Yet the deeply bowed set lips, which are framed by fine inci-

sions or moustaches along the inner contours of the cheeks, protrude above a firm chin in a pronounced scowl. Both the austere facial type and the agitated whorling draperies link the Lebanza figures to certain apostles on the façade at Moarves dated shortly after the group at Carrión de los Condes, ca. 1185. (García Guinea, *Palencia,* pp. 126 and 167, pls. 111 and 112a). However, this author's suggestion that the Moarves sculptor was the Master of the Lebanza capitals is not convincing on the basis of available photographic material.

García Guinea correctly linked to Lebanza a capital with Samson killing the lion at the church of Santa Eugenia at Dehesa de Romano (ibid., pl. 119, pp. 39–40 and 169–70) as well as several spirited historiated capitals on the portal at Arenillas de San Pelayo (ibid., pls. 183–85 and pp. 245–47). These latter works, which are exceedingly close to the Fogg capitals in figure style, provide an important link with two capitals in the Walters Art Gallery which have been related to Lebanza and associated generally with a Palencian milieu (D. Glass, *Gesta,* IX/1, 1970, pp. 57–58, figs. 21a–22b). Most significantly, the identical curious iconography of one of the Baltimore capitals, in which two figures place their hands in the mouth of an animal mask, occurs on two faces of one of the Arenillas capitals (García Guinea, *Palencia,* pl. 185c, illustrated also in Porter, *Spanish Romanesque Sculpture,* II, pl. 110). The relationship between these works is worth further investigation.

In conclusion, then, the similarity of style and iconography to north Spanish and particularly Palencian monuments affirms the general provenance of the unique Lebanza carvings and supports a date in the 1180s for the sculptures.

Thick foliate decoration on both abaci provide canopies over the faces of the capitals. Inscriptions, in decorative epigraphy, are carried on the upper part of the blocks while chains of entwined leaves curve around and under the lower portion. The foliage on the abacus above the Christ capital is lush and rhythmic, carved away from the angled ground in palpable clusters which overhang the capital like clouds. The leaves above the Marys capital are pointed, marked by prominent central veins and are punctuated occasionally by small drill holes. Patches of ornamentally shaped shadows separate the flat stencil-like petals which are organized at the center and ends to form a row of undulant stars.

Bibliography

Annual Report of the Fogg Art Museum, 1925–26, p. 272; M. S. Byne, *The Sculptured Capital in Spain*, New York, 1926, pl. 105; *Art News*, December 31, 1927, p. 1ff.; A. K. Porter, "The Alabanza Capitals," *Fogg Museum Notes*, II, 1927, pp. 91–96; Porter, *Spanish Romanesque Sculpture*, II, p. 32, pls. 103–104; *Fogg Art Museum Handbook*, 1931, p. 23; R. Navarro García, *Catálogo monumental de la Provincia de Palencia*, III, 1939, pp. 186–92, 275–76; J. Pijoán, *El arte románico:* Summa Artis, IX, Madrid, 1944, p. 537 and figs. 845–48; J. Gudiol Ricart and J. A. Gaya Nuño, *Arquitectura y escultura románico*, Ars Hispaniae, V, Madrid, 1948, p. 257 and figs. 404–5; M. A. García Guinea, *El Arte Románico en Palencia*, 1961, pp. 154–57, pls. 101–8; J. A. Gaya Nuño, *La arquitectura española en sus monumentos desaparecidos*, Madrid, 1961, p. 146; Scher, *Renaissance*, p. 119 and fig. 42a.

55. DOUBLE CAPITAL AND ABACUS. Santa María la Real, Aguilar de Campoo (Palencia).

Limestone. Ca. 1160–75.
H. 14 ⅝", W. 24 ⅝", D. 12 ⅜" (37 × 62.5 × 31.4 cm.).
H. 4 ⅞", W. 30 ¼", D. 19" (12.5 × 77 × 43.3 cm.).
No. 1933.99a and b. Gift of the Republic of Spain through the Museo Arqueológico Nacional and Professor A. Kingsley Porter. Fig. 216.

Fabulous animals entwined in a thick, deeply undercut vine ornament all faces of this double capital. A true griffon, identifiable by its feline body, the feathery wings and beak of an eagle, and the pointed ears and bearded chin of a goat, appears back to back with a wingless leonine monster on both of the long sides. The interval between the animals' heads is filled by a symmetrical interlace of sprouting tendrils; similar knotted forms replace volutes at the angles. The abacus is decorated with a running vine of fleshy coiled acanthus leaves accented at the angles by monstrous and human heads.

Addorsed griffons appear frequently on capitals at churches in the vicinity of Burgos and Palencia (J. Pérez Carmona, *Arquitectura y escultura románicas en la Provincia de Burgos*, 1959, fig. 132, Rebolledo de la Torre and fig. 198, Jaramillo de la Fuente; García Guinea, *Palencia*, pl. 250, Torre Marte at Astudillo). Animals, including griffons, caught in heavy vines are the theme of a group of capitals in

the south and west walks of the cloister at Silos (J. Pérez de Urbel, *El Claustro de Silos,* Burgos, 1930, pp. 161–70).

The Fogg capital was one of several removed in 1871 from the ruined church of Santa María la Real and taken to the archeological museum in Madrid. The first continuous evidence of the existence of the monastery, which lies a few kilometers from Aguilar de Campoo near Burgos, begins in 1039 when Countess Doña Ofresa made numerous donations in exchange for the promise of being buried there. In 1162, Santa María was given to the Premonstratensians and became their most important house in Spain (García Guinea, *Palencia,* p. 188). Rebuilding by the order made use of earlier construction at the church, particularly at the crossing (E. Lambert, *L'art gothique en Espagne,* Paris, 1931, pp. 124–25). García Guinea associated the Fogg and related capitals still in Madrid with the chapter house and attributed them to a sculptor who had worked with the second master of the Silos cloister around the middle of the century (*Palencia,* pp. 193–94). But a photograph of the chapter house shows it to be well preserved and in an austere Gothic style, consistent with the date of 1209 found on a column in the room (ibid., p. 189; cf. plate XIX in Lambert, *L'art gothique*). Durliat observed that the group of Madrid capitals came from a ruined cloister walk (*L'art roman en Espagne,* Paris, 1962, p. 74), a suggestion more in keeping with the stylistic evidence. A date late in the third quarter of the century is indicated by the similarities between the Fogg capital, one in the west walk at Silos (ca. 1150) and another in the chapter house of a Premonstratensian priory founded at Santa Cruz de Ribas in 1176 (García Guinea, *Palencia,* pp. 201–2, pls. 155–56). The Fogg capital was incorrectly located in Madrid in García Guinea's study on Palencia (ibid., pl. 138b).

Bibliography

V. Lampérez de Romea, *Historia de la arquitectura cristiana española en la Edad Media,* III, Madrid, 1930, pp. 405–10; E. Lambert, *L'art gothique en Espagne,* Paris, 1931, pp. 123–25, pl. XIX; *Annual Report* of the Fogg Art Museum, 1932–1933, p. 3; "A Gift of Romanesque Sculpture from the Spanish Government," p. 16, fig. 3; Navarro García, *Catálogo monumental de Palencia,* III, pp. 259–71; García Guinea, *Palencia,* pp. 185–95; Calkins, *A Medieval Treasury,* No. 49.

56. FRAGMENT OF AN ABACUS. Northern Spain.
Limestone. First half of the XIIth century.
H. 5″, W. 13″, D. 10″ (12.7 × 33.2 × 25.4 cm.).
No. 1949.47.22. Purchase Alpheus Hyatt Fund.
Formerly Brummer Collection. Fig. 217.

The badly eroded ornamentation consists of flat leaves framed by paired furled ones. Part of the central motif has been cut away on the right side. Deep undercutting which silhouettes edges of the central leaves is the most noticeable feature. The basic pattern appears frequently on capitals as well as abaci in southwestern French and Pyrenean churches. At Lescar, rich modeling defines each element more precisely (M. Durliat and V. Allègre, *Pyrenées romanes*, Collection Zodiaque 1969, fig. 98). The elongation of the leaves here and the emphatic pointed contours recall the foliate decoration on a capital at Loarre (G. Gaillard, *Les débuts de la sculpture romane espagnole*, Paris, 1938, pl. LXI-3).

57. ARCHITECTURAL FRAGMENT. North central Spain.
Limestone. Middle of the XIIth century.
H. 9″, W. 10″, L. 21″ (22.8 × 25.4 × 53.4 cm.).
No. 1949.47.153. Purchase Alpheus Hyatt Fund.
Formerly Brummer Collection. Fig. 218.

The stylized head and neck of a bull dominate this stained fragment. The tip of a tail is visible along the right flank, but the lower portion of the piece, including the mouth and crouching forelegs, appears to have crumbled away from deterioration. The piece is flat along the top and may originally have served as a corbeled support similar to the one beneath the figures of Saint Isidore and Saint Pelagius at San Isidoro in León (Porter, *Pilgrimage Roads*, VI, p. 696). The collar of rings around the neck and similar groups of shallowly carved ridges on the head and hips preserve the massive effect of the block. Only two large round bulbous eyes circled by multiple rings interupt the regularity of the surface skin. The fragment can be compared to the winged bull in the spandrel above the tympanum at the church of Santa María la Real in Sangüesa (L-M. de Lojendio, *Navarre romane*, Collection Zodiaque, 1967, figs. 53–55) and to the head of a bull at Santa María de Arbas (A. Viñayo Gonzalez, *Léon roman*, Collection Zodiaque, 1972, fig. 112).

XIII

Doubtful Authenticity

Wadsworth Atheneum, Hartford, Conn.

RELIEF WITH FIGURE PRUNING A PLANT.
Said to come from Autun.
Limestone. H. 11 ¼", W. 8" (28.5 × 20 cm.).
No. 1971.52.130. Bequest of Henry Schnakenberg.
Formerly Collections of Sigismond Bardac, George Hoentschel (1928),
and Alphonse Kann, Paris. Fig. 219.

Adaptation of a figure of the Mystic Winepress capital at Vézelay
(Salet-Adhémar, *Vézelay*, No. 20).

Bibliography

*Judaica . . . Medieval and Renaissance Art . . . from the Collection of Zalman
Yovely*, Parke Bernet, March 17, 1955, p. 48, No. 205.

Worcester Art Museum, Worcester, Mass.

ORANS VIRGIN.
Marble. H. 63 ¼", W. 16 ½" (161 × 42 cm.).
No. 1946.31. Formerly H. Daguerre, Paris, and J. Brummer, New York.
Fig. 220.

Bibliography

Worcester Art Museum Bulletin, May 1946; *Art Through Fifty Centuries*, Wor-
cester, 1948, p. 33; "A Romanesque Figure in the Worcester Art
Museum," *Art Quarterly*, 1946, pp. 78–79; S. L. Faison, *A Guide to Art
Museums in New England*, New York, 1958, p. 187.

Mead Art Building, Amherst, Mass.

CAPITAL.
Marble. H. 11 ¾", W. 12", D. 12 ¼" (30 × 30.5 × 31 cm.).
No. 1942.80. Formerly J. Brummer, New York. Fig. 221.

Mount Holyoke College Art Museum, South Hadley, Mass.

CAPITAL WITH PECKING BIRDS.
Limestone. H. 11", W. 8 ⅞", D. 8 ⅞" (28 × 22.5 × 22.5 cm.).
No. P.011.13.1959. Gifts of Mrs. Caroline Hill, 1959. Fig. 222.

Bibliography

College Art Journal, 1959–60, p. 69.

Isabella Stewart Gardner Museum, Boston

WELL HEAD.
Marble. H. 21", W. 34 ½", L. 31" (53 × 87 × 78 cm.).
Purchased from Francesco Dorigo, Venice, in 1899. Fig. 223.

Bibliography

Longstreet and Carter, *General Catalogue,* p. 45.

Boston Museum of Fine Arts

FRAGMENT OF A PILASTER.
Marble. H. 23 ½", W. 10 ½" (60 × 26.5 cm.).
No. 48.254. Formerly J. Brummer, New York. Fig. 224.

Copy of a section of the archivolt of the portal of Trani Cathedral.

Bibliography

Art News, Supplement, May 16, 1931; *Bulletin of the Boston Museum of Fine Arts,* 1965, p. 123; W. Cahn, *Gesta,* IX/2, 1970, p. 72, No. 14.

ANGEL WITH A TRUMPET.
Marble. H. 20", W. 6", D. 4 ⅝" (51 × 15 × 11.5 cm.).
No. 1970.268. Purchased from Harry Sperling, New York. Fig. 225.

Bibliography

The Museum Year, 1969–70, p. 44.

The William Hayes Fogg Art Museum, Cambridge, Mass.

WATER SPOUT.
Limestone. H. 53 ½", W. 10 ½" (135.9 × 26.7 cm.).
No. 1925.9.2 Gift of The Society of Friends of The Fogg Art Museum.
Fig. 226.

TWO RELIEFS WITH FANTASTIC ANIMALS.
Limestone. H. 34", W. 8 ¾" each (86.4 × 22 cm.).
Nos. 1965.67.1 and 2. Gift of the Dumbarton Oaks
Research Library and Collection. Fig. 227.

Bibliography

Fogg Art Museum. Acquisitions, 1965, p. 53.

TRANSENNA RELIEF WITH ANIMAL MOTIFS.
Marble. H. 18 2/5″, W. 61 ⅝″ (46.7 × 156 cm.).·
No. 1965.68. Gift of the Dumbarton Oaks Research Library and Collection. Fig. 228.

Bibliography

Fogg Art Museum. Acquisitions, 1965, p. 53.

TWO CHANCEL RELIEFS WITH SEA MONSTERS.
Marble.

(a) H. 28 ¼″, W. 39 ½″ (72 × 100 cm.).

(b) H. 25 ½″, W. 44 ¼″ (64 × 112 cm.).

Nos. 1965.69.1 and 2. Gift of the Dumbarton Oaks Research Library and Collection. Figs. 229 and 230.

Bibliography

Fogg Art Museum. Acquisitions, p. 53.

RELIEF WITH A WINGED HORSE.
Marble. H. 26″, W. 38 ¼″ (66 × 49 cm.).
No. 1965.66. Gift of the Dumbarton Oaks Research Library and Collection. Fig. 231.

Bibliography

Fogg Art Museum. Acquisitions, 1965, p. 53.

Hammond Art Museum, Gloucester, Mass.

All Romanesque sculpture exhibited appears to be of modern workmanship.

Bibliography

C. B. Witham, *The Hammond Museum. Guide Book,* Gloucester, Mass, 1966.

ILLUSTRATIONS

The
Wadsworth
Atheneum

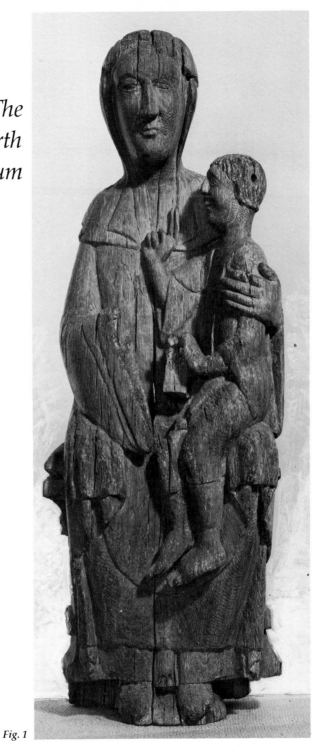

Fig. 1

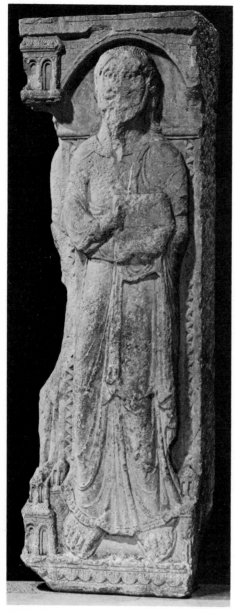

Fig. 2

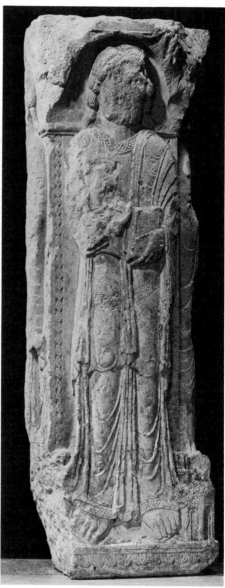

Fig. 3

Fig. 4

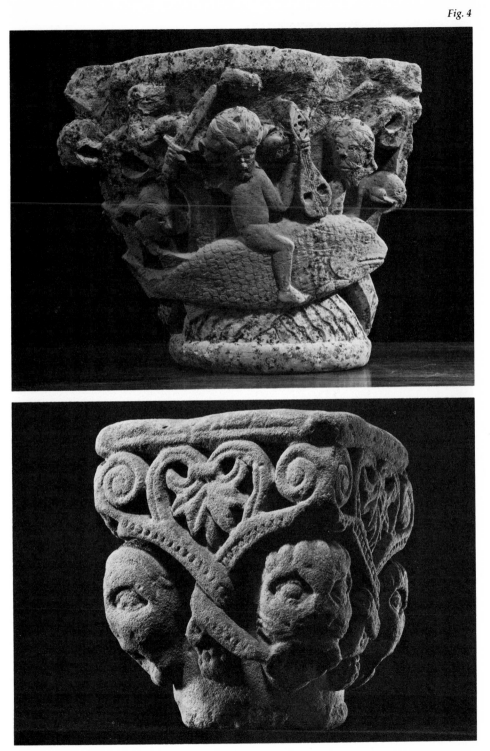

Fig. 5

Fig. 6

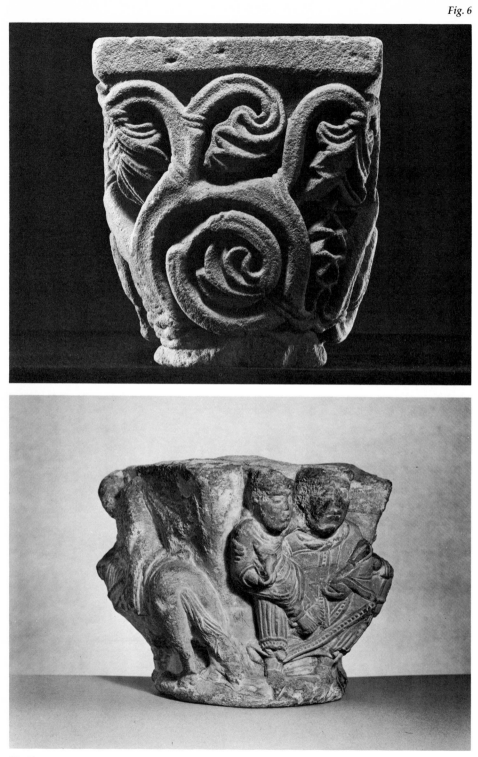

Fig. 7

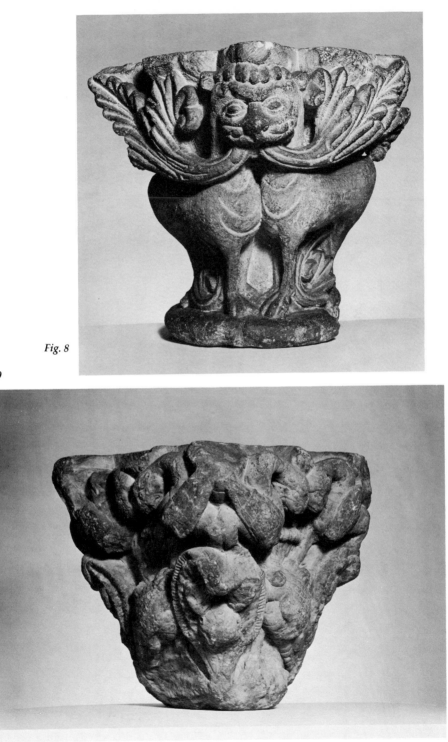

Fig. 8

Fig. 9

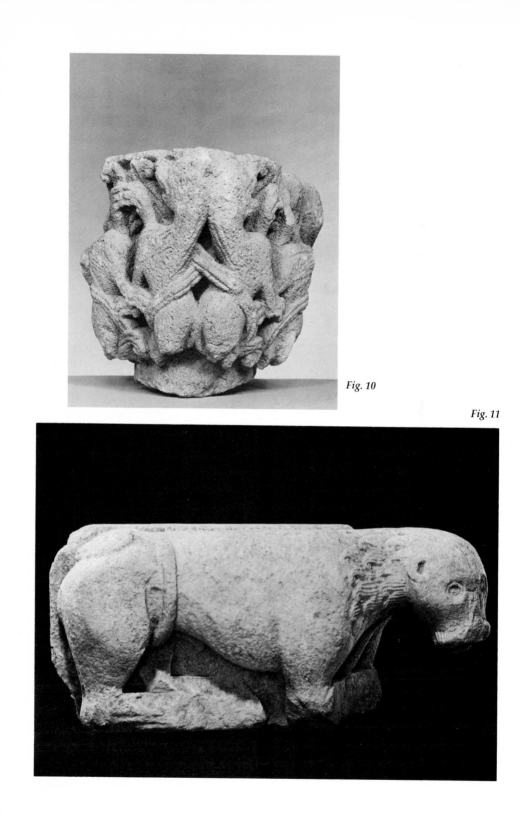

Fig. 10

Fig. 11

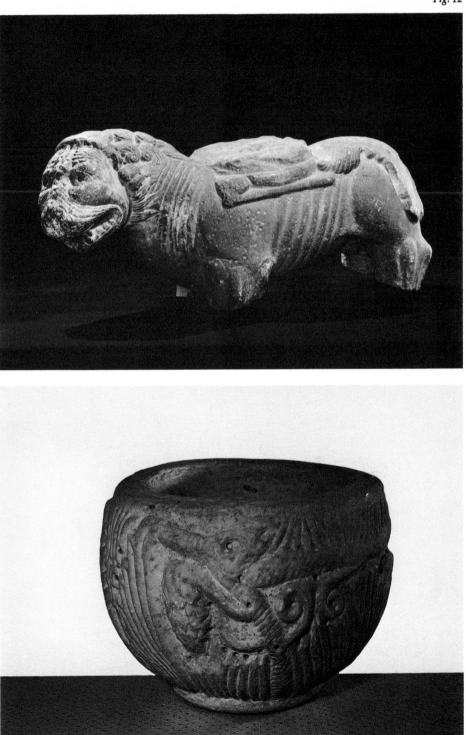

Fig. 12

Fig. 13

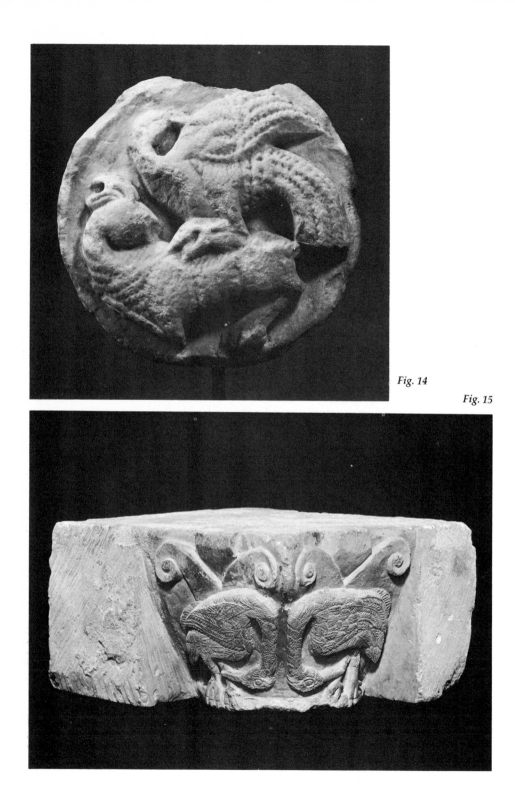

Fig. 14

Fig. 15

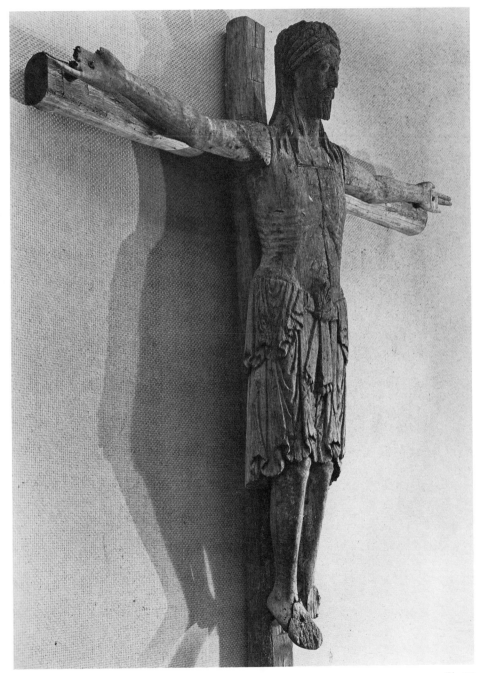

Fig. 16

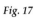

Fig. 17

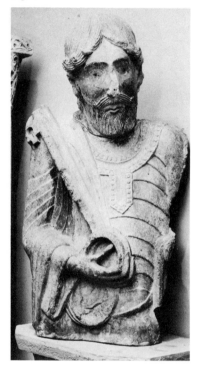

Fig. 19

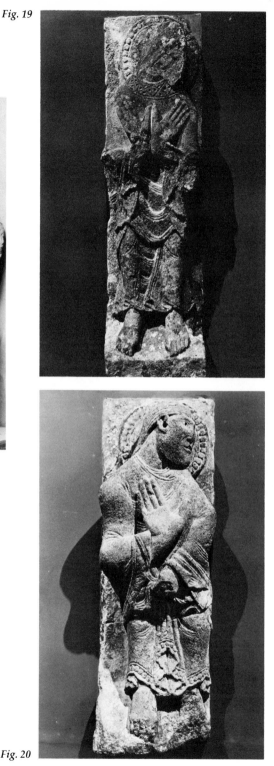

Fig. 20

Fig. 18

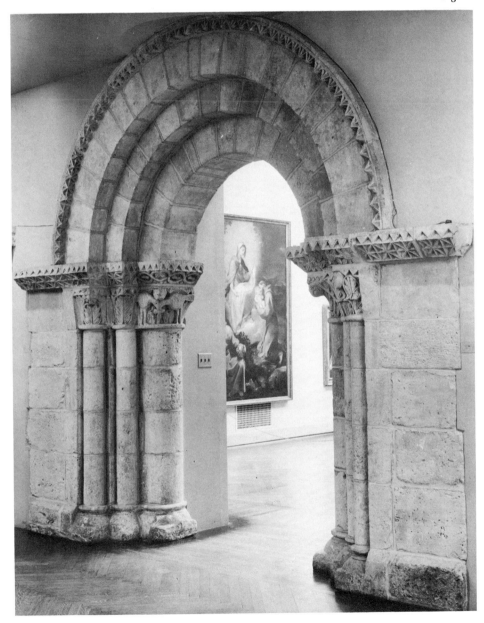

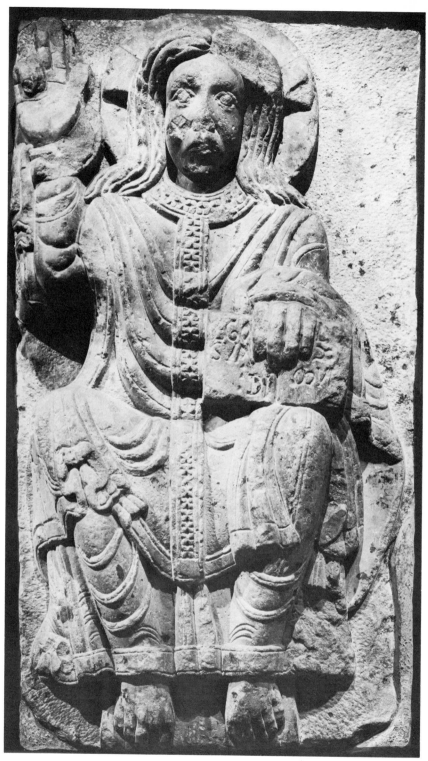

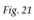

Fig. 21

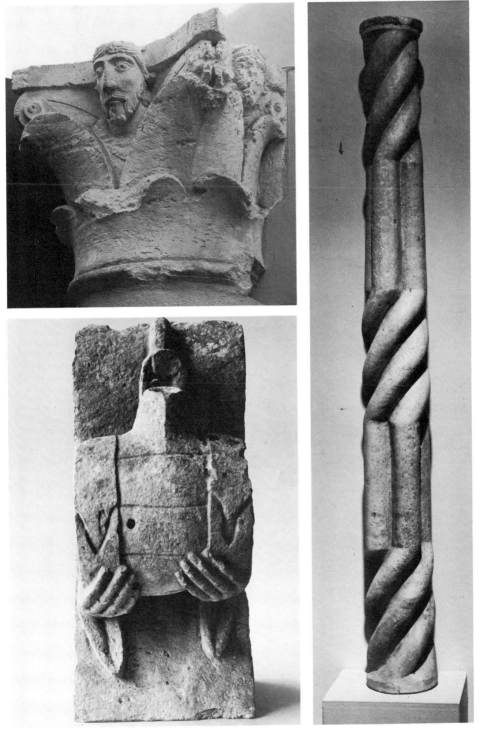

Fig. 22

Fig. 24

Fig. 23

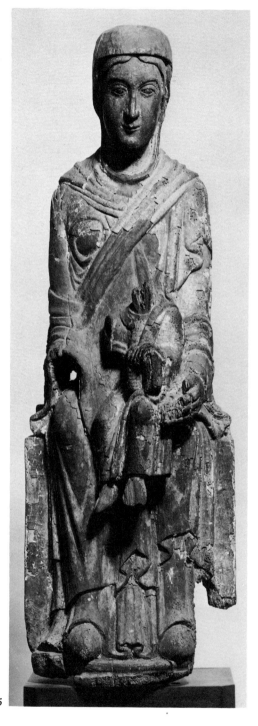

Worcester
Art
Museum

Fig. 25

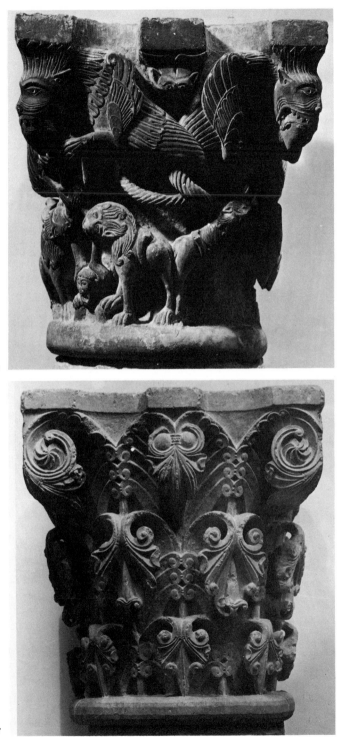

Fig. 26

Fig. 27

Fig. 28

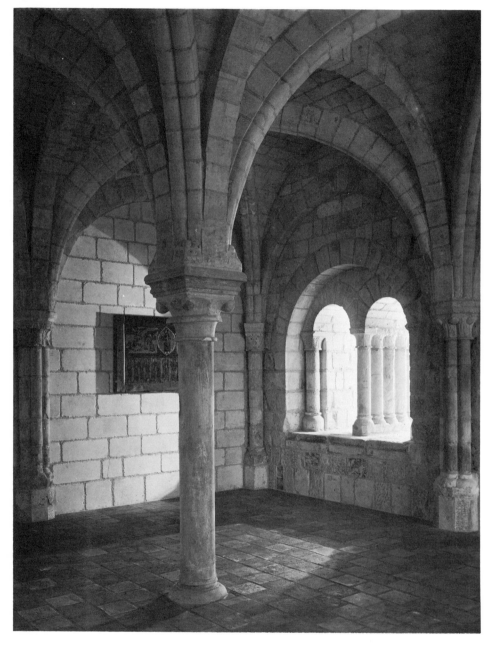

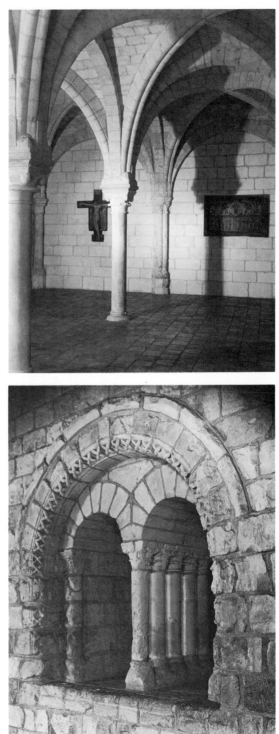

Fig. 29

Fig. 30

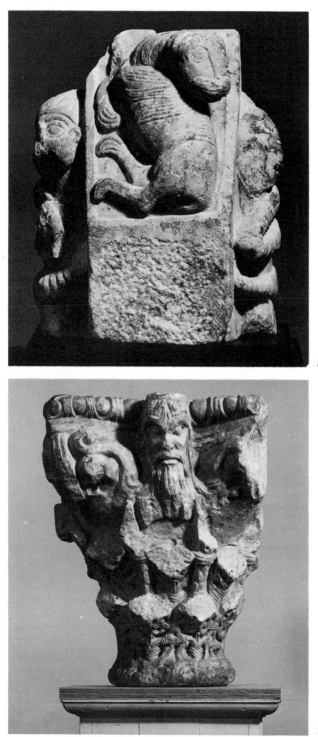

Fig. 31

Fig. 32

Mead Art Building

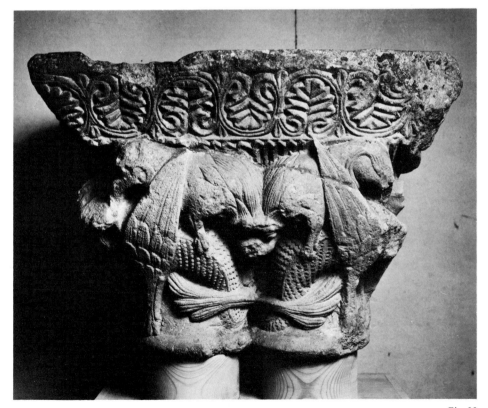

Fig. 33

Mount Holyoke College
Art Museum

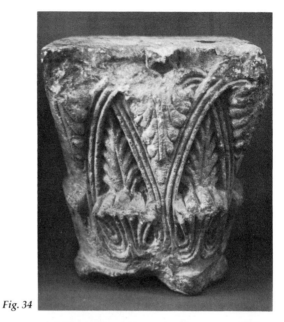

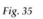
Fig. 35

Fig. 34

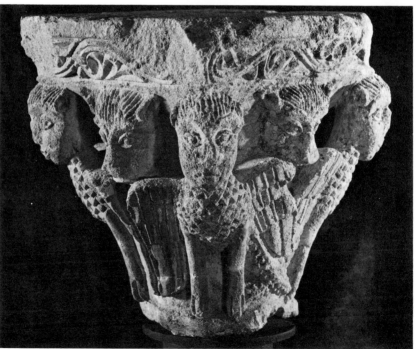

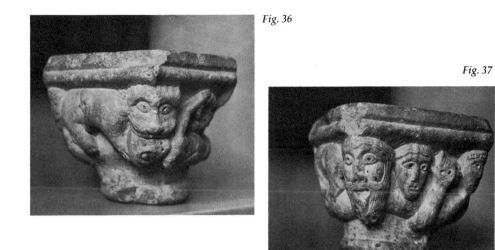

Fig. 36

Fig. 37

Fig. 38

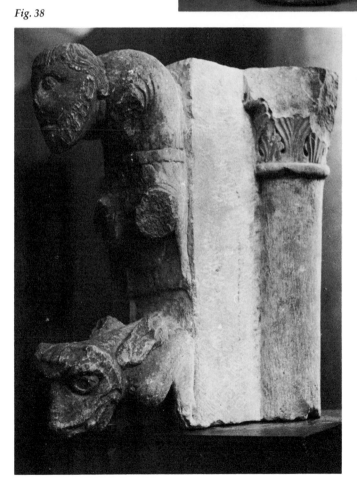

Fig. 39

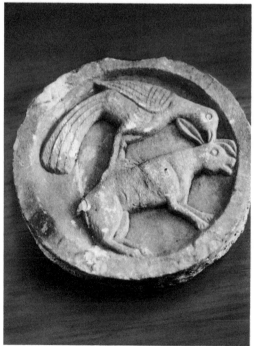

Fig. 40

Smith College
Museum of Art

Fig. 41

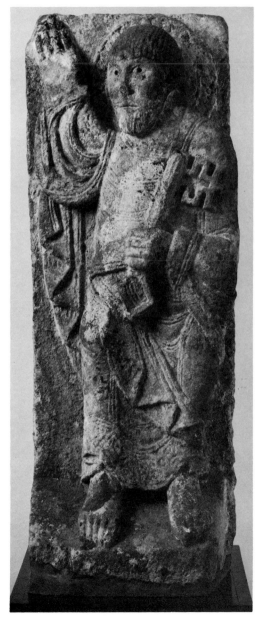

Fig. 42

Jewett Art Center
Wellesley College

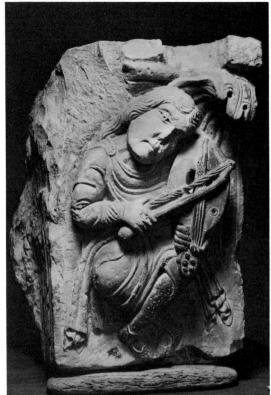

Fig. 43

Fig. 44

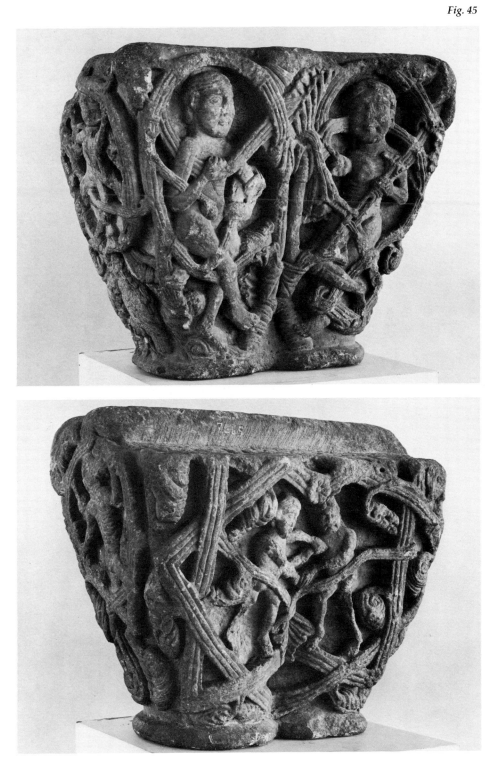

Fig. 45

Fig. 46

Lawrence Art Museum
Williams College

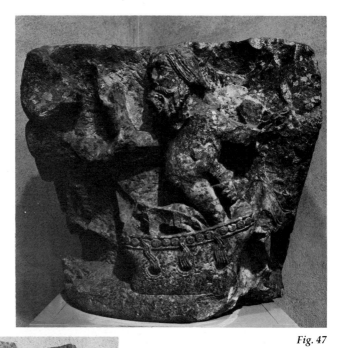

Fig. 47

Fig. 48

Fig. 49

Fig. 50

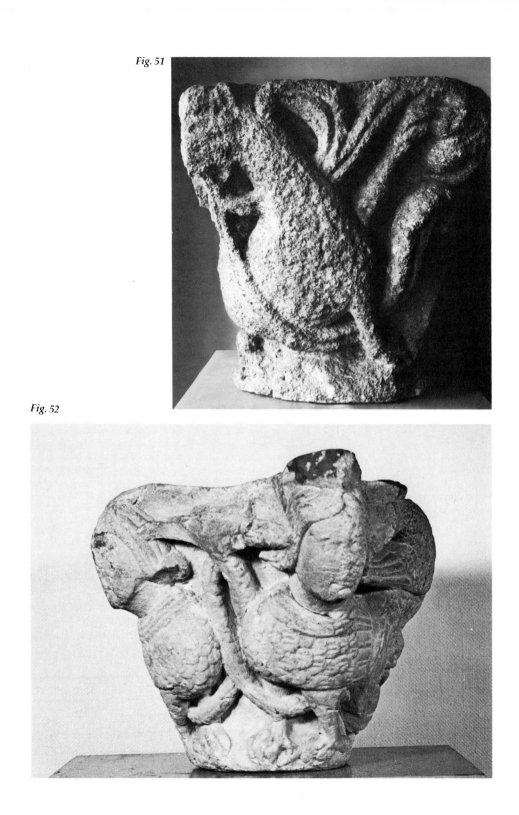

Fig. 51

Fig. 52

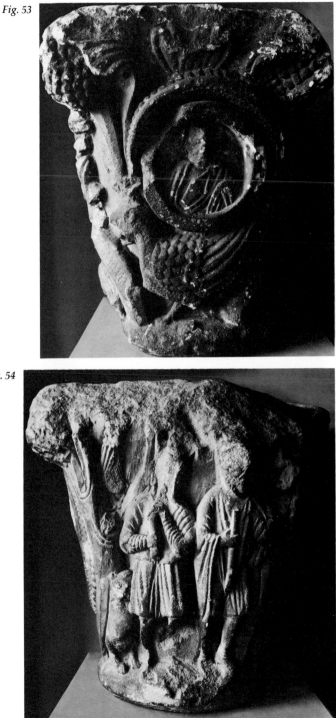

Fig. 53

Fig. 54

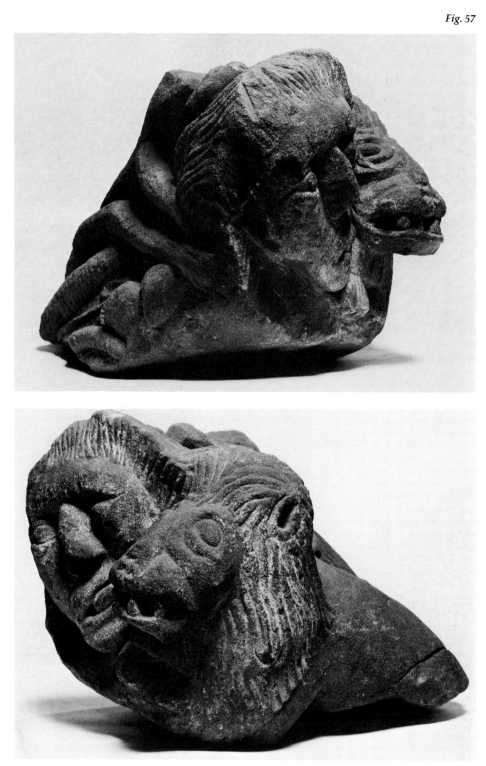

Fig. 57

Fig. 58

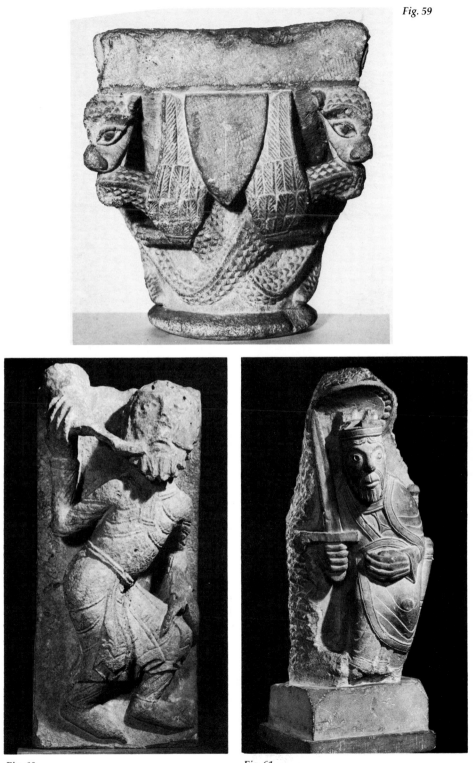

Fig. 59

Fig. 60

Fig. 61

Fig. 62

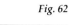

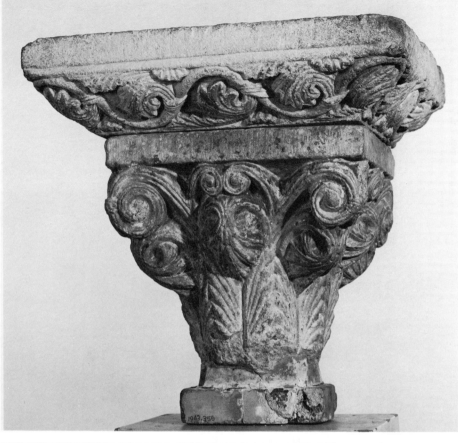

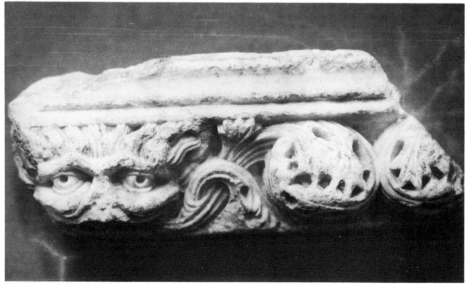

Fig. 63

Fig. 64

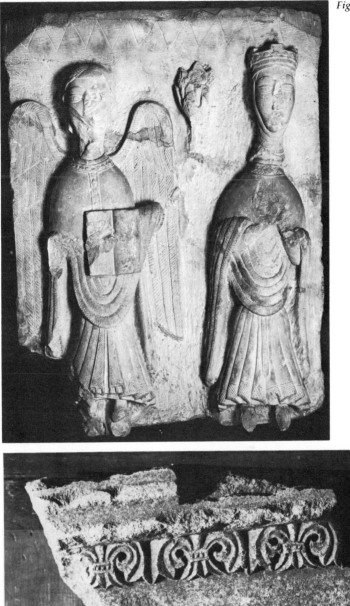

Fig. 65

The Isabella Stewart
 Gardner Museum

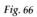

Fig. 66

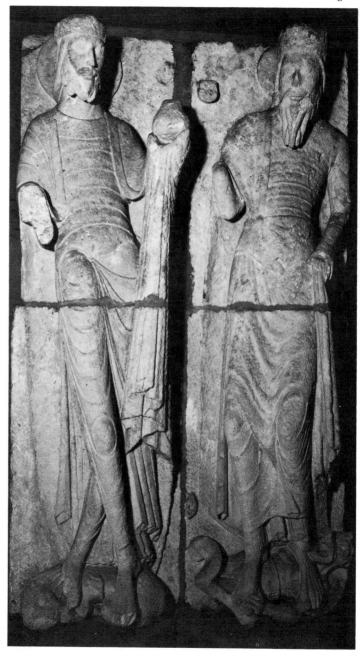

Fig. 67

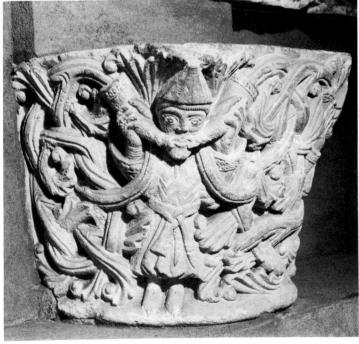

Fig. 68

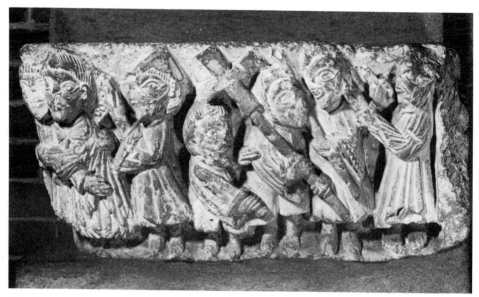

Fig. 69

Fig. 70

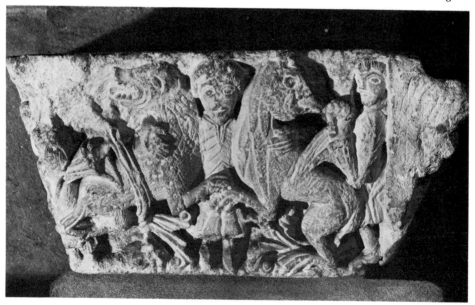

Fig. 71

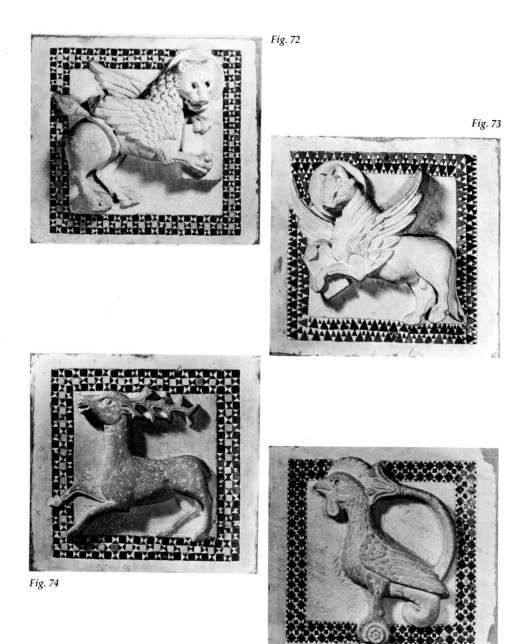

Fig. 72

Fig. 73

Fig. 74

Fig. 75

Fig. 76

Fig. 77

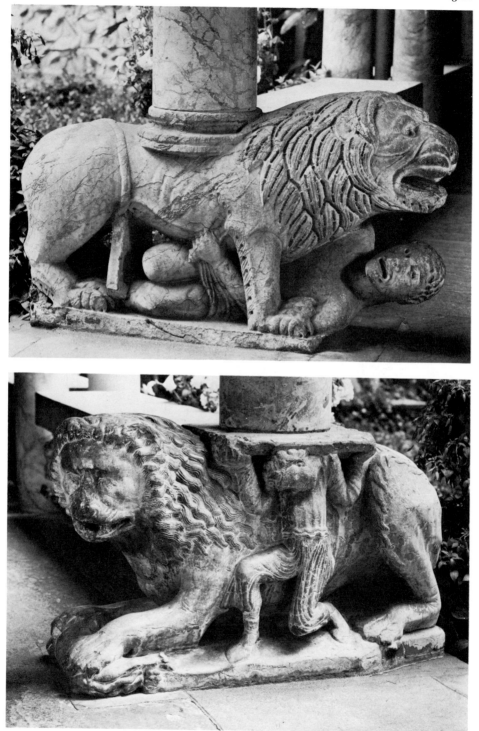

Fig. 78

Fig. 79

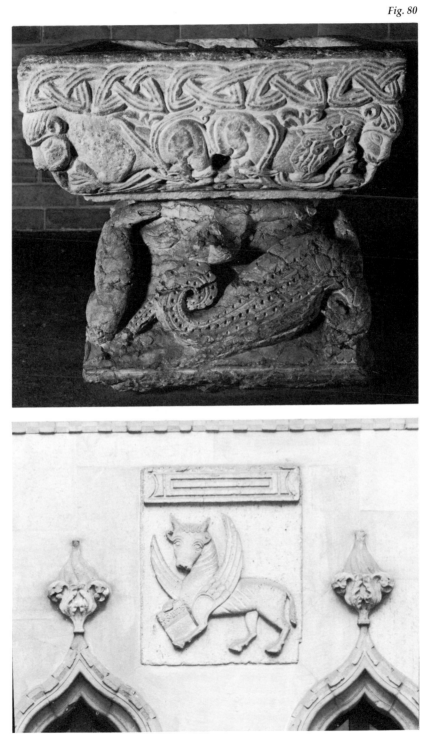

Fig. 80

Fig. 81

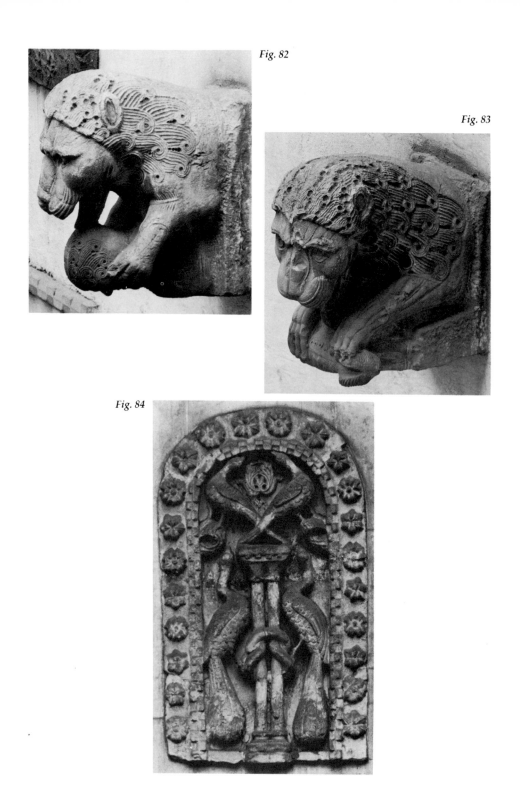

Fig. 82

Fig. 83

Fig. 84

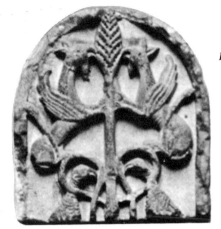

Fig. 85

Fig. 86

Fig. 87

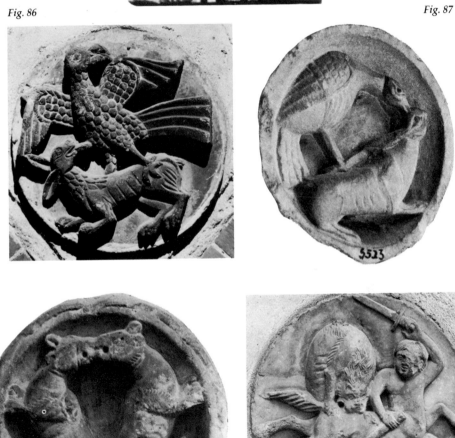

Fig. 88

Fig. 89

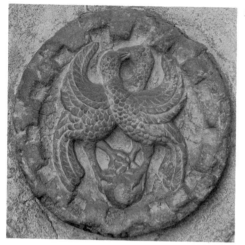

Fig. 90

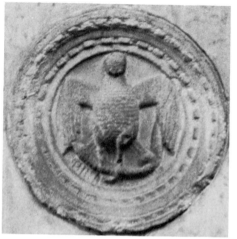

Fig. 91

Fig. 92

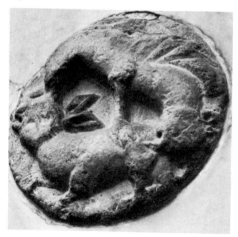

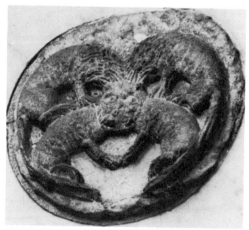

Fig. 93

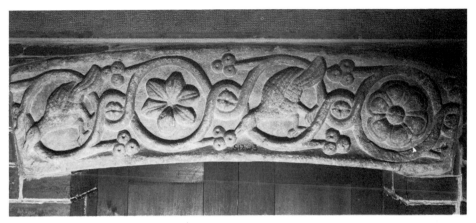

Fig. 94

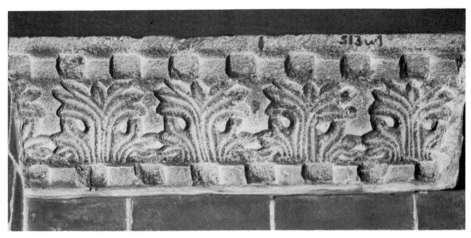

Fig. 95

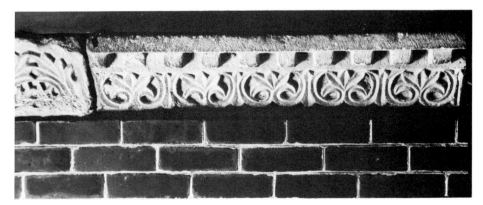

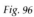
Fig. 96

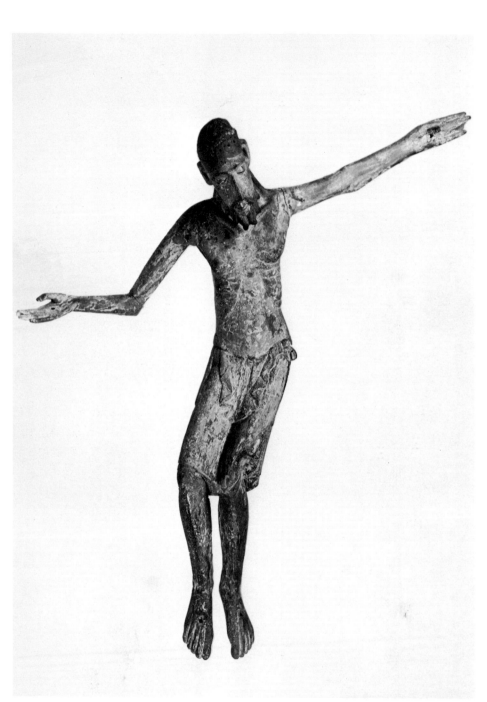

Fig. 97

The Boston Museum
of Fine Arts

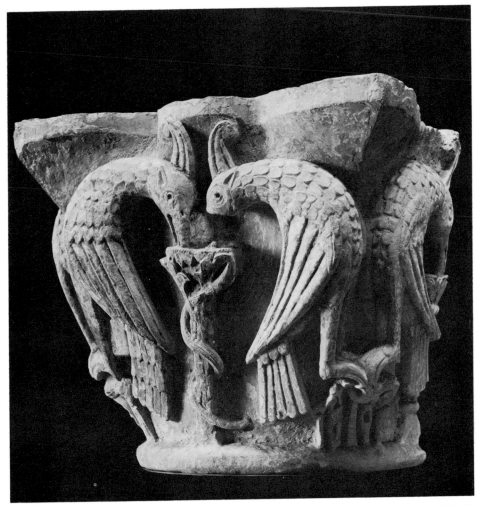

Fig. 98

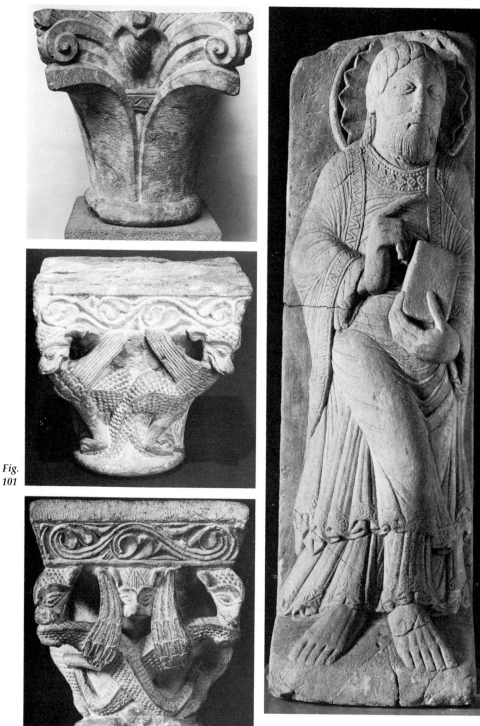

Fig. 99

Fig. 100

Fig.
101

Fig. 102

Fig. 103

Fig. 104

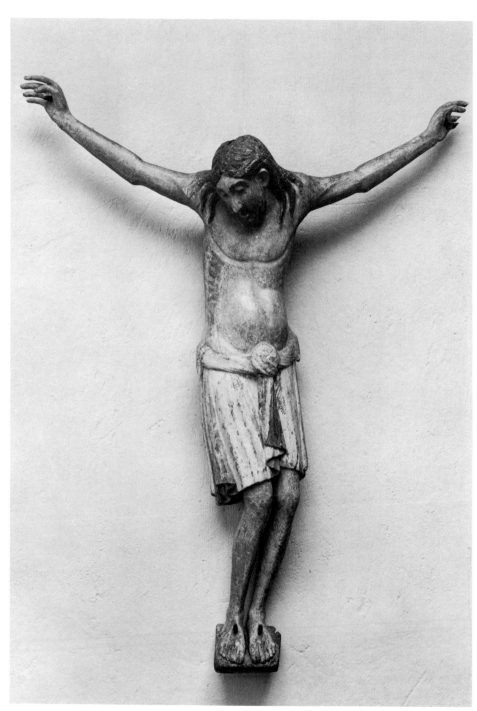

Fig. 105

Fig. 106

Fig. 107

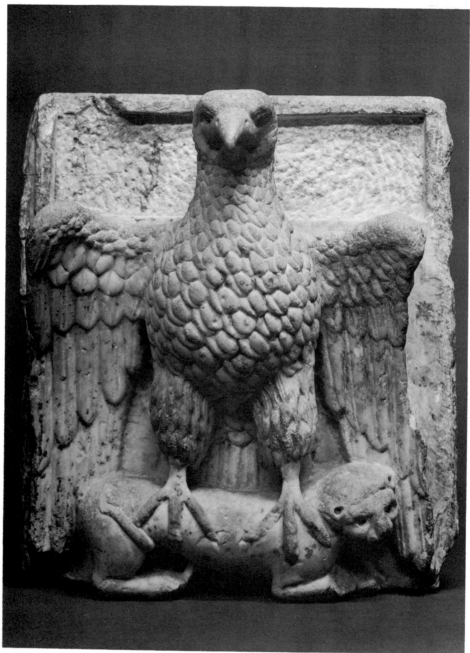

Fig. 108

Fig. 109

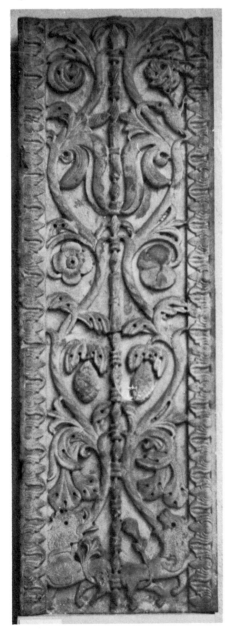

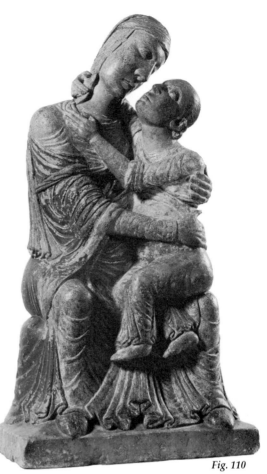

Fig. 110

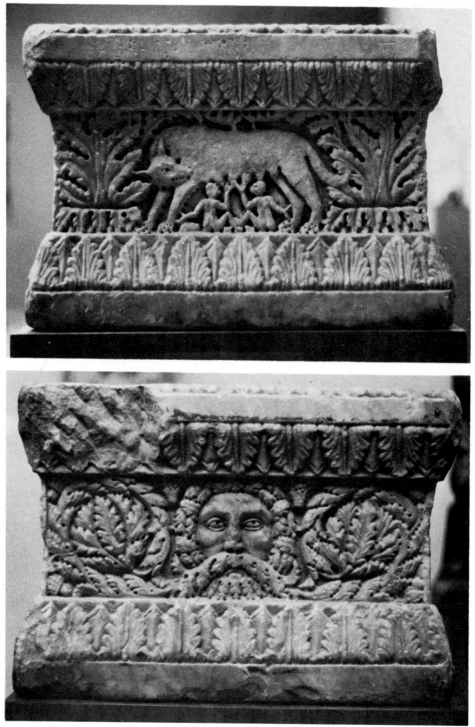

Fig. 111

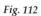

Fig. 112

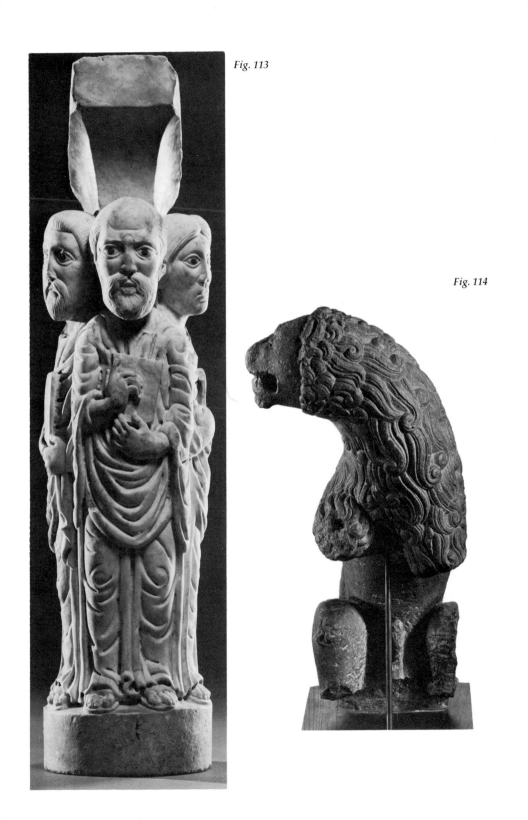

Fig. 113

Fig. 114

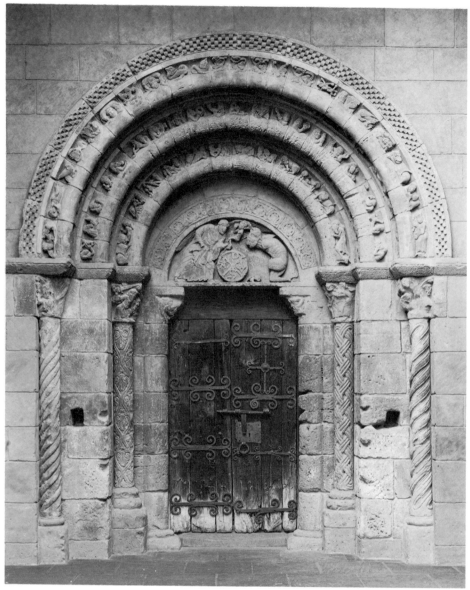

Fig. 115

Fig. 116

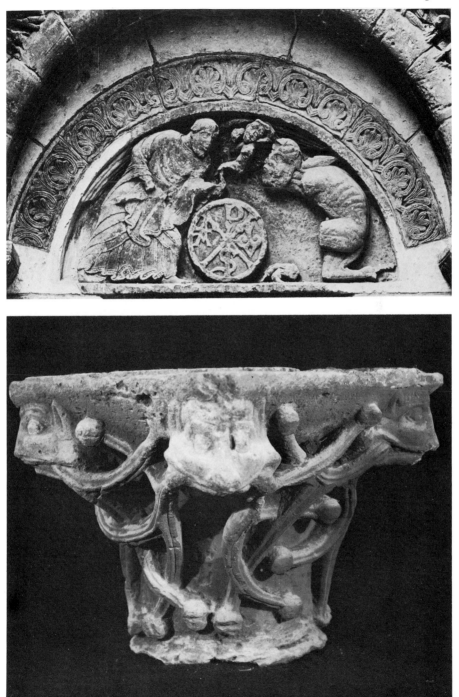

Fig. 117
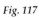

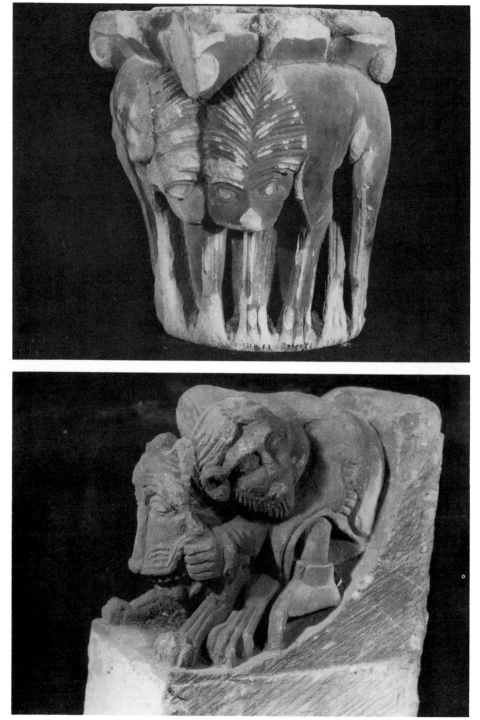

Fig. 118

Fig. 119

The William Hayes Fogg Art Museum

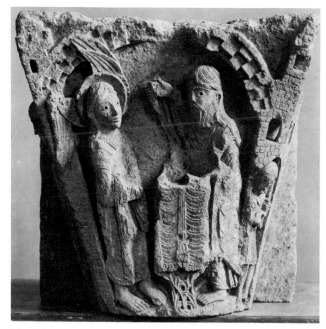

Fig. 120

Fig. 121

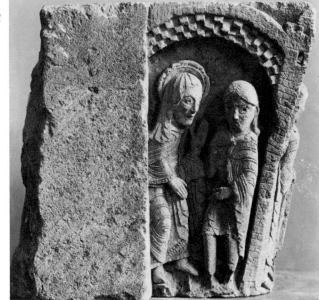

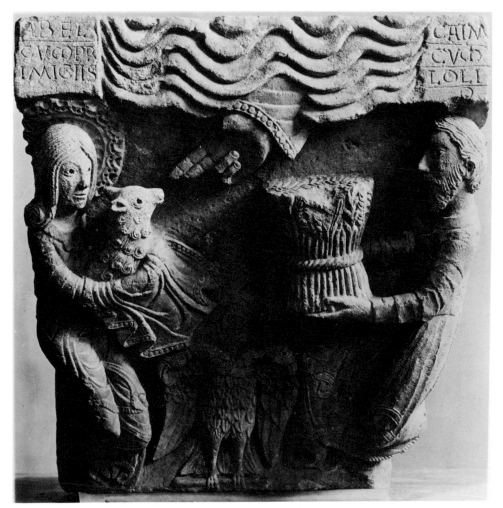

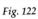
Fig. 122

Fig. 123

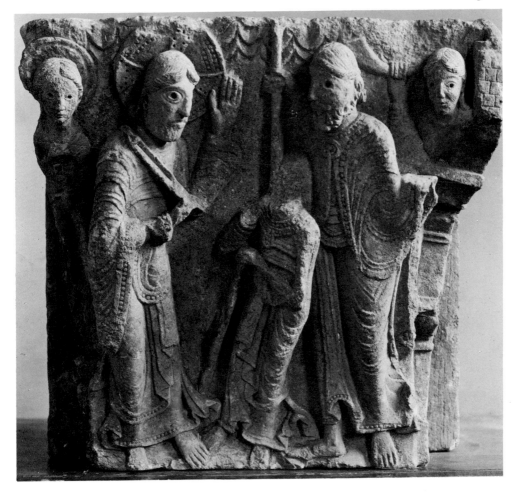

Fig. 124

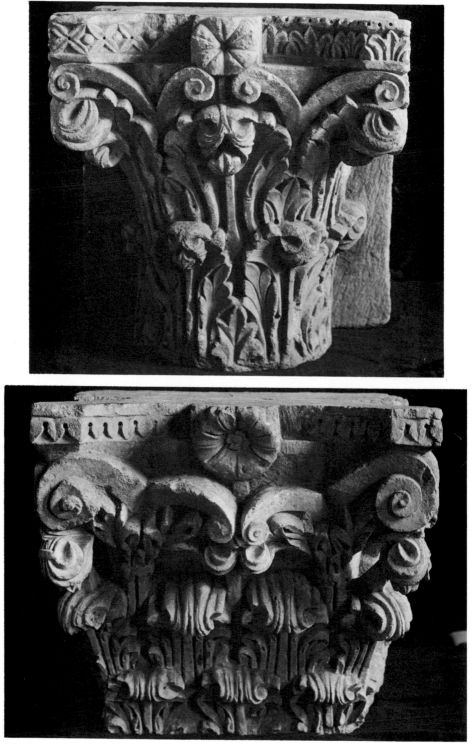

Fig. 125

Fig. 126

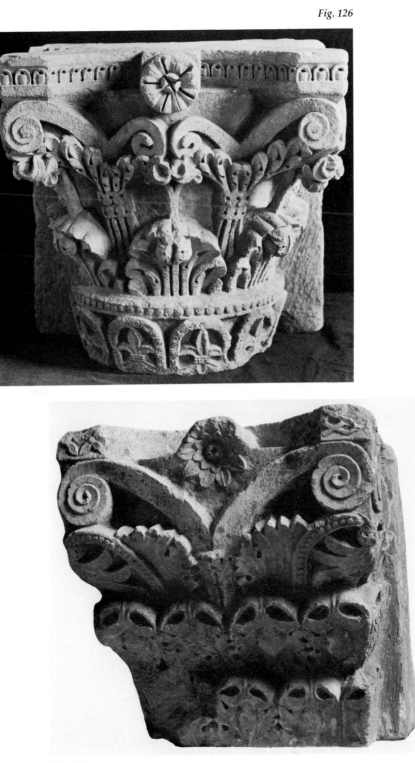

Fig. 127

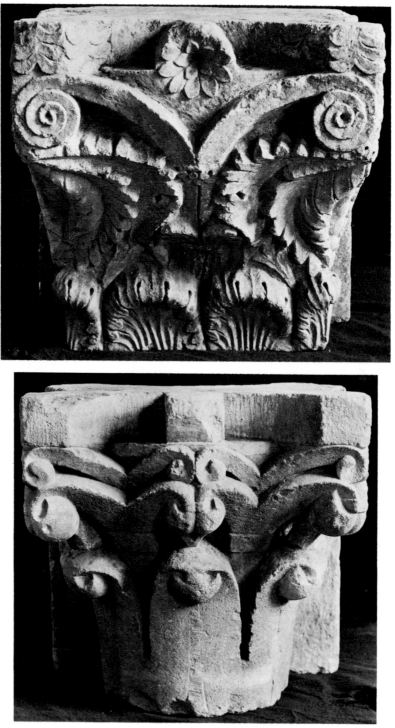

Fig. 129

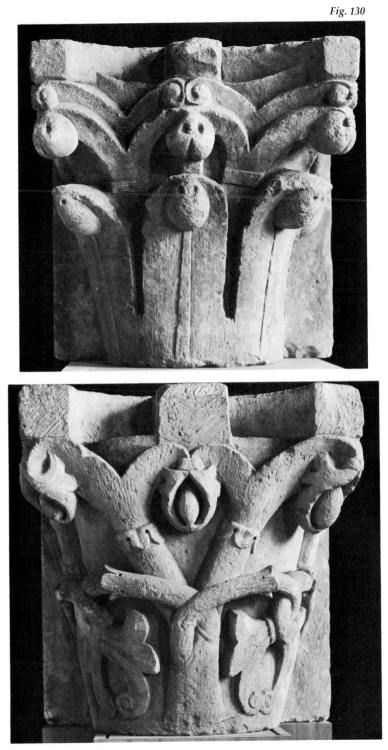

Fig. 130

Fig. 131

Fig. 132

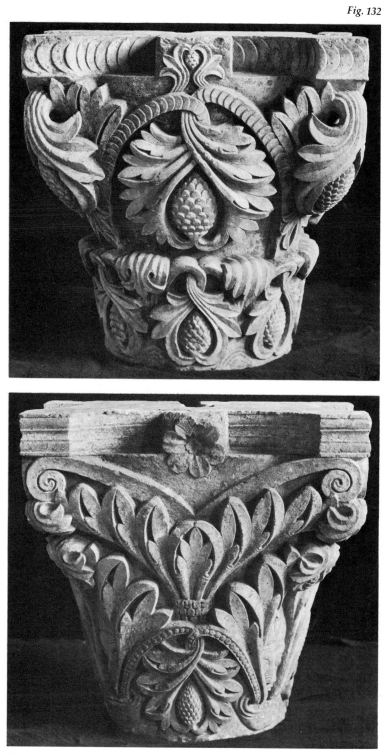

Fig. 133

Fig. 134

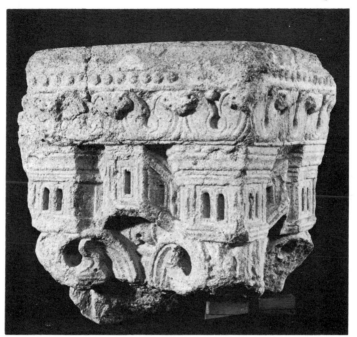

Fig. 135

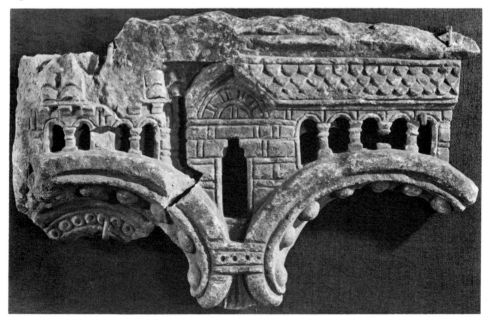

Fig. 136

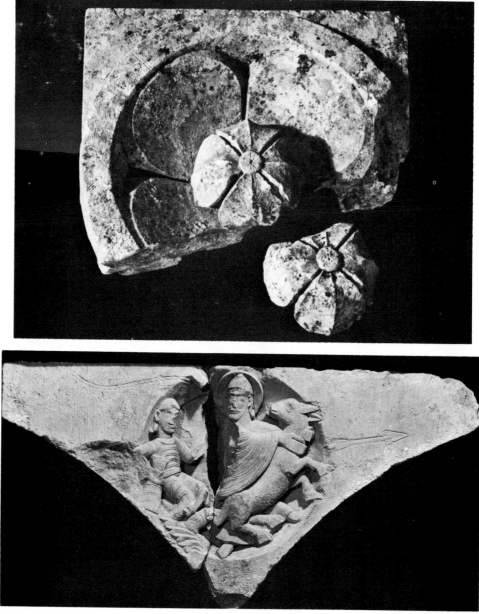

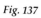

Fig. 137

Fig. 138

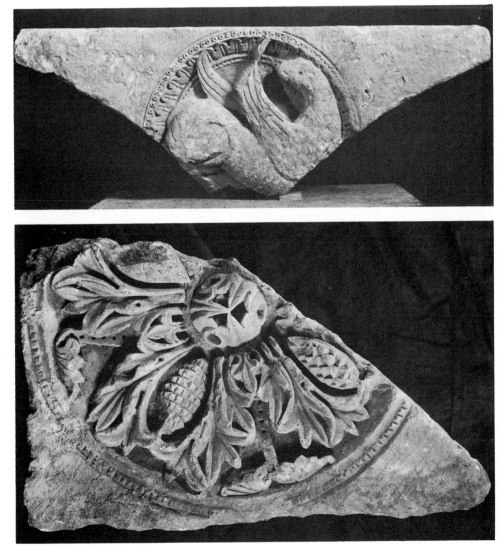

Fig. 139

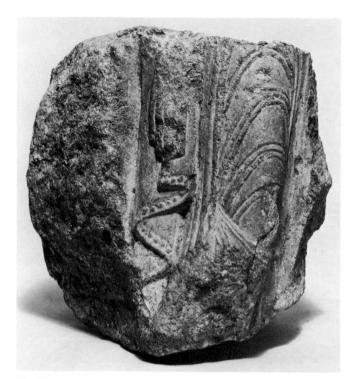

Fig. 140

Fig. 141

Fig. 142

Fig. 143

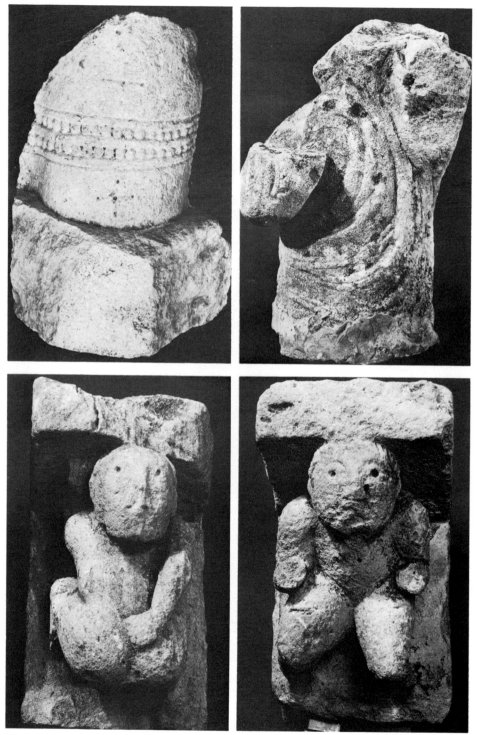

Fig. 144

Fig. 145

Fig. 146

Fig. 147

Fig. 148

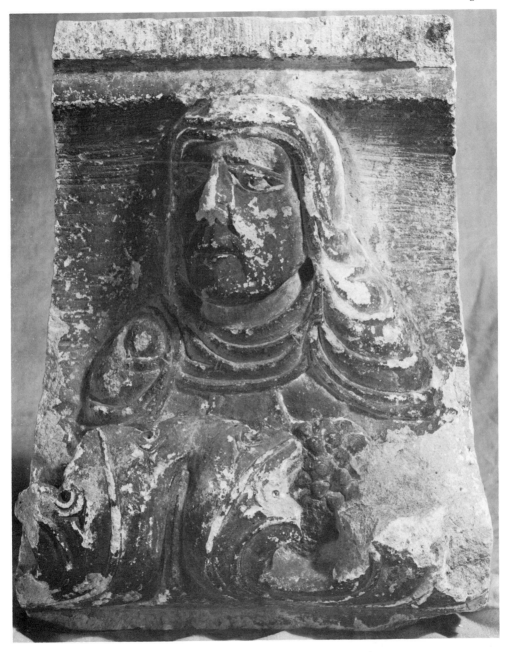

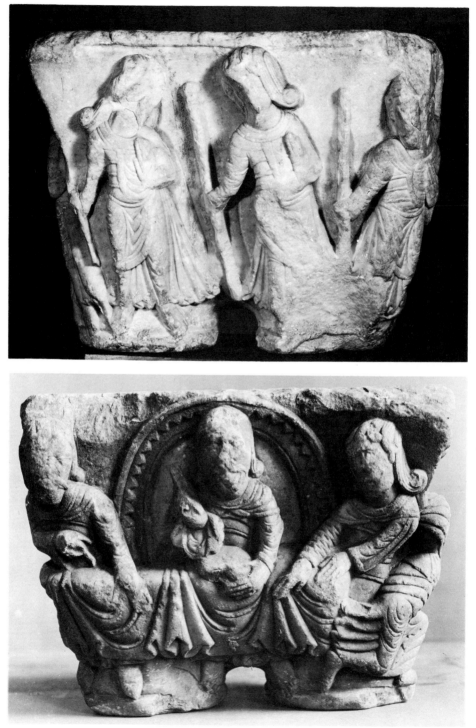

Fig. 149

Fig. 150

Fig. 151

Fig. 152

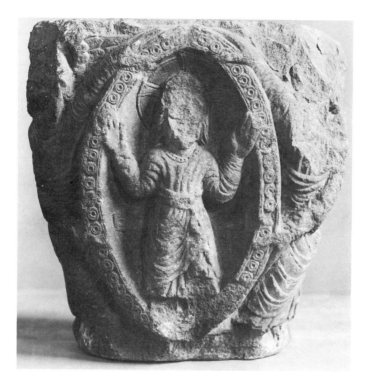

Fig. 153

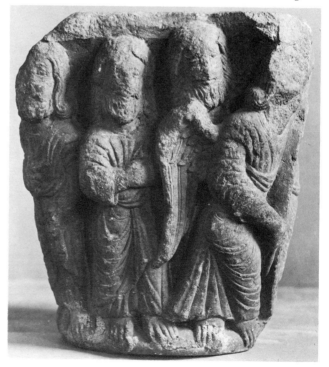

Fig. 154

Fig. 155

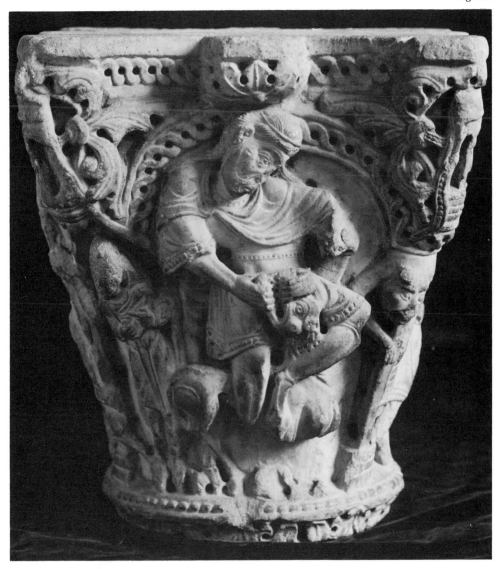

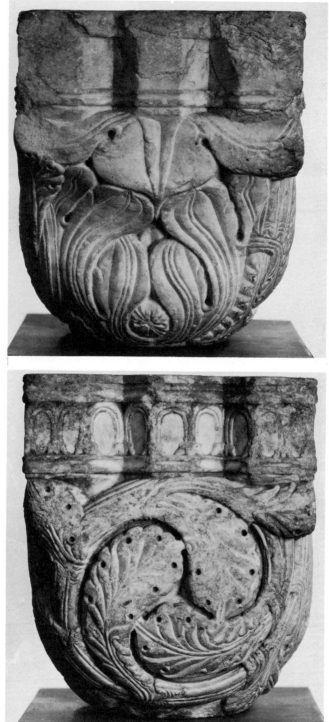

Fig. 156

Fig. 157

Fig. 158

Fig. 159

Fig. 160

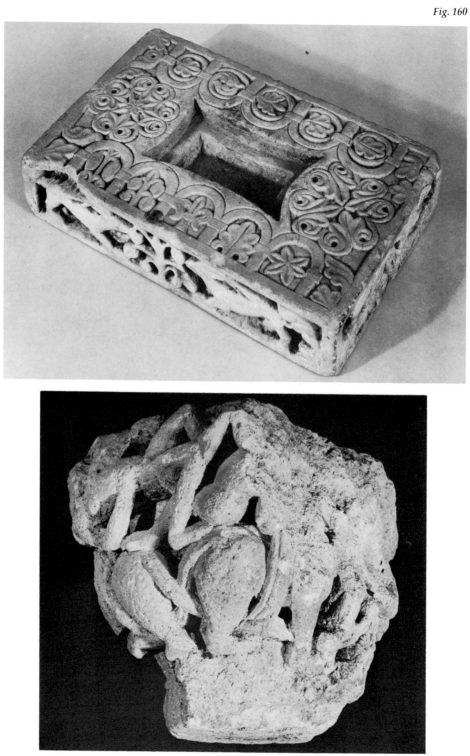

Fig. 161

Fig. 162

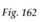

Fig. 163

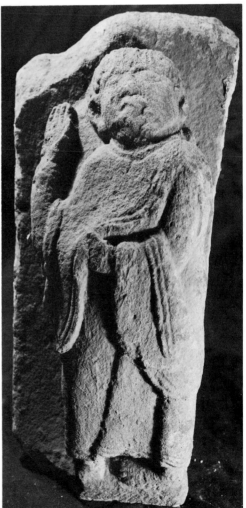

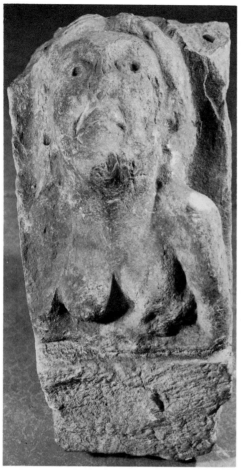

Fig. 164

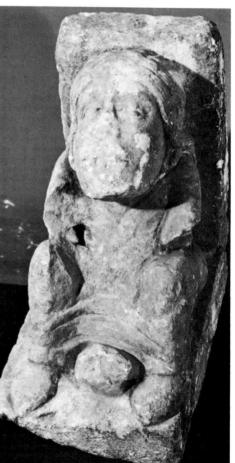

Fig. 165

Fig. 166

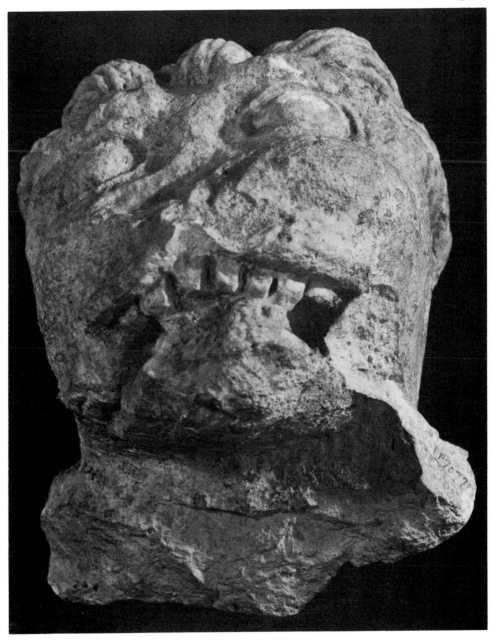

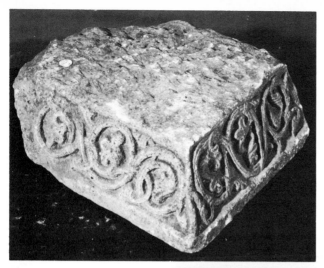

Fig. 167

Fig. 168

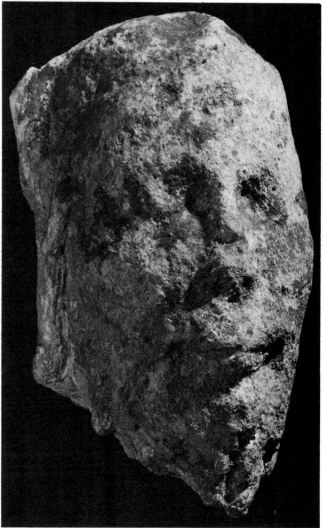

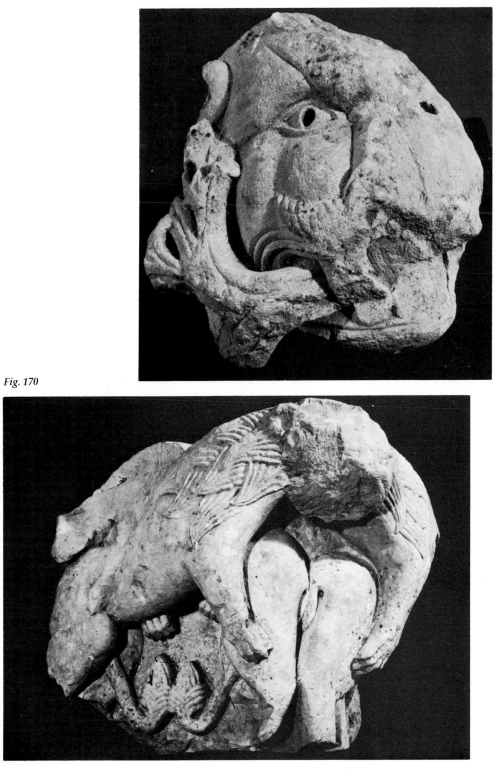

Fig. 169

Fig. 170

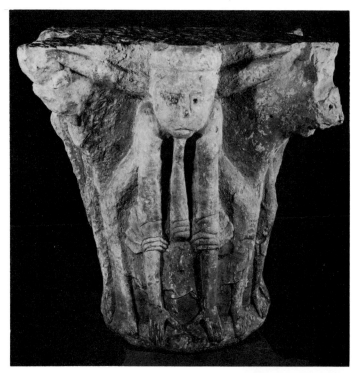

Fig. 171

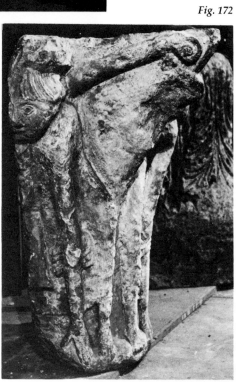

Fig. 172

Fig. 173

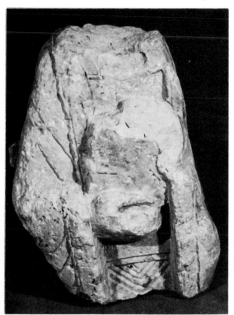

Fig. 174

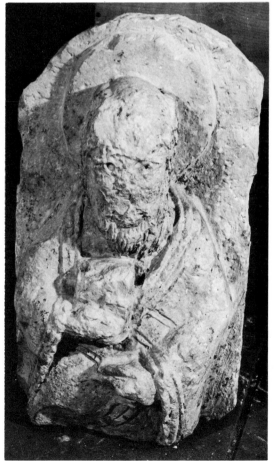

Fig. 175

Fig. 176

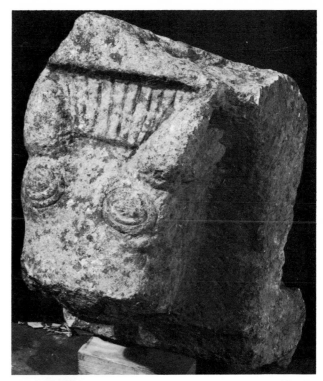

Fig. 177

Fig. 178

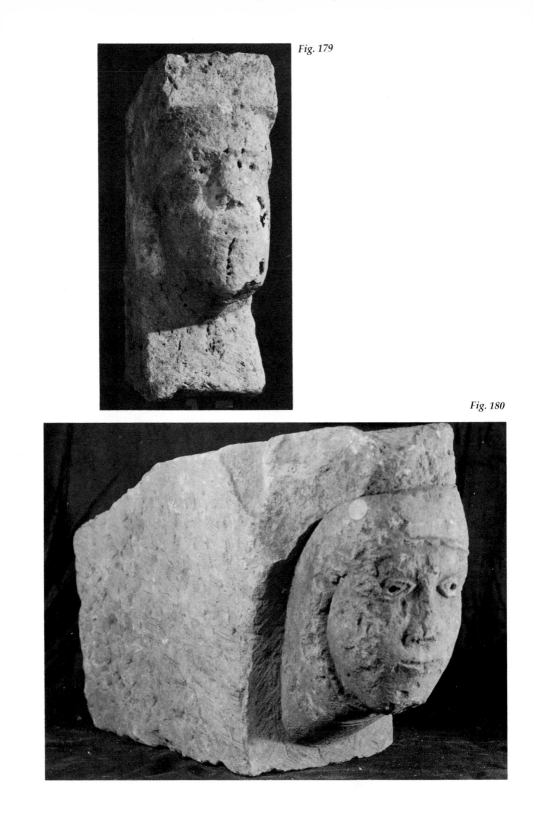

Fig. 179

Fig. 180

Fig. 181

Fig. 182

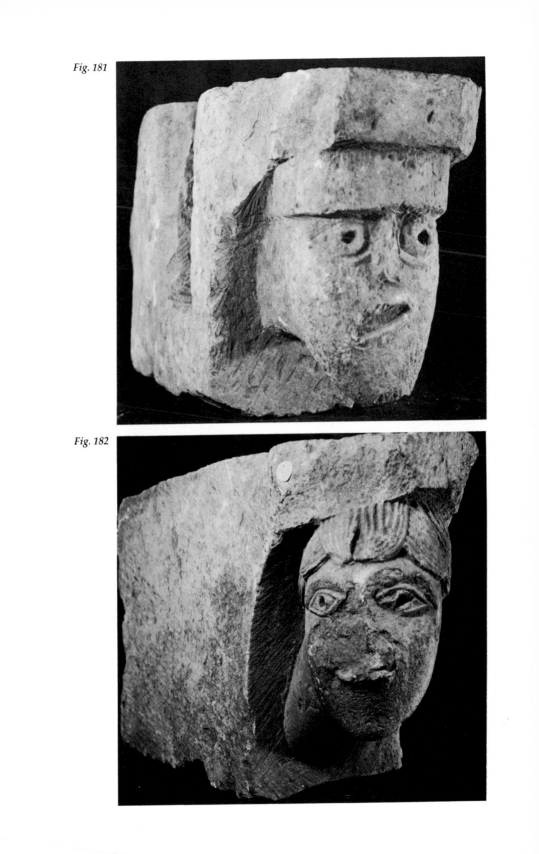

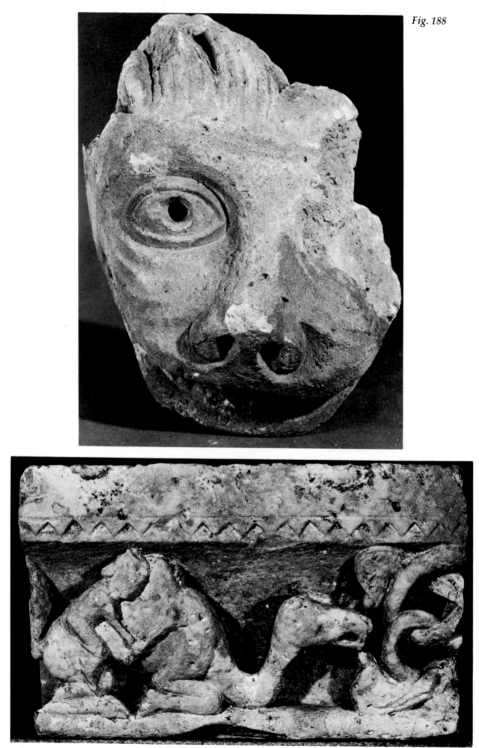

Fig. 188

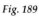

Fig. 189

Fig. 190

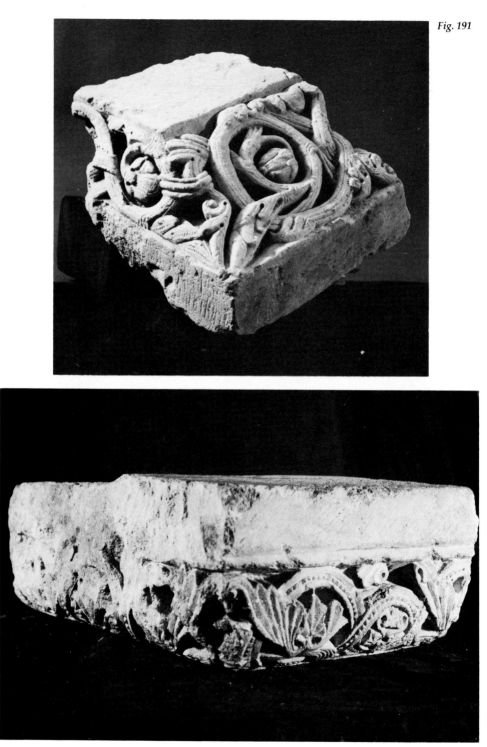

Fig. 191

Fig. 192

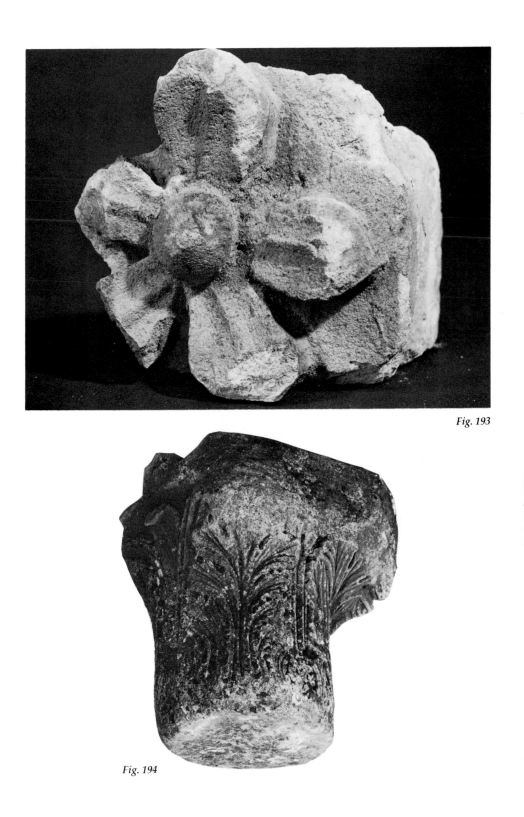

Fig. 193

Fig. 194

Fig. 195

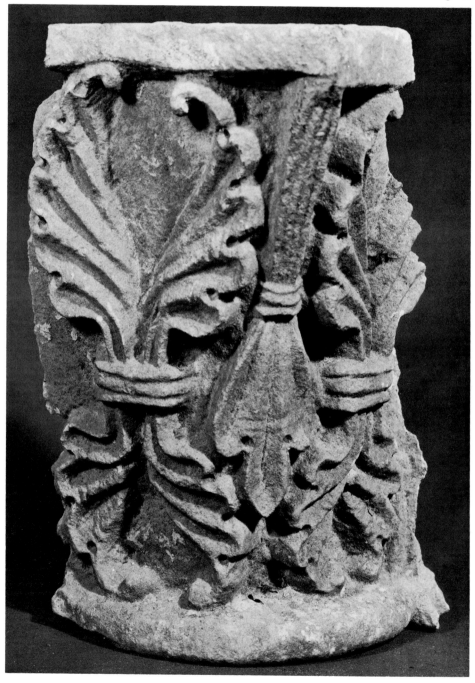

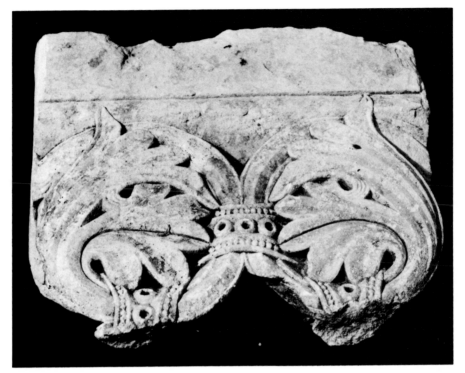

Fig. 196

Fig. 197

Fig. 198

Fig. 199

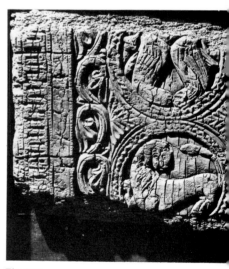

Fig. 200

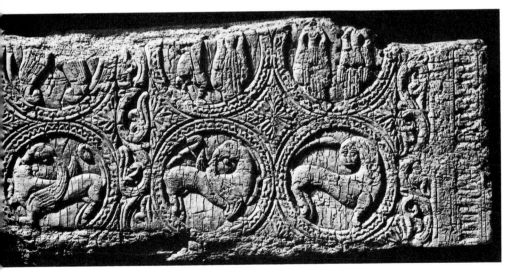

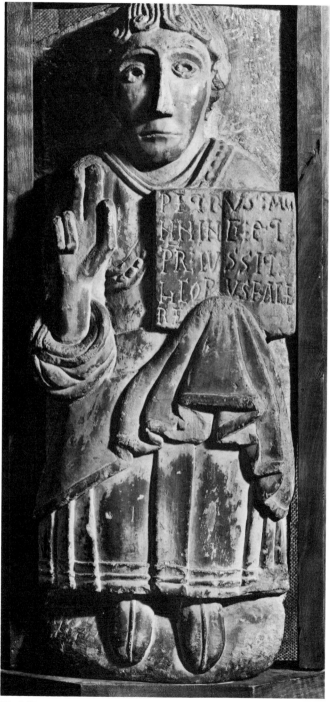

Fig. 201

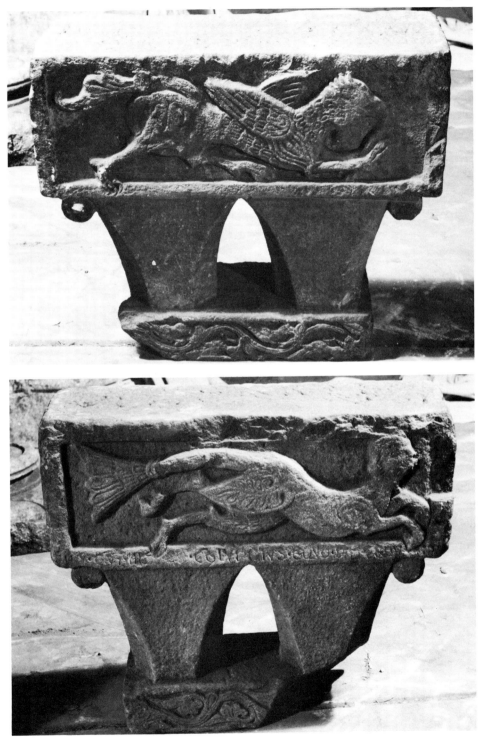

Fig. 202

Fig. 203

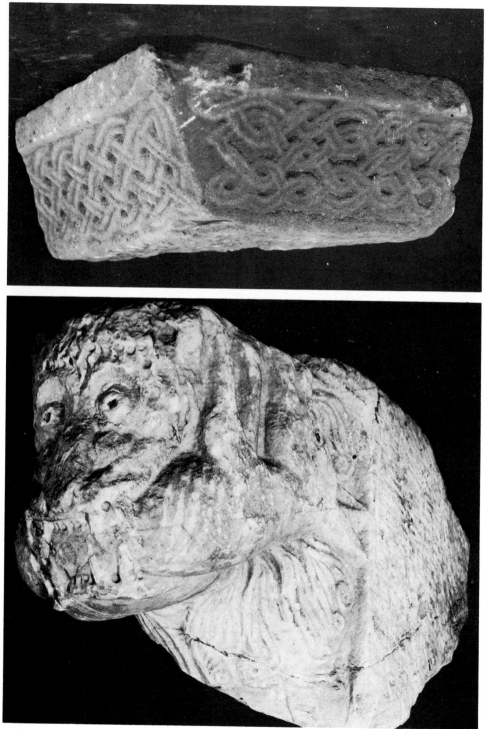

Fig. 204

Fig. 205

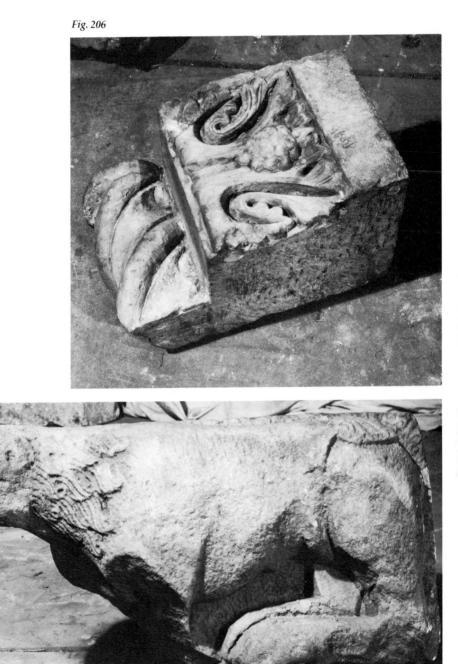

Fig. 206

Fig. 207

Fig. 208

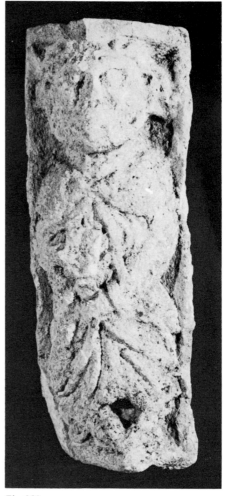

Fig. 209

Fig. 210

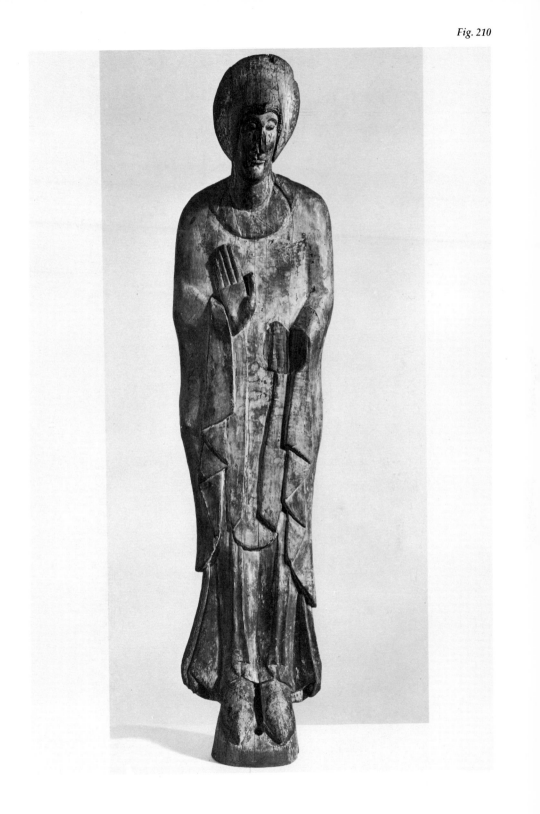

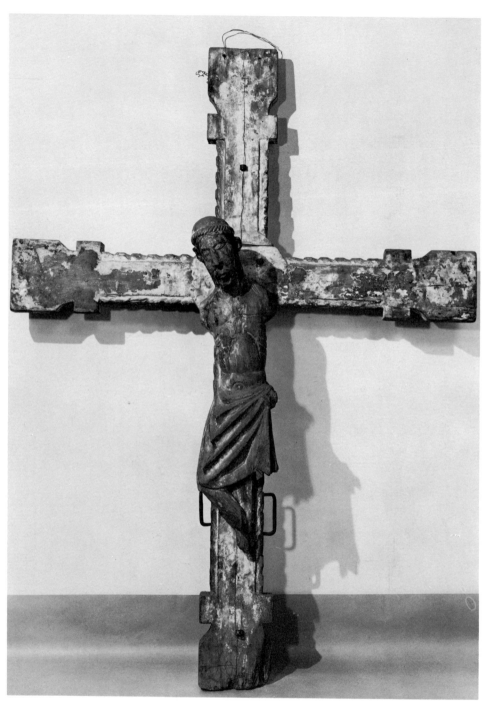

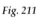
Fig. 211

Fig. 212

Fig. 213

Fig. 214

Fig. 215

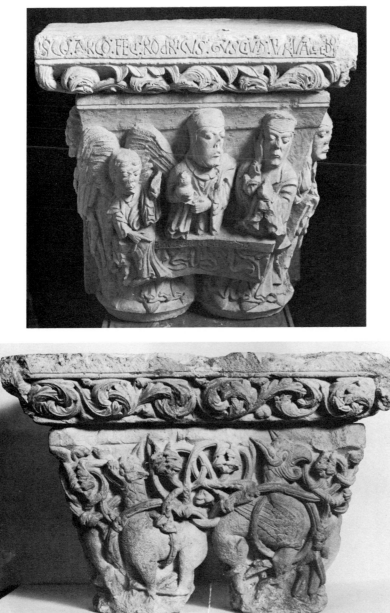

Fig. 216

Fig. 217

Fig. 218

Doubtful
Authenticity

Fig. 220

Fig. 219

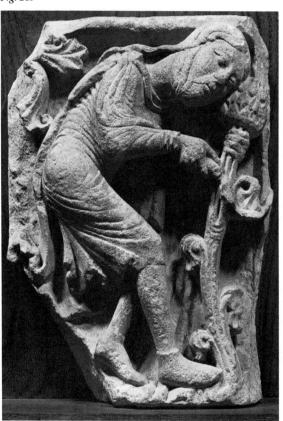

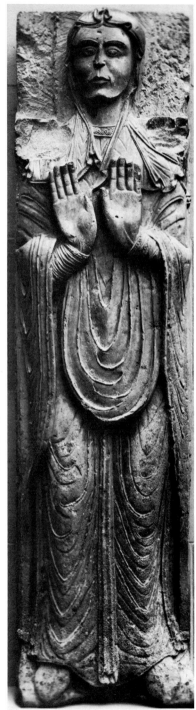

Fig. 221

Fig. 222

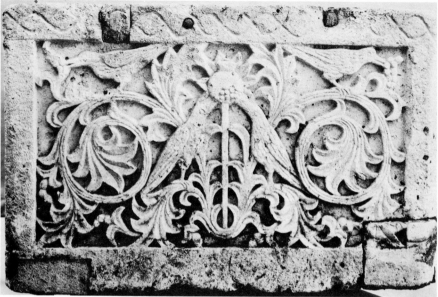

Fig. 223

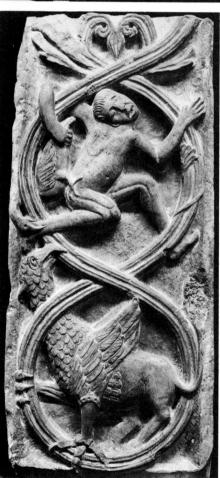

Fig. 224

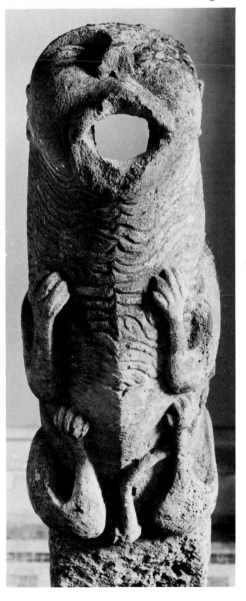

Fig. 226

Fig. 225

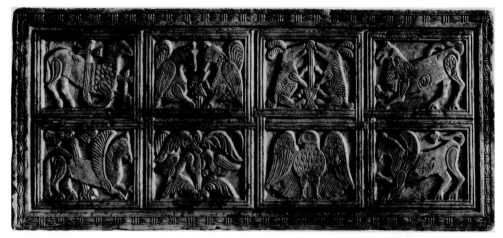

Fig. 228

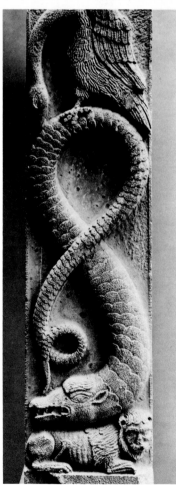

Fig. 227

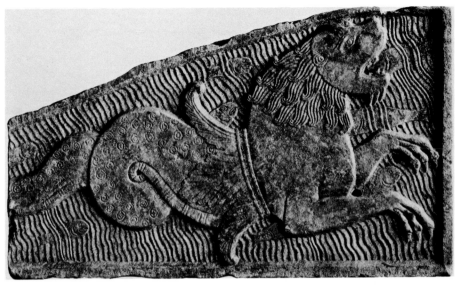

Fig. 229

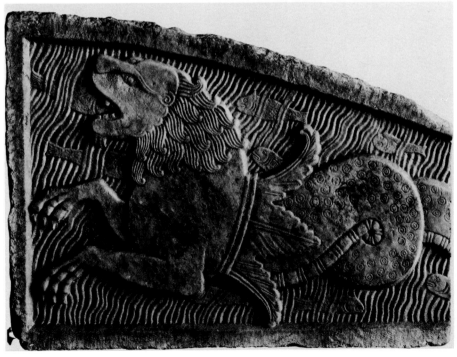

Fig. 230

Fig. 231

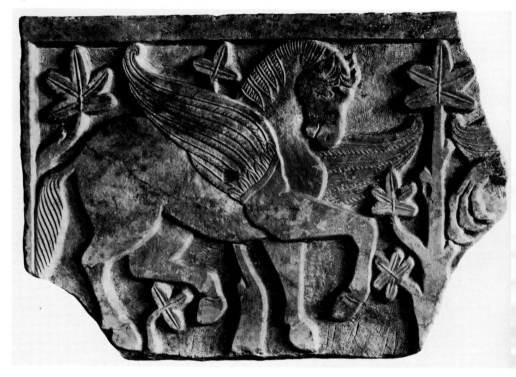

Index of Provenances

Index of Iconography

(Figures refer to page, chapter, and inventory number, in that order.)

1. Religious subjects

Adoration of the Magi, 22, I/5
Adoration of the Shepherds, 65, VIII/6
Angel, 104, XI/6; 150, XII/2
Angels with Lamb of God, 180, XII/29
Annunciation, 74, IX/8
Annunciation to Zachariah, 126, XI/1
Apocalyptic Elders, 77, IX/1; 169, XII/28
Apostle, 102, XI/3
Apostles, 34, II/4; 113, XI/15; 200, XII/53

Cain and Abel, 128, XII/1
Chrismon, 115, XI/17
Christ crucified, 105, XI/8
Christ from a Deposition, 97, X/17
Christ in Glory or Ascension, 159, XII/17
Christ in Majesty, 35, II/5; 204, XII/54
Crucifix, 29, II/1; 67, IX/1

Daniel in the Lions' Den(?), 82, X/4
Deposition, *corpus* from, and cross, 199, XII/52

Elizabeth and John, 126, XII/1
Entry into Jerusalem, 77, X/1
Evangelist symbols, 83, X/6; 88, X/10
Evangelists, 18, I/2

Feeding of Four Thousand, 157, XII/17

Hell-mouth torments, 60, VIII/1
Herod, 72, IX/5

Journey to Emmaus, 132, XII/1; 156, XII/17

King, head of, 184, XII/33

Marys at the Tomb, 205, XII/54

Noli me Tangere, 156, XII/17

Passion scenes, 81, X/3

Sacrifice of Blood, 157, XII/17
St. Gilles, 145, XII/6
St. Michael and the Dragon, 115, XI/17
St. Paul(?), 175, XII/29
St. Peter, 30, II/2; 54, VI/1
Sts. Peter and Paul, 55, VI/2
Samson scenes, 160, XII/18

Virgin and Child, 17, I/1; 40, III/1; 110, XI/13
Virgin from an Annunciation, 196, XII/51

2. Mythological, moralizing, and decorative subjects

Acrobat, 118, XI/17
Atlante, 52, V/4
Avarice, 105, XI/7

Barrel (Intemperance?), 38, II/7
Basilisk, 83, X/6
Bears(?), 92, X/14
Beasts, naked men, 41, III/2
Beasts, naked women, 51, V/3
Bird, 163, XII/20
Bird and basilisk, 95, X/15
Bird ensnaring hare, 27, I/12; 53, V/5; 92, X/14; 93, X/14
Birds, 24, I/7; 27, I/12; 33, II/3; 53, V/5; 89, X/12; 93, X/14; 94, X/14
Birds pecking grapes, 63, VIII/3

Dancer(?), 167, XII/24
Dragons, 70, IX/3; 87, X/9; 102, XI/4; 103, XI/5; 167, XII/24